2-10

THE PLEASURES OF
GOOD PHOTOGRAPHS

THE PLEASURES OF GOOD PHOTOGRAPHS

Essays by **Gerry Badger**

aperture

John Gossage, *First Day with the Leica, Washington, D.C.,* 2007

CONTENTS

INTRODUCTION

"Leaving aside the mysteries and inequities of human talent, brains, taste and reputations, the matter of art in photography may come down to this; it is the defining of observation full and felt." —Walker Evans[1]

It is just over thirty years since I wrote my first essay on the subject of photography, and over forty since I first became hopelessly beguiled by the medium. I began my writing career with a piece on the work of Wynn Bullock for the Royal Photographic Society magazine.[2] The great West Coast photographer was having an exhibition at the then RPS headquarters in South Audley Street in London's Mayfair, and I was "volunteered" to write the piece because I said I knew something about his work and was enthusiastic about it. I was most gratified to receive a fulsome letter from Bullock about the article—a letter I still treasure. I learned soon afterward from his daughter, Barbara, that the letter had cost him much effort, as he was in the last stages of his final illness. Indeed, a note from Barbara informing me of his death arrived soon after the first missive.

Wynn Bullock's kind letter encouraged me greatly, and reviews of exhibitions by Manuel Álvarez Bravo and Lee Friedlander[3] soon followed. In addition to taking my own photographs and pursuing a busy career in architecture, I have been writing about photography ever since.

So in a way, I rather stumbled into photo-criticism, but looking back at some of those first pieces, I realize that I was writing not so much to explain the work of these photographers to an audience, but to understand it for myself. And that, I hope, has been my guiding principle ever since. Rather than talk to the reader in the manner of a teacher—which often means talking down—I try to construct a personal meditation on a photographer's work, as if thinking aloud about it. I dislike hectoring criticism, and although I have strong opinions, I hope I leave room for other points of view in my writing.

I was fortunate also to begin by writing about the work of three great photographers. The richer and more complex the work, the more nourishment for the critic to feed upon.

My introduction to the medium in the early 1960s came at a time when John Szarkowski was leading the fight for photography to be recognized as a fully fledged art form. Szarkowski was the champion of classic modernist photography in the "documen-

tary mode," and this was—and still is—my basic approach. Yet when I began writing about photography in the mid-1970s different critical attitudes, often vehemently opposed to the Szarkowski position, were gaining ground. I fully admit that I was somewhat slow in taking to some of these ideas, particularly those of the French structuralists, and I still have grave doubts about the wilder shores of academic theory. Certain checks were necessary, I suppose, to counter the iniquities of reductive formalism, yet the pendulum on occasion undoubtedly swung too far. I still fundamentally believe—despite what many might say to the contrary in the furtherance of their careers—that most photographers make photographs not to illustrate theories but to make pictures. As I have said elsewhere, many things might move a photographer, but not always to take a photograph.

I suppose that I stand somewhere in the middle of the battle between the formalist and contextual schools of criticism. I still firmly believe—if not in genius—at least in talent. In my opinion, anyone who doesn't just isn't looking. But when I began in photography, my primary interest was in the fight for its recognition as art. Now, I am not sure if I care whether photography is art or not. Too often, those looking to make photographic "art" deny its basic documentary faculty. For me, the documentary, or the "documentary mode," remains not only the core of the medium, but the source of its greatest potency. Those making hybrid work, or photography about photography rather than the world, have to fight harder for my attention than those documenting modern life.

My feelings about the medium will emerge in greater detail during the course of these essays, which, with two exceptions, have been written for this book, although I have incorporated some material here and there from previously published essays.[4] This book could be looked upon as something of a survey of my past interests, so familiar names crop up, along with favorite quotes.

As far as writing about photography is concerned, for me the master was Szarkowski. He could be a little narrow in his perspective at times, but he was second to none as a stylist and was supreme in his insights. His great virtue was that he himself was a photographer, so he knew from experience the kinds of thoughts that went through a photographer's mind at the crucial moment of clicking the shutter.

Szarkowski, I suspect, learned a thing or two about photographic writing from Walker Evans, who might have been the best writer ever on the medium if he had written more. I don't know how much Evans learned from Lincoln Kirstein, but for me the finest single piece on the medium was written by Kirstein as the afterword to Evans's own great 1938 photobook, *American Photographs*. In that essay, Kirstein sketched a vision of photographic modernism that was much broader than simple formalism. It was an austere, yet grand vision, one that I feel remains as relevant today as on the day it was written. I frequently return to Kirstein's wise words when I am faced with, and am depressed by, some of the atrocities one sees at photo fairs and in the galleries.

American Photographs of course is one of the seminal photobooks. It certainly has been the biggest single influence on my photographic career. I have become particularly associated with the photobook—to my great delight—for it is in the photobook, in my opinion, where photography sings its loudest, most complex, and satisfying song. Many of these essays, while about a photographer's work, are about one or more of their books.

But these are interesting times for both the photobook and the medium. Photography's value as art has never been so high, yet in these mediawise and Photoshopping times its value as documentary has never been so questioned. The photobook is enjoying an unprecedented boom, although this phenomenon may simply reflect its last hurrah before the book as a physical object more or less disappears. Yet, excitingly, on the computer screen that may see it into history, photographers will be able to combine photographic images with text, sound, and segments of movie film. I like to think that the book will survive, but this may be only wishful thinking. At a symposium on the photobook in November 2006, I and the other speakers—all of a certain age—were optimistically expressing the view that the tactile qualities of the book would always be cherished, and who would want to stare at a computer screen, and so on and so forth. Then some kid from the audience, in his late teens or early twenties at the most, expressed the scornful view that we were all talking horseshit, or words to that effect, and he may well have been right.

Still, whatever the technology of production and dissemination, the basic act of photography, and the basic reason for doing it, will remain constant. You point the camera—or the cell phone—at the world, and take a picture, a little nugget of magic realism. This book hopefully is about what those little nuggets might mean to us, and that is a fascinating, a contentious, and an unending debate.

Notes

1. Walker Evans, "On Photographic Quality," in *Quality: Its Image in the Arts*, Louis Kronenberger, ed. (New York: Balance House, 1969), p. 170.

2. Gerry Badger, "Wynn Bullock," *Photographic Journal* (London), Vol. 115, No. 5, May 1975, pp. 206–13.

3. Gerry Badger, "The Labyrinth of Solitude: The Art of Manuel Álvarez Bravo," *British Journal of Photography* (London), Vol. 123, No. 6,043, May 21, 1976, pp. 424–28, and "Lee Friedlander," *British Journal of Photography*, Vol. 123, No. 6,032, March 6, 1976, pp. 198–200.

4. I have included the introduction to Anthony Hernandez's book *Waiting, Sitting, Fishing, and Some Automobiles (Los Angeles, photographs of)* and a review of the book *Anna Fox: Photographs 1983–2007*, both of which have been amended for this volume.

The Pleasures of Good Photographs

For as long as I can remember I have enjoyed looking at photographs. If I was pressed to recall when I began a lifelong pursuit of the ultimate photograph—that is to say, the next photograph to intrigue, appall, or delight me—I might say the 1950s and *National Geographic* magazine. It is fashionable today to decry the *National Geographic* of that era, with its barely disguised colonial attitudes, but for a child of nine or ten growing up in the austerity of postwar Britain, it was the most glamorous photographic magazine around. Its images fulfilled one of photography's basic requirements. They took you *there*—to exotic, sunny, and colorful places, far away from gray, damp, cold Britain. And in those censorious times, for a boy on the verge of adolescence, the fact that some of those faraway places seemed to be populated by women who apparently wore little in the way of clothing, added even more spice to the magazine's delights.

So, for me, looking at photographs is first and foremost a pleasurable activity, as it clearly is for Lee Friedlander. Friedlander is one of the most laconic of photographers and prefers to let his photographs do the talking, but in a 1974 issue of *Aperture* he ventured the following about the medium. It is one of his best-known and often-quoted aphorisms and seems to be a perfect summation of his own approach: "The pleasures of good photographs are the pleasures of good photographs, whatever the particulars of their makeup."[1]

But for "pleasures," also read "meaning," for I think this is what Friedlander was getting at when he coined the phrase. He was musing (though far from idly) upon the meaning, upon the "genius" of photography. And that immediately raises an anomaly. To talk about shared meaning or synonymous pleasures with regard to photography seems an inordinate conceit. The medium has such a diversity of aims and ambitions—creative, utilitarian, therapeutic, shamanistic—that meanings surely must be contingent and open-ended, fluid and provisional. Thus any meaning that I define or speculate upon is personal, a private meditation about what photography means to me as a practitioner and lover of the medium, and a firm believer in its efficacy as an art form. Yet I am also talking about the personal within a specific context, a shared tradition and a collective way of thinking about photographs. From everything I know about Lee Friedlander, that is to say from my experience of his work—and that of Walker Evans, Robert Adams, or Henri Cartier-Bresson, to name a select few—I feel perfectly in accord with that provocative statement. It is the pleasures of good photographs, and the pleasures afforded by good photographers, that I propose to explore in this book.

But if looking at photographs is a pleasurable activity—it is pleasurable in a complex, transformative, frequently unsettling sense. It is not pleasure unalloyed, for no profound pleasure is pure and photography is certainly no exception. Like many truly enriching

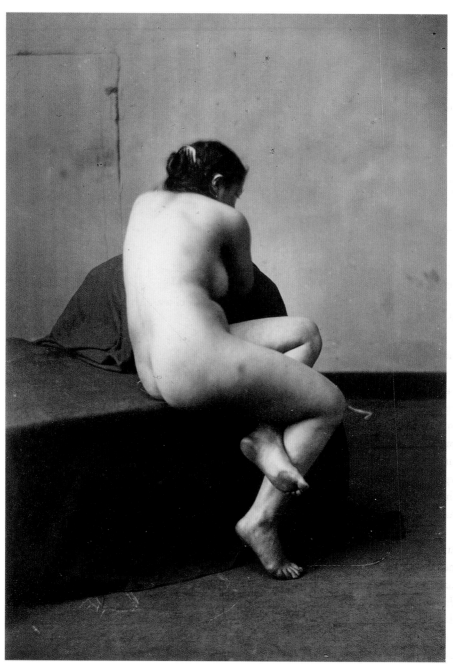

Paul Berthier, *Jeune femme nue assise, de dos*, ca. 1865

pleasures—Edgar Degas, Richard Wagner, mountains, deserts, Alice Munro, Maria Callas, sex—photography has its dark, troubling, even dangerous aspects.

Firstly, photography is fundamentally a deeply melancholic medium. The photograph, while evoking life, also inevitably evokes death. "All photographs are memento mori," wrote the late Susan Sontag.[2] By the time you photograph a moment, then develop the film and make a print, or nowadays download it onto your computer, that recorded moment is history. This does not mean that photography cannot be used to talk about contemporary life. Paradoxically, the best subject of photography is modern life, but that quickly passes into history. If photography's *subject matter*, the stuff photography deals with, is reality or actuality—what is out there in front of the camera—the *subject* of photography is, or should be, history in one form or another.

Some photographers—actually many photographers—deny that and attempt to make "timeless" photographs, often by photographing things like rocks or trees or mountains. Yet this I feel is to miss the point somewhat about the essential nature of photography. That is not to say that good photographs cannot be made of rocks or trees, but they will be all the better if the photographer can relate them to history, to the world of human culture rather than just the photographer's personal sensibilities. This, I believe, is true of all photography—and it can be done.

Secondly, any photographer of ambition, trying to say something significant with the medium, comes up against a fundamental question of perception. To make a photograph, you point a camera at the world in front of you, press the shutter, and it's done. What you have contained in the photographic print is a simulacrum of a fragment of the world, and that is precisely how many people view it, as a mirror of the world and not as an image, an intelligent representation of it. And this attitude can be found in even those one might imagine were photographic sophisticates. Susan Sontag, for instance, wrote one of the most fundamental modern texts in her 1977 book *On Photography*, yet a primary basis of her argument—a meditation upon photography's problems and a critique of modernist art photography—contains the following sentence: "In photographing dwarfs, you don't get majesty and beauty, you get dwarfs."[3]

This statement rather precludes Friedlander's contention that photographic pleasures have a common basis in the medium itself. The pleasures of good dwarfs clearly are not the pleasures of good horses, or good rocks. A photographer, in short, is his or her subject matter. An interesting photographer is one who can find interesting subject matter. Unpleasant subject matter generates unpleasant photographs, devoid of any pleasures. The photographer can do little to mitigate this fundamental limitation, except take the whole thing beyond photography into the realm of carefully constructed tableaux or joint ventures with other media, both of these now being made relatively easy by computer-image manipulation programs.

On these terms, Friedlander's assertion would seem to be doubly fallacious, a wrong-headed modernist/formalist conceit, for not only does it pander to the pleasure syndrome, it presupposes that all photographs share an internal language, a structural vocabulary independent of the subject. This is the modernist photographer's position, that by utilizing this vocabulary or language—the medium's unique formal properties—in tandem with his or her personal visual sensibilities, the would-be photographic artist constructs a unique "style," thereby earning the right to be considered an auteur.

In *On Photography*, Sontag questioned the whole idea of the photographer as auteur, the whole notion even, of photography as an art. Photography, she argued, presents particular stylistic problems by its very nature. Where, for example, she asked, was the authorial consistency in the work of the nineteenth-century photographer Eadweard Muybridge? Muybridge is known for his landscape photographs of Panama and Yosemite, his studies of clouds, and most notably, for his investigation into human and animal locomotion.[4] While each body of work exhibits stylistic consistencies in itself, there would be nothing, she postulated, to connect the Yosemite landscapes with the movement studies if we did not *know* that they were by the same author. Thus, style in photography, concluded Sontag, would seem to be more a by-product of subject matter rather than authorial treatment.

Sontag's book was of course one of the most prominent in a whole series of texts throughout the 1970s and '80s that questioned not just modernist photography but modernist art in general and modernism's primary creed that each artist was a creator, a genius with a unique style. The book was a challenge not only to the art museum establishment that had embraced photography, but to photographers of all persuasions. For since the beginning of the twentieth century, it could be said that the history of "creative" photography has been a dance by photographers round the totem pole of auteurship. One of photography's major themes has been that of the medium's upward mobility, and that of the photographer of ambition—whether operating in the journalistic, commercial, or "art" spheres—seeking a rise in status from journeyman to auteur, from auteur to artist.

It was never a question of steady progress. Photography's relationship with the modernist movement was always an unruly one. This upward mobility was granted to some photographers and not to others, however deserving or undeserving. It was granted generally to the medium in the 1960s by the art museum, snatched away in the '70s by postmodern theory, only to make a spectacular comeback in the '90s, courtesy of the contemporary art market and the rise of the "artists utilizing photography" syndrome.

Although the Museum of Modern Art had inaugurated a department of photography in 1941, it was not until the 1960s and '70s that photography was generally admitted to the academy, shown widely in museums, and, more crucially, taken up by the gallery. Photography seemed at last to be taken seriously, enough for a sector of the art market to laud the cult of the auteur and trade "original" prints like any other art commodity.

This revolution had hardly begun, when the seeds of the counter-revolution were sown, both from within and without. Having muscled in on the art world—albeit around its fringes—a lot of photography became afflicted by the very malaise affecting modernist painting, then undergoing what many now see as its terminal crisis. Many photographers—now would-be "artists"—turned from making pictures about the world to making pictures about the medium. Photography rapidly became coyly self-referential, reduced to formal gesture and bland decoration. Attempts were made to resuscitate old academic genres: the still-life, the studio construction, the staged event. Technical tinkering became common-place, marked not only by a concentration upon the "fine print," but a widespread revival of craft-orientated processes, ranging from hand tinting to non-silver prints to drawing on photographs.

However, this kind of vapid, self-referential photographic modernism was strangled by those forces that shifted the goalposts of visual culture—the phenomenon of postmodern-ism. *On Photography* was among the most prominent critiques primarily because Sontag, in this collected anthology of essays originally written for the *New York Review of Books*, actually wrote in clear, precise English. Interpreting a whole raft of ideas from various theoretical writers, dating back to Walter Benjamin and taking in the French structuralist school of criticism, she elucidated some difficult ideas without once patronizing her audi-ence. In these essays she took modernist photography thoroughly to task. Photography, she asserted, was a dangerous and inherently reactionary cultural tool. It could be per-ceived as a powerful political weapon because its immense plausibility masked its partial-ity, its apparent objectivity distorting the fragmentary and often dissociated nature of its nominal truths. Photographers as a breed, continued Sontag, were colonizers of reality, interposing an all too often mindless but hardly dumb instrument of judgement between themselves and the world.

The implications of Sontag's critique issue a clear challenge to photographers. They do so because much of the new criticism deems photographers largely irrelevant, and in many cases positive nuisances in that they hinder the construction of an ideologically cor-rect reading. To the contextualist the reality and complexity of the photographer's subject matter—that is, the world—will inevitably dominate the image and subvert the photogra-pher's intention. Subject matter is deemed so powerful as to be almost self-mediating, the camera proving an inherently transparent, relatively intractable tool. "In photographing dwarfs, you don't get majesty and beauty, you get dwarfs."

If photography's subject matter is the world, it means that anything and everything goes into the critical discourse, which is why photography is such an ideal departure point for the art-sociologist breed of critic. And so we get critical methodology in which the commentator has a rummage through such disciplines as psychology, sociology, art his-tory, literature, and politics, not, it would seem, with the intention of elucidating some-

thing about the image, but to demonstrate how many obscure academic publications he or she has read. The result is a cultural determinism that is at least as bad as the purely formalist approach. As Mary Warner Marien has written: ". . . it is difficult to see how a new history will emerge through ersatz Marxism, which threatens to enucleate the promise of social analysis with glib and giddy determinism, while making the study of photography extremely remote."[5]

It also, however, has affected the kind of photographs being made by contemporary photographers. To begin with, such dangerous qualities as the unruly and the phenomenal must be dispensed with. With the elitist hedonism of modernist formalism apparently vanquished by the demotic pluralism of postmodern contextualization, much photography seems to have been herded down a narrow box canyon with continental ambitions called representational theory. The late Lincoln Kirstein, a wise and eloquent advocate for photography, wrote that the photographer of ambition requires "a large quality of eye and a grand openness of vision."[6] Not so. The contemporary photographer, it would seem, requires Theory.

This new orthodoxy largely proscribes Friedlander's pleasures. It dictates that photographers must no longer take photographs in order to see what the world looks like in a photograph—the basic credo of modernism. Such a mission, it seems, is altogether too simplistic. Rather, our energies should be devoted to constructing photographic "texts," which refer to other photographic "texts," or "meta cultural texts" at large. The medium as message is dead. Long live the message as medium—except that very few proponents of such an outlook have anything much to say beyond quoting pre-existent messages, and quoting them in increasingly vapid and predictable fashion.

In addition to demoting the notion of visual pleasure, postmodern representational theory is predicated upon the idea that the texts embodied in works of art are not medium-specific. The fact that a subject is, for example, a nude—with obviously wide cultural, symbolic, and psychological implications—becomes more significant than the medium in which it is executed. If the primary modernist credo could be articulated as "it ain't what you do, it's the way you do it," postmodernism holds that the "what" is much more important than the "way"—particularly in light of another crucial tenet, postmodernism's disavowal of the artist as "creator" in favor of the admittedly more accurate "juggler of signs." In short, the old form-versus-content dichotomy has been stood on its head, and with it the belief that each medium has its own unique, expressive characteristics. *Inter-textual*, *inter-media* are the buzzwords.

However, at least the contextualists, especially the social contextualists, are concerned with meaning outside the fine art reservation. If theory taken to an extreme is unnecessarily limiting, so is the opposite extreme—that photography, like painting, should be independent of subject matter, its meaning residing primarily within the confines of the frame. This

credo holds that the individual sensibility of the photographer and the disposition of forms within the picture space are the only things that count. Frame the murder victim gracefully enough and the image becomes a metaphysical speculation upon the hereafter or man's eternal inhumanity to man rather than a specific report upon an act of violence. Photography, in short, is moved from the realm of the historic to the flaccid confines of the ahistoric. *Subject matter* becomes of minor import, and if it overwhelms photographer intention it is downright dangerous. *Subject* is the key, subject matter transmogrified by form, intent, ambition, causality. For the out-and-out photographic modernist, all the strategic formal devices deployed in other media should be simply at the dumb service of the "creative" photographer, and hang subject matter if it is anything other than the raw material for formal speculation, or actually means something out there in the world.

· · ·

So what is the optimum balance between form and content in photography? This million dollar question will be the focus for much that will follow, as will other dichotomies that, depending upon your point of view, either plague the medium or make it more interesting. There is no universal photographic culture, but a number of photographic cultures. They have emerged not just from matters of function and marketplace, but theoretical differences that also have practical and economic effects. There is, for example, the rift between modernism and postmodernism, the apparent reaction against the hermetic formalism of extreme modernism. There is the phenomenon whereby common or garden variety photographers are perceived as being inferior to "artists utilizing photography," and the result is not only a huge disparity in print prices, but also a subtle system of segregation employed by certain galleries. Even that hoary question, dating back to the medium's beginnings, is still with us. Is photography capable of being an art at all, and if so, what kind of art? And furthermore, where is the proper place for creative photography, where is the art of photography at its most potent? Is it an art that is closer to literature, an art destined to be put between covers, or is it a form of painting, best displayed upon the gallery wall, to be trumpeted as the "new painting," or even the "new history painting?" These questions, and a whole raft of anomalies, contradictions, and problems—aesthetic, cultural, and moral— will crop up again and again as I consider this fascinating and tantalizing medium.

Let me declare a position at the outset that I likely will contradict in the course of my musings. I may even finish with a different position, or at least have tempered my initial position with a number of caveats. If photography is so contradictory—and it often is— critics can reserve the right to be contradictory as well. I agree with the following plea from Mary Warner Marien, although I am not sure how close we might come to the ideal situation she articulates: "If in practice, not in theory, photography is a unique medium, that uniqueness must be spelled, not articulated as a matter of faith, and it must be brought to

bear equally on art photography, non-art photography, and mass media photography."[7]

The basis of my position is this. It rests, I think, upon two truths that I hold to be self-evident. The first is that photography is not only potentially an art form, it is one of the most important art forms of our time. The second is that photography is not simply an inferior form of painting, or a system of cultural signs, but that it has qualities—shared in part, but only in part, with film—which set it apart from other media, and that, despite its myriad problems, it is one of the most beguiling and (returning to Friedlander) pleasurable of mediums.

A clear answer to Warner Marien's observation is to stress photography's relationship with reality. Uniquely among visual media, the camera makes a trace of what is in front of it, slicing up pieces of actuality, parceling them up into sections defined by a particular moment in time and the boundaries of the viewfinder. The camera gathers evidence suggesting that something existed, providing, as John Stathatos has written, "a memory trace."[8]

And yet the photograph is only a trace of memory. As Roland Barthes wrote, "not only is the Photograph never, in essence, a memory . . . but it actually blocks memory, quickly becomes a counter-memory." The issue is not "a question of exactitude, but of reality."[9] The photographic trace provokes the certainty that something existed, yet it is only a simulacrum of reality. An infinite, circular equation, the answer to which must be (if we are dealing with a "true" photograph) that the power of authentication exceeds the power of representation. A fiction that is not a fiction, yet is and isn't a fiction.

Photography's relationship with reality, so simple, so profound, yet so damnably slippery, is unique. The pleasures of good photographs derive principally from an encompassing of that relationship within the image. Photography, more than any other art, is the "art of the real." The trade name of one of the new generation of color films, Fuji's Reala, attests to that fact, with perhaps a hint of irony as we enter an age when, courtesy of computer wizardry, we can generate a thoroughly "unreal," yet convincing "reality" at the touch of a button.

But even the unreal makes more of a point by referring to the real. Nonetheless, the good photograph, that is, the "true" photograph (for the photo-hybrid is here to stay, and we may need a new nomenclature for it) embodies an understanding of the medium's link with reality, evincing a respect for it on the part of the photographer. This understanding may be an intellectual one, or it may be intuitive, wholly unconscious. As serious photographers know, a simple snapshot, made by a child, may distill this ineffable quality more readily than a self-conscious attempt to produce photographic art. For the snapshot is concerned only with the fundamental task of reproducing reality. It demonstrates first and foremost a desire merely "to recognize and to boast," as Walker Evans put it.[10] The first great pleasure in photography, therefore, is a quality I would term "thereness." By no

means every photograph exhibits it. Indeed, at its freshest it is much rarer than one might suppose, and it can take a photograph a very long way in the pleasure stakes. Barthes defined it with admirable brevity, writing about an image of the Alhambra taken by the early photographer Charles Clifford: "This old photograph (1854) touches me: it is quite simply *there* that I should like to live."[11]

Thereness is a sense of the subject's reality, a heightened sense of its physicality, etched sharply into the image. It is a sense that we are looking at the world directly, without mediation, or rather that something other than a mere photographer is mediating. The camera alone perhaps, windowing the world without art or artifice, or that mysterious power itself—reality—gives form and shape by the magical conjunction of chemical surface and light. Such a feeling, such artlessness, when present in the photograph, can of course conceal the greatest photographic art. Thereness is seen at the opposite ends of the photographic spectra, in the humblest holiday drugstore print as much as the most serious "art" photograph; in the snapshot-inspired, dynamic, small-camera candid as much as the calm, meditative, large-camera view. Those photographs that conjure up a compelling desire to touch the subject, to walk into the picture, to know the photographed person, display thereness. Those photographs that tend toward impressionism, expressionism, or abstraction can be in danger of losing it, or never finding it, although there is no inviolate rule about this.

Thereness, in short, is a quality that has everything to do with reality and little to do with art, yet it is, I would reiterate, the essence of the art of photography. Walker Evans, whom I have already quoted, and whose own work I shall be coming to before long, and who could be called upon to define thereness, wrote the following about a photographic postcard—an image taken by a journeyman of modest talent and probably modest aspirations, but an image possessed of the one essential quality: "Made as a routine chore by heaven knows what anonymous photographer, the picture survives as a passable composition, a competent handling of color, and a well-nigh perfect rendering of place."[12]

But there is another element besides place that makes for thereness in photography, and that is time. As I found out during my early flirtation with *National Geographic*, photography takes you there, not just in a geographical but also in a temporal sense. Photography is a time machine, especially in relation to people. The vicarious attractions of photography might be measured largely by the medium's faculty to project us directly into visual contact with the physiognomy of someone at the farthest ends of the earth, or a human being who now exists only in history. That is powerful stuff indeed. For all their haunting presence, the faces of the individuals on Fayum mummy cases, Elizabethan miniatures, Jacobean engravings, and Renaissance oil paintings, are fictions. Whether painted by anonymous craftsmen, or by Holbein, Rembrandt, Ingres, or Sargent, they are filtered through the veil of a secondhand intelligence—be it adroit or maladroit, perceptive or imperceptive, stun-

ningly masterful or boringly mediocre. But no matter how technically inept, how lacking in considered formal qualities, a photograph must always stop us short. For it brings us into direct communication with time past, and it transcends geographical boundaries. It puts us into immediate touch with the long ago and far away, with the quick and the dead. Photography makes known the unknowable.

As Roland Barthes rightly remarked of photography's faculty to reproduce a trace of the actual, "this is a strictly scandalous effect. Always, the Photograph *astonishes* me, with an astonishment which endures and renews itself inexhaustibly." And he was moved further to proclaim that photography is "a *magic*, not an art."[13]

When early photographers from the colonial countries visited remote societies in the nineteenth century and demonstrated photography, there was a widespread belief among native populations in various parts of the world in the magic of photography, and that to be photographed meant that one's soul had been stolen. Like Barthes, I believe absolutely in the talismanic power of the medium, for the photographic portrait can be immensely potent, much more so than the painted portrait. And the emotions one feels when looking at a photographic portrait are so mixed.

But if the camera has the propensity to steal souls, the corollary of that is the confirmation of immortality, or at least a modicum of vicarious fame until humankind wipes itself out. To see a blurred, impassioned Thomas Carlyle is amazing. However indistinct, Julia Margaret Cameron's impassioned transcription is as fine a rendition of creative energy and human vitality as has been made. Alexander Gardner's portrait of Lincoln conspirator Lewis Payne makes us shudder. The nervous but still defiant and handsome face of the manacled youth seems so modern, so contemporary, as he awaits the fate decreed for him after the assassination. Unlike Payne, we can jump forward in time to another photograph taken by Gardner, of his body, head now hooded, dangling from the scaffold.

But it is not only those who are the subject of public scandal, the rich, the famous, the infamous—those who populate the pages of our history books and attract our prurient interest—who have thereness conferred by the camera. Consider E. J. Bellocq's Storyville prostitutes, each and everyone a sharply defined individual, and no object of lubricious spectacle. We do not know their names. Nor do we know the names of Paul Strand's heartbreaking blind woman, nor August Sander's three young farmers on their country walk, nor Henri Cartier-Bresson's family of would-be gourmands, picnicking by the Marne. In Cartier-Bresson's definitive decisive moment, we do not even see the protagonists' faces. Yet, I, at least, am affected by an overwhelming sense of something I cannot quite define, a sense of fellow feeling perhaps, an urge to share a glass of wine with them and know their stories, a compelling need to reach out and touch the real—and equally, to be touched by the real.

In 1998 a splendid, exemplary exhibition at the new Bibliothèque Nationale de France

in Paris, *L'Art du Nu au XIXe Siècle*, displayed photographs of the nude along with contemporary engravings and paintings inspired by the photographs.[14] In such a direct comparison, one thing was abundantly clear. The photographs generally were much more lively, moving, and involving than the paintings or drawings (most of which, admittedly, were not by painters of the first rank). For the most part, the graphic artists had copied the poses but had not captured the startling reality, the immediacy evinced by the photographs.

They had carefully smoothed out any bodily imperfections, and in so doing had created nymphs and heroes, gods and courtesans, but not men and women. Of course, the two great Courbet nudes[15] in a strictly realist vein, based on photographic poses by Julien Vallou de Villeneuve, could not be shown for reasons of space, nor anything by Degas, but the point was made. Many of these early nude photographs quite simply *touch* us, they contain reserves of poignancy few paintings can equal, though the same cultural and class attitudes that informed the nineteenth-century painted nude informs them. Indeed, we must not forget that we are talking of photographs made, under the paltry guise of academic studies, for often dubious purposes and a dubious clientele, images made by photographers who also produced out-and-out pornography.[16]

One of the most magisterial and touching photographs in the exhibition, no more than a paltry 7¼ by 5¼ inches, was a study by Paul Berthier—a clear example of a life study, not thinly veneered eroticism (page 10). In this supreme example of unadulterated *realism* in early nude photography, a "far from ideal" female figure sits slouched on the end of a chaise lounge. The lighting and compositional elements are stunningly "there" but, as in so many of these early photographs, we are drawn to incidental nuggets of reality that, as it were, have just been "dropped off" in the negative. The world-weary pose is amplified vividly by the model's grubby feet and the bruise on her thigh. This reminds us indelibly of the social exchanges that produced such imagery, Victorian "values" that necessitated the almost forced employment of servants and prostitutes to pose at a lowly few francs an hour. Here is photography at its most powerful, a nude equal to any bather by Degas, containing in abundance the one element that eluded even that great realist—the pungent whiff of reality itself.

Of course, it might seem that almost any photograph could contain such qualities by sheer accident. Did Berthier notice, or care about the model's dirty feet or bruised thigh? Any photograph must surely gain the luster of temporal fascination, irrespective of photographer intent, if we wait long enough. Indeed, photographs only a decade old begin to acquire the patina of long ago and far away. Clearly, almost any photographer, knowingly or unknowingly, can take a photograph displaying thereness on these terms, a quality that will only be enhanced as time adds an alluring melancholia—as the Bibliothèque exhibition readily demonstrates. That, as I have already intimated, takes us a long way in the photographic pleasure stakes, but only photographers of serious intent can venture beyond

that, beyond the single startling, poignant, beautiful photograph, for that requires a *body of work*.

It is a question, as in all art, of complexity, of the levels at which an image works. I frequently quote something that Robert Adams wrote, and make no apologies for quoting it once more, because it has a lot to tell us. Indeed, while we are in the business of offering no apologies, the frequent quotations department will be called into action many times during the course of this narrative.

Adams was writing specifically about landscape photography but he might have been talking about all photography. "Landscape pictures can offer us, I think, three verities—geography, autobiography, and metaphor. Geography is, if taken alone, sometimes boring, autobiography is frequently trivial, and metaphor can be dubious. But taken together . . . the three kinds of information strengthen each other and reinforce what we all work to keep intact—an affection for life."[17]

He might have added history to his list of verities, or psychology, but that does not matter. The point he was making was about the kinds of things photography and photographers can talk about, and the levels at which the medium might work, at least in the hands of a consummate photographer such as himself. And, note that in his exhortation to maintain an affection for life, he does not neglect the pleasures of photography.

Adams has also quoted a famous aphorism by Lewis Hine with regard to his work, as did Cornell Capa in his 1968 book, *The Concerned Photographer*, when trying to define what a "concerned photographer" actually was. On the occasion of a retrospective exhibition of Hine's work at the Riverside Museum in New York, an exhibition that marked his rediscovery after a period of isolation, he said to the writer Robert W. Marks: "There were two things I wanted to do. I wanted to show the things that had to be corrected; I wanted to show the things that had to be appreciated."[18]

Any photographer taking note of Hine's words, and who tries to put them into practice, is making a good beginning.

Notes

1. Lee Friedlander, quoted in Jonathan Green, ed., *The Snapshot* (New York: Aperture, 1974) *Aperture* magazine (published in book form), Vol. 19, No. 1, p. 113.

2. Susan Sontag, *On Photography* (New York: Farrar, Straus and Giroux, 1977), p. 15.

3. Ibid., p. 29.

4. Ibid., pp. 134–35.

5. Mary Warner Marien, "What Shall We Tell the Children? Photography and Its Text (Books)," *Afterimage* (Rochester, New York), April 1986, Vol. 13, No. 9, p. 7.

6. Lincoln Kirstein, afterword, in Walker Evans, *American Photographs* (New York: Museum of Modern Art, 1938), p. 188.

7. Warner Marien, "What Shall We Tell the Children?," p. 7.

8. John Stathatos, "Positively Art," in *02 Exposed*, supplement to *Tate: The Art Magazine* (London), January–April 1988, p. 5.

9. Roland Barthes, *Camera Lucida* (New York: Hill and Wang, 1981), pp. 91, 80.

10. Walker Evans, in *The Snapshot*, see note 1, p. 95.

11. Barthes, *Camera Lucida*, p. 82. The italics are Barthes'.

12. Evans, *The Snapshot*, see note 1, p. 95.

13. Barthes, *Camera Lucida*, p. 88. The italics are Barthes'.

14. *L'Art du Nu au XIXe Siècle: Le Photographe et son modèle*, curated by Sylvie Aubenas, Sylviane de Decker-Heftler, Catherine Mathon, and Hélène Pinet, was shown at the Bibliothèque Nationale de France François-Mitterand, Paris, from October 24, 1997, to February 21, 1998. A catalog was published with the same title.

15. These are *Les Baigneuses* (1853) and *L'Atelier* (1855).

16. *L'Art du Nu* concentrated upon *académies*, for it was these "studies for artists" that were deposited with the Dépôt Légal of the Bibliothèque Nationale from 1851 in order to copyright them and confer at least a semi-legal status for their makers. Most of these photographers, however, also produced imagery of a far from legal nature, pornographic photographs showing every conceivable kind of sexual coupling. Interestingly, the exhibition did display a few images of a more directly salacious nature, which entered the collection of the Bibliothèque having been the subject of police action.

17. Robert Adams, "Truth and Landscape," in Robert Adams *Beauty in Photography: Essays in Defense of Traditional Values* (New York: Aperture, 1981), p. 14.

18. Lewis W. Hine, quoted in Robert W. Marks, *Portrait of Lewis Hine*, in *Coronet* (New York), February 1939, pp. 147–57.

Literate, Authoritative, Transcendent:
Walker Evans's *American Photographs*

I think I first "got" photography—or at least made a giant step toward getting it—when I read an article by David Vestal in the thirtieth anniversary issue of *Popular Photography* in May 1967. I still have that copy of the magazine, now stuck together with tape.[1] When one is young, epiphanies strike with the force of a thunderbolt, so one tends to hang on to them—the battered magazine, the scratched copies of Miles Davis's *Kind of Blue*, Bob Dylan's single *Like a Rolling Stone*, or Karl Böhm's version of Mozart's *Così Fan Tutte*. The records are long gone, having been replaced by more convenient CDs, but I am looking at the yellowed pages of the magazine as I write this, and marvelling at how this epiphany emanated from a tiny, badly reproduced photograph and three short sentences.

By the time I bought this particular issue of *Popular Photography* I was in my twenties, and had graduated from *National Geographic* to other magazines such as *Amateur Photographer*, *Photography*, the *British Journal of Photography*, and a more individualistic and quirky British magazine called *Camera Owner*, which in rapid succession changed its name to *Creative Camera Owner*, and then dropped the last word to become *Creative Camera*. But before I grasped the full importance of *Creative Camera* (a more or less direct result of my David Vestal epiphany) and became an avid supporter of the magazine, I had been seduced by the two main American photo magazines of the day, *Popular Photography* and *Modern Photography*. To my untutored photographic mind, they were a more exciting blend of technical information combined with aesthetic comment. Most of the British magazines—like much in British society at that time—seemed to predicate a certain conformity, and in photography's case, a slavish adherence to a set of compositional rules derived from salon painting. The American magazines seemed more exotic, freer, open, and above all, more colorful. I also warmed more to the writing of such people as Vestal, Margery Mann, and Bob Schwalberg. (Years later, in Schwalberg's company, I spent a memorable evening in New York with Garry Winogrand, but that's another story.)

The thirtieth anniversary issue of *Popular Photography* was possibly the most interesting, and certainly one of the most ambitious in the magazine's history. I still return to it for a firsthand account by Beaumont Newhall of how he curated his landmark exhibition at the Museum of Modern Art, *Photography 1839–1938*, a seminal overview of photography in the year that *Popular Photography* was founded. There was also a three-way discussion on the art of Henri Cartier-Bresson by Vestal, Schwalberg, and Michael Korda, and a fascinating account by Brassaï on Picasso's view of photography. And thrown into this rich, thoughtful mix was the article by Vestal, *Thirty Years of Books That Shaped Photography*.

The article consisted of a listing, with brief commentary and sometimes a thumbnail

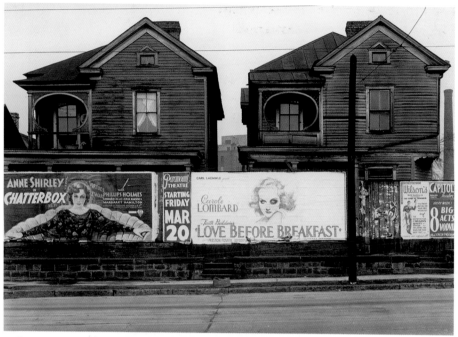

Walker Evans, *Houses and Billboards in Atlanta*, 1936

image, of some of Vestal's favorite photobooks from the period between 1937 and 1967. It began with several then recently published books, including John Szarkowski's *The Photographer's Eye* and Nathan Lyons's *Photographers on Photography*, followed by a historical listing, beginning in 1937 with Margaret Bourke-White's *You Have Seen Their Faces*, and then books such as Archibald MacLeish's *Land of the Free*, Robert Capa's *Death in the Making*, and Dorothea Lange's *An American Exodus*. But my eye was particularly drawn to a tiny illustration and three brief sentences on a book called *American Photographs*, by Walker Evans, published in 1938.

Looking at page 107 of that issue of *Popular Photography*, I still cannot quite understand what compelled me to go to my local bookshop, Bauermeister Books, in Tay Street, Dundee, Scotland, and ask if that book was available. The thumbnail of *Houses and Billboards in Atlanta*, 1936, which I and other Evans aficionados know as the "Love Before Breakfast" picture, is too indistinctly reproduced to mean much, though it is clearly differ-

ent from the others shown on that page. I have to conclude that it was what Vestal said that triggered my reaction: "I prize this book personally because it showed me for the first time that photography was a serious medium. After nearly thirty years, this book is completely modern: not 'dated.'"[2]

As luck would have it—and this whole episode converted me to a belief, if not in fate, at least in serendipity—the Museum of Modern Art had recently brought out the second edition, and a copy could be ordered easily—price 62 shillings and 6 pence ($7.50)—from the British importers. A week later I had my prize, something of a shot in the dark, for which (being an impecunious student) I had paid a considerable sum. With this book, my serious photographic education began.

I guess it was that word *serious*—a frequently dangerous word in relation to art—that drew me. So much photography, I surmised, was patently not serious, and furthermore, much of the photographic world itself didn't seem inclined to take the medium seriously. The mid-'60s was one of those periods when there was much debate about whether photography could be art at all, far less a serious or important art.

As soon as I studied *American Photographs* I had no doubts whatsoever. Even the afterword by Lincoln Kirstein—still one of the best essays ever written about the medium— reinforced both the seriousness and fundamental importance of this book: "Compare this vision of a continent as it is, not as it might be or as it was, with any other coherent vision that we have had since World War I. What poet has said as much? What painter has shown as much? Only newspapers, the writers of popular music, the technicians of advertising and radio have, in their blind energy accidentally, fortuitously, evoked for future historians such a powerful monument to our moment. And Evans' work has, in addition, intention, logic, continuity, climax, sense and perfection."[3]

Many at the time must have thought that Kirstein had been drinking from the well of hyperbole, but when I read his words in relation to Evans's photographs I considered them perfectly sober, prescient, apt, and measured. In so many of the pictures in *American Photographs*, I saw the kind of art photography could be, the kind of art I *wanted* photography to be. As Alan Trachtenberg has written, the book "introduced difficulty into modern photography."[4] It certainly introduced complexity, both in single images and in its sequential narrative.

Firstly, there was the image from Vestal's article. The prosaically titled *Houses and Billboards in Atlanta* depicts a line of movie posters on billboards, in front of two timber-framed houses with second-floor balconies. The central poster, the main area of light tone in a picture of generally dark tones, was for a film called *Love Before Breakfast*, starring Carole Lombard, who was depicted pouting ruefully and sporting a massive black eye. Behind the poster, the balconies of the two houses were framed by an oval timber trim that exactly matched the shape of Ms. Lombard's shiner.

Devastatingly simple stuff, yet not-so-simple stuff, a visual metaphor that presaged a picture full of bitter irony and poignancy, an image that talked about the gap between intention and reality, about sight, about violence and poverty, about restricted lives behind mean facades. It was all there. The picture delivered exactly what the title said—houses and movie posters in Atlanta—yet it also delivered so much more.

Here is a photograph fulfilling its primary function, a purely physical one of describing the world as precisely as it can, and at the same time a photographer demonstrating that the photograph can encompass an intellectual world. Here is photography working as a literary art rather than simply one of visual sensation. Visual sensation is the level at which the majority of photographers—even very good ones—operate. This photograph fulfilled the demands made of the medium by its maker, that it should be about "structure and coherence," certainly, but also as Evans stressed, about "paradox and play and oxymoron."[5]

Evans, of course, was a member of the most renowned documentary project in the medium's history, Roy Stryker's FSA photographic unit. Interestingly, one of Evans's FSA colleagues, John Vachon, also visited Atlanta, and made a photograph of the same two houses and line of billboards, so a direct comparison can be made—a comparison, one might say, between an interesting documentary photograph and a major work of art.

When John Vachon was hired by Roy Stryker, it was to organize the unit's files. Eventually, Vachon graduated to photographing out in the field, and regarded Evans as something of a mentor. From his experience with the files, he undoubtedly knew Evans's frame houses and billboards image, which had been taken in March 1936, so when he visited that city in May 1938, he clearly could not resist the temptation to make his own version.

Vachon's photograph is more formally expressive in composition than Evans's restrained rendition of the scene. He cut off half of one of the frame houses at the right-hand edge of the picture, and allowed the movie posters to float just above the foot of the picture frame. Evans, by contrast, did not compromise the wholeness of his subjects. The two houses are shown complete, in elevation. The posters are located in the environment and not just in the picture frame, for Evans included their base, and a portion of road and sidewalk. He also left appropriate space around the houses and included what might be a telling social detail, a factory chimney in the background to the right of the houses, indicating the industrial nature of the area. Looking at the two photographs side by side, one might think it was Vachon, and not Evans, who was the artist of the FSA group. But however much Evans considered himself the artist, his method was inevitably rigorously understated and firmly in the documentary mode, devoted, as he put it, to "picking up searing little spots of reality and underlining them, quietly, proportionately."[6]

There is another fundamental dichotomy between the two images that one could put down to either genius or serendipity. Evans happened upon the scene when *Love Before Breakfast* was playing at a local movie theater. A little over two years later Vachon did not.

Serendipity? Luck? The flame of recognition? Genius? That tiny detail, the dark shape around Carole Lombard's eye, was, as Roland Barthes put it, the "punctum" of the image, the thing that pricks the soul. Even the film's title, *Love Before Breakfast*, was fortuitous, while Vachon only had *Kentucky Moonshine* and *The Count of Monte Cristo* to work with. Breakfast? What did breakfast mean in a working class district of Atlanta during the Great Depression? However it came about, Evans had obeyed rule number one for any photographer. He got himself into the right place at the right time. His innate sense of elegant, exact, understated composition played its part, but Evans must have thanked the gods of photography when he saw that black eye. John Vachon made a fine photograph at that spot. Walker Evans made one of the finest photographs of the twentieth century.

And Evans made pictures of that quality again and again, not simply because he was talented, but because he wanted to, and because he was so persnickety. He allayed his undoubted talent with a fierce intelligence and obduracy. He was such a perfectionist that he was the least productive of the FSA unit, the official reason at least why Stryker made Evans redundant when the budget was cut. Unofficially, Stryker and Evans did not see eye to eye. The unit's most talented photographer was not a team player, he did not care for the propagandist imperative of the unit or Stryker's reformist zeal. "I didn't like the label," Evans once stated, "that I unconsciously earned of being a social protest artist, I never took it upon myself to change the world."[7]

But whatever his politics—and for someone who claimed to eschew politics he ran around with an actively liberal crowd—there certainly is dismay at the state of the country to be discerned in *American Photographs*. "Love Before Breakfast" is a case in point.

The first dozen or so pictures of *American Photographs* proclaim Evans's intellectual intent. From the first image, a view of a photographer's shop, *License-Photo Studio, New York*, 1934, followed by the famous *Penny Picture Display, Savannah*, 1936, and various photographs featuring signs and images in the landscape, Evans declares that this is not just a documentary book, but a complex meditation upon the nature of photographic representation. In a way that we might now regard as postmodern, Evans is commenting upon photography on two levels. Firstly, by continually featuring photographic images in his pictures, he is commenting upon the ubiquity, and therefore the importance of photography in modern society, and all that that implies. Secondly, at a deeper level, he is saying that he is a photographer, and furthermore, that he is a photographic artist. As Kirstein's essay implies (and the essay is an important part of it) *American Photographs* is Evans's calling card as an artist, his manifesto for the art of photography. He wanted his photographs to be "literate, authoritative, transcendent,"[8] he once said, indicating not only a massive ambition, but that in his view, although photography is rooted in the literal, the documentary, it should be eminently capable of dealing with ideas and feelings.

Evans is often regarded as a rather distanced, cerebral photographer, a view that I have

never understood, though his method certainly is rigorous and stark. If the first sequence in the book lays out its intellectual ambition, it also exhibits a psychological tenor that is far from cold and dispassionate. The Great Depression was a period of profound anxiety for many Americans. For many of the country's citizens, the world as they knew it had been turned upside down, and *American Photographs* is shot through with a feeling that civilization itself was crumbling. America "considered in the disintegration of chaos," as Kirstein put it.[9] Images of decay, even death abound, and one of the great themes of *American Photographs* is the plight of the little man, the terminal decline of an artisan's America, the small business and the craftsman swept aside by the big corporation and the machine, the care of the hand-wrought replaced by the anonymous and the ersatz. At the beginning of his photographic career, Evans photographed such symbols of modernity as the Brooklyn Bridge and the skyscraper, but when he selected the images for this book and exhibition at MoMA, modernism's high temple, the message was almost fiercely anti-modern.

In 1930, before he had made many of the photographs included in *American Photographs*, Evans reviewed a number of newly published photographic books in the magazine *Hound and Horn*. He begins this magisterial essay—as important a text as Kirstein's afterword—by stating that "the real significance of photography was submerged soon after its discovery." Photography in essence was hijacked by overt artiness, dishonesty, and "advertising values." What it must aspire to, he states, is "a photographic editing of society, a clinical process, even enough of a cultural necessity to make one wonder why other so-called advanced countries of the world have not also been examined and recorded."[10] Political? Not he.

Despite its dry humor, its sardonic tone, *Houses and Billboards* is a bitter, even angry image. *American Photographs* is full of ironies, made by juxtapositions between images of different classes and races, between the false and the true. But irony is an intellectual device, and Evans goes deeper than that, with images that, despite their apparent objectivity and disinterestedness, are as passionate as any in photography. Unease and anxiety abound in the faces of those he depicts—apart from the smugness of those in uniform. A nominally simple, unusually dynamic picture of a young couple in a car, *Parked Car, Small Town Main Street*, 1932, is a paradigm of uncertainty. The young man and woman stare at the camera, their faces gaunt with anxiety at a time in their lives when they should be looking to the future with optimism and hope.

This superb image is followed a few pages later by another of the book's key images, *Torn Movie Poster*, 1930, which demonstrates the sheer, unbridled passion that can be generated out of calm, proportionate objectivity. A close-up of a movie poster depicting the faces of a man and a startled woman becomes a heightened exercise in terror and apprehension because the casual, unthinking act of tearing a piece from the poster in the way children often do has created a great "wound" in the woman's head. This simple, found

effect is astonishing, as much for its simplicity and obviousness as anything else, and for the fact that it occupies a central position in a sequence of images with a clear subtext of anxiety. It is also interesting to note that the version of the picture reproduced in *American Photographs* is tightly cropped around the wound. An alternative negative does not have anything like the full coruscating power, and even the full negative area of the chosen image does not resonate as much.

The expressive potential of the unadorned close-up, where every last detail can be rendered in hyper-reality, was fully appreciated by Evans throughout his career, and is fully demonstrated, for example, in *Interior Detail of Portuguese House*, 1930, shot in Truro, Massachusetts. An unruly cactus in a wooden pot crowds out a variety of small objects on a mantelpiece and a table in front of it, including two studio family portraits and a miniature American flag. Space is further denied these cluttered objects by tight framing, but here a debt to Cubism, central to any modernist, might be discerned. The image is a jumbled, but tightly controlled arrangement of mundane domestic objects, similar to photographs made previously by Paul Strand and the New York-based Scottish photographer Margaret Watkins, but Evans's framing is even more radical and severe. And its context within the sequence of the book predicates narrative meaning and psychological import. Possibly it indicates that American values are under threat as the flag is almost throttled by the tangled plant. Perhaps it suggests the opposite, Old Glory rising proudly above the morass. More plausibly, it is an image about nature, humankind, and culture, which is surely one of the overriding themes of *American Photographs*. Again, maybe it is simply about the heady ability of the camera to capture objects with such mystery and clarity; about the things Evans liked to do with photography, "paradox and play" once more.

If you look hard enough at *American Photographs*, it seems to me that there is as much rage at the state of the country, at the legacy of President Herbert Hoover, as there is in the work of Evans's FSA colleague Dorothea Lange. It is coded, not nearly so overt, and the propagandist imperative is missing, but it is there. However, there is a distinctive aspect of Evans that seems somewhat at odds with the sociopolitical, the angry side of his work, probably because it was the primary impulse. And that—taking the "literate, authoritative, transcendant" triumvirate—would seem to be the transcendent aspect.

Walker Evans's America was delineated in the main through objects. Although there are some magnificent portraits in *American Photographs*, the overwhelming impression one takes from the book is that it is essentially a catalog of things. Of course, photography does this very well, but the relationship between Evans and objects takes a particular form, a form which, in spite of the European influences in his work, makes him the most American of artists.

The documentary photographers of the 1930s, both American and European, not unnaturally looked to popular culture for inspiration. In the *American Photographs* essay,

Kirstein took a swipe at a few cultural and photographic targets, and located Evans the artist within contemporary mass media rather than the fine arts world. "Only newspapers, the writers of popular music, the technicians of advertising and radio have, in their blind energy accidentally, fortuitously, evoked for future historians such a powerful monument to our moment."[11] He might also have mentioned the Hollywood movie, but Kirstein's lofty notion of the cinema owed more to Russia than Los Angeles. However, the populist aspect can be overemphasized. The important point is that it was literature and film—essentially narrative arts—that influenced both Evans and Kirstein in their thinking on photography rather than painting or the more traditional forms of visual art.

Like Kirstein, Evans reserved his greatest scorn for the kind of photographic pictorialism—"flimflam" he called it—that sought to ape painting in any way. Nevertheless, in his acknowledged debt to the transcendental stream of American literature—"If I'm satisfied that something transcendent shows in a photograph I've done, that's it"[12]—Evans tapped deep into the roots of American painting's characteristic way of depicting things in the world. He is often compared glibly in style to Edward Hopper, but the admitted similarities to be seen in the approach of the two men would seem less a matter of mutual influence than common heritage, an almost unconsciously imbibed methodology of describing objects and space. The immediate link in the case of both Evans and Hopper is the Precisionist movement of the 1920s and '30s, and in particular the work of the painter/photographer Charles Sheeler. But Precisionism was only part of a long cultural heritage, a persistent tendency in American painting regarding the depiction of the object that dates back to the colonial and immediately post-colonial eras.

The art of Walker Evans, like so much produced by the very best American artists from Martin Johnson Heade to Andy Warhol, is about the integrity of the object, the thing. Of course, the photographic medium by its very definition brings the artist into an almost unique relationship with physical actuality, a relationship that has the clear potential to be as direct and as transparent as any relationship between artist and object stimulus can be. Therefore it may be contended, as indeed it was by Edward Weston, that photography is a mode of expression peculiarly suited to the American sensibility. Certainly, albeit for reasons multifarious, the United States has produced what might be considered more than a significant proportion of the most significant photographic artists. And the oeuvres of those two men, Evans and Weston, are in their differing ways the epitome of a pure American photography.

From his first pictures of those symbols of modern constructive, progressive energies—the Brooklyn Bridge, the Chrysler Building, and the electric paradise of Coney Island—Evans's primary concern was with the object. Indeed, his concern with the object was so overwhelming, so consistent, that his whole oeuvre, barring his cataloguing of human types (rather fewer in number), may be categorized as a celebration, a collection, an inventory of

things—the stuff of American civilization. To Evans we might apply most readily George Santayana's observation about the Roman poet Lucretius: "The greatest thing about this genius is the power of losing itself in its object, its impersonality. We seem to be reading not the poetry of a poet about things, but the poetry of things themselves. That things have their poetry, not because of what we make them symbols of, but because of their own movement and life, is what Lucretius proves once and for all to mankind."[13]

A more precise, more pertinent description of Walker Evans's particular genius, as demonstrated time and again in the pages of *American Photographs*, could hardly be found. And this is where we may obtain an insight into the qualities that make Evans such an important photographer, and such a palpably American artist in the widest sense. That observation of Santayana's was quoted in a seminal critical essay, written by John I. H. Baur in 1954 on nineteenth-century American painting, specifically defining the Luminist style. Luminism was one of the most indigenous and characteristic styles in American painting, a point that has come to be understood fully by critics only in the last four decades, most notably in Baur's pioneering article, and in Barbara Novak's book from 1969, *American Painting of the Nineteenth Century*.

Flourishing mainly in the 1850s and '60s, the Luminist vision was primarily a topographical one, marked by an especially lucid quality of line and atmospheric description. But it was a style with widespread philosophical overtones. As Baur noted, the Luminist ethic denoted not only an attitude to *light* but to *things* in nature. The sharp, all pervading light that typifies Luminism describes and reveals the thing—directly and immediately. This direct transcription stressed the role of the artist as almost one of anonymity—Ralph Waldo Emerson's "transparent eyeball"—yet as Baur contends, the essence of Luminist expression was achieved through a subjectivity so powerful that the artist's seeing was transferred straight to the object with no sense of the artist as intermediary. Luminist realism, as Novak pointed out, is therefore, "a realism that goes far beyond 'mere' realism, to be touched, in some instances, with super-real overtones and, in others, to register that magnified intensity that turns realism into a form of impersonal expression."[14]

The parallel between the quoted tenets of Evans and this view of Luminism is immediately clear and quite striking. The Luminist style, exhibiting many of the recognizable traits of later American painting, was essentially a somewhat precarious blend of conceptual realism, classicism, and an idealism that took full cognizance of the spiritual through the transcendent. This comes close to an Evans manifesto. And therefore, almost by definition, a manifesto for much of 1960s, '70s, and '80s American photography.

For the basic credo of Evans was twofold—and seemingly as contradictory upon superficial acquaintance as Luminist philosophies. Firstly, Evans accepted without hesitation the camera's faculty for precise description, for accurately preserving on film a literal fragment of time and space. "The great, the incredible instrument of symbolic actuality,"

he termed it.[15] He called for "absolute fidelity to the medium."[16] That is, he believed that the photographer was obligated to interfere as little as possible with the "pure," transcriptive photographic process. The photographer must impose nothing upon direct and undiluted experience. He must discover, divine, and reveal his truth rather than construct it. However, Evans's second tenet—derived almost straight from nineteenth-century American philosophy—was a conviction that the very act of respecting an object and recording it with the utmost perceptual clarity is in itself a transcendental, almost mystical act. The recognition of the object by the photographer and his donation of the gift of ultra-lucidity through the agency of the camera in effect raises that object to a higher plane of reality. It becomes "a thing, yet more than a thing," to paraphrase Edward Weston—a fellow transcendentalist, though of a slightly different order. Our awareness of the object becomes intensified, much more so than if we were to confront it in actuality, outside the photograph. Every last detail, every subtlety, every minutia is immutably frozen and preserved for our elucidation, our delectation, and our dissection. But such clarity, far from displaying the dry, dull hermetic quality of the plain empirical record, may almost engulf and dazzle us with its intoxicating intensity. The spots of reality picked up by photography must be searing. As Ralph Waldo Emerson wrote: "Because all knowledge is assimilation to the object of knowledge, as the power or genius of nature is ecstatic, so must its science or the description of it be. The poet must be a rhapsodist—his inspiration a sort of bright casualty: his will in it only the surrender of will to the Universal Power."[17]

In the typical Evans image then, even of people, there is little flow or sweep, but rather a containment of each pictorial element within its own space. This generally precludes a sense of kinesthetic movement around the frame, arresting the moment decisively and expanding it into that transcendental stillness described by Emerson as "concentrated eternity."[18] This is the Evans world of stillness and silence noted by so many commentators. As Mike Weaver has written, Evans typically sought "total stasis in the subject and a static style in handling it."[19] Stillness—the expanded moment—is of course the near inevitable result of view camera usage, but this frozen continuum is not absolute. It assumes different forms with different photographers. Evans's stillness, his silence, is clear, measured, glowing. The objects in an Evans photograph, like those in a painting by the leaders of the Luminist School, Fitz Hugh Lane and Heade, are bathed in a soft, iridescent glow. Each thing basks in that glow, and the projected feeling—though no less intense than the darker mysteries of chiaroscuro—is of calmness, of serenity. Evans is regarded, along with Lange, as *the* chronicler of the desperate poverty of the Depression. Yet *American Photographs* could hardly be more different in both form and intent from *An American Exodus*,[20] Lange's great documentary manifesto from the era. Evans's sharp, analytical lens, more often than not, found not just disquiet but *reverie* among the decay of the waste of civilization, amidst the shards of a civilization of waste.

One final point must be made about Walker Evans. I have devoted a lot of space to him, not only because he was so fundamental to my understanding of photography, but also to that of many other people. Just noting that he was mentor to such figures as Robert Frank, Diane Arbus, Lee Friedlander, and Garry Winogrand says it all.

It seems important, indeed crucial, that my introduction to the kind of complex art that photography could be, came in the form of a book. No matter how marvelous Evans's individual images, no matter how well observed and constructed, their ultimate impact was as part of the narrative sequence in this classic of photographic literature. In *American Photographs*, Walker Evans demonstrated that photography need not be concerned just about simple formalism, simple propaganda, or simple sociology, it might carry all the complexity of an artist's internal musings upon the nature of culture and human experience, mediated through the nominally superficial medium of instantaneous sight impressions. Furthermore, he greatly expanded the potentiality of the serious photographic book, creating a sequence of photographs that has stood the test of time, bearing the depth and richness in allusive terms of an epic poem, a major film or novel, fully persuading us, as John Szarkowski writes, "of a new set of clues and symbols bearing on the question of who we are."[21] Alan Trachtenberg still seems somewhat nervous—in a way that only a non-photographer could be—that Evans's America, far from being a "real and demonstrable America,"[22] is a fiction, an America of the imagination, but he fully acknowledges the breadth and depth of the intelligence that made it.

In a preface to the 1938 edition of *American Photographs*, Evans wrote the following: "The responsibility for the selection of the pictures used in this book has rested with the author, and the choice has been determined by his opinion: therefore they are presented without sponsorship or connection with the policies, aesthetic or political, of any of the institutions, publications or government agencies for which some of the work has been done."[23] This seems a determined manifesto for a photographer to be regarded, if not as an artist, at least as an author, or an auteur, at least between the pages of a particular book.

Yet, before we are too carried away, one might take issue with one word Kirstein used in relation to *American Photographs*, "perfection." Although it is arguably the most important photographic book of the century, in that it sets a new agenda for the kind of art photography might be, I think that *American Photographs* is far from perfect. It is, in a sense, a curiously unfinished work, almost a work in progress rather than a rounded out and highly polished work of art. Certainly, the book's opening pages, as Trachtenberg has demonstrated in a detailed analysis,[24] are marvellous, with metaphor piling upon metaphor, the full panoply of Evans's "paradox and play and oxymoron" being brought into being (into play in fact), and the whole "text" moving along in an irresistible forward sweep. But am I alone in feeling that in the second section, the momentum grinds to a halt, and a different kind of rhythm set up, much more static and less immediately moving, where

perhaps Evans, as Kirstein notes, was simply content to pile "fact upon fact?"[25] The two halves of the book, I have always felt, sit slightly awkwardly together. It makes *American Photographs* less fully resolved than, say, Robert Frank's *The Americans*, but then Frank of course had the example of the earlier work as a reference point—and indeed took full advantage of it.[26]

The problem is, I believe, the circumstances under which the book was put together. It was not the result of a specific project, however loose in conception, but a compilation of different pictures selected from the broad base of Evans's oeuvre, ranging from his earliest street experiments with the camera, the Victorian architecture project done with Lincoln Kirstein, and work shot during his tenure with the FSA, through to the singular essay on three tenant farmers he had just completed with James Agee. In this, the earlier part of his career, before he settled down to a regular job with *Fortune* magazine, Evans was never a programmatic, disciplined photographer. Inspired intuition and spontaneous feeling played a larger part in his work than one might realize, and *American Photographs*, I feel, reflects this. Despite his intelligence and intuitive understanding, to a degree Evans himself was groping toward the light.

But however "imperfect, unfinished, provisional" it might be, *American Photographs* perhaps only reflects the nature of photography itself, with all its paradoxes and infuriating loose ends. It remains a great work of art, a touchstone for every photographer since who has ever made a book in the documentary mode, from Robert Frank, through Lee Friedlander and Garry Winogrand, to Robert Adams, Nan Goldin, John Gossage, Martin Parr, Michael Schmidt, and Boris Mikhailov. In *American Photographs*, Walker Evans demonstrated to photographers—including himself—the medium's full potential.

Notes

1. David Vestal, "Thirty Years of Books That Shaped Photography," *Popular Photography* (New York), May 1967, Vol. 60.

2. Ibid., p. 107.

3. Lincoln Kirstein, afterword, in Walker Evans's *American Photographs* (New York: Museum of Modern Art, 1938), p. 190.

4. Alan Trachtenberg, "Walker Evans: The Artist of the Real," *Afterimage* (Rochester, New York), December 1978, Vol. 6, No. 5, p. 13.

5. Walker Evans, "On Photographic Quality," in *Quality: Its Image in the Arts* (New York: Balance House, 1969), p. 169.

6. Ibid., p. 180.

7. Walker Evans, "The Thing Itself Is Such a Secret and So Unapproachable," *Image 17* (Rochester, New York), December 1974, No. 4, p. 14.

8. Walker Evans, quoted in John Szarkowski, *Walker Evans: Photographs* (New York: Museum of Modern Art, 1971), p. 13.

9. Kirstein, *American Photographs*, p. 191.

10. Walker Evans, "The Reappearance of Photography," *Hound and Horn* (Cambridge, Massachusetts), October/December 1931, p. 125.

11. Kirstein, *American Photographs*, p. 190.

12. Leslie Katz, interview with Evans, *Art in America* (New York), March–April 1971, Vol. 59, No. 2, p. 87.

13. George Santayana, quoted in John I. H. Baur, "American Luminism," in *Perspectives U.S.A.* (New York), Autumn 1954, No. 9, p. 98.

14. Barbara Novak, *American Painting of the Nineteenth Century: Realism, Idealism, and the American Experience* (New York: Praeger Publishers, Inc., and London: Pall Mall Press, Ltd., 1969), pp. 96–97.

15. Evans, "On Photographic Quality," p. 169.

16. Ibid.

17. Ralph Waldo Emerson, quoted in Parry Miller, *The American Transcendentalists, Their Prose and Poetry* (New York: Doubleday, Inc., Anchor Books, 1957), p. 62.

18. Emerson, quoted in Alfred Kazin and Daniel Aaron, eds., *Emerson: A Modern Anthology* (Boston: Houghton Mifflin, 1958), p. 122.

19. Mike Weaver, "Walker Evans: Magic Realist," *Creative Camera* (London), September 1977, No. 159, p. 292. Weaver was talking, as I am, about Evans's view camera, or static style, as distinct from his parallel, yet quite different work with the 35 mm camera. There are memorable photographs in *American Photographs* taken with the small camera, but the majority of the book's imagery is taken with the view camera, and it would be fair to say that it is essentially the view camera with which one associates Evans. To me, his handheld, small camera work (with notable exceptions), does not attain the fluidity of such masters as Henri Cartier-Bresson, Robert Frank, and Garry Winogrand.

20. Dorothea Lange and Paul S. Taylor, *An American Exodus* (New Haven, Connecticut, and London: Yale University Press, 1979). Reprint of 1939 original.

21. John Szarkowski, *Walker Evans: Photographs* (New York: Museum of Modern Art, 1971), p. 20.

22. Alan Trachtenberg, "Walker Evans' America: A Documentary Invention" in David Featherstone, ed., *Observations: Essays on Documentary Photography* (Carmel, California: Friends of Photography, 1984), p. 56.

23. Evans, in *American Photographs*, first edition, no page number.

24. Trachtenberg, "Walker Evans' America," pp. 56–66.

25. Kirstein, *American Photographs*, p. 194.

26. See Tod Papageorge, *Walker Evans and Robert Frank: An Essay on Influence* (New Haven, Connecticut: Yale University Art Gallery, 1981). In the catalog of a joint showing of work from *American Photographs* and *The Americans*, Papageorge states that Frank used Evans's work as an "iconographical sourcebook for his own pictures," p. 1. Evans, of course, supported the Swiss photographer in his 1955 application for a Guggenheim Fellowship.

Simply the Best: John Szarkowski and Eugène Atget

After discovering Walker Evans, I was drawn to another book in David Vestal's photobook article, and promptly ordered that. This was John Szarkowski's *The Photographer's Eye*, also published by the Museum of Modern Art. I had also bought a book published in Britain by an American photographer, which, because it had a Scottish subject, I found in my local library. That was *Tir a'Mhurain*, by Paul Strand and Basil Davidson, Strand's study of a Hebridean island.

As a result of buying these three books, and a few others in the same vein—Robert Frank's *The Americans* followed not long afterward—I had a singular photographic education for someone living in Scotland at that particular time. Broadly speaking, my take on photography revolved around the view of modernist photography demonstrated by Evans and articulated by Lincoln Kirstein, a view that was carried on, in a slightly different vein, by John Szarkowski during his influential tenure at the Museum of Modern Art. It was very much an American view. It could be called the MoMA view of photography, and while it has been very influential, thanks to Szarkowski's articulate and passionate advocacy, it has also been widely criticized, primarily by the theoretical brigade. And a particular focus of that criticism has been directed at another of the photographers I want to talk about. Actually, to be absolutely accurate, the criticism has been directed not at the photographer, Eugène Atget, but at Szarkowski and MoMA's championing of his work, and their subsequent determination of his status within the photographic canon. This debate epitomizes the schism between the two photographic cultures, between contextualism on the one hand, and formalism on the other.

Basically, the contextualists' or theorists' argument with the MoMA view is a sociopolitical one. In a nutshell, they argue that the type of formalism espoused by those at the Museum of Modern Art and other art museums essentially aestheticizes photography—at the expense of depoliticizing it. The theoretical viewpoint opposing this "connoisseur's" viewpoint, broadly speaking, is an updating of the left-wing, socially progressive ideas that accompanied European modernism in the 1920s, when art-educational establishments in Germany and the Soviet Union sought to banish the distinction between "high" and "low" art or "fine" and "useful" art. The aim of institutions such as the Bauhaus, founded in Dessau in 1919, was to democratize all the arts, making art the tool of the masses and freeing it from bourgeois snobbism and elitism. As Margit Rowell has written, at its most extreme—in the Soviet Union: "The role of the artist, would also be recast as a catalyst for social change, conceived first as a 'worker,' comparable to the proletarian worker, and eventually as a 'constructor' or 'engineer.' The notion of art as the expression of individual genius was officially proscribed, and replaced by an art that would be

politically effective, socially useful, and mass produced."[1]

Ironically, it was the Museum of Modern Art, the target of so many theorists, that became the first major American museum to extensively incorporate some of these radical European ideas and bring the so-called popular arts, such as cinema, graphics, and industrial design, within its sphere. Alfred Barr, MoMA's first director, was impressed by the broader view of modernism he had encountered on visits to Europe. He introduced many progressive ideas into the museum's curriculum, including a department to collect photography. But ultimately, the economic structure of the American museum, with its reliance upon the philanthropic patronage of the rich, predicates an inherent conservatism, and a concentration, no matter what the medium, upon aesthetic values before all others.

When John Szarkowski succeeded Edward Steichen as director of MoMA's photography department in 1962, the broader cultural role of the museum as envisioned originally by Barr had narrowed somewhat. Under the Democratic presidency of Franklin D. Roosevelt in the 1930s, American art had approached the socially useful values of progressive European modernism. By the end of the 1950s, under the Republican presidency of Dwight D. Eisenhower, a period haunted by the recent specter of McCarthyism and the incipient threat of the Cold War, American art had largely turned inward—upon itself and upon the individual. In painting, the dry hermeticism of Abstract Expressionism was the all-prevailing tendency—not simply aesthetics, but the purest, most reductive imaginable.

Shortly after taking over at MoMA, Szarkowski produced his manifesto for modernist photography, *The Photographer's Eye*.[2] Like Walker Evans's book a quarter of a century earlier, Szarkowski's volume was published to accompany an exhibition. Like *American Photographs*, although it is a case of the picture editor as author rather than photographer as author, *The Photographer's Eye* is a polemic about photography, and what is more, about photography in society. Further, as in *American Photographs*, anonymous, vernacular photography is very much in evidence, but unlike Evans's masterpiece, *The Photographer's Eye* is primarily an aesthetic manifesto.

To be fair, that is its avowed aim. But, say Szarkowski's many critics, that was generally his aim throughout his career—to reduce a rich and culturally complex medium to a point where aesthetic discussion attained a hegemony over all other, and equally valid considerations. It is, say the contextualists, precisely the reductive, elitist program one might expect from the institution regarded as the high temple of modernist formalism.

In the case of *The Photographer's Eye*, however, such a sweeping indictment is generally unwarranted. As a demonstration of photo aesthetics, it sticks firmly to the purist wing, to the documentary mode. As an examination of the formal vocabulary straight photographers largely work with, it is exemplary, and for someone coming to the medium at that particular time, it was not only useful but an inspiration. Demonstrating how different photographers from different periods, and with very different intentions, have nevertheless

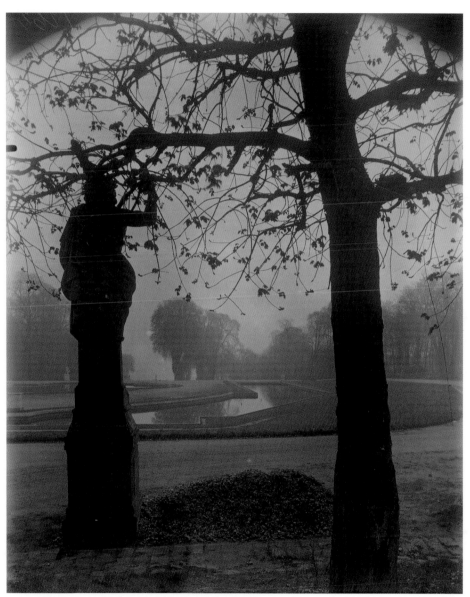

Eugène Atget, *Saint-Cloud—9 h. matin*, March 1926

utilized such basic formal elements as light, time, and viewpoint, does not provide a critical solution to the medium's many contradictions, but is a necessary and interesting exercise. Any photographer—firstly, if not foremost—has a formal problem to solve. To talk about form in this context is not necessarily to aestheticize. To show the work of anonymous journeymen or amateur snapshooters alongside that of sophisticated professionals or artists is not necessarily false consciousness—and does not necessarily distort intentionality or demean the photographer of high ambition. Szarkowski was talking about the building blocks, and if there was confusion about who had actually built a palace or who had erected a shack, that was not the goal of this particular exhibition.

A solution to that question—or even more confusion—was to come a few years after *The Photographer's Eye.*[3] Included in the *Eye* exhibition was the French photographer, Eugène Atget, around whom some of the fiercest photo-critical battles of the 1970s and '80s would rage.

Atget, who died in 1927, had been a willfully old-fashioned architectural-topographical photographer, using nineteenth-century methods until well into the twentieth. From around 1890 until his death, for almost forty years, Atget made an extensive, if idiosyncratic documentation of Paris and its environs, amounting to around 8,500 negatives—those he kept, anyway. He had nothing to do with the modernist avant-garde or the salon Pictorialists, but sold his prints for modest sums to private clients and various cultural institutions. Primarily because they lived on the same street in Montparnasse, the rue Campagne Première, Atget's work briefly came to the attention of Man Ray, but at the time of his death, Atget was regarded generally as a competent, somewhat reclusive commercial photographer, his imagery destined to remain within the confines of the institutional archives that housed much of it. He was looked upon by Man Ray and the Surrealists in much the same way that Le Douanier Rousseau was looked upon by Picasso and his circle.

But a young American photography pupil of Man Ray, Berenice Abbott, had a different view. She saw in Atget's unfussy, straightforward approach the epitome of an ethic for modernist documentary photography. With the help of another young American acquaintance of Man Ray, Julien Levy, Abbott bought half the contents of Atget's studio, over four thousand prints and negatives, for the sum of $1,500. Some forty years later, in 1969, this collection was sold by Abbott and Levy to the Museum of Modern Art—for considerably more than the original price—and the controversy over Atget began. Szarkowski presented Atget, not just as a fine documentary photographer but as an artist, a colossus of twentieth-century art photography, "perhaps the best example of what a photographer might be."[4]

In a series of exhibitions and books spanning over a decade, Szarkowski set out to prove this contention. His position was clear. For him, photography has a record of formal achievement. Detractors view it as the hierarchical canon that is a necessary pillar of the

art museum, but for Szarkowski it is photography's "tradition"—an edifice that has been, and is constructed by every photographer who has made, or makes a formally successful photograph. And because any formally successful photograph can be regarded in aesthetic terms, any photographer who has made one can be regarded as an artist, if only for that single picture.

Leaving aside questions of artistic intentionality, or who decides what is formally successful, in Szarkowski's view Atget was an artist—and a major artist at that—because he made numerous photographs embodying the formal quality identified by Szarkowski as "grace." (Atget also made many photographs that, as Szarkowski himself admitted, do not exhibit this quality, but we will deal with that non sequitur in due course.)

What is grace? A typical term of aesthetic mystification and meaningless modernist connoisseurship, according to the contextualists. And even for aestheticians, it represents an ineffable, elusive quality, like swing in jazz. You either sense it or you don't. It is the felicitous disposition of forms, certainly, but it is also the way a photographer tends to repeat patterns of composition, over many photographs, establishing a visual signature or "way of seeing."

Here, the question of intentionality might be dealt with. Some photographers develop stylistic or compositional traits in a deliberate and self-conscious manner. Particularly today, where the art market demands an instantly recognizable style that can be neatly packaged, photographers tend to limit both their range of subject matter and its treatment in a search for brand identity.

Atget had a market for his photographs, but it was subject-driven. His clients were not buying an "Atget." They were purchasing a detailed record of a storefront, a street, or a piece of decorative ironwork. *Documents pour artistes*," read a sign outside his studio at one point, and that was his self-proclaimed role, a supplier of views and architectural photographs to the Parisian creative sector and the French national archives. Atget, it would appear, did not think of himself in the least as an artist, although on the cover of some of his presentation albums, he described himself as an *editeur-auteur*, an important point to which we will return.[5]

Once, when we were discussing Atget in his office at the Museum of Modern Art, John Szarkowski asked me the following question: "Do you think that, when he looked through the ground-glass screen of his camera, Atget knew exactly what he was doing?"

As a young Atget enthusiast, faced with the foremost Atget expert of our time, I took the craven way out. "We can't really know that," I replied.

"Of course he did!" snapped Szarkowski, and when I thought carefully about it, I realized he was right. You can't use a large-view camera without knowing exactly what you are trying to achieve. Atget may not have been able to articulate an aesthetic or theoretical position as an artist, but when he looked at the upside-down image on his ground-glass

screen, he must have fiddled with the camera, possibly moving its position until the picture satisfied him—until, to his eyes, it looked right. Whether or not he could describe in words what "right" was, he knew it when he saw it, and tripped the shutter accordingly.

Photography, at the moment of the shutter's release, is a formal business. For any photographer, whatever he or she may think prior to or after that crucial instant, they are faced with an aesthetic problem, how to arrange forms in space and time. That is the Szarkowski position in a nutshell.

But Szarkowski's formalist position has been misunderstood in certain respects, especially by the hard core of the contextual wing, who are instinctively anti-modernist and anti-art museum, with MoMA—the "Kremlin of Modernism" as Martha Rosler has called it—the number one target on their hit list. How could Szarkowski declare Atget an artist when the man apparently had no pretensions to making art? How could Szarkowski laud Atget's formal brilliance when he appeared to have had at least three misses to one hit in aesthetic terms? And who decides what a formal hit—an image of grace—is anyway?

So when Szarkowski and the Modern mounted a massive, four-exhibition and four-monograph survey of the Frenchman's work,[6] there was a predictable sharpening of the critical knives. As cocurator and collaborator for this massive project, Szarkowski had a former student of his from Columbia University, Maria Morris Hambourg. Under Szarkowski's tutorage, Hambourg's doctorial thesis unraveled the complicated system Atget had used to number and categorize his pictures.

This unlocking of the "code" to Atget's working practices had been something of a Holy Grail for Atget scholars. Now his photographs could be dated with confidence, and the series (often overlapping) into which he grouped his images could be studied and analyzed. Hambourg's thesis, appropriately entitled "The Structure of the Work," could be incorporated into the MoMA project,[7] and there is no doubt that it is one of the most important pieces of Atget research ever accomplished.

But although it enables some commentators to talk about "early Atget," "middle-period Atget," and "late Atget," it did not assuage the criticisms of the contextualists. Indeed to talk about Atget in such art historical terms simply enraged them and attracted their scorn. As Rosalind Krauss, for example, wrote: "The Museum undertook to crack the code of Atget's negative numbers in order to discover an aesthetic anima. What they found instead, was a card catalogue."[8]

Of course, we knew that already. Szarkowski and Hambourg knew full well that Atget was a journeyman making documentary photographs to satisfy a commercial demand for images that could be grouped under the broad rubric of "Old Paris." Yet Szarkowski and Hambourg, and Berenice Abbott before them, also knew—at the very least—that Atget was an idiosyncratic, nonconformist member of the loose group of photographers making images of Old Paris around the end of the nineteenth and the beginning of the twen-

tieth century. Some of his imagery, if measured by conventional documentary standards, is downright peculiar, even allowing for the fact that Atget was not the most scrupulous of technicians. As Max Kozloff—a sensible critic who could be said to be in neither the formalist nor the contextualist camp—has written: "The viewer of these images falls prey to a loveliness unbounded by any consideration of trade. Going through this archive more carefully, one can be enveloped in reserves of poignancy, for which the extensively modest function of the imagery and the mechanistic aspects of its coverage do not prepare. In this accumulative experience, a sense is gradually built up that the explicit, mundane program of the work has been infused into an infinitely larger and more private vision that nowhere acknowledges itself. The problem of Atget is how to talk about that."[9]

Probably more time has been given over to musing about the "problem of Atget" than any other area of photographic studies. His work, his life, his photographic practice, and crucially, his intentions, have been at the cutting edge of criticism, certainly throughout the 1980s and '90s. As I would place myself with one foot in the formalist and one foot in the contextualist camp, I am sometimes bemused by the extreme positions some committed camp followers—from both sides—feel obliged to take. I consider that by sticking rigidly to party lines they are blinding themselves to certain aspects of Atget, and therefore missing his true importance. For there is no doubt that, whatever one's personal solution to the "Atget problem," he—or at least his work—has been central to the development of twentieth-century photography. More important, Atget's work has become central to our understanding of what photography at its best might achieve.

But where does one begin? Let's put theorists and curators aside for a moment and start with photographers. For a number of reasons, Atget is an important influence upon many photographers. Indeed, I would almost go as far as to say that if photographers don't "get" Atget—or Walker Evans for that matter—they don't really get photography. He is as fundamental as that.

And though contextualists might carp, one important reason for Atget's influence is formal. Photographers are always looking to learn formal lessons, and Atget is a veritable encyclopedia, demonstrating a myriad of ways to put together a picture. He used nineteenth-century methods and a large-format camera, which has caused some contextualists to ask what makes his pictures of a disappearing Paris different from those of, say Charles Marville, who photographed a similar subject in the 1860s—old streets and alleyways under threat of demolition as part of the planning schemes of Baron Haussmann.

Well, the aesthetic quality distinguishing the best of Atget is one fundamental difference. A major formal problem facing the user of a large-format camera is that of animating the picture frame. Large-format photographs, where the camera by necessity is secured on a tripod, can often look rather static. They can look monumental, calm, measured, and considered certainly, but also lifeless and dull. Atget images all too frequently can seem

dull, but they are seldom lifeless, for he had an innate knack for utilizing angular lines and steep perspective to animate the frame to an extraordinary degree.

This went somewhat against the conventions of the kind of documentary record photography Atget was nominally practicing, and it may be that—being self-taught—he was slightly inept. However, reiterating the point John Szarkowski made to me, you look at the ground-glass screen, you like what you see, you take the picture. It's a visual, visceral, intuitive process, not a calculated, intellectual one—at least not at that crucial juncture. And leaving aside considerations of editing, sequencing groups of pictures, ruminating about what one is trying to "say," that intuitive moment, the moment when the shutter is released, is the "decisive moment."

A frame as dynamically charged as Atget's may have defied the conventions of the record photography mode that circumscribed his commercial practice, but it appealed to the new breed of '30s modernist photographers working "in the documentary mode," such as Berenice Abbott, Walker Evans, and Bill Brandt. Nevertheless, Atget's formal example is not the only reason why he was—and remains—such a touchstone for photographers. Once more, as Max Kozloff has remarked: "If an Atget image were endowed with all the (formal) grace in the world, but bereft of Atget's time-honored sense of the world, we would not recognize or care that the image is his. It would be truly soft in content, regardless of how well masses are arranged within the frame."[10]

We arrive at the heart of the matter, although it remains a difficult thing to describe. What photographers have sensed in Atget, I think, is a point where photography itself, rather than the commercial practice of photography, became his obsession, and his images began to speak with a much more individual voice, a voice embedded within the rhetoric of the kind of photograph he was required to make for his clients. Back in 1931, only a few years after Atget's death, the young Walker Evans wrote the following: "His general note is lyrical understanding of the street, trained observation of it, special feeling for patina, eye for revealing detail, over all of which is thrown a poetry which is not 'the poetry of the street' or 'the poetry of Paris' but the projection of Atget's person."[11]

The contextualists of course will not have this. This merely echoes the romantic wish-fulfillment of the modernist, they argue. Even direct evidence of Atget's desire to claim not simply authorship of the photographs, but the role of an auteur in selecting and sequencing them, is not enough.[12] Nor is the overwhelming evidence of the change in his practice following the First World War. Atget was growing old, his methods were anachronistic, he was distinctly unfashionable, and his markets were dwindling. Yet he persisted, and made many of the most astonishing images of his career—astonishing not just in the sense that they were among the most formally lovely, but because one is hard put to explain why he took them. Except to conclude that he was compelled to do so.

In the spring of 1926, when in his mid-sixties, he regularly made the journey out to

some of the great château parks on the fringes of Paris, such as Saint-Cloud and Sceaux. Traveling out there by public transport to these suburbs, then walking to the sites of his pictures carrying a heavy camera, tripod, and glass plates, would tax anyone, never mind a man in his sixties. I know from experience, because I've done it.

And what kind of pictures did he take there? Images of trees and lakes, partially dissolved in shimmering, early morning mist and a watery sun. Along the banks of the Seine, he shot directly into the light and through screens of trees, hardly the stuff of documentary record, but certainly in accord with a man exploring the world, especially his own world, through the medium of photography. I am not claiming that Atget thought of himself as an artist, even for a moment. Call him a glorified snapshooter if you will, for that gets close to the spirit of these photographs. But I am certain that a passion existed, a compulsion that went far beyond the bounds of any commercial imperative.

Literary criticism's intentional fallacy, which holds that a work of art has meaning distinct from the artist's intent, can be applied to photography as much, if not more than, to literature. And so with Atget it seems mandatory to invoke D. H. Lawrence's famous dictum, "Trust the tale, not the teller." We are impelled to return always to his photographs, and then, if we have any feeling at all for photography, we are compelled to marvel at many of them.

If one compares the photographs of Marville to those of Atget, besides certain formal preferences, there seems one distinct, and crucial difference. Marville, like Atget, made a magnificent document of a changing Paris, exhibiting a particular quality prized by the French—clarté—which is an exalted kind of lucidity. They lack, however, Marville. And given the task with which Marville was charged, that is juste comme il faut—exactly as it should be. The documentary photographer of Old Paris, its streets and monuments, is not supposed to put himself in the picture.

In Atget, however, one feels the presence of the photographer almost everywhere. As Evans said, we feel the "projection of Atget's person." Kozloff talks about the infusion of "a more private vision." Hambourg believes that Atget's work gradually acquired more and more of "an existential tenor."[13]

Yet even if only a feeling—the photographer's ghostlike presence as it were—we do not sense it in any number of other nineteenth-century topographical photographers. Even if a mere figment of our imaginations, it remains a strong and persistent feeling in Atget—one that has been expressed, in various guises, by many commentators. Nevertheless, as Kozloff says, the problem remains—how to talk about it. John Szarkowski, for example, begins by speculating, like Kozloff, that Atget was the "servant to an idea larger than he,"[14] and names this overarching theme as "history."

Whether driven by the demands of commerce or by more personal motives, Atget photographed in a continuous dialogue with history. History, contends Szarkowski, deter-

mined and molded the shape of Atget's endeavors with the camera as much as he himself did. To be sure, there are different kinds of history, and different kinds of dialogue with history to be made with photographs. Atget's relationship with history, as with the graphic disposition of forms within the frame, was not constant. Indeed, it was maddeningly inconsistent. He made many different kinds of "documents" for different clientele, that clientele including, we should now perhaps note, himself. The bulk of his business, that is, the documentation of *Vieux* Paris that he made for his institutional and professional clientele, served a particularly sentimental, sanitized, bourgeois construct of history. But it is surely where Atget interrupted, contradicted, and subverted this bourgeois history that our interest is most engaged. It is here, we might surmise, where the photographer himself, a lifelong socialist and eccentric nonconformist, became most fully involved.

Therein lies the joy, the challenge, and the frustration of Atget. His working methods were fragmentary, contingent, and idiosyncratic, if judged by the standards of his fellow documentarians. Different histories enter and quit the fringes of the main enterprise, and he deviated from the norm in often quirky and apparently inconsequential ways, never leaving a thread that can be traced with confidence throughout the grand design, never allowing a substantial, far less a definitive ideological profile to be built up by the determinist critic. It does not do to be too dogmatic about Atget. For instance, one recently popular view of Atget, the antithesis of the modernist, is the sociopolitical. Here, Atget is seen as furtively harboring a dissident political consciousness that underscores the work in varying ways, and even surfaces when the opportunity presents itself—as Molly Nesbit has pointed out, in his *Intérieurs* album, for example. In this album, and others dealing with the contemporaneous rather than the nostalgic, she argues that we might glimpse a politically aware, conscious auteur of a very different tenor to the one envisaged by Szarkowski.

Nevertheless, mindful of the ambiguities in Atget—his evident love for vapors and evanescent trees as well as *petits métiers*, for plump naked women as well as destitute ragpickers—Nesbit is somewhat circumspect in her socially derived reading. She views Atget as an indexer of class mores, the indexing thread inseminated deep within the outward and traditional form of his documentary practice. One major, and unsettling paradox, noted by many commentators—Atget's "infernal emptiness"—she contends developed from functional necessity, the stasis induced by his view camera and tripod, to a point where Atget could consciously utilize it as a device for commentary, subverting the preconceptions of the bourgeois viewer he nominally served "by taking human relations out just at the point where one expects to find them."[15] By focusing upon potential social and political meanings, Nesbit gives due weight to an important strand in Atget's makeup, and in so doing effects an invaluable contribution to the debate, not simply the Atget debate, but the whole debate about photography as a means of creative expression. For the Atget problem is also the problem of photography.

Thus Nesbit is absolutely right in attempting to rescue Atget from the vacuity of formalist modernism, just as Szarkowski and Hambourg are right to rescue Atget from creative photography. It should be Atget's work in its entirety, formally "flawed," quixotic, academically frustrating, which is cherished, then sensibly evaluated. The late pictures, those elegiac, misty-eyed landscapes from Saint-Cloud and Sceaux, wonderful though they are, should not be divorced from the rest of his production and trumpeted as proof of his formal genius, without considering, in equal measure, other, perhaps more prosaic aspects of his imagistic personality. And if we are left with an oeuvre upon which it is difficult to impose any rational context or formal order? That, it seems to me, is just too bad. Many things might move a photographer, but not always to take a photograph.

Beyond the dictates of commerce, varying impulses seemed to have gained sway over Atget at various times. Why photograph tree roots, for example? Why the apparent obsession with autumnal specters? Is it too absurd to grant Atget such motives for pointing the camera as personal interest, or the simple joy of looking? Not to my mind. Is it too absurd to credit Atget with some aesthetic awareness, even aesthetic ambition in a modest sense? He was, after all, a widely read, if a self-educated man. Is it equally absurd not to recognize his political voice in the work, however subtly realized? If the work is in some way a projection of his personality, his different interests must be contained within it. Is it intellectual snobbism of the narrowest kind—art historical "theory"—that would deny him anything other than a journeyman's voice? I believe that we do not perpetrate some forbidden, untoward inversion of an immutable, higher moral order (except possibly that of the aforementioned art theory) if we recognize widely differing Atgets—a public, a private, a mundane, an inspired, a formalist, a political, and so on. To do so merely suggests, as John Szarkowski has rightly indicated, that one might observe in Atget the same quality that can be observed readily about many other photographers: "In Atget, the idea itself seems provisional and open, imperfect, unfinished; in the process of taking form from the facts of the image before us."[16]

But still we are left up in the air, grasping tantalizingly at the substance of the grand idea to which Szarkowski alludes, yet seems agonizingly diffident about defining in detail. Is this perhaps why so much of photography positively infuriates the analytical theorists and induces scorn in academic quarters? Because its very potency, the galling mysteriousness of nominal "fact" clearly stated, resides in it being so "provisional, open, imperfect, unfinished?"

Perhaps Atget's own words might offer a clue. He wrote of his "immense production made more for love of Old Paris than for profit."[17] Even more tellingly, he said, "I can safely say that I possess all of Old Paris."[18] *Possess*—that is an interesting and psychologically revealing notion in relation to photography. *Reclamation* is another. In writing about Garry Winogrand, Leo Rubenfein noted that the psychological tenor of his work

constantly suggests "estrangement from the world and the photographer's imaginative reclaiming of it."[19]

Look at Atget and the way he constantly stresses the city seen from an "ordinary" point of view. Look how one enters and flows round an Atget image, compelled by its dynamic formal qualities. We are invited to possess or reclaim the picture space in a way offered by few other photographers. Consider also the areas of Parisian experience reclaimed by Atget. "All of Old Paris." Not at all. Atget's Paris—the Paris of his most engaged work—was pedestrian Paris, working class Paris, a largely pre-industrial, small-scale, disregarded Paris of narrow streets and hidden courts. If not quite a Paris of the "other," at least a Paris of the ordinary. Bourgeois Paris, the Paris of the *Grands Boulevards*, or Bourbon Paris was antithetical to Atget's true domain, creeping into his grand design only as far as was necessary to furnish his living. Out in the great parks, it was not so much the architectural monuments as the landscape—the ponds and trees, the silent but animate statues—that claimed his most rapt attention.

In 1971, the author John Fraser wrote an interesting essay, "Atget and the City,"[20] in which he mused upon the experiences offered to us by the photographer. Atget, suggested Fraser, articulated the experience of the ordinary city dweller, the pedestrian moving around the city and consuming its sights, its merchandise, and its vicarious pleasures. Fraser points in particular to how the kinesthetic dynamism created by Atget's faulty use of the wide angle lens expands the sense of space in the picture and invites our eye to enter.

This visual accessibility, characterized by his often asymmetrical, restless compositions, draws us in and out of the frame, and suggests the continuity of things beyond it. We are given frequent glimpses around corners and through doorways. The visual rhythms of streets and pathways seem almost to flow out of the picture and past the viewer. It is difficult to ignore the sensation of walking or standing. The texture of the floorscape cannot be missed: paving slabs, paths, steps, and above all, the large square cobblestones (so beloved by would-be revolutionaries). We feel we would like to walk into and inhabit these pictures.

Atget would often trawl down a street, making views at intervals, photographing doorways, frontages, and architectural details. Although this was a natural and pragmatic part of his commercial practice, the accumulative effect is of a wholly personal walk down the street, or around the neighborhood. One of my favorite sequences comes from his work in the Zone Militaire, the unbuilt area just outside the city's walls that served as a barrier in case of war. In Atget's day, this area had become overgrown and served as a kind of unofficial park for nefarious working class activities. Their documentary value is minimal, but they take us on a mysterious little journey that offers a strange kind of intimacy, as we are put in the role of a dog following a scent, a photographer following a trail for a purpose I am certain even he couldn't guess at.

Possession and reclamation—if we speculate upon those motives, and grant them to Atget, this act of imaginative possession seems twofold—at once purely personal, seeking time regained in a Proustian sense, and also personal-political, seeking to reclaim French culture for his class, inculcating another, subtly dissident voice into the official archive. We can mark a profound shift from a record of observation to a record of experience.

And this, it seems to me, is where the importance of Atget lies, at least the importance the "great photographer" as opposed to the documentary chronicler. Atget, however wittingly or unwittingly, was the first to demonstrate that documentary photography could be a complex business, that it could be a complicated blend of the objective and the subjective. He confirms for us that it is a photographer and not a camera who takes photographs, and therefore, being essentially subjective, documentary photography can attain the best attributes of art. Atget may have been the last of the long line of nineteenth-century French topographical photographers, but he was also the "first" twentieth-century photographer. His heirs are not only the twentieth-century masters of the documentary mode—Evans, Frank, Friedlander, Adams (R), Shore, and the like—but all those kids of the twenty-first century making photo-diaries for their web-blogs.

Notes

1. Margit Rowell, "Constructivist Book Design: Shaping the Proletarian Conscience," in Margit Rowell, *The Russian Avant-Garde Book 1910–1934* (New York: Museum of Modern Art, 2002), p. 61.

2. John Szarkowski, *The Photographer's Eye* (New York: Museum of Modern Art, 1962).

3. Szarkowski's title, *The Photographer's Eye*, is close to one of the publications accompanying the monumental 1929 exhibition *Film und Foto* (Film and Photo), held in Stuttgart. This polemical extravaganza set the seal upon the first phase of European modernist photography, and while it included the work of leading American modernist photographers such as Edward Weston, it also featured anonymous news and advertising photography. At the instigation of Abbott, photographs by Atget were also included, less than two years after his death, the first time Atget's imagery was set in such a context. Accompanying the exhibition was Franz Roh and Jan Tschihold's *Foto-Auge. . . Oeil et Photo. . . Photo-Eye* (Stuttgart, Germany: Akademischer Verlag, Dr. Fritz Wiedekind & Co., 1929), which reproduced Atget's (now) famous image of a corset shop on the Boulevard Strasbourg. It is interesting to note that Szarkowski shifted the emphasis of "eye" from "photo"—that is to say "camera"—to the photographer.

4. John Szarkwoski, from a wall label to *Atget*, an exhibition shown at the Museum of Modern Art, New York, December 1, 1969, to March 22, 1970.

5. See Margaret (Molly) Nesbit, "Atget's Seven Albums," PhD dissertation, Yale University, New Haven, Connecticut, 1983, published as *Atget's Seven Albums* (New Haven and London: Yale University Press, 1992). Nesbit's excellent analysis of the albums Atget made between 1909 and 1915 as "prototypes for books that were never published" examines both his working practice and a case for him as an auteur exhibiting both a subtle political identification with the radical left and a sense of modern life and popular culture.

6. The four monographs are John Szarkowski and Maria Morris Hambourg, *The Work of Atget, Vol. 1: Old*

France (New York: Museum of Modern Art, 1981); *The Work of Atget, Vol. 11: The Art of Old Paris* (New York: Museum of Modern Art, 1982); *The Work of Atget, Vol. III: The Ancien Régime* (New York: Museum of Modern Art, 1983); *The Work of Atget, Vol. IV: Modern Times* (New York: Museum of Modern Art, 1985). In addition, John Szarkowski published a volume of essays on individual Atget pictures. John Szarkowski, *Atget* (New York: Museum of Modern Art, 2000).

7. Hambourg, "The Structure of the Work," in John Szarkowski and Maria Morris Hambourg, *The Work of Atget, Vol. III* (see note 6). Hambourg also drew upon her research to write a biography of Atget. Maria Morris Hambourg, "A Biography of Eugène Atget," in John Szarkowski, and Maria Morris Hambourg, *The Work of Atget, Vol. 11* (see note 6).

8. Rosalind E. Krauss, "Photography's Discoursive Spaces," in *The Originality of the Avant-Garde and Other Modernist Myths* (Cambridge, Massachusetts, and London: MIT Press, 1986), p. 147.

9. Max Kozloff, "Abandoned and Seductive: Atget's Streets," *Afterimage* (Rochester, New York), April 1986, Vol. 13, No. 9, p. 13.

10. Ibid., p. 17.

11. Walker Evans, "The Reappearance of Photography," *Hound and Horn* (Cambridge, Massachusetts), October–December 1931, Vol. 5, p. 126.

12. Nesbit, *Atget's Seven Albums*. Nesbit amplifies her arguments for Atget the editor-author in *Eugène Atget, 1857–1927, Intérieurs Parisiens: Photographies* (Paris: Musée Carnavalet, 1982), an examination of his album of Parisian interiors, which is in the collection of the Musée Carnavalet.

13. Hambourg, "The Structure of the Work," p. 26.

14. Szarkowski, "Atget and the Art of Photography," in Szarkowski/Hambourg, *The Work of Atget, Vol. 1*, pp. 18–19 (see note 6).

15. Nesbit, *Atget's Seven Albums*, p. 122.

16. Szarkowski, "Atget and the Art of Photography," p. 25.

17. Eugène Atget, letter to Marcel Poëte, curator of the Bibliothèque Historique de la Ville de Paris, June 14, 1912. Quoted in Hambourg, "The Structure of the Work," pp. 9, 29.

18. Eugène Atget, letter to Paul Léon, Ministre des Beaux Arts, November 12, 1920. Quoted in Hambourg, "A Biography of Eugène Atget," p. 29.

19. Leo Rubenfein, catalog introduction to *Garry Winogrand*, exhibition at Grossmont College Gallery, El Cajon, California, March 15 to April 2, 1975, unpaginated.

20. John Fraser, "Atget and the City," in *Studio International* (London), December 1971.

A Tale of Two Portraits: *La Comtesse de Castiglione* and *Blind Woman*

In *Camera Lucida*, his magisterial rumination on photography, Roland Barthes developed the notion of the "punctum." The punctum, Barthes wrote, is the aspect of a photographic image that "pricks" or touches us, stops us short or jolts us. The punctum can be many things, but it is always the point of the image, whether or not intended by its maker. It can be as ineffable as a sigh or as blatant as a mountain. It is that elusive something that one might define by saying, "I know it when I see it." The intelligent photographer will always recognize and honor it, even if, as most frequently happens, it just drops into the picture. In the next shot, he or she will seek it, or try to divine something like it.

The punctum is related, or at least not unrelated, to James Joyce's idea of the epiphany, that sudden "revelation of the whatness of a thing, the moment in which the soul of the commonest object . . . seems to us radiant."[1] We might say therefore, that it is related closely to the soul of the image, and yet the pragmatic Barthes' choice of the term (from the Latin *puncta*: "pricking") in relation to the camera-produced image was inspired, for the feeling is one of pain as much as pleasure.

Nowhere is the sweet and sour nature of the punctum more apparent than in the portrait. Of all the fields of photographic endeavor, portraiture is arguably the most widely practiced, and surely the most widely consumed. There are probably more photoportraits in the world than bricks. It is also the most charismatic genre, because portrait photographs prick us time and time again.

Photography was invented almost simultaneously by three people: William Henry Fox Talbot in England, and Louis Daguerre and Hippolyte Bayard in France. Bayard, whose process was the least practical, did not receive the material rewards or plaudits accorded the other two. However, posterity will record that Bayard was arguably the medium's first artist. As a bitter riposte to those who ignored him, he contrived an acid tableau, a parody of David's *Death of Marat*, depicting himself as an unclaimed cadaver in the Paris morgue, a poor martyr driven by an uninterested world to commit the desperate act of drowning himself. In so doing, he gave us what might be ascribed the first photographic portrait, the first photographic nude, the first photographic self-portrait, and, by virtue of its mocking, ironic self-referential qualities and written caption, possibly the first postmodern image-text piece: "The corpse of the gentleman which you see on the other side is that of M. Bayard, the inventor of the process whose marvelous results you have just seen or which you are going to see."[2] It is, also, the first direct example of the photographic lie.

Bayard craftily utilized the camera's propensity for combining verisimilitude with metaphor to convey his disgust at his treatment, his "mortification." In modern British

parlance, one might also say that he was "gutted." Clearly, in this startling image, one of the earliest photographs we know, the photographer displays an immediate and sophisticated awareness of the medium's endemic ambiguities. He was aware that he was fabricating a believable representation of death, not simply sleep, and that both were false.

This sardonic fiction, this play on appearances, was the image's punctum. Now, as the filmmaker Peter Greenaway has observed, Bayard himself is long dead—"dust and bones for more than a century"[3]—but the photograph itself still exists to render its own ironies twice as bitter, the prick twice as painful.

A play on appearances. That might serve to define the whole photographic enterprise; it certainly defines the game of portraiture. Portraiture is about appearances and looking, about the look and the gaze. We might say that the game is a contest between being scrutinized and scrutinizing, though the object of scrutiny is not always the sitter. As Barthes wrote: ". . . Photography's inimitable feature (its *noeme*) is that someone has seen the referent (even if it is a matter of objects) *in flesh and blood*, or again *in person*. Photography, moreover, began, historically, as an art of the Person: of identity, of civil status, of what we might call, in all senses of the term, the body's *formality*."[4]

I would like to consider in some detail two exemplary, and favorite portraits—as good as photographic portraits get—which play upon appearance and looking, and subtend other issues as well. The first is a portrait the commercial studio Mayer and Pierson took of the celebrated aristocrat, the Comtesse de Castiglione in the 1860s. The second is Paul Strand's *Blind Woman*, 1916, a key work of early photographic modernism.

Closely related to the question of appearances is the pose. Indeed, Barthes went so far as to write that "what founds the nature of Photography is the pose."[5] If photography is essentially about scrutiny and observation, it must also be about the pose, for the pose is the subject's presentation of his or her identity to the photographer, an act which ensures the preservation of that identity. The idea that a photograph steals the soul dies hard—not altogether without cause—and the pose is the subject's defense. In a world that has become increasingly preoccupied with appearances, the notion of the pose has moved far beyond the hermetic context of the painter's or photographer's studio into the wider sea of social mores. We speak of "putting one's best face forward" or "putting a face on it." A poseur is someone who displays a false face, an artificial persona, who dissembles, as we all do at times, in an aggressive rather than purely defensive manner. More recently, the term "posing" has achieved a less pejorative connotation in the clubbing and gay subcultures. In the eighteenth and nineteenth centuries the equivalent of posing in a night club was flirting at a masked ball. *Plus ça change.*

Mayer and Pierson, the leading commercial photographic studio in Second Empire Paris, made hundreds of portraits of the Comtesse de Castiglione, but it is the one dubbed *Game of Madness* (*Scherzo di Follia*), a playful mocking of the conventions of the masked

ball, which has endured above most of the others. The Comtesse, one of the great beauties of the age, the fabled "mistress of Napoléon III and many of his courtiers,"[6] in the words of George D. Painter, flirts with the camera like a fan dancer teases her audience. She grants us only a tantalizing glimpse of the face that was her fortune by covering most of it with a photo frame, held up with a slightly plump arm, whose bared condition, and a similarly exposed shoulder, serves to accentuate the tease. The oval aperture frames her artfully made-up eye like a mask. The weight of the whole portrait is concentrated upon this unblinking organ, upon this frank stare, and is an extended pun upon looking. It becomes a clear case of us looking at her looking at us looking at her. The viewer of the day was invited to gaze at her, like a prospective lover, and wonder whether her reputation as a beauty, not to mention that of aristocratic courtesan, spendthrift, and mistress of court intrigue was merited. Her cool, calm, yet inviting gaze tells us that it was, but that she would be a dangerous plaything, this woman who was bold enough to appropriate the male gaze for herself in such an epoch and stare down the whole of posterity.

This complex, clever portrait, like Hippolyte Bayard's, juggles puns and visual references as adroitly as any product of postmodern irony. The oval frame declares emphatically that the viewer is looking at an image, a fiction, and that appearances are not necessarily to be believed, especially when constructed by a subject whose life was ruled by appearance and who knew the full value of it.

There is a third, even fourth allusion at work, peculiar to this outstanding individual. Besides the metaphors of the eye, mask, and of course the looking glass, there is the keyhole, which reflects the Machiavellian world of the spy and the political intriguer. When she arrived in Paris in 1855, the young Virginia Oldoini had been charged by the Italian patriot Cavour to win over Napoléon III to the cause of Italian unity by "any means she chose."[7] The method she selected is clear, and as also seems quite apparent, she positively reveled in the particular joke of this image, which she herself carefully constructed.

La Castiglione was one of the first celebrated women to realize the iconic potential of the camera in this first period of photography. We might say that she was celebrated for being photographed, though that is to obscure the material reasons for her fame, or rather infamy, and the fact that her photographed image would have been available to a relatively limited circle. Nevertheless, like Sarah Bernhardt, another great beauty of the Second Empire, the Comtesse visited the photographic studio at frequent intervals, and like Bernhardt she seems to have been aware of the necessity for control, a concern to use the camera rather than let the camera use her. Her chosen studio, Mayer and Pierson, made over seven hundred images of her, an enterprise that, in photography's earliest years, represented a considerable investment in time and effort. And, as Pierre Apraxine has written, much of that effort was expended by the Comtesse herself to ensure that the resultant images were under her firm control: "In a reversal of roles the sitter would direct every

Pierre-Louis Pierson, *La Comtesse de Castiglione [Scherzo di Follia]*, 1863–66

aspect of the picture, from the angle of the shot to the lighting, using the photographer as a mere tool in her pursuit of self-absorbed, exhibitionist fantasies."[8]

One could argue that Apraxine is being too moralizing in tone in the last part of an extremely interesting observation. Whether she considered it desirable or not, the Comtesse de Castiglione had a vested interest in her looks. As a woman, she was judged by them, fairly or not. Her looks were her only passport to the world of affairs—in every sense of that word—and she would have been only too aware of the truly vicious comments habitually made by male society about aging courtesans. It would seem to my mind, that we are seeing self-regarding exhibitionism as much as the tentative beginnings of publicity photography, photography with a specific, quite ruthlessly determined cultural purpose. Again, a parallel with Sarah Bernhardt seems entirely appropriate. The acclaimed actor certainly utilized the camera as a blatant publicity tool. It seems plausible that the Comtesse, in a social arena that was only slightly less public, was in the same calculated business of creating a public persona, formulating her own legend. Admirers purchased photographs of their favorite aristocrats almost as readily as their favorite actresses.

It might be noted that a large part of the Bernhardt legend revolved not only around her art and beauty, but her willingness, indeed her need, to pursue her career until long "past her prime." Famously, she even trod the boards with a wooden leg after an accident necessitated an amputation. The camera, however, came galloping to her aid. Photographs helped maintain the fiction that her youthful beauty endured, and the rest was left to the equally tricky crafts of stage lighting and greasepaint. The syndrome, of course, is still with us. It seems almost mandatory for mature actors—of either sex—to allow at least a ten-year period to elapse before a publicity photograph is relieved from active service. And so it would seem with La Castiglione, whose talents would appear to be not so different from that of the actress. All the evidence indicates that the Comtesse, like any woman renowned for her beauty, or a too handsome youth for that matter, had an inordinate dread of aging, a trait that has its narcissistic, self-indulgent elements, but also its purely practical aspect, related to career and status in society.

Like the Marschallin in Richard Strauss's opera *Der Rosenkavalier*, a woman all of thirty-one years of age, who would creep downstairs in the middle of the night and stop the clocks in a vain attempt to arrest time, the Comtesse de Castiglione seems to have utilized the camera in a talismanic attempt to preserve her youth and beauty. And not just the loveliness of her face, but other parts of her anatomy as well, which were selected, scrutinized, amortized, then fetishized like so many specimens. She even hiked up her skirts so that her naked feet and legs might be photographed in an extraordinary series of études. It was one thing in the 1860s for a prostitute or serving girl, even an actress, to bare her flesh for the camera, quite another for one of the "great and the good." The Comtesse turned also to another typically nineteenth-century method of immortalizing parts of the

body: life masks cast in plaster. The poet and aesthete Count Robert de Montesquiou possessed a plaster cast of her knees as well as 433 photographs of her.

When de Montesquiou, the primary inspiration for Baron de Charlus, the éminence grise of Marcel Proust's great masterpiece—which of course had more than a passing interest in the poetics of time and remembrance—dedicated a semi-mystical cult to her beauty and her eminently transgressive career, the Comtesse was a prematurely aged recluse, bald and toothless though she was hardly sixty. George Painter recounts that she "still lived in the Place Vendôme, half-crazed, emerging only at night, lest people should see the ruin of her beauty."[9] But she persisted in calling upon the magic power of the camera. Pierre-Louis Pierson, himself in his seventies, was ordered out of retirement to make a further series of photographs of La Castiglione, in which she adorned herself with roses, covered up her baldness with a wig, and struggled into the costumes she had worn in her prime. These later pictures hint at desperation. On one set of prints the Comtesse marked with slivers of paper exactly where the negative was to be retouched in order to regulate her fuller figure. More camera magic, a century before Photoshop. But judgments of obsession, of narcissism, or craziness, it might be noted, are almost exclusively male, and might reflect not so much the reality but the thin veneer of appearances once more, only what was expected of women in the nineteenth century by bourgeois society when they were deemed past their somewhat limited "sell-by" date. The lady, it might be said, did nothing more reprehensible in the photographic studio than try too hard.

Mayer and Pierson's portrait of the Comtesse de Castiglione with the oval frame is, like Hippolyte Bayard's self-portrait, about representation. Of course, any photograph is about representation, but Mayer and Pierson's image is not just a representation of a human being, it is specifically a meditation *upon* representation itself. And gratifyingly, it enters our own contemporary dialogue totally on its own terms. As a photograph, in its concept, it is as contemporary as tomorrow. Many early photographs are subsumed by accident or default into the great late-twentieth-century representational debate, plucked out of context by commentators with the prescience of hindsight in order to demonstrate this or that premise concerning postmodern or structuralist theory. The Comtesse's portrait, however, is quite a different matter. We might say that it was made by a media sophisticate—the Comtesse rather than the photographer, it seems clear—delving into complex issues revolving around appearance, sight, and desire. To be sure, La Castiglione would not have been able to articulate these issues in contemporary terms, but intuitively, purely visually, with sense, logic, intention, and perfection, the photograph says it all, and pricks us more deeply than any dry academic text.

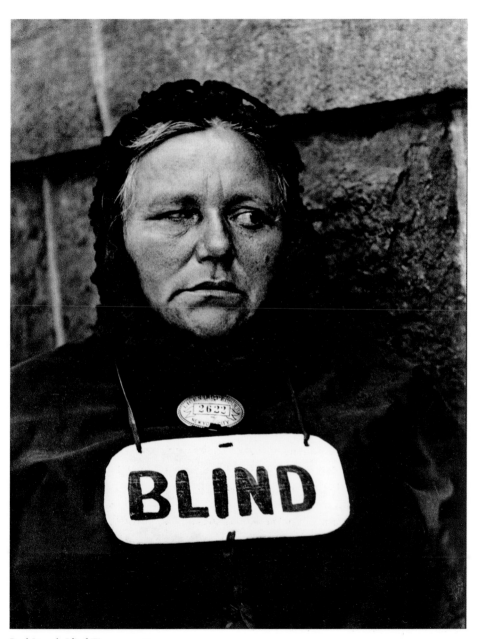

Paul Strand, *Blind Woman*, 1916

The portrait of the Comtesse de Castiglione with a frame is about appearance, about what is perceived and understood by our eyes, mediated by sight. It is also about controlling what we see, what we allow to be seen, and what is represented by appearance, about what is represented in the fiction of an image. Another renowned photograph, Paul Strand's *Blind Woman*, is about the same important things, but the story it tells and the effect it has upon our sensibilities, are quite different.

The first observation to be made about the image is that it is a supreme example of what is essentially a twentieth-century photographic mode, the candid camera. The image derives from a series Strand made on the streets of New York in 1916, of surreptitious portraits of strangers in public places.[10] By today's standards, Strand's medium-format, relatively bulky camera would not be considered suitable for such a task. Nevertheless, by means of the crude but evidently effective subterfuge of a false lens screwed on to the camera's side, and much perseverance, Strand made a startling series of images, praised extravagantly by Alfred Stieglitz for their modernity, in that they outlined a new subject, the heroic proletariat—and a new form, the candid street portrait.

Of course, the blind woman was one of Strand's easier targets, precisely because she could not see the photographer at work. Thus the image emphasizes, cruelly yet most vividly, the control of the photographer who captures or steals an unasked-for representation of a wholly unsuspecting soul. It is Richard Avedon, rather than the more cautious and circumspect Strand, who made the most candid admission of the fact that, in the portrait-making situation, control over the final product essentially lies with the photographer. He averred that his sitter's "need to plead his case probably goes as deep as my need to plead mine, but the control is with me."[11] Even when the indomitable Comtesse de Castiglione was arranging things, Pierre-Louis Pierson still had the crucial option of deciding when to trip the shutter. Nevertheless, in most cases the portrait—at least the posed portrait—is a three-way dialogue between sitter, photographer, and viewer. The candid portrait directly removes one-third of that dialogue, a fact made brutally apparent in the case of the blind woman. She has been represented, immortalized, courtesy of a complete stranger, without her complicity, her consent, probably even her knowledge. In one way or another, that is the "prick" common to most candid street portraits. In this instance, it is sharp enough almost to draw blood.

Again, like Mayer and Pierson's mask image, we have a wonderful example of the photographic image knowingly working at the level of allusion, switching back and forth between hard fact, metaphor, symbolism, and formal poetry. The woman is evidently blind, yet around her neck she wears a sign with the word *blind* written upon it.[12] The picture carries its caption contained within it. She is sightless, but has been pictured by *the* medium of instantaneous sight impressions, by an instrument that is an all-seeing eye. The poignancy

of this is unbearable, a devastating commentary upon the fragility, yet crucial importance of all that we gauge by appearances and with our eyes. And yet there is no complicit irony, no shrug of regret or cheerful defiance to leaven the gloom of harsh reality in Strand's picture. It is as despairing an image as any in the medium, and fully confirms photography's profound melancholy.

If the power of the photographic medium—its leitmotif or meta-punctum—lies in its relationship with reality, or rather, *actuality*, nowhere is that power quite so apparent as in the portrait. In spite of innumerable attempts, if not to sever, to at least subvert photography's umbilical cord with actuality—from self-consciously "arty" confections to computer alchemy—photography, and particularly the portrait, continues to defy those ashamed of unadorned reality. The photograph continues to astonish us chiefly by virtue of its faculty as a realist medium, by virtue of the simple statement "this is how something, or someone, appeared then." A painted portrait by say, Holbein or Rembrandt, is an extremely complex artifact, part icon, part representation, part symbol, part antique. In viewing a Holbein or a Rembrandt "in the flesh," so to speak, we are looking both at an image and an object dating from the time it was made, and a complicated cultural talisman that subtends a multiplicity of interconnected considerations, one of which is certainly monetary. Even in reproduction, we can hardly look at a Rembrandt as a mere image, without also considering it as a banknote of boundless denomination.

The photograph is quite a different kettle of fish. Unless it is a so-called vintage print, which is a somewhat spurious attempt by the art market to lend the photograph the aura and the cachet of the painting/antique, the photograph largely blows extra-pictorial issues of market provenance away. Almost any half-decent reproduction of the *Game of Madness* or *Blind Woman* conveys their power. A photograph by definition is a reproduction rather than an original, a reproduction that carries and confronts us directly with an actual chemical trace of a human being in a particular place at a particular time. If we pause to think about that for a moment, we must admit that this is awesome, but it is an awesomeness of a totally different order to the painterly wonders of a Holbein or a Rembrandt.

Our engagement with the photographic portrait, unlike that of the painted portrait, is not that of the connoisseur but that of the voyeur. We gaze not at the painter's work but at the photographer's subject. Sometimes, like La Castiglione, the subject gazes back, giving as good as she gets, but perhaps more often she is like the blind woman, sightless and unapprehending. Our gaze as viewers is essentially one-sided, with all the assumptions of privilege and power that entails, given to us by the momentary, often unthinkingly casual act of clicking a shutter, with or without the subject's consent. The photographer, therefore, bears a degree of responsibility. He or she really is in the business of stealing souls, or, if we put a positive spin upon it, of conferring the gift of immortality. For why do we almost obsessively take so many portraits of ourselves and our loved ones, if not to confirm our

existence and immortalize ourselves by arresting time for an eerie instant, vainly erecting this flimsy bulwark against time and decrepitude?

Ultimately, there is one great difference between the Castiglione and *Blind Woman* portraits. It is the difference between what I would term the celebrity portrait and the social portrait, between an image of one who has a certain status in society and one who has very little, who is, to all extents and purposes, an anonymous member of society. Of course, one's place in society is not simply a case of have or have not, but is a complicated continuum. Nevertheless, the distinction I have made between two types of subject is a sustainable one, I believe. In the case of the celebrity portrait one tends to read biography, in the case of the social portrait, one tends to read sociology. In the celebrity portrait, we acknowledge an individual, in the social portrait we study a type.

The Comtesse de Castiglione as a member of a wealthy and privileged class had a comfortable, acknowledged, indeed envied place in society. As the mistress of the emperor, a suspected spy, and habitué of masked balls, a certain notoriety added spice to the mixture of her celebrity and secured her a piquant place in history. A full biography, indeed, has been written in the last four decades,[13] so her fame, while hardly of the first rank, is reasonably secure. It is this fame, and not simply her ability to manipulate her own photographic image, which protects her from the worst excesses of the photographer, and by extension, our gaze. Photographers may have intruded into the life of the late Princess Diana in a manner few of us can fully comprehend, but their many photographs of her contributed immeasurably to her popularity, both when she was living and even more so posthumously. As well as being manipulated by it, Princess Diana exploited photography shamelessly and recklessly. It was clearly a two-edged sword, upon which, we might say, she finally fell. But who can say with certainty whether she was feted, immortalized, terrorized, or ultimately degraded by the camera?

The blind woman has her measure of posthumous fame, and has become an icon of sorts, but it is not as an individual; it is as a subject, or more accurately, as a subject-object. There may be biographies written about Paul Strand the celebrated photographer, but none about probably his most renowned subject. We can only speculate about her life in the vaguest sociological terms. She is mute as well as blind, given only her master's voice in the person of the photographer. And yet we cannot condemn that furtive, selfish act of Strand's outright, for if it was done with a sharp-eyed lack of sentimentality it was not done without compassion, although whether we read that compassion retrospectively, with regard to his later work, is a matter for conjecture. No matter, there are photographers one would not trust in this game of soul taking, and relatively few others, such as Strand, whom one would trust completely, though possibly not in this particular case.

In the long run, when face-to-face with a subject, when putting us face-to-face with them, the photographer makes choices in accordance with his or her sensibility, his morality

and compassion or lack of it. Every portrait photographer sets down only surface aspect, that in the hands of the wrong sensibility might merely reveal opportunism and brutish misanthropy. In the hands of the right sensibility it can reveal much more, a life, a fellow human being, a mensch, and what photographer Charles Harbutt has described as "the flip side of the soul."[14] Every photographer confers the gift, welcome or unwelcome, of some kind of seditious immortality upon a sitter. Whether that gift is conferred carelessly and without charm, making it hardly worth a row of beans, or with grace, style, and moral rectitude, making it worth at least the fabled thousand words, is quite another matter.

Notes

1. Richard Ellman, *James Joyce* (London, Melbourne, and Toronto: Oxford University Press, 1966), p. 87.

2. The text for Bayard's image, dated October 18, 1840, continues: "As far as I know, this ingenious and indefatigable researcher has been busy perfecting his invention for about three years. The Academy, the king, and all those who have seen his drawings, which he himself considered imperfect, have admired them as you are admiring them at this moment. This has honored him greatly and has earned him not a penny. The government, which had given far too much to M. Daguerre, said it could not do anything for M. Bayard, and the poor man drowned himself. O, the fleeting nature of human things! Artists, scientists, and newspapers have been concerned with him for a long time, and now that he has been exposed at the morgue for several days, nobody has yet recognized him or asked for him. Ladies and gentlemen, let us pass on to other things, for fear your sense of smell may be affected, for the head and the hands of the gentleman are beginning to rot, as you can see." Michel Frizot, *The New History of Photography* (Cologne: Könemann, 1998), p. 30.

3. Peter Greenaway, *Talking Pictures: Hippolyte Bayard*, wall label to exhibition at the Photographers' Gallery, London, 1991.

4. Roland Barthes, *Camera Lucida* (New York: Hill and Wang, 1981), p. 79. The italics are Barthes'.

5. Ibid.

6. George D. Painter, *Marcel Proust: A Biography* (Harmondsworth, England: Penguin Books, 1983), p. 121.

7. Pierre Apraxine, in Pierre Apraxine and Maria Morris Hambourg, eds., *The Waking Dream: Photography's First Century* (New York: Metropolitan Museum of Art, 1993), p. 339.

8. Ibid.

9. Painter, *Marcel Proust*, p. 79.

10. See Maria Morris Hambourg, introduction to *Paul Strand Circa 1916* (New York: Metropolitan Museum of Art, 1998), pp. 34–39.

11. Richard Avedon, foreword to Richard Avedon, *In the American West* (London and New York: Thames and Hudson, 1985), unpaginated.

12. Strand's image is often titled *Blind Beggar Woman*, rather than *Blind Woman*, incorrectly according to Hambourg, *Paul Strand Circa 1916*, p. 37 and footnote 123, p. 47. Apparently the photographer, sensitive to the candid nature of these street images in relation to the studied nobility with which he tried to invest later subjects, insisted that the woman was not totally blind, and was not a beggar, but had a license from the city of New York to trade on the streets.

13. Alain Decaux, *La Castiglione, dame de coeur de l'Europe* (Paris: Le Livre contemporain, 1959).

14. Charles Harbutt, "Charles Harbutt Workshop: Learning from Atget," *Popular Photography* (New York), Vol. 40, No. 1 (January 1976), pp. 100–107.

The Other *Americans*: Richard Avedon's *Nothing Personal*

Anyone looking at photographs, considering them, and then writing about them, tends to have strong opinions, frequently to the point of inflexibility. Many critics indeed, are not only inflexible, but hopelessly prejudiced. It goes with the territory, I guess, for critics generally become critics because they feel that their opinions are the only ones that matter. I must admit that I began to write about photography not only to learn about it for myself, but also because I felt few of the writers I read knew much about it. When I was young, I also felt that only writers whose opinions coincided with mine—like John Szarkowski for instance—knew anything. Now I can respect writers whose opinions I disagree with totally. I respect their knowledge, their critical position, and their writing. Although ultimately, of course, they're wrong.

There is a certain arrogance in being a critic, or perhaps a certainty, which derives from a passion for what one is writing about. A wishy-washy critic is generally not a very good critic. But as always there is a balance to be struck. The know-all, inflexibly opinionated critic, the kind who loves the sound of his own voice (they're usually male, I'm afraid), and who patronizes his audience, pretending only he has the keys to critical explication, is to be avoided at all costs.

Here, I tend to agree with Robert Adams, who in his excellent essay, "Civilizing Criticism,"[1] argued broadly that the critic's task is not so much one of criticism, but more a matter of appreciation. I have come round to this position over the years. Fired by the zeal and moral certainty of youth, I was a fierce critic, but nowadays I tend to write about work I like and generally ignore work I dislike. A negative review, I feel, takes up valuable space that might be utilized more profitably to encourage readers to appreciate rather than avoid. On occasion, one might need to show disapprobation, but my disapproval is reserved usually for work that I regard as dishonest or inauthentic. I see little point in tearing apart the bad pictures of some beginner when I might instead encourage the promise of another. On the other hand, it can sometimes be necessary to write a corrective where one believes that an established photographer and his or her work has been overinflated.

It is also my belief that critics should confine their remarks to the work and not its creator. This is sometimes easier said than done—if the art is any good then it *is* the artist. But what I mean is that a critic should try not to second-guess an artist's motives. In this age, when art has become so commercialized and so much an object of hype, where so much is shallow, derivative, and nakedly commercial, one still should attempt to judge the tale rather than the teller. Art criticism should be neither a species of gossip, nor a form of character assassination.

I have made these remarks about the critic's role for two reasons. I want to talk about

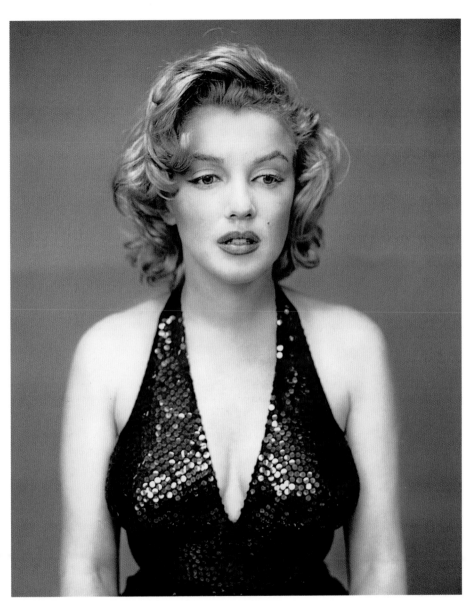

Richard Avedon, Marilyn Monroe, actor, New York, May 6, 1957

a photographer who had enormous commercial success, yet attracted a mixed critical reaction. And I also want to retract some of the things I have said about him in the past. A critic's opinions can change—there is nothing wrong with second thoughts, especially as one becomes older and (hopefully) wiser, and, importantly, one simply learns more.

Richard Avedon was the most successful fashion and society portrait photographer of his time, but he also made work that could be considered noncommercial and artistic in intent. It is this that has divided commentators. Some critics believe that commercial work is of lesser import than self-styled creative work, therefore a photographer who makes his living primarily from fashion, editorial, and advertising photography cannot possibly be a serious artist. Others become suspicious when highly successful photographers proclaim artistic ambitions, feeling that this is just another strategy of their commercial practice, motivated simply by the desire to make another buck. Avedon suffered more than most from these kinds of attitudes.

Interestingly, he suffered vituperative criticism on those grounds in a way that his close colleague, Irving Penn, did not. Both were fashion and celebrity portraitists, and both made portraits of non-celebrities, of "ordinary" people. Penn photographed various indigenous peoples throughout the world, Avedon tended to stick to Americans. Yet Avedon's efforts in the field of social portraiture were heavily slated, while Penn's "native" portraits, which one might have expected to be questioned at the very least, have been largely accepted with barely a murmur. Why this noticeable discrepancy?

Part of the reason, I feel, is that whatever one might think of it, Avedon's work digs, and digs deeply, whereas Penn's is all surface elegance. Yet in the 1950s, both Penn and Avedon were bracketed together, usually in friendly rivalry, as the creators of the "anti-celebrity" portrait, which challenged the respectful sycophancy that usually marked the genre. Both were credited and accused in equal measure of depicting the famous not as retouched, soft-focused "beautiful people," but as plain, wrinkled, old, or ugly. It was part of a general opening out of Western society following the Second World War, when a gradual relaxation of class barriers created a climate in which heroes might be overtly deflated as well as feted, a trend that is commonplace today.

The anticelebrity portrait was a surefire index of fame, a backhanded compliment of the best kind. And it still has much currency, contemporary equivalents being Annie Leibovitz or David LaChapelle persuading celebrities to do silly things, or Terry Richardson persuading them to do obscene things.

But if one compares the anticelebrity portraiture of Penn and Avedon, Penn's seems so much softer in content. Penn backed his sitters up into a corner, creating a kind of faux-discomfort. He tended to use natural light, or attempted to replicate it with his studio lighting setups, while Avedon preferred to exploit the harsher qualities of electronic flash, utilizing the extreme close-up to reveal every natural blemish in a face, rather in the

manner of a medical photograph. As Janet Malcolm has written: ". . . his camera dwells on the horrible things that age can do to people's faces—on the flabby flesh, the slack skin, the ugly growths, the puffy eyes, the knotty necks, the aimless wrinkles, the fearful and anxious set of the mouth, the marks left by sickness, madness, alcoholism, and irreversible disappointment."[2]

When both turned to natural north light for their social portraits (interestingly, there was an element of tracking each other's careers), Avedon again proved himself to be the much tougher photographer. Despite their superficial modernity, embodied in a square format and high-contrast tonalities, Penn's portraits of Cuzco *campesinos*, Papuan tribesmen, and also hippies in San Francisco, replicated a trusted genre. Penn's book, *Worlds in a Small Room* (1974),[3] demonstrated a romantic view of the "primitive" that was not so far removed in tone from Edward S. Curtis's view of the American Indian. While both photographers were concerned with describing types rather than individuals, Avedon's approach, especially in his controversial book, *In the American West* (1985),[4] seemed influenced more by August Sander's sociopolitically based portraiture of the Weimar Republic.

In the American West was Avedon's primary statement as a social portraitist. It was widely criticized, most notably by Max Kozloff. Like many commentators, Kozloff was both puzzled by, and critical of the relentlessly downbeat nature of the book. Avedon's cast of characters consisted almost entirely of the Western underclass: the unemployed, hobos, drifters, low-paid menial workers. As Kozloff wrote: "I am thoroughly downcast by his terrible perspective on the West . . . but that is his right. Obviously, whole spheres of Western culture—the sun-belt retirement communities, the new wealth grown up through oil and computer development, the suburban middle class—are ignored in Avedon's gallery. He is definitely obsessed by a myth based on geographical desolation, rather than engaging with any real society."[5]

It was this narrow focus that worried me in an article I wrote about the book, an essay that was also highly critical.[6] I still agree with much that I wrote in the piece. Like Kozloff, I feel that by focusing upon one class (a disadvantaged underclass) and one mood (largely one of misery and despair) Avedon misused some of the most powerful and haunting portraits made toward the end of the twentieth century. If only he had broadened the social catch and expanded the mood, what a book it could have been. As it is, *In the American West* remains a book to be reckoned with, a flawed masterpiece. It is a major demonstration of the fact that it's not just the photographs, it's what you do with them.

What interested me about the book, and about other aspects of Avedon's work, was not the fact that he was trying to be an "artist," but that inside the fashion and commercial photographer another photographer seemed to be trying to get out—not simply a documentary photographer, but a sociopolitical documentarian.

This is seen most clearly two decades earlier in his collaboration with the writer, James

Baldwin, in *Nothing Personal* (1964).[7] It is a book that always intrigued me—another flawed masterpiece I would have said twenty years ago—but it was not until I reexamined it closely while researching the photobook history with Martin Parr[8] that I became more than intrigued by it, and more than that, by the apparent mass of contradictions that was Richard Avedon. I began by reading Baldwin's text, which I admit to having ignored until this point. This startled me, to such an extent I asked Martin whether he'd read it, and he hadn't, or it had been so long ago he couldn't remember much about it. I asked a few more people whom I knew were acquainted with the book. Again, the answers were uniformly negative, which if nothing else served to confirm something I'd always suspected—that texts in photobooks tend to be ignored by those primarily interested in the photographs.

Max Kozloff has a few bones to pick with *Nothing Personal* as well. And here I find myself disagreeing with one of my favorite writers on photography. He begins by dismissing the text, finding Baldwin "at his most self-indulgently alienated and bitter,"[9] and goes on to conclude that "*Nothing Personal* certainly gets one's attention, but it doesn't add up."[10] Perhaps the clearest indication of his basic attitude toward Avedon comes where he describes the photographer as "the impresario of haute couture,"[11] although to be fair, Kozloff at least tries to talk about the book itself most of the time.

That is certainly not the case with the theater critic, Robert Brustein, who reviewed *Nothing Personal* in the *New York Review of Books* when it appeared at the end of 1964. Kozloff's suspicion of Avedon's supposed commercialism is nothing compared with Brustein's, who puts the boot in with his opening sentence: "Of all the superfluous non-books being published this winter for the Christmas luxury trade, there is none more demoralizingly significant than a monster volume called *Nothing Personal*."[12]

Brustein continues in this vein, talking more about the motives of Avedon and Baldwin rather than, it would seem, the work itself: "*Nothing Personal* pretends to be a ruthless indictment of contemporary America, but the people likely to buy this extravagant volume are the subscribers to fashion magazines, while the moralistic authors of the work are themselves pretty fashionable, affluent and chic."[13]

The implications of this critique are clear. Brustein accuses photographer and writer of dishonestly concocting a coffee-table book that purports to be a heartfelt work of political criticism—a classic piece of liberal chic. In adopting a critical stance—or to Brustein's mind, affecting a pseudo-critical stance—Avedon and Baldwin were being nakedly commercial and opportunist, taking cynical advantage during what, following the assassination of John F. Kennedy, was a time of national anxiety and political protest in America.

A few weeks after this vituperative review appeared, the *New York Review of Books* received a missive from no less a personage than Truman Capote. Capote had written the introductory text to Avedon's previous book, *Observations* (1959),[14] and fully acknowl-

edged his friendship with the photographer in the letter, but had this to say about the motives of both the authors of *Nothing Personal*:

"... of Brustein's many injustices, the most unjust is in his depicting Avedon as merely an 'affluent' fashion-photographer whose main motivation in assembling this book was to exploit the American desire for self-denigration and, so to say, cash in. Balls. First of all, if the publisher of this book sold every copy, he would still lose money. Neither Baldwin nor Avedon will make twenty cents. Brustein is entitled to think that Avedon and Baldwin are misguided; but believe me he is quite mistaken when he suggests, as he repeatedly does, that they are a pair of emotional and financial opportunists."[15]

This whole exchange, and the way Avedon's motives were so often questioned, unlike those of other equally renowned photographers, is interesting. Clearly, Avedon was a very successful photographer, among the highest paid in the world for many years, and this inspired much envy. Some felt that he was not worth the money he was paid. Some were resentful of the power that accompanied his success. One result of the exercise of that power was *Nothing Personal*—what other photographer would be allowed such an indulgence? Some took the line that a fashion photographer had no right to commit the sin of hubris by claiming he was an artist. Some considered that a photographer clearly taking the capitalist dollar could not possibly make an antiestablishment political statement— especially through the medium of an extravagant coffee-table tome.

Why not? Both Avedon and Baldwin were successful, but does that rule them out from having genuine, heartfelt, and critical opinions? At one basic level—and *Nothing Personal*, I would suggest, is more complex and multileveled than some have given it credit for—the book is clearly about the civil rights movement. Baldwin's text is one of most anti-American texts ever written by an American, a passionate, angry, and eloquent rant at the state of his country from the point of view of a gay African-American. Baldwin may have been welcome in literary salons and among gay intellectuals, but a lot of his writing deals in one way or another with being a double outsider in mainstream American society. He was active in the civil rights movement, but even that was not easy for him, for many conservatives in the movement disapproved of his homosexuality. I am surprised that his political commitment was ever seriously questioned.

Avedon, Baldwin's friend since high school (they attended DeWitt Clinton High School in the Bronx and coedited the school's literary magazine), is a perhaps more ambiguous, and interesting case, because of his apparent contradictions.

One term that crops up from time to time in writings about Avedon is the description, "Jewish liberal." Given the tenor of *Nothing Personal*, this seems apposite, in more ways than one. Being a Jewish liberal does not just mean left-leaning politically, it encompasses a whole raft of social and cultural values inherited from Middle Europe and transplanted to America, especially New York, by waves of migrants. It is one reason why New York City

overwhelmingly votes Democrat, and more broadly speaking, the Jewish liberal tradition embodies some of the finer values at the core of American democracy, including education, tolerance, and respect.

As a rising young star in the fashion world, Avedon supported the Photo League, even after it was declared a subversive organization during the McCarthy era. Talking about his attraction to the postwar Italian films of Vittorio de Sica and Roberto Rosselini, he stated that "they expressed something about what it meant to be a liberal, humanist-minded person."[16] He was also politically active. In 1963, he supplied equipment to young black photographers from the South and encouraged them to return home and record the civil rights struggle. In 1972, he was arrested at an anti–Vietnam War demonstration in Washington, D.C., and jailed for a short time.

Nothing Personal is, I believe, as much about being Jewish in America as it is about being black in America. Avedon's photographic essay speaks as much about his values — and also his demons — as Baldwin's text speaks about his.

I shall argue that contention directly, but firstly, let us deal with another much criticized aspect of *Nothing Personal*, its presentation. There is no doubt that it is a handsome book, a large-format volume with white card cover and slipcase, the titles in black within a silver embossed box on both book and slipcase. It certainly is a commercial approach to the photobook, but not an uncommon one in the context of the 1950s and '60s. Henri Cartier-Bresson's *The Decisive Moment* (1952), William Klein's *New York* (1956), and Eikoh Hosoe's *Killed By Roses* (1963) are prominent examples of the rich rotogravure printing and high production values that mark *Nothing Personal* (as well as *Observations*). The book was designed by Marvin Israel, who had a long and close collaboration with the photographer, and was also responsible for *In the American West. Observations* was designed by Alexey Brodovitch, emphasizing the point that Avedon always took great care to collaborate with the very best in their respective fields.

Avedon was known for his obsession with technical perfection. He didn't make any distinction between his commercial and his personal work, unlike many of his critics. *Nothing Personal* might represent Avedon the art photographer, it might be political in tone, but neither the photographer nor his publishers saw any reason to compromise on production values.

In actuality, the book's form might subvert the content a little — but it is the content that counts, making *Nothing Personal* one of the most interesting books of the era. *The Americans* it ain't in terms of presentation, but there are several points of useful comparison to be made with Robert Frank's masterpiece of grunge existentialism.

Nothing Personal is a close collaboration between a photographer and a writer, but rather like the collaboration between Walker Evans and James Agee in *Let Us Now Praise Famous Men* (1941), the photographic and literary texts are self-contained. Avedon and

Baldwin might be dealing with the political, but it is mediated through the highly personal. There is little, if any cross-referencing between the two "texts."

Let's begin with Baldwin. Broadly speaking, his thesis is how America has put commercial values ahead of the spiritual, thus enslaving large sections of the population, blacks clearly, but also poor whites: "We have all heard the bit about what a pity it was that Plymouth Rock didn't land on the Pilgrims instead of the other way around. I have found this remark very funny. It seems wistful and vindictive to me, containing furthermore a very bitter truth. The inertness of that rock meant death for the Indians, enslavement for the blacks, and spiritual disaster for those homeless Europeans who now call themselves Americans."[17]

He continues in this vein. "This is no place for love," he declares,[18] and warns about the false sense of euphoria created by America's vision of itself, a vision created by the values of Madison Avenue and Hollywood: ". . . the relevant truth is that the country was settled by a desperate, divided, and rapacious horde of people who were determined to forget their pasts and determined to make money."[19]

Baldwin mentions the death of President Kennedy (the only reference in the book to that recent event), pouring scorn on the official version that the crime was committed by a leftist, in a city where pamphlets had been distributed among the Right describing Kennedy as a traitor. But America he says, has long been in denial about the endemic violence in its midst: "The America of my experience has worshipped and nourished violence for as long as I have been on earth. The violence was being perpetrated mainly against black men, though—the strangers; and so it didn't count."[20]

Toward the end of his essay, Baldwin becomes extremely personal, and perhaps ironically, because he is an American, seeks—like Avedon—some form of redemption and a positive ending. His last three paragraphs are separated from the rest, text and photographs coming together for the first time. They act as captions to three pictures Avedon made on the beach at Santa Monica, gathered at the end of the book. The first shows a couple standing in the sea, the man proudly feeling his partner's heavily pregnant belly. The second depicts a black child clinging to a white woman in the sea. The third is of a man, on the beach at twilight, holding a small child high above his head. Baldwin calls for everyone to embrace life and love rather than hatred and death, and bear witness:

"For nothing is fixed, forever and forever and forever, it is not fixed; the earth is always shifting, the light is always changing, the sea does not cease to grind down rock. Generations do not cease to be born, and we are responsible to them because we are the only witnesses they have.

The sea rises, the light fails, lovers cling to each other, and children cling to us. The moment we cease to hold each other, the moment we break faith with one another, the sea engulfs us and the light goes out."[21]

Baldwin's text is at once baldly analytical about the state of America, but also highly emotive and personal. The same might be said about Avedon's photographs, which consist primarily of a portrait gallery, preceded by a brief prelude and ended by what can be described as a complicated double coda. The three Santa Monica beach pictures form the second coda, along with a civil rights group portrait—of the Student Non-Violent Coordinating Committee—the final image in the book. The first coda is very specific, and somewhat controversial. I'll describe it in a moment, but the book opens with another Santa Monica beach picture, of a man building castles in the sand. Sometimes obvious metaphors can be very effective, especially when made visually. This image precedes the title page, which is followed by a series of portraits taken of couples in the Marriage Bureau of New York City Hall. It is one of the book's primary features that celebrity portraits are mixed with images of anonymous individuals. The couples getting married are not the country's movers and shakers, but are important to Avedon, signifying immediately that the book is about community, but also about individuals.

The main body of the book, so to speak, consists of a portrait gallery—a lexicon of American faces both known and unknown, although well-known personalities predominate. Two points can be made about this gallery. Firstly, although Baldwin makes a reference to the Kennedy assassination, no figures appear from the "New Camelot" that was built up around the JFK administration. *Nothing Personal*, though it appeared a year after Kennedy's death, is not about that brief era of hope, or even the 1960s. It is, rather, about the 1950s. The only presidential portrait shown is that of Dwight D. Eisenhower; two others in the gallery, Adlai Stevenson and Norman Thomas, ran unsuccessfully against Eisenhower.

Secondly, I believe it can be looked upon as a gallery of heroes and villains. Avedon was always adamant that his portraits told *his* story more than that of his subjects. "The control is with me," he said with commendable honesty.[22] So given his politics—and crucially, I feel, his heritage—it is not difficult to surmise just who was a hero or a villain in the photographer's eyes, and who was somewhere in between. The pictures tell their story, and other facts would seem to confirm what the images say.

A quick example will serve to make the point. There is a double-page spread with George Lincoln Rockwell, self-styled "Führer" of the American Nazi Party and a few of his "storm troopers" on the left-hand page, and on the right, a naked, hirsute Allen Ginsberg. Rockwell's goons are depicted giving the Nazi salute. Ginsberg, one hand over his groin, raises the other in either a Buddhist benediction or maybe a pledge of allegiance.

Nothing Personal is a book about racism, that is clear, with Avedon supporting his friend James Baldwin in the civil rights movement. But with Avedon, racism doesn't end with civil rights for African-Americans. It is, I believe, also about anti-Semitism in America, which was particularly pernicious in the 1950s; one of the villains in the book is the racist, anti-Semitic political boss of Louisiana, Leander Perez, who went so far as to deny

the Holocaust. (Prior to photographing Perez, Avedon was warned not to say that he was Jewish.) If, on the other hand, we take a hero, the Jewish playwright Arthur Miller, who refused to name names, Avedon's powerful portrait reminds us that there was a distinct anti-Semitic tone to the whole McCarthy episode, with so many Jewish liberals coming under the spotlight of the House Un-American Activities Committee.

In a film made about him in the American Masters series for PBS television in 2002, Avedon admits to not being religious, but stresses the cultural importance of his heritage. And in a revealing sequence, he talks at length about how he took his renowned portrait of the Duke and Duchess of Windsor. This is one of his most savage portraits—unnecessarily savage, some might say—and Avedon makes his feelings toward the Windsors quite plain. At one point in his narrative, referring to the couple's pet pooches, he says with real feeling: "They loved their dogs more than they loved Jews."[23]

So Avedon evinces little sympathy for the infamously racist Governor George Wallace, while the American socialist Norman Thomas, who stood unsuccessfully for the presidency six times, smiles, a real rarity in Avedon. As far back as the 1930s Thomas had campaigned for the United States to open its doors to Jews persecuted by the Nazis.

Other heroes? There is Marilyn Monroe (who died before the book was published). Taken toward the end of a long, and clearly exhausting photo session, Avedon portrays her as a woman rather than a movie star. She looks tired and drawn, but this is a sympathetic portrait, one of the finest, if not the finest ever taken of this American icon. There is the philosopher Bertrand Russell, an assiduous antiwar campaigner, and the scientist Linus Pauling, who won the Nobel Peace Prize in 1962 for vehemently opposing atmospheric nuclear tests.

Generally, it would seem that the artists and the thinkers, the creators, are favored over the politicians, the spoilers. And then there are the "ordinary" people—two young black students, Jerome Smith and Isaac Reynolds, one with his "Freedom Now" badge prominently displayed, representing the hope and the anger of the young generation, while the powerful portrait of William Casby, "Born in Slavery," represents the dignity of the old.

Sometimes Avedon's stance seems more ambiguous, as in the image of Eisenhower, although the ex-president's creepy, lined reptilian face might place it in the negative column of the ledger. The blurred portrait of Malcolm X is also in this vein. Malcolm X, unlike the Reverend Martin Luther King, condoned violence, and the ominous quality of this powerful image suggests that Avedon was uncomfortable with this, the more militant face of the struggle for African-Americans.

Violence is another subtheme of *Nothing Personal*. Malcolm X would be assassinated in 1965; Avedon's image of him was not just powerful, it was prophetic. In another potent double-page spread, he portrays the offspring of celebrated parents. On the left-hand page there is Cheryl Crane, the daughter of movie star Lana Turner, while on the right is

Martin Luther King III, the reverend's son. In 1955, Crane murdered Johnny Stompanato, a gangster who had abused her mother. In 1968, King's father, would be gunned down in Memphis. Avedon's prescience seems almost uncanny.

This litany continues until the last picture in the portrait gallery, before the first of the codas: a tightly framed close-up of Major Claude Eatherly, one of the pilots involved in the bombing of Hiroshima. In Avedon's ferocious, but telling portrait, he holds up his left hand, as if to shield his eyes from the glare of the "thousand suns" unleashed upon the Japanese city, or maybe to blot out the knowledge of the tens of thousands killed in the world's first nuclear holocaust.[24] As well as unimaginable violence, this is also a portrait of madness. Avedon made the photograph soon after Eatherly had been released from a Texas mental institution, where he was being treated for extreme depression. As Gilane Tawadros has written of this picture: "When Avedon met him at a motel close by the asylum after he had been discharged, Eatherly was entirely monosyllabic. He had marks on the side of his head and Avedon suspected he had been given electric shock treatment."[25]

This last image of violence and madness segues into Avedon's first coda, one of the most controversial features of *Nothing Personal*, indeed one of the most controversial bodies of work in his career, exceeded perhaps only by the series he made of his father dying of cancer. Avedon had shot some of the book's portraits in the South—Leander Perez and Eatherly among them—thanks to introductions effected by his friend, Marguerite Lamkim, a Southern socialite and descendent of Robert E. Lee. Lamkin also arranged for him to photograph inside the East Louisiana State Mental Hospital, where he made the photographs that make up the first coda.

Shot in a grainy expressionistic style, the Louisiana asylum pictures remind one of theater photographer Max Waldman's later interpretation of Peter Brook's renowned *Marat/Sade* production, but Avedon's depictions of dementia, rage, and extreme withdrawal are only too real. He faced the usual accusations of intrusion over these images, but the sequence clearly forms an important part of the book. It's too easy to characterize it as an allegory for the madness of America—it clearly does perform that function—but there may be other reasons for its inclusion.

In the American Masters film, Avedon hints at his personal demons, his difficult relationship with his father, and the fact that there were frequently dark sides to his work: "I think I have photographed what I have been afraid of, things I couldn't deal with without the camera—my father's death, madness."[26] It is almost as if he needed the froth and glitz of the fashion world to keep these other tendencies from intruding too much, either into his work or into his life: "If I lived with the dark side of myself all the time, I'd be nonfunctional."[27] In the film, he also mentions his sister Louise, who spent much of her life in mental institutions. So this harrowing, and for some gratuitous sequence, may have had much more personal, as well as political and social implications for Avedon.

In my 1988 essay about *In the American West*, I made a distinction between the social portrait, portraits of anonymous individuals, and the society portrait, portraits of notables. In the social portrait, one reads sociology, but in the society portrait, one reads biography. By combining the two kinds in *Nothing Personal*, especially the latter, Avedon built up a complex reading. Through biography, we know who is the anti-Semite, who is the racist, who the man of violence, who the man of peace, who the persecutor, and who the persecuted. If we simply read the book through the surface of Avedon's superb portraits, its meaning is fairly clear, but a knowledge of the period and the photographer's cast list reveals just how he built up that meaning, and uncovers unexpected depths, further subtleties that combine to give the lie to the authors' title. *Nothing Personal* was a bitter irony—the book was absolutely personal from beginning to end, a passionate and heartfelt joint political testament. Was that why it was so heavily criticized? Did it touch too many nerves?

One further point—and this is just a feeling on my part rather than anything I can prove. *Nothing Personal* demonstrates a vision of 1950s America that is not only as incisive as the vision of Robert Frank in *The Americans*, but is as bitter. To be sure, it is couched in very different terms. The style of both photography and book emanates from the world of commercial photography, but I wonder whether, on some level, Avedon's book was intended as his version of *The Americans*, a direct challenge to Frank in artistic terms. One can say indeed that the concerns about the country shown by Avedon, however personal, were less self-reflective than Frank's, stemming from a more sharply focused political viewpoint. As Jane Livingston has written, the book "constitutes Avedon's first mature political statement, engaging the related subjects of the civil rights movement and the ever-present strains of American fascism."[28]

I must say that a closer acquaintance with *Nothing Personal* has caused me to revise many of my previous opinions about Richard Avedon, a complex and fascinating photographer. I believe that it is not only a misunderstood photobook, but one of the best to emerge from America during the turbulent decade of the 1960s.

Notes

1. Robert Adams, "Civilizing Criticism," in Robert Adams, *Beauty in Photography: Essays in Defense of Traditional Values* (New York: Aperture, 1981), pp. 51–61.

2. Janet Malcolm, "Men Without Props," in *Diana and Nikon: Essays on the Aesthetic of Photography* (Boston: David R. Godine, Inc., 1980), pp. 44–45.

3. Irving Penn, *Worlds in a Small Room* (New York: Grossman Publishers/The Viking Press Inc., 1974).

4. Richard Avedon, *In the American West* (London and New York: Thames and Hudson, 1985).

5. Max Kozloff, "Richard Avedon's *In the American West*," in Max Kozloff, *Lone Visions, Crowded Frames: Essays on Photography* (Albuquerque: University of New Mexico Press, 1994), p. 74.

6. Gerry Badger, "I Want to Be an Artist Like Diane," in Peter Turner and Gerry Badger, *Photo Texts* (London: Travelling Light, 1988), pp. 125–36.

7. Richard Avedon and James Baldwin, *Nothing Personal* (New York: Atheneum Publishers, and London: Penguin Books, 1964).

8. Martin Parr and Gerry Badger, *The Photobook: A History*, volumes 1 and 2 (London: Phaidon Press Ltd.: Vol. 1, 2004; Vol. 2, 2006).

9. Kozloff, "Richard Avedon's *In the American West*," p. 66.

10. Ibid.

11. Ibid.

12. Robert Brustein, "Everybody Knows My Name," *New York Review of Books*, Vol. 3, No. 9, December 17, 1964.

13. Ibid.

14. Richard Avedon and Truman Capote, *Observations* (New York: Simon & Schuster, 1959).

15. Truman Capote, letter to the *New York Review of Books*, Vol. 3, No. 12, January 28, 1965.

16. Richard Avedon, quoted in Jane Livingston, *The New York School: Photographs 1936–1963* (New York: Stewart Tabori & Chang, and Professional Imaging, Eastman Kodak Company, 1992), p. 271.

17. Baldwin, *Nothing Personal*, unpaginated.

18. Ibid.

19. Ibid.

20. Ibid.

21. Ibid.

22. Avedon, foreword to *In the American West*, unpaginated.

23. Richard Avedon, in Helen Whitney, producer and writer, *Richard Avedon: Darkness and Light*, American Masters series, Thirteen/WNET New York, 2002.

24. Although Eatherly was the most vocal in expressing contrition for the bombing of Hiroshima, his involvement in the mission was peripheral. He was the pilot of a weather reconnaissance aircraft that flew over the city at least an hour before the *Enola Gay* to report on weather conditions, but he did not witness the delivery of the bomb and the explosion.

25. Gilane Tawadros, *Strangers and Barbarians: Representing Ourselves and Others*, in Gilane Tawadros, ed., *Brighton Photo Bienniale 2006* (Brighton, England: BPB and Photoworks, 2006), p. 23.

26. Avedon, in *Richard Avedon: Darkness and Light*.

27. Ibid.

28. Jane Livingston, "The Art of Richard Avedon," in Mary Shanahan, ed., *Richard Avedon: Evidence 1944–1994* (New York: Eastman Kodak Professional Imaging, in association with the Whitney Museum of American Art, 1994), p. 34.

Ruthless Courtesies: The Making of Martin Parr

The first thing to be said about Martin Parr is that you cannot separate the man from the work. This is a cliché frequently written about artists, and like all clichés, it is broadly true. I know many artists and photographers whose work and personalities, whose work and lives, seem oddly disconnected, although at some level they cannot be, if they are any good. But Martin Parr as a personality—photobook collector, curator, patron of young photographers, all-round enthusiast—is at least as important as Martin Parr the photographer.

I have been associated with Martin for many years. We spent some five or six years alone working on our two-volume history of the photobook,[1] yet apart from assorted short essays, dust jacket blurbs, and reviews, I have never written an extended essay about his work—an omission I propose to rectify here and now.

Martin Parr is an exemplary photographic figure at the beginning of the twenty-first century. Not quite an out-and-out modernist, not quite a postmodernist, he is a leading light, indeed a founder, of the New European Color Photography School, yet is also a member of Magnum, photojournalism's premier agency. So he is familiar with the contemporary treadmill of the successful photojournalist, but he also frequently works in a "conceptual" way, and shows in art galleries as well as purely photographic galleries.

He occupies, in short, a central place in photography. He is a photographic polymath, not that somewhat sad species, the commercial journeyman seeking the cachet of artist, but a genuinely versatile photographer, one who lives, sleeps, and breathes photography in all its manifestations, from base function to lofty art. Martin's whole modus operandi, like that for instance of Juergen Teller, depends upon slipping deftly between photographic worlds, thereby instinctively addressing such issues as the role of the photographer, the status of the photographic image in our culture, and indeed the very nature of contemporary culture itself. Parr's whole career, and more pertinently his imagery, asks questions about high and low culture, art and commercialism, the duplicity of the photographic image, and (not a whit incidentally) about the lives we live today.

Surely all ambitious photographers ask such questions? Of course they do, but few are in such a privileged position (a position he has gained for himself), operating at a fortunate interstice between art, fashion, and popular, that is to say, common culture.

The second thing to be said about Martin Parr, which might be obvious—though it doesn't ring true to me—concerns his perceived aggression and cynicism toward his subjects.

Cynicism as well as irony. These are the two presumed characteristics trotted out in at least three-quarters of the discussions on the work of Martin Parr, in the same way that in almost any article on the work of Diane Arbus, the word *freak* seems mandatory. Or to

Martin Parr, *Badminton House, Badminton Horse Trials, Gloucestershire, England*, 1988, from the series The Cost of Living

take a contrary example, has there been anything written about André Kertész in which the word *humanist* fails to appear?

So Martin, because his various projects have tended to deal specifically with an uncompromisingly direct, even confrontational depiction of social groups, is branded as aggressive, which is then conflated in many peoples' minds with cynicism. Anyone with more than a passing interest in photography knows of the antipathy felt by the late Philip Jones Griffiths who famously opposed Parr's election into Magnum, saying that the latter's work opposed everything the agency stood for, and that he would subvert its proud humanistic tradition.[2]

Parr's style is undoubtedly direct, "in yer face," one might say. Such directness on the part of photographers has always had its problems, and attracted its share of moralizing detractors. Ever since the destitute sharecroppers recorded in Walker Evans's *Let Us Now*

Praise Famous Men became upwardly mobile and ashamed of their former poverty, charges of misrepresentation, stereotyping, manipulation, even imagistic assault, have attended the photographer depicting the social acts of human beings. The standard device for deflecting critical flak of this nature has been to intone the incantation "social documentary," a strategy that immediately claims for the work qualities such as honesty of purpose, authenticity, right-mindedness, evidential relevance. By claiming that documentary is good for you, that it is the proper study of humankind by humankind, the cunning photographer attempts to wrest the moral high ground from potentially aggrieved subjects, thereby fobbing off the critics, and in the process acquiring the useful bonus of political "street cred."

To his great credit Martin Parr does not court the safety of the social documentary alibi. He roundly dismisses those who do so for their evident hypocrisy, while at the same time castigating the cant of their critics. For Parr is well aware that many, if not most photographers of the social landscape—the good ones anyway—are not simpleminded advocates for social groups. Their games are usually far more complex, even those of the politically motivated. If they encompass the aims and aspirations of those whom they photograph then well and good, but although the photographer might tell the stories of his subjects, the story he is most concerned with telling is his own. To pretend differently is precisely to adopt the mealymouthed, hypocritical stance that Parr despises. As he has remarked, with commendable honesty: "Have you ever heard a photographer speaking about the power he or she has over people? Yet it's unquestionably there. Photography isn't innocent, it's riddled with ulterior motives."[3]

Let's add another note into the debate. If Parr talks about the power the photographer has over people, what about writers? Novelists frequently talk about it—they can kill a character with impunity if they so wish. And they regard it as their heroic imperative to filter, edit, mold, interfere, and importantly, use their imagination. In short, the right to *create*. I recall reading somewhere the writer and critic, Frederic Raphael, using words like *devour* and *cannibalize*, when defending the novelist's prerogative to be shameless about such practices. And in a wider context, such a sense of divine mission is extended to other forms of writing. One or two additional moral caveats may be placed upon the writer of reportage, but they are as nothing compared to the ethical injunctions by which the moral watchdogs of matters cultural seek to restrain the photographer.

The reason for this is clear; its logic may be challenged only in part. No matter how firsthand or direct his or her experience, the account of the writer is discreetly diverted—sieved and sifted in varying degrees through the screen of the auteur's sensibility. The very nature of the medium—indirect, displaced, and with a desperately slow, manual mode of operation—dictates that. And the same may be said of painting or sculpture. But the photograph is something else, fixed immutably (Photoshop notwithstanding) in one five-hundredth of a second. In less time than the blinking of an eyelid, it is set down, fully formed, like Athena from the

head of Zeus. It would appear to be a simple, mechanical trace of reality, delivering an actuality that is nominally unmediated.

Consider, for example, the most popular of photographic genres, the portrait. We are not given a mere image, a likeness, a representation. We are given Jane Smith herself. At least, that is the common perception. And it is, I would venture, only partly a misconception. For it cannot be denied, least of all by the photographer, that what we have is, verily, Smith. This, after all, is why the particular medium of the camera was chosen—for its undeniably seductive specificity. But of course the photographer is playing a complicated, some might say dangerous and duplicitous game. He or she is, paradoxically, out to transcend that "simple" verisimilitude. The photographer is as concerned as anyone to make an image, to create. To encapsulate Smith certainly, but also to render so much more than Smith, to progress beyond the superficial record and suggest deeper, more meaningful issues. Like life and death and the immortality of the soul. Or the iniquities and inequalities of history. Or perhaps just sex and drugs and rock 'n' roll.

However, perhaps Ms. Smith might not care to tread this larger stage, to be cast in the big picture or made to serve as the principal symbol in an allegory. Perhaps she dislikes being seen as a designer-wearing, Amex-brandishing, yuppie harpy when as everyone knows, in reality, she is nothing of the sort.

In a photographic cause célèbre, Shirley Brown, to be precise, felt slighted by misrepresentation of this sort. The culprit was Martin Parr and the vehicle was his project *The Cost of Living* (1989),[4] his nominal portrait of the aspiring middle classes in consumerist '80s Britain. Pictured at an art gallery opening in chic pillbox hat, and clutching a glass of wine as if to the manor born, Brown complained that Parr's lens branded her maliciously as "affluent" and "consumerist."[5] She states that in reality she and the four companions so depicted in Parr's image were employed part-time by the gallery at considerably "less-than-affluent" rates of remuneration. Another of the women in the photograph, we are told, requested the photographer to withhold publication or exhibition of the picture, feeling that she had been "photo-raped."[6]

Without wishing to discount a genuine grievance, one might ask whether it was the rhetoric surrounding them as much as the pictures themselves that unsettled and prompted the plaintiffs for the prosecution. Possibly a little negotiation or explanation might have softened attitudes and assuaged bruised egos. To the dispassionate eye the image in question certainly seemed to delineate champagne aspirations, whether or not the protagonists had beer incomes at the time. It is the perennial dilemma. Any photographer or writer has his or her story to tell. If, as I have said, it encompasses the stories of his subjects that is one thing. If it does not, then there is the potential for dispute. But why does the photography of Martin Parr or Diane Arbus in particular raise this issue more than, say, the work of Kertész?

Here are a few more names plucked from the documentary canon, almost but not quite

at random: Sebastião Salgado, William Klein, Tony Ray-Jones, Garry Winogrand. With the exception of Salgado, none could be termed social documentary photographers in the purest sense, though all have been concerned with demonstrating personal views of modern urban reality, views that certainly subtend social issues. Yet if asked to comment upon them, many would probably laud three—Kertész, Ray-Jones, Salgado—as great humanists, concerned photographers who patently did not manipulate their subjects in a manner that was wholly ruthless, emotionally detached, and thoroughly exploitative. Arbus, Winogrand, and Klein, on the other hand, most likely would be castigated for those very misdemeanors.

However, I wonder whether many commentators are not so much criticizing methodology and intent, but rather voicing an instinctive reaction in favor of three essentially optimistic visions on the one hand, and against three essentially pessimistic visions on the other. Of course, I am oversimplifying matters considerably. Nevertheless, I doubt that my so-called humanistic trio were any less prone to objectifying their subjects than Arbus or Klein or Winogrand. I am convinced that few people really look at photographs and think, not simply about how they were made, not simply about how they represent things, but about what the artist was trying to say, what the artist was attempting to re-present. Even experienced critics are frequently taken in by this old chestnut, that the *subject matter* before the camera is the *subject* of the *image*, that *re-presentation* and *representation* are mutually *inclusive*.

Thus we are often in danger of setting moralistic double standards when dealing with photographs of the social landscape. Show the subject smiling, and the critics smile with you. Show a frown, and it will be mirrored by the frowns of the critics. Approach the subject directly, and you are more likely to be regarded as confrontational rather than open and honest. Adopt an oblique approach, and the chances are that it will be seen as sly and deferential rather than sly and shifty. Espouse a specific social rather than an artistic cause or your humanity and concern will be found wanting.

For all his acclaimed humanist bonhomie how deeply did André Kertész actually dig into the human condition? It seems to me that much of the delight in Kertész—and it cannot be denied that there *is* delight—derives from his images' elegant, painterly formalism. Often, Kertész's people are reduced, albeit painlessly, to mere formal ciphers, to compositional elements. This by itself is not eternally damning, but to my mind the bittersweet whimsy afflicting so much of Kertész is the simple obverse of the eternal, coruscating angst that drags down the work of say, Garry Winogrand. Both in a way are equally narrow and one-sided—great artists though both of them are. The light, elegiac novella versus the sour, overwrought kitchen sink drama. I might point equally pejoratively to the pseudo-irony of Ray-Jones at his least, or the overblown, operatic mock heroism of Salgado at his worst. To be sure, I may well have felt more comfortable being photographed by Kertész than Arbus. Kertész's result may have been more pleasing, warmer, and certainly less painful to me on

a superficial level, yet I feel that Arbus would have shown a greater all-round sense of purpose in human and in social terms, demonstrating, in short, more real humanity, however uncomfortable the experience might have seemed to me at first glance. I fully accept that this might be a minority view, because Arbus, of course, was an uncompromisingly aggressive photographer.

One of the fascinating things about Martin Parr is that we are faced with a figure who has worked, or has appeared to work, both sides of the conceptual street I have outlined, the sunny and the shady. And interestingly, the crossing-over itself was fairly abrupt, marked by what many would regard as a paradox. In the early '80s, Parr switched from black and white to color, and switched the tenor of his vision from gritty romanticism to hyaline realism. To be sure, important elements of the new vision were always there. Parr's typically English dry sense of humor, for instance, had long been a salient factor, but even that developed from a 1960s whimsy in the manner of the late Ray-Jones into an acerbic '80s irony, which appears to teeter on the edge of downright cynicism and is authentic Parr. Indeed, he may be said to have written the book on this particular quality. It is one of the singular characteristics that his numerous followers cannot hope to match, unlike his choice of medium-format equipment, a predilection for flash-on-camera, and a nervy, off-kilter way of framing.

But irony, even irony that might seem in danger of lapsing into cynicism, is not cynicism. It first emerged—the charge of cynicism, that is—when Parr published his first major body of color work in 1985, *The Last Resort*.[7] He had moved to the town of Wallasey, across the River Mersey from Liverpool, and began to photograph the declining seaside resort of New Brighton, a few miles from his home. *The Last Resort* burst upon the photographic scene with the force of a volcano, producing, to say the least, a mixed critical reaction. Parr had dropped a large stone with some force into the British photography pond, and its ripples not only spread out but rocked the boat considerably. It is no exaggeration to say that *The Last Resort* was a defining moment in British photography.

Reactions were extreme, and I want to examine them, because they not only reveal something about Martin Parr, but define the parochial nature both of British photography and British society at that time, something that he was challenging whether he knew it fully or not. After all, Parr was only making photographs. *The Last Resort*, as Val Williams rightly notes, was basically "an exercise in looking."[8]

For example, art critic David Lee's review berated Parr for taking as a middle class photographer (middle class in the British and European sense) a patronizing view of the working class: "[Parr] has habitually discovered visitors at their worst, greedily eating and drinking junk food and discarding containers and wrappers with an abandon likely to send a liberal conscience into paroxysms of sanctimony. Our historic working class, normally dealt with generously by documentary photographers, becomes a sitting duck for a more

sophisticated audience. They appear fat, simple, styleless, tediously conformist and unable to assert any individual identity. They wear cheap flashy clothes and in true conservative fashion are resigned to their meager lot. Only babies and children survive ridicule and it is their inclusion in many pictures which gives Parr's acerbic vision of hopelessness its poetic touch."[9]

And Robert Morris in the *British Journal of Photography* was equally damning: "This is a clammy, claustrophobic nightmare world where people lie knee-deep in chip papers, swim in polluted black pools, and stare at a bleak horizon of urban dereliction."[10]

But what were the reasons for this extreme criticism? I failed then to see it in the work, which to my mind was as affectionate and as tender as it was acerbic, although certainly sharp. But what is required of photographers if not to have a sharp and penetrating vision? I must say that I was amazed at some of the more vituperative comments, and wondered if these critics were not simply looking at the pictures and seeing their own prejudices reflected.

Of course that begs the question, quite a large question, in relation to photography. Perhaps I was looking and reflecting my own prejudices. Everyone brings prejudicial baggage to images, and Martin has had more than his fair share of detractors, some a little envious of his success. But he has also had many fanatical admirers, especially outside Britain. Inside his own country, he has had a particularly polarizing effect upon this island's photography. Or, I should say, did have, because the worst of the controversy has largely, although not completely, fallen away as he has attained the status of an "Old Master." Indeed, *The Last Resort* work was chosen recently as one of "1000 Artworks to See Before You Die" in the *Guardian* newspaper, and Elisabeth Mahoney's view seems to be the one that has prevailed: "At the time, Martin Parr's series of photographs from New Brighton, a dilapidated seaside spot on the Wirral, were seen as condescending. But now they look humorously engaged and fond, bringing British working-class nook and crannies into view, and reminding us how unusual that was (and is) in art photography."[11]

Quite. It is now high time to focus upon Martin Parr's real achievement, but let us remain with *The Last Resort* for just a moment longer, and consider what it represents, not just in terms of a seismic shift in British photography—but later in European photography.

The black-and-white or color issue is clearly an important one. "Black and white are the colors of reality," remarked Robert Frank back in the 1950s. Indeed, for almost two decades following this notable aphorism, that was the avowed belief of most serious photographers. Color, it was believed, trivializes. It prettifies, privileges the exotic, and softens the harsh grayness of life's realities. Serious photographers, the medium's macho men, would have no truck with it, leaving it to the mass-media dream merchants and espousing the gloomy chiaroscuro of monochrome. By the mid-'70s, however, it was realized by this tiny band of self-styled "independent" photographers that everyone in the wide world bar themselves was utilizing color. Color was commonplace, cheap (or getting cheaper), and

cheerful. With this realization, which happened at a point in time around 1980, it was black and white that suddenly seemed exotic.[12] If color trivialized, so much the better. What better medium to record our trivial contemporary culture?

Suddenly, it was black and white that developed the air of unreality, seeming to glow with the obsolete bloom of yesteryear's medium. "Black and white are the colors of nostalgia," Frank might have said in the 1980s. And black and white in British photography seemed to refer to a mythic past as much as a material present. In imagery dealing with the social landscape, the twin specters of *Picture Post* magazine and Bill Brandt seemed to hang heavy at times. I do not intend that to be a negative observation. That black and white promotes at least a whiff of nostalgia has been a central tenet of photographic representation since the inception of the medium, yet seems a particularly pertinent issue at this particular moment in the development of expressive photography. All photographs, however, become instant history, and many of today's spicy color observations will, in turn, pass their sell-by dates, in spite of the best intentions of their auteurs. They will acquire the rosy cast of nostalgia before the yellow cast of decay, the notoriously fugitive nature of color materials notwithstanding, although Parr's color images, by virtue of their biting sharpness and depth, should survive this fate better than most.

In a way, color—and Parr's, in particular—seemed to signal the end of the humanist phase in British documentary photography. Although in truth, concerned photography had been changing for three decades or more—since the halcyon days of such photographers as Robert Frank and Ed van der Elsken. Since, as John Szarkowski succinctly put it, "a new generation of documentary photographers has directed the documentary approach toward more personal ends," with their aim "not to reform life, but to know it."[13]

In Britain, a decade or more after Szarkowki's shrewd observation, the reformist imperative remained firmly entrenched. There was a vigorous and certainly beneficial climate of public sponsorship for 1970s photography. But the left-leaning agenda of bodies like the Arts Council of Great Britain, which championed art as an instrument of social analysis, ensured that concerned documentary remained in ideological vogue longer than elsewhere. British photography was also heavily in thrall to the theoretical tenets of structuralism, which provided a bitter opposition to the unbridled capitalism of Margaret Thatcher's monetarist conservative government.

But why Martin Parr was perceived as being so at odds with this general documentary agenda is an interesting question. To be sure, he did not accompany his pictures with a polemic, but neither did others, including his friend Chris Killip, whose book *In Flagrante*,[14] published in 1988, was rather differently received, criticized yes, but not perceived as almost subverting the proper purpose of documentary. Killip said of his book that it was "a fiction about metaphor,"[15] but that somehow escaped the notice of reviewers from the concerned wing, and his book was generally seen to be on message, unlike Parr's.

Yet in essence, the gritty, black-and-white flavor of Killip's view of the northern working class, despite its superficial similarities to the "classic" tradition, was neither more didactic nor concerned than Parr's, nor less personal and aesthetically derived. A slight difference in emphasis marks these two important views of the working class in Thatcher's '80s Britain—they are both fiercely independent, individualistic photographers, yet they were perceived as being worlds apart. One has to conclude that the use of color was a substantive one, and that many were taken in by this factor, a matter of style rather than substance. Indeed, I have always argued that the great divide between the old and new schools within Magnum—which basically began when the agency took on color photographers Harry Gruyaert and Parr—has been largely a question of style wars.

Magnum's reputation as home for some of the world's best and most concerned documentary photographers did not collapse overnight when Parr joined them. The style of some of the photography changed. There was a difference in emphasis here and there, but like the rest of his colleagues in the agency, Martin Parr remains basically a documentary photographer. He might channel his work through art galleries, make artist's books, and so on and so forth—as do most of his colleagues—but fundamentally he is concerned with documenting contemporary life, surely the ideal mission statement not only for Magnum but most of photography. Martin may deploy humor, in a typically English, somewhat mordant fashion, but at root he is commenting upon modern mores, from a sharp, edgy, ironic, critical, yet consistent political point of view. Far from being an embodiment of "the moral climate of Thatcher's rule," as Philip Jones Griffiths ungraciously put it,[16] Parr is a trenchantly critical observer of the dumbed-down, consumerist culture that emerged during the Lady's premiership, and not a caricaturist of individuals.

There is a big theme here—how consumerism and the pursuit of a quick buck has come to dominant our lives and our thinking—which has been a constant thread in Parr's work since *The Last Resort* and his early color work from the north of England. And this was certainly confirmed by the 1989 *Cost of Living*, which contains some of his sharpest, and possibly sourest social observations. It is far more critical in tone than *Resort*, and if anything could be considered his chronicle of the Thatcher years—it is surely this, one of his most acerbic, and important books.

And yet, as always in Parr, among the implicit and explicit social criticism, the needle-sharp observation, there is a degree of warmth and affection for the foibles of human beings, though there are occasional exceptions. The hair-flicking girls at badminton, for instance, always remind me of Szarkowski's observation about a Brassaï: "Who else ever made a picture so full of wormwood?"[17] Martin Parr did. There is also the forlorn spectator at a Greenock Morton football match.[18] His scarf is emblazoned with the word *Morton*, but a fold has obscured the "t," so in the picture it reads *Moron*. Incidentally, this is a tiny detail in a complicated image, so I cannot believe Martin noticed it when shooting. I am

full of admiration that he even noticed it at the proofing stage. The result is a brilliant, very funny, savage picture, but as I say, these are notable exceptions. Parr's humor may be sly, or pointed, but I firmly believe he tends to poke fun—for the most part—at society rather than individuals. The Greenock picture was just one of those gifts for which he had to thank the photographic gods.

Any photographer, no matter how much of a social critic—unless photographing something as desperate as war or utter social deprivation—must have affection for his or her theme, and it should show. Frequently, as Parr clearly demonstrates in his work, it is a two-edged sword, a love/hate thing. The ambivalence of *Last Resort*, which leads to the even more apparent ambivalence of *Cost of Living*, might be traced back to his grandfather, who not only introduced him to photography, but to the northern English resort of Scarborough and the delights of this hitherto forbidden fruit. And what were its delights? Like much forbidden fruit, the seaside was vulgar. As culture it was distinctly low, yet the tantalizing promise of lubricious pleasures hovered in the seductive haze, around the bared flesh, the seedy pleasure arcades and gaudy cafés. As Parr says, "if the seaside was tatty and more than a little run-down, it was also vibrant."[19] Thus a simple—and of course not-so-simple—correlation, an indisputable truism, was formed in the mind of the young Parr. *Tacky* frequently means *lively*. Whether or not one assumes that the automatic corollary must also pertain, it does not matter. The celebrated Parr penchant for all things kitsch has indelible links with the seaside. His seaside observations in general have the intensity of a Proustian recall from childhood or adolescence, a sudden unlocking of a half-remembered, half-forgotten strata of the imagination.

Thus although Martin Parr is often regarded as a satirist in a typically English mode running all the way from Jonathan Swift to *Monty Python's Flying Circus* and the magazine *Private Eye*, one must qualify that characterization. Satire at its purist predicates a biting anger, a political edge verging on the anarchic and blatantly misanthropic. Some certainly have seen a nihilistic, even antisocial strain in his work, but I would beg to differ. Like one of his heroes, the late comedian Tony Hancock, Parr has too much affection for his subjects. He patently loves the seaside, kitsch, and the excesses of consumerist culture. For him they are an entertainment, a sustenance for the spirit, a laboratory for photographic experiment. His vision might be sharp and skeptical—he certainly has the essential pessimism of the satirist—but it is also playful and whimsical, even surprisingly gentle at times if one looks closely enough. He lies much more within the mainstream English comic tradition of self-deprecating irony. Unlike the true satirist, Parr is not disaffected. He is assuredly a part of the world he photographs, and if clearly not sharing all its values, he is not seeking to demolish it totally. After all, it furnishes him with endless raw material.

Like many artists, his attitude toward his material is ambivalent. So many photographers today are preoccupied with photographing the scrofulous interface of our "denatured"

world, pretending varying degrees of righteous indignation or nonchalant contempt, but where would they be without the starting point for their formal speculations? Martin Parr loves kitsch, but that does not prevent him from railing at the bland blanket of uniformity with which an indiscriminate culture of kitsch has smothered us.

The big theme therefore, emerged gradually, organically, as Parr both developed his vocabulary—the fill-in flash, the close-ups, the garish color—and his thoughts about what he was doing. After *Cost of Living* and his admission into Magnum, his perspective became more international, and so the theme and its various interrelated sub-themes, both broadened and deepened. Not that everyone saw it that way, because the third body of work that contributed fundamentally to the making of Martin Parr was another fundamental shift, and for some a shift too far.

Common Sense (1999) is where some felt that Parr had gone completely off the rails, placing artiness before documentary values. Launched in over forty galleries more or less simultaneously all over the world,[20] with the resultant media razzmatazz, *Common Sense* consisted of sets of Xerox copier prints presented in large, Becher-like grids. The exhibition was accompanied by a photobook[21] with full double-page bleeds, and colors that were lurid even by Parr standards.

Yet *Common Sense* is important because it demonstrated, as it were, another string to his expressive bow. Most photographers have only one—think about it—but having two gives Parr an enormous advantage in broadening his range. The first Parr mode, of course, is the color "street" photograph. *Common Sense* marks the most important manifestation of his second mode of expression, the forensic close-up. Working in this long-established artistic genre—hence the appeal to the art world—also enabled him to explore certain cultural themes close to his heart.

Parr has made no secret of the fact that the inspiration for this way of seeing came from Nobuyoshi Araki, and in particular Araki's book *The Banquet*,[22] in which Japan's best-known photographer made a record, a "food diary," both in black-and-white and color, of the food he ate with his wife, Yoko, before her death from cancer in 1990. Martin was intrigued by Araki's use of ring-flash and a macro lens, a technique normally used in medical photography to make close-ups of skin diseases and organs. It was the forensic nature of the imagery created by this method that was of interest to Parr, imagery that was repellently revealing, or perhaps revealingly repellent.

And we certainly get morbidly fascinating, often cringe-making close-ups in spades, beginning with food. A cup of tea, Britain's national drink, sitting on a checked tablecloth, is all very well, but two melting ice creams, chorizo sausage, a bowl of jello (especially when a fly has landed on it), and confections covered in fluorescent-colored icing sugar look revolting when given this degree of attention. So do used hairbrushes, kitsch ornaments, kitsch items of clothing, and wrinkled skin (especially if sunburnt). Even generous

cleavage does not look inviting in this context, and as for the forest of cigarette butts stuck in a sandtray . . . well.

As Val Williams has written, "*Common Sense* is a violent book, its violence made even more acute when Parr interleaves his images with photographs that speak of his own veneration for the gentle and the traditional: a woolly mauve hat worn by an elderly woman, a cup of tea in a willow-patterned tea cup, a pensioner in flowery oven gloves holding a pile of flowery plates."[23] And, as she concludes: "*Common Sense* is like a dictionary of sins, a malodorous concoction of the sugary, rotting and fascinating detritus of the Western world."[24]

Recently, Parr has widened his indictment to include the non-Western world, showing neither fear nor favor, but as always, it would seem that it is this duality, the combination of fascination with repulsion, the contrast between the facelessness of corporate consumerism, and the idiosyncratic consumerism of individuals, between the bland and the eccentric, that makes for the particular quality with which the best of Parr is suffused. Whereas it is usually more subtle in his street photography mode, in *Common Sense* it is writ large; the dualism is laid out in fierce detail and vibrant color. And one can note, given the reaction to this important body of work, that Parr's public was also divided—the diehard documentarists generally hating it, the art world reacting much more positively.

But, as Martin himself has pointed out, *Common Sense* and his forensic mode is simply another kind of documentary photography, another way of commenting upon modern life. As an avid consumer of every kind of photobook, from artist's books to commercial catalogues, he does not make distinctions between genres of photograph, only between good and bad. His relationship with the photobook is sometimes underestimated, I feel, seen as a rather acute case of the mad collector syndrome. It is in fact central to his whole being as a photographer.

Val Williams notes that *Common Sense* can be seen as a pictorial compendium of modern mores embedded in everyday objects. In *The Photobook: A History*, Martin and I included *Point It*,[25] where the conceit was that if you were in a country where you didn't know the language and needed, say, a car, or a chicken, you just pointed to a photograph of one in the book and your needs would be satisfied. In a similar vein, we included one of a series of Dutch books entitled *Useful Photography*. Number two[26] in the series featured photographs of objects posted for sale on eBay. In both books, the photographs look remarkably like those of Martin Parr in still-life mode. Indeed, the forensic still-life has been widely imitated in contemporary photography—partly, though not solely, as a result of Martin's employment of the ring-flash and macro lens.

Looking at all these images, however, whether by anonymous or known photographers, or by Parr, one can only paraphrase (yet again) Lincoln Kirstein's remarks about Walker Evans and say that compared to the current cornucopia of still-life imagery, Martin's pho-

tographs have "in addition, intention, logic, continuity, climax, sense and perfection."[27]

The point is that Parr has his themes, the aspects of contemporary life about which he wants to talk: globalization, consumerism, kitsch, eccentricity, national identity, cultural clichés. Whether he chooses to do this as a documentary photographer or an artist doesn't matter. Let's just call him a photographic auteur.

Martin has sometimes self-deprecatingly remarked (and I'm not sure just how much he means it) that his best photographs are behind him rather than in front of him. What I think he means is that his breakthrough is behind him, but that is the case with most senior artists. Artists tend to break through when young, but that does not necessarily negate what they do later. In Parr's case, I feel it is the whole body of work that matters; it is both varied and consistent, broad in reach, and much more (dare we say it?) humanistic and complex than it appears at first glance. The retrospective of his color photography, *Assorted Cocktail*, shown in Berlin in 2007–8, was an extremely strong show, and gave no indication of a flagging talent.[28] It demonstrated that, as one of the photographers most aware of the breadth of the medium (thanks to the photobook), he is constantly reinventing himself. As Thomas Weski has rightly remarked, "his photographs are original and entertaining, accessible and understandable. But at the same time they show us in a penetrating way how we live, how we present ourselves to others, and what we value."[29]

In short, for me they demonstrate what I believe are photography's core values. Martin Parr has been the dominant force in British photography over the last thirty years and one of the most dominant in European photography. Everywhere in fact, except perhaps in the United States. Despite the initial doubts of some of his older Magnum colleagues, he has revitalized the agency by continuing in his inimitable way with its core mission, which is to interpret contemporary life, but he has done so with an especially impeccable, unerring sense of the zeitgeist.

Notes

1. Martin Parr and Gerry Badger, *The Photobook: A History*, volumes 1 and 2 (London: Phaidon Press Ltd.: Vol. 1, 2004; Vol. 2, 2006).

2. When Parr was up for election at the 1994 Magnum Annual General meeting to become a full member, Jones Griffiths led the opposition, circulating a vituperative memo that contained the following: "He (Parr) is an unusual photographer in the sense that he has always shunned the values that Magnum was built on. Not for him any of our concerned 'finger on the pulse of society' humanistic photography. . . . His membership would not be a proclamation of diversity but the rejection of those values that have given Magnum the status it has in the world today. . . . Let me state that I have great respect for him as the dedicated enemy of everything I believe in and, I trust, Magnum still believes in." Parr was accepted for membership by one vote. See Russell Miller, *Magnum: Fifty Years at the Front Line of History* (London: Pimlico, 1999), pp. 294–5.

3. Martin Parr, lecture at the Photographers' Gallery, London, January 30, 1990.

4. Martin Parr, *The Cost of Living* (Manchester, England: Cornerhouse Publications, 1989).

5. *Bristol Evening Post* (Bristol, England), Thursday, November 16, 1989, p. 7.

6. Ibid.

7. Martin Parr, *The Last Resort* (Manchester, England: Cornerhouse Publications, 1985).

8. Val Williams, in *Martin Parr* (London: Phaidon Press Ltd., 2002), p. 161.

9. David Lee, review of *The Last Resort* in *Arts Review* (London), August 1986, quoted by Williams in *Martin Parr*, ibid.

10. Robert Morris, review of *The Last Resort* in *British Journal of Photography* (London), August 1986, quoted by Williams in *Martin Parr*, ibid.

11. Elisabeth Mahoney, in *1000 Artworks to See Before You Die*, supplement to the *Guardian* (London), October 29, 2008, p. 10.

12. The publication of *William Eggleston's Guide* (Museum of Modern Art, New York, 1976), the book accompanying an exhibition of Eggleston's color photographs, together with bodies of work by Stephen Shore and Joel Meyerowitz, is regarded generally as the "beginning" of color photography, that is to say, the point when the art museum and art market in general, and the Museum of Modern Art in particular, deemed color photography to be respectable.

13. John Szarkowski, wall label to *New Documents*, an exhibition of photographs by Diane Arbus, Lee Friedlander, and Garry Winogrand, held at the Museum of Modern Art, New York, February 28 to May 7, 1967.

14. Chris Killip, *In Flagrante* (London: Secker and Warburg, 1988), republished by Errata Books, New York, 2008.

15. Ibid.

16. Miller, *Magnum: Fifty Years at the Front Line of History*, p. 295.

17. John Szarkowski, *Looking at Photographs* (New York: Museum of Modern Art, 1973) p. 110.

18. This image comes from a commission by the Glasgow firm of architects, John McAslan and partners, to photograph the A8 road between Glasgow and Greenock. Greenock Morton is one of the "little" teams of Scottish football, the butt of jokes from supporters of the "big" teams in the main urban centers of Glasgow and Edinburgh. It is they who would most appreciate the joke. See Martin Parr, *A8: JMP Journal No. 1* (Glasgow: McAslan, 2005).

19. Martin Parr, in conversation with the author, Bristol, England, May 27, 1999.

20. *Common Sense* opened in forty-three galleries worldwide during the month of March 1999, beginning at the Rocket Gallery, London, on Wednesday, March 10.

21. Martin Parr, *Common Sense* (Stockport, England: Dewi Lewis Publishing, 1999).

22. Nobuyoshi Araki, *Shokuji (The Banquet)* (Tokyo: Magazine House, 1993).

23. Williams, *Martin Parr*, p. 278.

24. Ibid., p. 279.

25. Dieter Graf, *Point It: Traveller's Language Kit* (Munich: Graf Editions, 2004).

26. Hans Aarsman, Claudie de Cleen, Julian Germain, Erik Kessels, Hans van der Meer, editors, *Really Useful Photography* #002 (Amsterdam: Artimo, 2003).

27. Lincoln Kirstein, afterword, in Walker Evans's *American Photographs* (New York: Museum of Modern Art, 1938), p. 190.

28. Martin Parr, *Assorted Cocktail: Colour Photographs*, was shown at C/O Berlin, International Forum for Visual Dialogues, December 12, 2007, to March 3, 2008.

29. Thomas Weski, wall label to *Assorted Cocktail*.

A Certain Sensibility: John Gossage, the Photographer as Auteur

Another of my closest friends and colleagues in photography is the Washington, D.C.–based photographer and photobook maker John Gossage. Friendships in photography, as in anything, tend to stem from shared values and enthusiasms. In our case, the first point of contact was John's photobook, *The Pond*, published in 1985.[1] I was bowled over by it when I saw it soon after publication, and it retains an exalted place in my personal all-time photobook pantheon.

I have written extensively about *The Pond* elsewhere, including an introductory essay to the new edition, so I shall not deal with it directly here. What I am more interested in is John Gossage's career in general, a career largely defined by *The Pond*. I am interested in how this breakthrough book influenced what followed, and marked the real beginning of one of the most interesting careers in late twentieth-century and early twenty-first-century American photography—interesting, because it has not been entirely mainstream.

It is true to say that in the minds of many shrewd judges, John Gossage is widely admired, yet still underrated in view of his talent, possibly because he has not had a retrospective exhibition in a major museum, or a monograph survey from a major publisher. He is one of the most prolific and to my mind original American photographers of the last three and a half decades, but he has a lower profile than he merits, while others with not a third of his talent are art market favorites.

John has frequently been called a "photographer's photographer," although such a designation, like "painter's painter" or "musician's musician," can sometimes be a difficult accolade to shoulder. It suggests a degree of admiration beyond the commonplace because artists might fool many people—critics, collectors, curators, dealers—but rarely their fellow practitioners. Yet it also indicates that there is something difficult about the work, and that it will never quite garner the plaudits of the mob. So it can be something of a two-edged sword, predicating artistic success, but something less in commercial terms, until the world (that is, the art market) catches on and catches up.

There are signs that John Gossage is at last getting some of his due, but for those out there who still have some catching up to do, this essay aims to present the case for regarding him as a great photographer.

What makes a very good, or a great photographer? Is it a steady accumulation of stunning single images, in the manner of a painter, the standout pictures that catch the eye in an art gallery and immediately attract their imitators, perhaps forming the beginnings of a school? The painterly photographers, or the photographic painters, if you will, like Andreas Gursky or Jeff Wall, would seem to think so, although this is not to say that their particular oeuvres are simply disconnected successions of highlights without an overarch-

John Gossage, *Untitled, Washington, D.C.*, 2008, from the series The Thirty-Two Inch Ruler

ing meaning, an accusation one might certainly fling at the less-gifted followers of this tendency.

Is the great photographer characterized by style? There is a presumption, with the recent art market interest in the medium, that photographers who are artists rather than mere photographers distinguish themselves as such by exhibiting a marked style. Therefore there is a tendency, encouraged by the work of the Bechers and the Düsseldorf School, to progressively distill one's vision, reducing the range of subject matter and its treatment until it can be claimed—usually by the gallerist—that so-and-so has developed an original and instantly recognizable style. Style equals branding, and branding means sales, so we get the fairly common phenomenon of the photographer who hits upon one extraordinary image and then repeats it, with minor variations, for the rest of his or her career. In short, the Mark Rothkos of photography.

Or are the really great photographers drawn from the ranks of those who reject visual style in favor of visual sensibility, those who recognize that the medium is profligate rather than reductive, and more akin to the film or the novel than the painting? Those accordingly, who tend to put content before form.

Of course, there are no rules for creating great photographers. Great artists, great photographers, reach such a pinnacle because they do not follow the norm. They break the rules. They follow their instincts and convictions, not the herd and the smart money. But in my view at least, the best photographers tend to come from the last category, those whose style and individuality emanates from deep within them, and is not, as is the case I feel with all too many, something grafted on from outside.

I have already mentioned, earlier in this book, Susan Sontag's skepticism regarding the whole notion of photographic style. Style in photography, she argued, was largely a function of subject matter. And using the example of Eadweard Muybridge, she pointed out that there was absolutely no stylistic consistency between his Yosemite landscapes and his renowned motion studies. Certainly not of the stylistic consistency one finds, say, between the landscapes of Edgar Degas and his studies of women bathing. But painters, of course, are recognized by the signature of the marks their hands make, no matter what the subject matter. A photographer's signature is defined by things a deal more subtle, and harder to quantify.

Sontag's argument has a point, indeed a serious point, but Muybridge was not attempting to be a Degas, far less a Rothko. Indeed, it is doubtful whether he regarded himself as an artist in that sense, except that we do know he harbored a certain aesthetic ambition in his work, in even the nominally scientific motion studies. But he can hardly be regarded as an artist in the sense Sontag meant, although I certainly believe that he was a great photographer.

So perhaps I view photography as a different kind of art than Sontag, not so dependent upon the market and the museum's notion of an artist with a consistent visual signature and

a consistent stylistic progression within the confines of that signature. The British archi-tect, James Stirling, used to be criticized for a lack of a signature style in his buildings, and his defense was a simple one. He pleaded appropriateness, claiming that he always adopted "the style for the job."

In other words, he saw himself not so much as an artist, but as a workman, doing a job. *Artist* is a pretentious, somewhat meaningless term if you put it on your passport to signify your occupation, but one that means everything if you gain the approbation of your peers for doing an excellent job and making work of a standard to which they might happily aspire. For Stirling, the art of architecture was not a matter of style, but a problem to be solved. His artistry derived from the imaginative and appropriate way he solved the problems set by a particular commission—not an artificial set of stylistic conventions pre-determined and imposed by the client's requirements.

In my view photography is a similar kind of discipline. Each clicking of the camera shutter should be a new adventure, an imaginative and appropriate response to a problem. Sontag, I feel, was right to be suspicious of an insistence upon consistent style within pho-tography, the Rothko imperative. Style in photography—at its best—should emanate from a particular response to a particular subject and a particular set of circumstances, acted upon by a particular sensibility. So we can identify almost immediately a Robert Frank, a William Eggleston, or a Robert Adams, but we cannot ascribe to them a particular style, a predeter-mined aesthetic, as we can to so many other photographers who take care that their look, pared down to the reductivity of a signature, makes them easily branded in the market.

I have indicated that I consider John Gossage a great photographer, which means I would define him as an exemplary photographic artist in terms of his sensibility, but what exactly do I mean by this? Firstly, he has a rare sensibility for an American photographer working in the last quarter of the twentieth century and into the twenty-first, one that is neither entirely modernist nor entirely postmodernist. One could say that he has a foot in both camps, but that does not quite describe it either. It would be more accurate to say that Gossage has remained true to his modernist background while taking a lively and receptive interest in postmodernism. By the same token, he has stayed a photographer, yet one who evinces the keenest interest in contemporary art, especially that of the conceptual wing. But while this informs his practice, he has not become, unlike his good friend Lewis Baltz, a conceptual artist. He is essentially a phenomenological photographer, remaining more or less in the documentary mode.

Baltz and Gossage have one important thing in common, besides a lifelong friendship. They are both thoroughly American artists, yet have worked extensively in Europe (Baltz now lives in Paris) and have seen their work acquire a European inflection. The European connection is significant. In the early 1980s, Gossage, along with Baltz and William Egg-leston, had begun to exhibit in Berlin, at the Werkstatt für Fotografie in Kreuzberg. So at

the beginning of the decade, there was an interesting period of cross-fertilization between American and German photography. It had a profound effect upon Gossage's work. He began to photograph Berlin, a subject that occupied him for a decade and has yielded four major photobooks so far.[2] And the contacts had equal benefits on the German side. It is likely, for example, that Michael Schmidt's book *Waffenruhe* would be somewhat different if he had not met and talked with the likes of Gossage and Baltz, and seen their approach at firsthand.

No American photographer, with the possible exceptions of Baltz and Robert Adams, has taken a keener interest in the photographic book, but Gossage's involvement has extended way beyond the gathering and sequencing of photographs into the published photographic statement. He has taken a full hands-on role in their making. He is a designer, publisher, and collector of photobooks, and although he has exhibited his photographs widely and has been represented by major gallerists, including Leo Castelli, it can be said that his primary focus has been upon the creation of fine photobooks rather than fine prints, superb printmaker though he is.

Few believe more in the art of photography, but John Gossage I think would be pleased to be termed an auteur rather than an artist, for this seems a more accurate description of his attitude toward the medium. Or an *éditeur-auteur*, to paraphrase Atget, one of the photographers he most admires. He consistently sees photography in terms of the collective statement contained in the book rather than the individual statement circumscribed by the picture frame. For him, the photobook is not just a statement made by gathering photographs between covers. It is an intellectual experience and also a physical object, a work of art in itself, and indeed the arena where the photograph is at its most complex.

When I came to work with Martin Parr on our two-volume history of the photobook, John Gossage was one of an unofficial committee of advisers,[3] and it was he who provided us with a succinct and pertinent definition of a great photobook. In an email, he stated that the great photobook should fulfill the following criteria: "Firstly, it should contain great work. Secondly, it should make that work function as a concise world within the book itself. Thirdly, it should have a design that complements what is being dealt with. And finally, it should deal with content that sustains an ongoing interest."[4]

Although the photographs of John Gossage are made to serve the photobook, it will be noticed that his first criterion for the successful book is the work. Gossage is a great photographer because he makes memorable photobooks. He makes memorable photobooks because he makes memorable photographs. He has been extremely attentive to matters of design and bookcraft, but he never forgets the first principle. Make good photographs and you have a good chance of making a good photobook. Pay close attention to the other aspects of bookmaking, and your book will go the extra ten yards, maybe even score a touchdown.

And if, in enumerating my thoughts on what makes a great photographer, I have given the impression that aesthetics and style do not matter so much to a photographer like Gossage, this is not so. To be sure, his style is eclectic, and he has things on his mind other than providing a gallery signature, yet his sensibility is such that a Gossage photograph is fairly recognizable. He certainly could be termed a "style for the job" man, which ensures, as it should, that his photography is basically subject matter–driven. And, as he is essentially a street photographer, his photographs taken while walking around, his imagery is very much driven by spur-of-the-moment impulses.

The sensibility that draws together diverse subject matter from two continents— America and Europe—encompasses not only a grand subject, a concern with what could be described loosely as "history," and which will be defined more precisely in due course, but a mood, a consistent feeling that pervades his imagery. Its precise tenor is again difficult to describe, but in general, it is not a feeling of light and happiness. John Gossage is not a comfort photographer. Although his work is both beautiful and poetic, it is also disquieting and dark. It is serious work, in the sense that it addresses some of our darker problems, not in any obvious way, but by various subtle, insidious means that gradually but insistently get right under the viewer's skin. John's friend, the late writer and educator Gus Blaisdell, put it as well as anyone, I think, when he wrote the following: "Premonition and foreboding settle in around a Gossage as atmospherically as Atget's groundfogs in his parks."[5]

Gossage is a street photographer, but is primarily interested in the landscape and things as opposed to people, though soon he will probably surprise us and produce a people book. He generally employs a medium-format camera, and can be counted as a fellow traveler with the New Topographics "school" of the 1970s, although he was not included in the original exhibition of 1975. However, *The Pond*, as his first published book,[6] is a monument of the New Topographics movement, if this moment—important and influential to be sure—in late twentieth-century photography could be called that.

I think that *moment* rather than *movement* is the more apposite designation. The leading lights of New Topographics were too individualistic to be pigeonholed, and Gossage is no exception. The crucial thing about the *New Topographics* exhibition was not, as it seemed initially, its beguiling nature as an aesthetic whose chief qualities were a nonjudgmental, deadpan quality. The organizer, William Jenkins, might have termed it a "stylistic exercise,"[7] but that was one of the most disingenuous statements ever made by a curator. New Topographics was important for two reasons. It represented a coming together of American photographers and European artists, and a new attitude in the depiction of the landscape—one in which representation of both the natural and man-altered landscape was seen for the complex cultural, social, and historical construct that it actually is.

It is not generally known that three of *The Pond* images were made in Berlin. The

bulk of the book was shot on the outskirts of Washington, D.C., when Gossage made his commute from his D.C. home to the University of Maryland, where he taught for a time, but three images from Germany were embedded in the book and foreshadow his future direction.

If *The Pond* was the breakthrough, his Berlin work was the consolidation of that (in itself) considerable achievement. When Gossage first went there, in 1982, Berlin was still a city divided by two political systems and the ultimate symbol of that ideological divide, the Wall. Adjacent to the Wall, but also everywhere else, there were vast tracts of *terrain vague*. As depicted in *The Pond*, such wastelands lay like a vast open, archaeological excavation, a cross-section through the traumas of recent European history.

If Gossage's subject in *The Pond* was history as embedded in the landscape—exploring themes like the making and scarification of the land, or the psychological hold that place, or non-place has upon us—in Berlin his thematic material was broadened beyond measure. No wonder that, when he first saw *die Mauer* running along Niederkirchnerstrasse, dividing the old East Prussian parliament building and the former Third Reich air ministry building (in the East) from the Martin-Gropius-Bau museum and the waste ground where the Gestapo headquarters once stood (in the West), Gossage felt like the veritable kid in the candy store. In the space of two city blocks a significant slice of German history was concentrated, the past confronting the present with a particular intensity, heightened by the baleful presence of the Wall. The material was so rich he photographed it for almost a decade, then waited another decade to publish the "big, impossible book." *Berlin in the Time of the Wall* (2004) contained no fewer than 464 images; he then followed it with a sequel of only 134 images, *Putting Back the Wall* (2007).[8] He was clearly getting lazy.

Berlin refined and expanded both his stylistic and thematic repertoire. One of the most striking photographs in *The Pond* is of a fence, an image that is as arresting formally as it is psychologically. The fence, a thin metallic sliver in steep perspective, its shadow forming a long triangle, pushes up against the right-hand edge of the picture frame, while the rest of the image is taken up with the kind of scrubby, prickly vegetation that would scratch to bits anybody trying to get near. This is a serious "Keep the Fuck Out" kind of fence, but pales somewhat alongside *die Mauer*, which allowed him to meditate upon the arbitrariness and iniquity of boundaries on a positively monumental scale. As I wrote in my essay for *Berlin in the Time of the Wall*:

"Berlin, one might say, is the place where photography became both easy and difficult for him. Easy because there was such a rich vein of subject-matter, history piled up in front of his eyes, one metaphorical layer upon another, like the different strata that can reveal so much to the archaeologist when a trench is cut through a site. But such strata, translated into the archaeologist's sectional drawings, are notoriously difficult to read, and that, in a nutshell, was where the difficulty, the challenge lay for Gossage. He was faced with the task

of evaluating the evidence, reading it, recording it, interpreting it, and fashioning it into a coherent 'report'—both for himself and for his audience. Of course, as John Gossage is an artist, the 'report' may be oblique, poetic, metaphorical, subjective, and ambiguous. In short, it is a creative interpretation."⁹

As always with Gossage this meditation upon boundaries was reiterated—he is very much a theme and variations kind of artist—in *There and Gone* (1997)¹⁰ where he photographed along the U.S./Mexico border, and again examined the division between ideologies and peoples. As he said, "There is no reason in the lay of the land that anything should change in a walk of 50 meters, but it does and profoundly. So, it is an aesthetic judgment—the aesthetic of politics, the aesthetic of economics—imposed upon a rather neutral and unconcerned landscape."¹¹ But as always, he never goes over ground he has previously investigated in an obvious way. He is always searching for new means of expression, saying different things, and through his constant reinvention of the photobook form, surprising and delighting us with a new physical object.

Berlin also added new stylistic twists to his personal photographic vocabulary, notably his so-called surveillance mode, where he used long-focus lenses and high-speed film to photograph across the Wall from a distance, often at night, making extremely evocative, mysterious images, but at the same time reminding us of the medium's negative capability, its voyeuristic tendency, where it can be utilized surreptitiously to gather information and become an instrument of control. The surveillance mode was used to good effect in *There and Gone*, when he made images of Mexicans bathing in the sea at Tijuana from a San Diego beach, the camera conceptually connecting the physically disconnected, as it had in Berlin.

This particular, important inflection of Gossage's visual vocabulary also crops up in *Empire* (2000),¹² a book of apparently innocuous urban landscapes from Washington, shown in conjunction with found nineteenth-century photographs of Egyptian monuments made by Dr. Hermann W. Vogel. In photographing government archive buildings in D.C., Gossage is making a point about empires and colonialism, a contemporary empire juxtaposed with a recent empire and a long-gone ancient empire. The metaphors are perhaps obvious and there to be read, but Gossage never labors such things. They are embedded within the inventive formality of both his individual images and his books.

If great photography, like any art, is an adroit conjunction of form and content, John Gossage never forgets that without significant form to heighten it content can be flat, and we would not care to read it. It is like the old argument about opera—*la musica* or *le parole*—is it the music or the words, the drama, that is of greater importance? In one sense, the debate is specious, both are of course crucial. Yet, it is Verdi and Mozart whom we celebrate, and not their librettists, Boito or Da Ponte—the direct emotion of music must always touch us before we engage with the more cerebral appeal of the libretto. Despite

the protestations of the theorists and contextualists, formal qualities must have the greater sway, at least if one is going to call it art.

Take another leitmotif of Gossage's: the degradation of the environment. Not long after he had completed *The Pond*, Gossage turned his attention to contaminated land, photographing sites on Staten Island, and around Syracuse, New York, sites that contained some of the worst environmental pollution and industrial waste on the Eastern seaboard. How to do this? Well, you could take the factual, documentary approach, and maybe do a photo-text piece, making straightforward photographs of the sites with captions detailing the percentage amount of heavy metals in the soil, and so forth. Or, being John Gossage, you could take the poetic, imaginative approach, and the result might be a book like *Hey Fuckface* (2000).[13]

Hey Fuckface is one of Gossage's most distinctive books because it pushes the definition of *book* to the breaking point, and is really only a book because he says it is. It consists of original mounted silver-gelatin prints of the contaminated sites presented in an elegant wood and Plexiglas box, which can be taken apart so that one's chosen print of the moment can be "in the frame." Thus one of the salient characteristics of the conventional book is subverted, with the reader, as it were, deciding upon the pictures' sequence.

Such a group of pictures as this functions better with a text, so Gossage takes the notion of cursed sites, and combines them with actual curses, culled from graffiti and written by hand across mounts and pictures. A simple idea? A banal idea? Or an inspired idea? Try the latter, because it works to great effect. *Hey Fuckface* transcends perhaps obvious but politically important facts to become an affecting visual work of art, a concrete poem, that works upon both our emotions and our intellects, form and content coming together in the most surprising way.

This would not work quite so effectively on the gallery wall, but John Gossage has always been one of the most fervent advocates of the photobook, and has a personal bibliography that is second to none, particularly in the way it allies bookcraft and design aspects with the photography. However, what of the photography? Whether seen in a book or on a wall, his actual photographs are the key, the bedrock of his art. His attitude was made plain when we talked about a young maker of photobooks—who shall be nameless—and John delivered his verdict: "He needs to stop making photographs that are clever," he said, "and start making photographs that are good."[14]

It seems interesting that, although a Gossage photograph is immediately recognizable, the Gossage style is less easy to pin down. Formally, he seems to utilize a number of styles, from the hyaline lucidity we habitually associate with New Topographics and the Düsseldorf School, to extreme shallow-focus images that might be seen as a kind of updated Pictorialist aesthetic, yet he is anything but a Pictorialist. One might think from the remark I have just quoted that he is a formalist. He is not, at least not an out-and-out formalist, but

he is completely devoted to the task of making pictures, and the first thing one has to do in order to make effective pictures—whatever effect one is trying to make—is to organize forms within the frame, and organize them in a way that brings the viewer up short and makes him think.

Gossage makes as many surprising photographs—and it takes a lot to surprise crusty old critics—as any photographer I know, yet as I have indicated throughout this essay, they are at the service of mood and his singular sensibility. His pictures, as has been noted frequently by many commentators, are strangely unsettling and vaguely disquieting. He often demonstrates a mordant humor, both in the images and in the texts he chooses for his books. However, the word I would choose to describe the overall tenor of his work is *forensic*. And here again he can be closely linked with that favorite photographer of his, Atget.

It was Walter Benjamin (and others) who noted Atget's "infernal stillness" and the fact that his photographs of Parisian streets and interiors looked like "crime scenes." Gossage certainly shares that ominous stillness in his imagery, and in much of his work (including *The Romance Industry* [2002], which deals with the industrialization of Venice/Marghera), it can be argued that some kind of crime has been committed. As Gus Blaisdell wrote: "Not far away from Weegee's crime scenes with the bodies and gawkers removed. All the stains in the street and the curbside trash remains. Nature for Gossage is a place bristling with the attractive repulsion of armpits and crotches, and it is always alive, about to declare its animation, the shrubbery like David Lynch's trees tossed in a night wind, violated by a motion characteristic of anxiety, dread and agony."[15]

The overwhelming experience of Berlin, I think, politicized his photography, not in the sense of becoming a self-proclaimed "political" photographer, but by turning an already non-conformist thinker—another trait he shares with Atget—into a slightly more dissident one, thereby broadening and darkening the sense of history already embedded in the work.

Unlike Atget, however, Gossage is not so much a photographer of place per se. Both the mood and locations of his photographs are frequently too ineffable to function as external documents of place. He is, rather, one of the greatest of still-life photographers, conjuring baleful histories out of the most ordinary and apparently innocent objects. If John Gossage photographs the Devil, the devil is in the details.

Although he will never neglect black and white, he has recently turned to color, and one of the first exercises in that medium is a study of his own neighborhood in D.C., one of the city's more salubrious areas, populated by consulates, embassy residences, and homes belonging to some of Washington's movers and shakers. A block or so away from Gossage lives Donald Rumsfeld, not that the two are on buddy-buddy terms, as far as I know.

The Thirty-two Inch Ruler/Map of Babylon[16] is composed of the type of picture that Gossage does best: urban details, fragments of the city scene such as front doors, windows,

gardens, and street furniture, taken over a year. A seemingly neutral and innocent view of a typically prosperous neighborhood anywhere in the Western world. Any good street photographer suggests what is going on under the surface. Here, it goes on behind those closed front doors. The streets are quiet, being populated in the main by well-honed men trying a little too hard to look like utilities workmen and not secret service operatives. And what goes on behind these particular closed doors affects us all, it is nothing less than the process of making history through the exercise of power. The process, as Gossage's photographs hint, is not dramatic in itself, though its results certainly may be far-reaching and dramatic.

But the Benjamin/Atget syndrome is always at work, insidiously and remorselessly, in the photographs of John Gossage, and in his continual reinvention of the photobook, *The Thirty-two Inch Ruler* adds a surprising new twist.[17] And that above all makes him one of the best of recent American photographers.

Notes

1. John Gossage, *The Pond* (New York: Aperture, 1985). A new edition, also by Aperture, is underway and scheduled for publication in 2010.

2. The four are: *Like a Mother Fucker (LAMF): Three Days in Berlin 1987* (Berlin: self-published, 1987), *Stadt des Schwarz: Eighteen Photographs by John Gossage* (Washington, D.C.: Loosestrife Editions, 1987), *Berlin in the Time of the Wall* (Bethesda, Maryland: Loosestrife Editions, 2004), and *Putting Back the Wall* (Bethesda, Maryland: Loosestrife Editions, 2007).

3. Just for the record, the others were Chris Killip, from Harvard University, Christoph Schifferli, from Zurich, and Joan Fontcuberta, from Barcelona.

4. John Gossage, email to Gerry Badger and Martin Parr, August 6, 2002.

5. Gus Blaisdell, in "Thirteen Ways of NOT Looking at a Gossage (in memory of Arnold Gassan)," in John Gossage, *The Romance Industry* (Portland, Oregon: Nazraeli Press, in association with Comune Di Venezia, 2002), unpaginated.

6. *The Pond* was his first conventional book. Prior to that he published *Gardens* (Washington, D.C.: Hollow Press/Castelli Graphics, 1978), a bound set of twenty-four silver-gelatin prints made between 1974 and 1978, with printed texts chosen by Walter Hopps.

7. William Jenkins, introduction to *New Topographics: Photographs of a Man-altered Landscape* (Rochester, New York: International Museum of Photography at George Eastman House, 1975), unpaginated.

8. The interim reports and the final two Berlin books (unless there are more to come) are detailed above. The two recent volumes, *Berlin in the Time of the Wall* and *Putting Back the Wall*, can be obtained in a combined slipcase edition, entitled *The Complete Berlin* (Bethesda, Maryland: Loosestrife Editions, 2007).

9. Gerry Badger, "You Always End Up at the Wall, the Berlin Photographs of John Gossage," in *Berlin in the Time of the Wall*, p. 440.

10. John Gossage, *There and Gone* (Berlin: Nazraeli Press, 1997).

11. John Gossage, in *Quit while u kan*, supplementary booklet to *There and Gone*, p. 2.

12. John Gossage and Dr. Hermann Vogel, *Empire: A History Book* (Portland, Oregon: Nazraeli Press, 2000).

13. John Gossage, *Hey Fuckface* (Portland, Oregon: Nazraeli Press, 2000). Eighteen original black-and-white silver-gelatin prints in a wood and Plexiglas box, with texts handwritten by the artist.

14. John Gossage, in conversation with the author, London, June 1, 2008.

15. Blaisdell, *The Romance Industry*, unpaginated.

16. John Gossage, *The Thirty-two Inch Ruler/Map of Babylon* (Göttingen, Germany: Steidl, 2009).

17. Typically, *The Thirty-two Inch Ruler/Map of Babylon* is another piece of Gossage "switcheroo," as Walker Evans might term it. This is two books in one, beginning at both ends and meeting in the middle, as it were. If *The Thirty-two Inch Ruler* deals with Gossage's immediate neighborhood, *Map of Babylon* deals with the "world."

Pleasant Sundays: Robert Adams's *Listening to the River*

Despite the carping of postmodernists and contextualists—those who would deny the whole notion of creative authorship and reduce the world to a system of preexistent signs—or the wariness of those who rightly suspect newness for its own sake, what we look for in a work of art is this. We look for something we have not seen or heard before. So we shiver at that different, unheard-of combination of words or notes from the poet or composer. We purr at that judicious new twist to an old narrative from the novelist or moviemaker. In the case of the photographer, the tingle factor comes from something perhaps even more ineffable—the simple, yet profound pleasures that emanate from seeing something few would notice and drawing attention to it. As Tod Papageorge has rightly written: "This is not transport, or celestial transcendence, but that more footed joy and grief found near any clear sighting of the world."[1]

Few photographers have made as many clear sightings of the world in the last four decades as Robert Adams. His photographs are the epitome of lucidity, as nominally simple and transparent as any. And yet they encompass a wide-ranging subject matter with a complexity and a poetry that only a handful have matched. He is one of the most important artists of the late twentieth century, yet he is not making art so much as encapsulating life.

His spare, elegant style was first seen widely in his 1974 book, *The New West*,[2] and then in the *New Topographics* exhibition the following year. Such was the authority of his imagery that he became regarded widely as the quarterback of the New Topographics all-stars. Somewhat ironically, because New Topographics was never a team, or a school. It was at best a loose grouping of individuals who shared a stripped-down approach. This common stance was seen by many as simply a stylistic conceit, a reductive formalism in line with then-current minimalist art practices, rather than (as it certainly was in Adams's case) a reaffirmation, both ethically and conceptually, of the medium's documentary roots. To be sure, the original exhibition showed figures from very different theoretical backgrounds, thus tending to obscure some widely differing philosophies. And some of those involved in the exhibition—to Adams's bemusement—have shifted ground considerably over the years,[3] moving closer to the theoretical and conceptual stance that characterizes so much contemporary "photographic art."

But Adams has stayed admirably, even unfashionably consistent, maintaining a scrupulous balance between the subjective and the objective, between the conceptual and the phenomenological, between the aesthetic and the social. While others have become out-and-out polemicists or "conceptual artists," Robert Adams has remained a *photographer*, when others have decried photography and rushed to proclaim themselves *artists*.

This adherence to photography has various implications that color Adams's whole

Robert Adams, *Untitled*, ca. 1991, from the book *Listening to the River*

approach. Firstly, it indicates that he takes his primary cue from life rather than art or some aesthetic posture. His subject is the world, which means that his work is basically phenom-enological in tenor, dealing with sight impressions rather than theoretical concepts, though this does not mean that it lacks ideas. Form is a major, though not preeminent issue. It also means that Adams does not adhere slavishly to the notion of newness, which afflicts so much of contemporary photography, the insistent siren call—"if it's new, or different, it must be good"—that generates novelty rather than vision. Adams is content to photograph a tree or a mountain for the umpteenth time, in a relatively plain manner, because he is not interested so much in the typical as in the specific, the individual—a particular tree or mountain in a specific location at a specific time and in a particular light.

The work of Adams was also somewhat at odds with another theoretical plank of New Topographics in a quite fundamental way. His pictures were quiet, restrained, understated, but they were not cool in tone, or *nonjudgmental*—which seemed to be the exhibition's buzzword. For him, subject matter was not simply a motif; he cared passionately about what was happening to the landscapes he was photographing.

And he has continued to care. His work has never sought to deny the sociopolitical con-nection between man and nature—positive and negative—and that makes it both didactic and historical in tenor. Although Robert Adams's didacticism is subtle and complex, even paradoxical at times—he is no believer in the notion that photography in itself can move mountains or change the world—the polemical strain was always there. It remains there in his imagery, sometimes overtly, sometimes buried deep within the fabric of the image, but always *there*.

His whole oeuvre is marked by a gravity and a humanity, which derives from the unflashy nature of his seeing. Whatever he photographs, from a tree or a mountain, to suburban detritus or a tacky mall, to his wife Kerstin or his West Highland terrier Sally, is given the same scrupulous attention. He may be considered nonjudgmental in that sense, in that everything is given the same kind of nonhierarchical scrutiny, where expressive excess is strictly shunned, and each thing he pictures has its material integrity as an object respected. But there his objectivity ends.

Like Walker Evans, Robert Adams may be said to speak through things rather than about things. His poetry, like that of Evans, is the poetry of things in themselves. But contrary to the frequently cold and impassive Evans, there is nearly always a warmth in his imagery. Tod Papageorge uses the word *ardently*—and it's a good word—as he talks about the way Adams pulls off a difficult feat: "Adams manages something extraordinary, creating a body of photographs that speaks ardently about its subject even as it remorselessly catalogues it."[4]

I'm not quite so sure about the word *remorselessly*, for as in Evans, there is a rhapsodic element in Adams, which can be similarly compared to the exhilarating lucidity of the Luminist painters and their attitude to both form and light, with those philosophical overtones that relate to American transcendentalism. I don't particularly like either the words *transcendent* or *spiritual* in relation to art. I'd rather have an artistic rather than a spiritual experience when looking at a work of art, but I think that up to a point, both terms might be advanced (with caution) in relation to Adams, although *rhapsodic* remains for me the more accurate.

Certainly, Robert Adams's photographs are generally infused with the sharp, clear light of the American West. No matter the chaos and destruction he is describing, the light in his images is usually clear and sharp. He is not a photographer of gray days and gloom, and he prints toward the higher (lighter) end of the black-and-white scale. High-key is the old-fashioned term for it. It is a particular feature of American photography, in contrast to the moody printing of much European photography.

This dazzling light, however, is not merely at the service of American positivism, banishing the gloom and furnishing us with an upbeat Hollywood ending. It might be a consoling element, but it does not blind us to the social realities brought to our attention. Indeed, it reveals them. Nothing is obscured in the bright glare, and here is the rationale for Papageorge's "remorselessly." When required, Adams literally sheds light upon humankind's stewardship—at best careless, at worst criminal—of the natural world.

So in Adams's work, and perhaps in much of photography, light has a dual function, revelation on the one hand, redemption on the other. And Adams is keenly aware of both. One might say that he suspends them in a delicate balance in his best images. After all, despite the creeping—no, galloping—suburbanization of the Rocky foothills and the

Pacific coast, the all-enveloping light and the surging ocean will probably outlast human-kind's increasingly questionable tenure of this planet.

Adams is one of the few photographers who, if not totally resolving the impossible contradiction between environmental reality and visual beauty in landscape photography, has reached a sound, if sometimes uneasy balance in his work. In *The New West*, a damn-ing indictment of tawdry development along the Rocky Mountain foothills, he wrote the following: "The subject of these pictures is, in this sense, not tract homes or freeways, but the source of all Form, light. The Front Range is astonishing because it is overspread with light of such radiance that banality is impossible."[5]

This seems no formalist cop-out but an honest attempt to elucidate his imagery's trou-bling complexities. Adams's work is never without either its elegiac qualities or its moral passion, and if elegy seems to be winning out at any particular moment, he is quite likely to confound any expectation of a permanent retreat into transcendental contemplation with a blatantly political approach in his next body of work. That is one of his great strengths, and why he is a more intelligent photographer than most—his vision is complex enough to allow aesthetics and polemic, and any other kind of rhetoric he feels is appropriate for the particular task in hand.

Robert Adams is one of the most important American makers of photobooks in the last thirty-five years. He holds a doctorate in English literature, so it is perhaps not surprising that his approach to photography is literary, in the sense he always wants to get his mes-sage across, not so much in didactic but in narrative terms. He is interested in the formal qualities of each image he makes, but he also cares deeply about the collective meaning they convey.

So although his work is highly charged and political at times, he is also willing to relax and let it take a personal turn. Images of a degraded landscape or clearcutting mark the more overtly polemical side of his work, while the personal is marked by photographs that speak of his love for the sea, or trees, or pictures that simply document the walks he takes with his wife.

Rather than further talk about Robert Adams's work as a whole, I would like to talk in detail about one of his books. I have chosen *Listening to the River* (1996),[6] because it is somewhat disregarded, although I believe that it is one of his best. It is certainly one of my favorites, partly because I didn't "get it" when I first saw it. But like that piece of music you didn't care for when you first heard it, but nags at you, *Listening to the River* soon worked its magic. So often the works of art that puzzle one at first end up the most deeply loved.

Listening to the River exhibits all the qualities I mentioned at the beginning of this essay. It is full of photographs that I have never seen before, photographs that are as sharp and as crisp as newly minted money or a clear, cool spring morning. Furthermore, Adams is suggesting new ways of combining photographs, a method that relies less upon symbolic

association and more upon formal, physical qualities. In short, this fine artist proves that there is a lot more life yet in the old dog of traditional straight, so-called modernist photography. Indeed, he proves that terms like "traditional," "straight," and "modernist" are somewhat meaningless when applied to acutely perceptive photography in the documentary mode. Photography that looks at the world with intelligence and feeling will always be modern, will always be at the cutting edge.

But *Listening to the River* is not just an exemplary demonstration of the basic impulse of the photographic act, which is to look at some small part of our existence and record that seeing—in both visual and emotional terms—with simplicity and directness. It is also a sophisticated work of art, a work that expands the vocabulary of straight photography and also acts as a subtle polemic. This polemic not only embraces Adams's troubled view of humankind's stewardship of the environment and his own love for the land, but also strikes a keen blow for the modernist point of view in the face of the all-prevailing postmodernist tendency.

The subject matter of *Listening to the River* is familiar to anyone who knows Robert Adams's work, namely the unpretentious, homely workaday landscape of the American West—the workaday landscape of almost anywhere within the world's temperate zones, for that matter. Adams does not look to the national parks, to the operatic, scenic extravaganzas that were the trademark of his namesake, Ansel Adams. Nor does he focus upon the trash heaps and contaminated spoil tips of the doomsday landscapists like David T. Hanson. He concentrates rather upon the great mass of landscape in between, neither protected "unspoilt" national park nor ravaged strip mine nor bombed-out military firing range. He looks at the lived-in landscape just a few miles beyond our suburban backyards, the landscape worked over, not just by some faceless conglomerate or mindless government agency, but by you and me and our neighbor's neighbors. He looks at the kind of landscape which, if not actually disregarded, is somewhat carelessly regarded, and is probably next to be swallowed up in the inexorable march of the suburbs over the countryside. "Any tree in the path of development appears to have an uncertain future," Adams avers.[7] This is the landscape he asks us to regard with much more care—and in this book vividly compels us to do so.

The subject of *Listening to the River* however—and it is not usually the subject of his books—might be said to be the means by which Adams compels our regard, doing so with such authority and grace. And these means are space and time. For all its power as a method of representing the real, photography's monocular nature has long been considered its limitation. The photographer is obliged to operate from a single, fixed viewpoint, bound to a single moment in time. Of course, these limitations are at one and the same time the medium's grandeur, especially that startling, unprecedented capture of the significant microsecond. Nevertheless, many photographers throughout the medium's history have

tried to expand both the temporal and spatial boundaries of the photographic view, and transcend its restricted faculties as a reliable vessel of narrative, its frankly unpredictable record as a teller of tales.

One obvious way to do this is to combine single photographs into a larger, more complete entity either as a composite picture, the photo collage, or in a series, the photo sequence. Artists such as Ray Metzker and David Hockney (historically, it seems to be artists rather than photographers who have been more dissatisfied with photography's natural boundaries) have stuck small single images together to form much larger, painting-size constructions. Metzker came to prominence in the 1960s with his large grid constructions mirroring the kaleidoscopic, repetitive patterns of urban life, while Hockney in his "joiners" of the 1970s and '80s, endeavored to subvert the singular viewpoint by creating so-called cubist photo collages. Both artists have been highly influential, and strategies based on their example are now commonplace among photographic artists. In the world of "regular" photographers, the sequence—the setting of two or more images to play against each other in visual association—has long been regarded as the way to create narrative without recourse to the crutch of captions.

Others deliberately make a virtue out of photography's limitation. Bernd and Hilla Becher or Hiroshi Sugimoto for example, photograph different objects using an identical viewpoint each time, accentuating either shifting temporal or taxonomic differences but rigidly regulating the frame—a case of honing down in the manner of conceptual minimalism in order to concentrate the mind in a narrow, but hopefully deep focus. An early and singular example of this was Ansel Adams's Surf Sequence, possibly one of the influences upon *Listening to the River*. Ansel Adams positioned his camera on the top of a cliff, more or less looking straight down at the beach and the incoming surf. The five images in the sequence show different surf patterns, and when hung in a row, form a glittering, semi-abstract pattern.

The approach of Robert Adams in *Listening to the River* is looser, less programmatic and far more flexible than anything I have previously described. It consists of joining images together in sequences, from two to seven prints on each double-page spread. These sequences then feed into the book's larger structure, and importantly, interact discreetly with the poems of William Stafford. They do not follow a set pattern, except that every image in the book is vertical. Each group of prints has its own internal logic, for Adams is not following rigid, carefully calculated schema, but rather the relaxed, joyful prompting of his own intuition. He is concerned with describing an expanded sense of space and time, but this formalist problem is not an end in itself. It is the beginning, and is at the service of emotional content. In *Listening to the River*, form and content are intricately balanced, interdependent, pulling and pushing at each other simultaneously, as happens in all the most significant works of art.

But to give a flavor of this unique book, we must describe some of it. The sequence on pages 100 and 101, for example, consists of three images. In image one, we look down a dirt road toward a range of hills. The sun is bright, off to our right. There are only a few wispy cotton wool clouds in the sky. In the middle distance, a line of dark trees can be seen to fringe the road on the right. There is another clump of tightly grouped trees in the field off to the left, the side that Adams has favored in his view. In the second image, we have moved perhaps twenty or thirty yards down the road. The trees lining the track now loom in front of us, largely obscuring the sky, as the camera has now been swung over to favor the right-hand side of the road, and we see little of the field on the left. In the third picture, we have drawn level with the roadside trees, but Adams has moved the view back to favor the left, so the clump simply acts as a frame to the right-hand picture edge, and the image is dominated by the dark shadows cast across the road.

How ordinary, mundane even, this all sounds when described in bland prose. How wonderful to see it in precise but poetic photographs. In three images we have walked some fifty to one hundred yards down a sun drenched dirt road in Colorado, glancing to the right and left—as one does—moving out of the heat and harsh glare into the welcome shade of the trees. What Robert Adams has given us is the experience of the Sunday after-noon stroll in the country, or, as dictated to me by my metropolitan existence, my walk on London's Hampstead Heath. A perhaps banal, commonplace experience, but a profound and fundamental necessity for most of us, a function as necessary to our well-being as healthy food, wine, music, and good friends.

Earlier in this book, I mentioned John Fraser's essay on Eugène Atget in which he described how one could "enter" and "move around" an Atget picture. "There is indeed something peculiarly compelling about Atget's city streets that seems to place the viewer in them almost physically," he wrote.[8] Relating the Frenchman's work to a kinesthetic sense of moving around the city, Fraser extended that notion to our everyday experience of the metropolis—in spatial, psychological, and ultimately political terms. The political aspect should not be overlooked, for both the city and the landscape, and our lived experiences of them, whether one comprehends it or likes it or not, are shaped by politics in innumer-able ways. Thus Adams's encapsulation of an "ordinary," "everyday" experience of an unspectacular landscape makes a strong polemical point, one that has of course been taken up by many contemporary landscape photographers. The national park landscape can take care of itself, or rather, is taken care of by the government. Landscape of a more modest demeanor is under constant threat.

If Robert Adams has given us the experience of being in the landscape, he has also given us—as one might expect from an artist working in this late twentieth-century modernist/ postmodernist milieu—the experience of making photographs, that is to say, process in a pure, unadulterated form. Adams takes us back, as he nearly always does, to the roots of

the photographic medium, an almost overwhelming impulse to record something of our experience. We take a stroll with our cameras and dogs in tow. We see something that interests us. We stop, we trip the shutter. We maybe change our point of view slightly, more than once if the scene is interesting enough, and snap one or more shots. Or we move quickly on until we get another itch to record. I do not know whether Adams has chosen to print three, four, or five consecutive frames from a roll of film, or selected them in qualitative terms. It does not matter. What we have is a vivid sense—as immediate as that in the work of Cartier-Bresson or Garry Winogrand or Robert Frank—of photographs being taken on the wing, edited with the eyes, compulsively, intuitively, rather than being made. Here is a supremely eloquent rejoinder to those who insist that photographs should be preconceived, and the image constructed precisely, though that is not to say that Robert Adams was intellectually unaware, and did not think long and hard about what he was doing— before, during, and after the taking.

The utterly compelling aspect of *Listening to the River* is the fluidity of Adams's vision. I have never seen space described in photographs in such a natural, nominally simple yet inventive way. His method relates closely to one of the most basic photographic strategies—sticking prints together to make a panorama—but his utilization of this commonplace notion is cunningly inventive. If many of the book's double-page image groups could be described as loose panoramas, it does not begin to describe the varying ways that space and time are overlapped, interlinked, twisted, and expanded in the different sequences. As well as more or less conventional wide-view panoramas, we have, as we have seen, sequences progressing toward a distant objective, sequences compounded of four right-angled views at a crossroads, and sequences where the images have been gathered together in even more informal, even more intuitive groupings.

The sum of this, as I have intimated, is a sense of motion, a sense of being in and moving around the landscape evoked by the photographer and shared by the spectator. And in this evocation of personal experience, the work could clearly be termed diaristic, although that is hardly the limit of its ambition. After all, the formal project of seeing, comprehending, and describing space has been a fundamental mission of twentieth-century art. But so has the diaristic impulse—from the time of the Impressionists—and nowhere so much as in photography, with not just an aesthetic, but a complex ethic grounded in humankind's basic visual diary, the family snapshot. Many of the great photographic books and bodies of work might be characterized broadly as made as much for ineffable personal reasons— the urge to confirm one's existence, the need to reach out and grasp reality—as well as the more public goals of documentation or art-making. Just consider Walker Evans's *American Photographs* or Robert Frank's *The Americans*, Larry Clark's *Tulsa*, Nan Goldin's *Ballad of Sexual Dependency*, or John Gossage's *The Pond*. Think of the oeuvres of Eugène Atget, Henri Cartier-Bresson, Lee Friedlander, or Garry Winogrand. Such works, even Evans's

and Atget's supposedly documentary chronicles, are infused with deeply personal, private inflections that to my mind enhance rather than impair the work's ultimate value, both as document and work of art.

Listening to the River is an important book, one of the most significant photographic books of the 1990s. It is a vivid, constantly surprising, brilliantly inventive, yet conspicuously true addition to this diaristic canon. To some, the diaristic mode might seem a relatively modest backwater. In my view it is an absolutely fundamental and assuredly grand tradition. But I will leave the last words on the subject—both pertinent and elegant—to Robert Adams himself:

"Sometimes there doesn't seem to be anything there at all—just two roads, four fields, and sky. Small things, however, can become important—a lark or a mailbox or sunflowers. And if I wait I may see the architecture, the roads and the fields and the sky. Were you and I to drive the prairie together, and the day turned out to be a good one, we might not say much. We might get out of the truck at a crossroads, stretch, walk a little ways, and then walk back. Maybe the lark would sing. Maybe we would stand for a while, all views to the horizon, all roads interesting. We might find there a balance of form and openness, even of community and freedom. It would be the world as we had hoped, and we would recognize it together."[9]

Notes

1. Tod Papageorge, quoted in Jonathan Green, ed., *The Snapshot* (New York: Aperture, 1974), *Aperture* magazine (published in book form), Vol. 19, No. 1, p. 27.

2. Robert Adams, *The New West* (Denver: Colorado Associated University Press, 1974). A second reissue was published by Aperture in 2008.

3. Lewis Baltz, for example, has declared that "photography is dead." See "A Conversation with Lewis Baltz," in Andrew Wilson, Gillian Wearing, and Carol Squiers, *Paul Graham* (London: Phaidon Press Ltd., 1996), p. 134.

4. Tod Papageorge, in Robert Adams, *What We Bought: The New World* (New Haven, Connecticut: Yale University Art Museum, 2002), p. 23.

5. Adams, *The New West*, p. XII.

6. Robert Adams, *Listening to the River: Seasons in the American West* (New York: Aperture, 1996).

7. Ibid., quoted on the dust jacket.

8. John Fraser, "Atget and the City," in *Studio International* (London), December 1971, pp. 231–46.

9. Adams, *Listening to the River*, quoted on the dust jacket.

INTERLUDE: THE WALK TO PARADISE GARDEN

I have stated already that I consider the greatest virtue of photography to be its ability to transport us through time and space and give us a direct glimpse of a world that is far away or a human being who is gone forever—to take us *there*. Photography annihilates time and space, transforming an instant into a moment that endures, making it one of the most haunting and memorable of visual media.

I have often wondered how movie stars feel when, having lived to a ripe old age, they see one of their early films. It was the films of Fred Astaire and Ginger Rogers that first prompted this thought. In 1960s Britain, reruns of Astaire films always seemed to turn up on television over the Christmas holidays, and as I watched this dancer of incomparable grace, even as a teenager, I would muse morosely upon the passing of time. Did Fred the old man get out his films and watch them over and over? Or did he resolutely and studiously ignore them?

Now that my dancing, or team sports days, are over—except strangely, but insistently, in dreams—I realize that although we are the same person, the young self is also completely different, a stranger. As L. P. Hartley wrote in *The Go-Between*, his great novel of childhood remembrance, "the past is a foreign country: they do things differently there." So when we get out those old family snapshot albums, we can largely view them with a degree of equanimity and detachment, although that can be punctured sharply at intervals by the prick of an individual memory, whether sweet or painful.

I am not going to talk here about time, but rather the evocation of place, by looking at photographs of paths and roadways. "Path" imagery has always been one of my

favorite sub-genres because I am always interested in photographs where, as it were, one can psychologically enter the world depicted, and inhabit the picture space. It is strictly a sub-genre, because I am considering only those pictures where the photographer looks straight ahead down the thoroughfare into the distance, usually by standing in the middle of it. In these, we are given as direct an invitation to enter and stroll down that path as it is possible to get.

And I shall restrict the definition even further—while retaining the right to make an exception or two—by declaring that these photographs are, nominally at least, extremely straightforward in conception, shot from around eye level, and employing "normal" perspective. In short, they are as transparent as any in photography, not only giving us the world with the minimum of fuss or interpretation, but generously inviting us to share it.

The path is frequently used as a metaphor for life, employed in generations of church sermons. Do we take the smooth, broad highway, the easy road sought by those who will selfishly do anything to make things comfortable for themselves, even to the detriment of others? Or do we choose the hard, stony road, fringed on either side with thorns, the path of the righteous? Frequently, as in the path of life, the way ahead is never as straightforward as it seems, and the road is blocked, requiring detours of one kind or another. At other times, we can be swept along irresistibly, never quite in control.

The path is also the great symbol for hope, for moving on. If life is hard, pick up sticks, load the furniture onto the back of a truck, and head down the highway for the promised land. This of course is a particular part of American mythology, but the impulse to move

on to pastures new is a fundamental one, embedded deep within the human psyche, as can be seen by the various religious as well as cultural diaspora, which have been such a feature in the world as forms of transport have improved. Whether hopes are fulfilled or dashed, it does not matter—initially the path is seen as the route to salvation.

Whether used symbolically or as a compositional device, the path was first utilized in painting, especially by those who developed the naturalistic landscape, in Holland, then in England and France. Jacob van Ruisdael and John Constable, for instance, often featured pathways in their work, but the early masterpiece of the genre surely is *The Avenue at Middelharnis* (1689) by Meindert Hobbema. Around the time of photography's invention, painters of the Barbizon School, such as Camille Corot, and then the Impressionists, made images in which paths appeared, and their visions influenced the early landscape photographers. In 1852, Gustave Le Gray made a number of photographs of the *Pavé de Chailly*, the road to Chailly, just outside the village of Barbizon. One of his views was replicated almost exactly in a painting by Claude Monet in 1865, but that was most probably coincidence rather than direct influence, although by that time, there were cross influences between the two media.

The Impressionists were the painters of modern life. The poet of modern life, Charles Baudelaire, defined the modern man and one of its most compelling types, the flâneur. The flâneur compulsively walks the city streets, an anonymous observer of the metropolitan theater, taking pleasure in the flux of street life for its own sake. He—and the flâneur by definition is a he—might be described as a street photographer without a camera.

The great photographic flâneur, and the greatest, most prolific path photographer, was Eugène Atget. So much of his oeuvre, including those inimitable pictures where cobblestones recede sharply away from the camera, evoke the experience of strolling. The steep perspective draws in the viewer, more beguilingly than in the work of any other photographer, to a Paris that is not simply Paris, but Atget's Paris.

Path photographs are personal and immediate, because a potential narrative situation is set up involving the viewer. We walk down the path, or we imagine the photographer walking down the path, perhaps taking another picture further on, which is precisely what Atget did, and what Robert Adams has done in his three-picture sequences. Although they describe their world with precision and clarity, they are also images of real mystery and allure, because, as with a road or path in actuality, we are compelled to see what lies around the bend or over the next rise.

This interlude is intended as an informal homage to John Szarkowski, whose book *Looking at Photographs*, which consisted of one-page essays on one hundred photographs in the Museum of Modern Art's collection, has been a source of inspiration and guidance to me since it was published in 1973. And, of course, the title comes from W. Eugene Smith's enduring image from 1946 of his children walking along a wooded pathway. Smith, in turn, borrowed his title from the piece of music by Frederick Delius, an orchestral intermezzo from his opera, *A Village Romeo and Juliet* (1901).

Eugène Atget *Parc de Sceaux—7 h. matin*, June 1925

Choosing just one path photograph by Eugène Atget was not easy. Does one select an early image, made on the city streets, or a late one, made in the great parks around Paris? Atget made compelling path pictures at every stage in his career.

Much has been written about his intentions, about whether or not he should be regarded as an artist. What seems clear is that when Atget began to photograph, and had a commercial documentary practice to service, he was interested in the materiality of things, their solidity and substance as objects. Later, when commercial considerations were not such an issue, this trait seems to have been reversed, and he turned to the evanescent, to immateriality and the depiction simply of light and space. Yet his photographs always remained vivid documents of a world we could metaphorically feel and touch, although the later images give us more of a glimpse into his psychological world.

Some of his last, and greatest images, made in his mid-sixties, were of the parks of Saint-Cloud and Sceaux, on the outskirts of Paris. It is tempting, and too easy, to regard this work as an autumnal *Abschied*—a farewell—yet these pictures do seem suffused with both the passion and the sadness of an artist saving the best until last—a rare condition in photography, which is generally a young person's game.

Little needs to be said about this picture, one of Atget's most ethereal. It is a landscape some would find ordinary, a rutted path through woods, yet Atget's attentiveness to it elevates it to one of sublime beauty. A photograph like this reminds us of life's small, simple, but infinitely precious joys. It reminds us not to underrate the everyday and the ordinary, and that to wander in woods like these on a radiant June morning is truly something to be cherished.

Walker Evans *Post Office, Sprott, Alabama,* 1936

This is one of the first photographs to enter my consciousness as a great path picture. And it entered somewhat by stealth. At first glance, the image doesn't appear to be about the path or the road at all. Initially, given the photograph's title, and the dominance of its primary subject, it seems to be simply a photograph of a piece of vernacular architecture.

The crazy clapboard building itself is almost a summation of some of Evans's primary themes. It demonstrates his interest in signs in the landscape and vernacular American architecture, his empathy with handcraftsmanship and local business, as opposed to mass production and the inhuman values of the corporate ethic.

Evans made two negatives, one a vertical picture of the building alone. But if that fulfills a documentary function, the horizontal image showing the building in its crossroads setting, is poetry. The former gives us facts, the latter draws us in.

In the more inclusive picture, Evans has conjured up the experience of life, surely the goal of realist art. He has pinned down not only his experience of sight, of spatial and physical awareness, but, we may fancy — of touch and sound and smell. We are compelled to imagine the feel of the hot, dusty track upon the soles of our feet. We may also taste the dust upon our lips and in our nostrils, and blink at the intensity of the light. We may feel the heat of the sun upon our faces and hear the buzz of a thousand crickets. We are beckoned, drawn down that road, past that enigmatic shadow (literally the only shadow cast across the picture's elegiac mood), past that amazing building and on into the Deep South — America *profond*, as the French might say.

Dorothea Lange *The Road West*, 1938

There are two particularly well-known images of the American highway stretching into the far distance—one by Robert Frank in *The Americans*, and this one, of U.S. 54 in southern New Mexico, taken about twenty years earlier, by Dorothea Lange. Although one is a vertical and the other a horizontal image, they are formally similar. They also, I think, share a psychologically dark, or at least ambiguous tone, yet their meanings within the context of each photographer's oeuvre are quite different.

Frank's crisscrossing of the U.S. in the 1950s was a journey in search of America certainly, but given his links with the Beats and his exile from Europe, it was also a journey in search of the self. Lange, unlike Frank, was not documenting her own journey, but that of many others, the journey westward to California, the golden land of opportunity—telling much the same story as John Steinbeck did in *The Grapes of Wrath* (1939), two artists sharing a similar mission, to point out injustices but also celebrate the ordinary American without being overly sentimental about it. Although Lange was possibly more successful than Steinbeck in achieving this latter aim.

The ambiguity in the picture perhaps comes from what we know about the migration to California, although Lange makes it clear that this a long road. In the novel, published a year after this image was taken, the Joad family's trials and tribulations, like those of the Israelites, are only beginning when they reach the Promised Land. Lange's photograph is one of the great images of redemption, but the decidedly ominous quality tells us that redemption will be hard won, and is not at all certain.

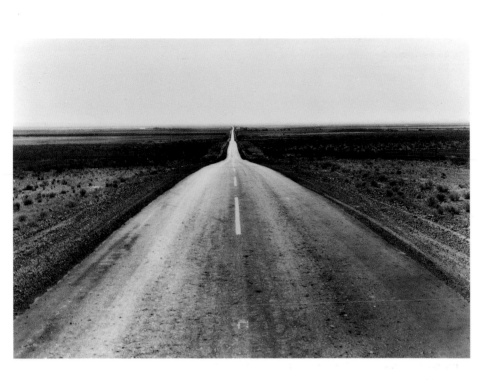

Stephen Shore *Presidio, Texas*, February 21, 1975

Stephen Shore's work of the early to mid-1970s emanated from traveling, a series of road trips across the United States. The symbols of road travel—automobiles, motels, gas stations, even roadside diner meals—are well documented in his two series American Surfaces and Uncommon Places, though it is the driving rather than the walking experience that is usually depicted.

But you get photographs by using your feet, so in Presidio, Texas, on the Mexican border, Shore got out of his car and walked around to great purpose. On the outskirts of town, he set his eight-by-ten-inch view camera to look up a dusty side street, probably at right angles to the main drag.

The picture was taken either in the early morning or late afternoon. The shadows are long and the whole image is suffused with the clear light of the American desert, in which color is reduced largely to ochre and the bright azure of the sky.

We look between a low row of buildings on the right and a wire fence on the left, toward a range of hills. It would be a hot and dusty walk to venture there, but even were we inclined to make the effort to see what lies at the end of the street, there might be a problem. A figure slouches by a doorway, a black dog near him.

At the moment, all is well. But inhabitants of small border towns can be mighty suspicious of strangers. The presence of man and dog lends a decidedly ominous edge to the proceedings, lifting what was an intriguing, lucid landscape into one of the major images in a major body of work.

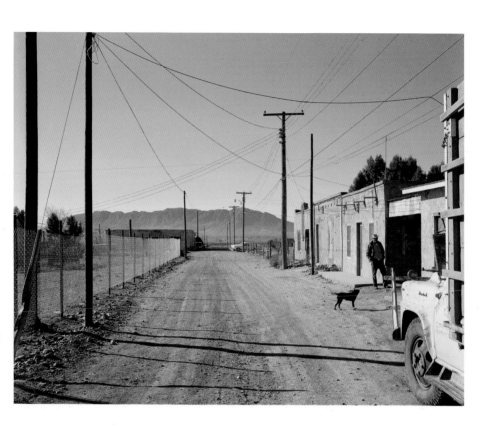

Martin Parr *Halifax, England*, December 1978, from the series Bad Weather

For photographers, good weather means good light and the reasonable expectation that their pictures will turn out. For walkers, good weather means that the rain stays away and the threat of catching pneumonia is averted.

They say that only mad dogs and Englishmen go out in the midday sun. Some, it seem, also go out in the rain and snow and fog—among them Martin Parr, who in the late 1970s made a series he called Bad Weather. Something of a conceptual exercise—going against the conventional photographic wisdom about good weather and therefore producing original pictures—the series was also a very British thing to do, for in Britain the weather is an obsession that few nations seem to share. But then few nations get weather that runs through four seasons in one day.

The result is pictures that are funny, but that also comment subtly upon the English social landscape. Here, on a stormy evening in Halifax—or was it just a summer afternoon shower?—a comedy of manners is about to ensue. Does the rather wary looking individual walking briskly toward Parr on the edge of the sidewalk, itself an idiosyncratic thing to do, force the photographer to pass him on the right, against the fence, or on the left, thereby forcing him to step into the road? Were words exchanged? We shall never know, for photographs are silent, though they are not mute.

A final point. This image echoes another famous path picture taken in the same city, Bill Brandt's *Snicket in Halifax*, from 1937, although in this case a house is a convenient understudy for the dark satanic mill.

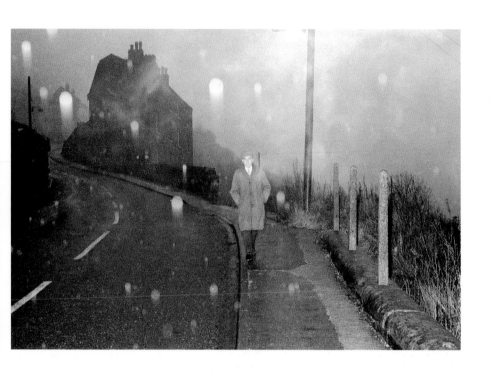

Anthony Hernandez *Wilshire Blvd. & Wilton Pl.*, 1979

In the Los Angeles photographs he made between 1979 and 1983, Anthony Hernandez combined two distinct tropes, the use of the large-format camera on a tripod and the candid approach of street photography. His series of people waiting for buses resonates with so many layers of meaning relating to the first city that seemed tailored specifically for the automobile.

Formally, Hernandez's images are perfect path pictures, with both sidewalk and highway stretching into the far distance and beckoning us toward the horizon. But we are unlikely to walk anywhere meaningful down the sidewalk, except perhaps to a bus stop. It is the highway that matters. The distances between destinations of interest are just too vast in Los Angeles, a city almost completely reliant upon the internal combustion engine. So we drive, or take the bus.

In L.A., however, only those who can't afford the payments on a car take the bus. Like any good photographer, Hernandez was exploring the medium's formal qualities, but at the same time he was making a social point, making visible for our thoughtful consideration people whom most Angelinos, cocooned in their automobiles, pass by without noticing. These are stunning, formally adroit photographs. They are also quietly hard-hitting political documents.

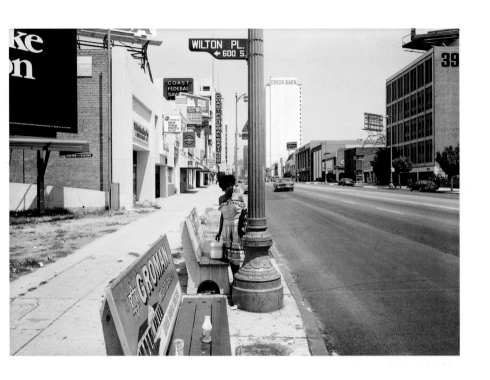

John Gossage *Berliner Forst Tegel #111, 1982*

In a dark forest, a muddy path leads to a distant patch of light. Halfway into the picture, the path divides and takes a detour to the right, so we can, if we wish, take a more meandering perambulation toward the light, and to what looks likes some kind of structure.

It is indeed a structure, but not a building. It's *die Mauer* — the Berlin Wall. Our walk, therefore, is likely to be terminated abruptly at this implacable barrier dividing a nation and two opposing ideologies. But the picture promises something different. The wood is beautiful, but dark and somber, while the Wall shimmers in the distance. In the image, we move from darkness into light, while in actuality we would be moving from the light of nature to one of humankind's darker creations.

The Wall seems far more insubstantial than the woods, so maybe the picture is a reflection of what Gossage thought when he first saw it, and began to photograph Berlin obsessively: "It was so ridiculous and crazy, I knew it couldn't possibly last."

Perhaps given that sentiment and the Wall's evanescence, we will be like the two angels in Wim Wenders's film, *Wings of Desire*, and upon reaching the barrier, simply disappear through it, then reconstitute ourselves, miraculously, on the other side. But now Gossage's prediction, and our hopes, have been fulfilled, we can proceed unhindered, without the need of a miracle — although our progress may be watched by ghosts.

Robert Adams *Sally, Weld County, Colorado,* 1984

Robert Adams has probably made as many great path pictures in his career as Atget, reminding us that, however much photographers have depended upon the car, to get the best pictures, at some point you have to get out and walk. Known for his passionate documentation of man's despoiling of the environment, Adams has also produced a body of work that deals with family life, and in particular his walks with his wife Kirsten and their dogs. This image from his book *Perfect Times, Perfect Places* (1988) does this in a singular and spectacular way.

And yet Adams never lets us forget that the simple, but profound pleasures depicted here can be taken for granted and are under constant threat. The pictures in this book were taken in the Pawnee National Grasslands, a reserve established in northeastern Colorado during the 1930s to rehabilitate part of the dustbowl. It's not a spectacular landscape in the conventional sense, except in terms of wide open spaces and magnificent skies, but Adams's pictures, understated like the landscape, fully convey what a joy it must be to walk there. As in Evans's Alabama crossroads, I would like to hike down that road to the far horizon, feel the sun on my arms, the cooling breeze on my face, and hear the silence, broken perhaps by the cry of a bird or the rustle of the wind. I would like to stop, open my backpack and eat a tasty picnic lunch, perhaps fortify myself for the hike ahead with a nip of Jack Daniels.

Dorothea Lange's road expresses hope, but hope that is far from sure, fulfilled only by hard work and the certainty of a multitude of setbacks. Robert Adams's road, with West Highland terrier Sally leading the way, also expresses hope, but hope that is certain, built from small joys. A hope, that Adams writes, "is at once personal and common to centuries of dreams: peace, light, and fond company."

Jitka Hanzlová *Untitled*, from the series Rokytnik, 1990–1994

If you live in a village and walk around regularly you tend to meet your neighbors. When Jitka Hanzlová, a Czech who had gone to study photography in Germany, returned at intervals to her native Bohemian village of Rokytnik, she walked around with intent, plotting a path in order to take pictures, producing the series that made her reputation.

Using the side of the road as an impromptu outdoor studio, she photographed her friends and neighbors, quickly and with a minimum of fuss. In the strict sense of the word they're snapshots, but snapshots made by a highly sophisticated photographer—images that declare her interest both in the process of making these seemingly casual, spontaneous portraits, and the kind of representation that accrues from these brief encounters and the process of photographing. In this series, Hanzlová generally knew her subjects, but even when she photographed strangers, the results are virtually the same—an intriguing amalgam of the formal and the informal, depicting an individual rather than a type.

Thomas Joshua Cooper *A Premonitional Work (message to Cézanne and O'Sullivan)/ Bibémus Quarry, Aix-en-Provence, France, 1995–2003*

Sometimes a path can appear blocked, as here in the Bibémus Quarry near Aix-en-Provence. The way ahead might lie through the small triangular area in shadow, or it might be around to the left, between the slab of rock lit by the sun and the rock edge in deep shadow. But our onward route doesn't matter for the moment, because we are pausing in our journey to contemplate the play of light on the rocks, and think about Paul Cézanne.

Thomas Joshua Cooper made this photograph as part of a BBC television program made in conjunction with the Cézanne retrospective shown at the Tate Gallery in London in 1996. The Bibémus Quarry was where Cézanne painted some of his best and most mysterious pictures, where he both collapsed and expanded space in works that virtually mark the beginning of modern art. Cooper does the same—and it is not an easy trick to pull off—in a picture that is not only an homage to the master but also a masterly exposition of the ability to create landscape photographs that are both teasing and complex amalgams of the figurative and the abstract. Cooper levitates us from the ground so we can float around this image, float around this enchanted glade that figures so highly in the history of art.

And when we continue our journey and climb out of the Bibémus, we look across the plateau to another major motif of Cézanne's—the Mont Sainte-Victoire. Maybe serendipity took Cooper to the Bibémus at precisely the right time, but he was certainly there to recognize his good fortune, fully "booted and spurred," as Walker Evans put it. The shadow on the left uncannily echoes the silhouette of Cézanne's mountain, confirming Edward Steichen's much-quoted observation that it's a strange thing that the best luck seems to fall in the lap of the best photographers.

Michal Rovner *Border #8*, 1997–98

This striking image comes from Israeli artist Michal Rovner's film *Border* (1997), which was largely shot around the main road from Israel into Lebanon, which has been used frequently by the Israeli military, including their 2006 incursion north to fight Hezbollah forces that were firing rockets into Jewish border settlements. Rovner's film contains sequences of a troubled but beautiful landscape, yet the most haunting images are of the border road itself, with cars and people moving slowly up and down the single carriageway.

Basically a "frame grab," Rovner made fifteen digital files of the picture. She then had them digitally air-brushed onto canvas, creating fifteen variations, each subtly different. This image ignores traditional categories of process, fusing the real and the imaginary, yet defies my normal dislike for the constructed photograph, in that it deals imaginatively with a very real and pertinent subject.

The result of her technical manipulation is a compelling image, which although still, seems to shimmer with movement. But the mood is somber. The road here is not a metaphor for life and hope, but functions as a harbinger of death. A highway between two countries should be a cause for celebration, it should be bringing people together. Here it serves to keep them apart, and is the unwitting agent which fosters grudges that last for generations.

At the moment, the road plays host to a solitary, forlorn looking figure, but tomorrow it might be occupied by a swiftly moving military column.

Anna Fox and Alison Goldfrapp *Untitled*, 1999, from the series Country Girls

Anna Fox's Country Girls, a series of staged and collaborative photographs made with her friend Alison Goldfrapp, paints a bleak picture of the prospects rural life holds for young women. Fox and Goldfrapp portray lives constricted by tradition, tradition that ensures women's lives are largely there for the convenience of men. The series was originally inspired by a Victorian murder case notorious for its grisliness. In 1867, in Alton, Hampshire, eight-year-old Fanny Adams was murdered and butchered by twenty-nine-year-old Frederick Baker, a solicitor's clerk.

Baker was tried and hanged, but the tragic affair might have been forgotten if not for the macabre humor of British sailors, who, served with unpleasant tinned meat rations in 1869, declared that the tins' contents must hold the remains of "Sweet Fanny Adams." Gradually accepted throughout the military as a euphemism for "sweet nothing" or "sweet fuck all," the phrase passed into common usage.

So violence is at the core of the series, but not only physical violence, for violence can also be psychological, and equally scarring. Nevertheless, a number of images show Adams/Goldfrapp as a corpse, presumably the victim of foul play perpetrated by a man. The young Fanny's body was found on the edge of a hop field. In Fox's image, a naked corpse has been pushed into a hedgerow, by a path along the edge of a field. Eventually, someone walking along the path, out for a morning stroll with their dog, or a search party, will make the unpleasant and disconcerting discovery.

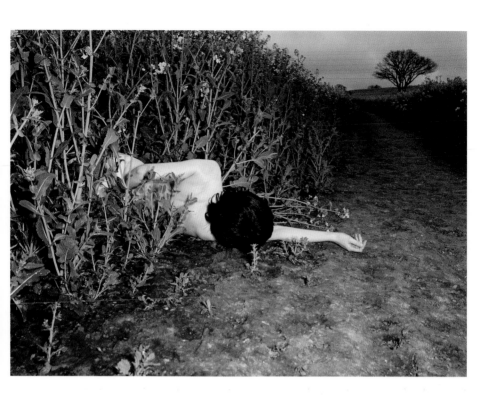

Paul Seawright *Valley, Afghanistan*, 2002, from the series Hidden

After Paul Seawright made this picture, he remarked to colleagues that he "had made a Fenton." Such a remark refers, of course, to Roger Fenton's renowned 1855 image of a cannonball-strewn track in the Crimea, a photograph that in itself is a reference to Lord Tennyson's poem *Charge of the Light Brigade*, and the "valley of the shadow of death" in the twenty-third Psalm.

Most photographs, however, even if they reference others in a secondary sense, seldom do so in a primary sense. Seawright did not set out to make a "Fenton." He was in Afghanistan, making photographs for the Imperial War Museum, London, when he came across this deadly litter. Fenton was probably the furthest thing from his mind when he readied the camera to accept this gift of a picture, but the connotation between this view of a contemporary imperialist war and an ancient one would be clear enough in retrospect.

And the path itself? Fenton's track, despite the spent cannonballs, would have been safe enough. The war had moved on to safe distance by the time his photograph was made. But this Afghanistan road, with its unexploded ordnance and the possibility of buried mines, is a different prospect. The war had not moved on, it was all around.

The title of Seawright's series, Hidden, indicates that the violence is in the areas Mark Durden says are, "still to come, present but hidden, primed, a future devastation." Seawright went no closer than to make the photograph, a simple document of war that is also a work of art with a complex set of contextual connotations. And also a rare path picture— one that does not invite us in.

Susan Lipper *Untitled*, from the series New Landscapes, 2006–9

In his 1912 album on the Zone Militaire, the ring of open land around Paris that formed part of the city's military defenses, Eugène Atget made a number of images where he appeared to follow a nondescript path through some decidedly scruffy undergrowth. There seemed little reason for doing this, that is any practical reason connected to his commercial practice. So one wonders what private motive prompted him to make these intriguing photographs, which are, essentially, pictures of "nothing."

This image by Susan Lipper, which could also be termed a picture of "nothing," comes from a series of landscapes in and around Grapevine, West Virginia. Lipper has been making photographs in Grapevine for over two decades, so it can be assumed that she is thoroughly familiar with the area, and fully comfortable with it. Her photographs of small paths and roads and details of woodland are the kinds of landscape that denote familiarity, but they seem far from comfortable. In their attention to detail, they could be described as forensic, and while they describe extremely commonplace scenes, their very ordinariness seems to lend them an uneasy quality.

One of the themes of Lipper's Grapevine work is male violence. Some of the subjects of the early portraits she made there have suffered untimely, and violent deaths. This is a frontier community. In many ways, Grapevine, and hundreds of similar small hamlets buried deep in rural America, mark a kind of Eden—wild, free, and unrestrained. But as Lipper's peaceful, yet remarkably ominous landscapes remind us, at any moment you might find an apple tree, but you also might step on a snake.

Patrick Zachmann *Marseille by Night, Marseille, France,* 2007, from the series Un Jour, La Nuit

Patrick Zachmann calls his series, Un Jour, La Nuit (A Day in the Night), a *ballade*, indicating perhaps that these impressionistic, poetic photographs show his lighter side. Nevertheless, he remains a serious photographer and social issues are never far away. Many of the images in the series take us into bars, brothels, and nightclubs, and other places where the human denizens of the night can be far from benign. Ballad or not, we remain in the twilight world depicted in many of his projects concerning illegal immigrants, who often work at night and are taken advantage of by the crime gangs who got them there, which in turn exploit the people on the search for vicarious thrills.

The series takes the form of a nocturnal ramble, or as the filmic title suggests, a series of stills from a movie. The beautiful French title also might suggest Eric Rohmer or Claude Chabrol, but the pictures are more David Lynch, or one of the younger, tougher, post–New Wave directors. The mood is uncertain, a mixture of excitement and fear perhaps, but Zachmann has been shrewd enough to allow us to construct our own narratives around these enigmatic images.

This picture, taken on an escalator in Marseilles, certainly suggests the giddy thrills of nocturnal adventure, a feeling of anticipation perhaps tinged with unease. There is a figure ahead, but it's difficult to know whether it's coming toward us or moving away from us. We'll soon find out whether this strange apparition might bring us joy or sorrow, or will simply pass us by, just another ship in the night.

Donovan Wylie *The "Green Zone," Baghdad, Iraq,* 2008

Donovan Wylie has been photographing the architecture of conflict for a number of years, beginning with Northern Ireland's notorious Maze Prison, near Belfast. As an Ulsterman, he was photographing his own history, and firmly believes that photographers are beholden to explore their own culture, its past, present, and future.

The conflicts in Iraq and Afghanistan are now part of all our histories, and Wylie regards his work in these zones of war as a natural extension to his Northern Irish work. This image comes from a yet-unpublished series on the Green Zone (now the International Zone) in Baghdad, the large area in the city center that was turned into a heavily fortified "safe area" for coalition military and civilian personnel (primarily U.S.), and Iraqi government employees. To make the area safe, almost anything that doesn't move is hedged around with high concrete antiblast walls, including the roads. The result is a labyrinth, and the psychological effect of living in the Zone, contends Wylie, is like being a mouse in a laboratory maze.

Influenced by the Düsseldorf School, Wylie's approach is low-key, affecting a studied neutrality. Yet as we look down this concrete hedged highway, unsure of where we are, it is tempting to think of this image, and others in the series, as a metaphor for the Iraq adventure. It was easy to get into, but a lot more difficult to plot a way out through the political, religious, and social maze created by the invasion, and extricate ourselves in an honorable fashion.

From Here to Eternity:
The Expeditionary Artworks of Thomas Joshua Cooper

One of the key tropes in American modernist photography has been the concept of the transcendental photograph, promoted firstly in the 1920s by Alfred Stieglitz, and then in the '50s by his ardent disciple, Minor White. Stieglitz developed the notion of Equivalence, proposing that photographs, rather than simply documenting surface appearance, could function like any other kind of art, as equivalents for philosophical ideas and psychological feelings. For Stieglitz, the photograph ideally would become an abstract carrier of meaning and emotion in the manner of music. Like Walker Evans, a transcendentalist of another order, Stieglitz could be said to have been in the business of introducing difficulty into photography, transforming it from a simple art into a complex one.

It was an ambitious program, taken up enthusiastically by Minor White after World War Two when he taught photography, first at the Rochester Institute of Technology and later at MIT. He also created a forum for his ideas in the quarterly magazine *Aperture*, which he cofounded, in 1952, and edited until 1975.[1]

The Stieglitz/White approach was poetic and formalist, tending toward abstraction in order to thwart photography's annoying literalness. The idea was to read things in the image, rather like staring at the flickering flames of a fire and letting the imagination wander. This kind of abstract formalism, finding patterns in nature and creating compositions in the darkroom, also enjoyed a brief postwar vogue in Europe, with Dr. Otto Steinert's *Fotoform* movement of the 1950s, and his book, *Subjective Fotografie*, but White's updating of Stieglitz had a sturdier theoretical base, and also the invaluable platform of *Aperture*, which rapidly became one of the most important photographic magazines of the late twentieth century.[2]

Minor White's influence reached its height in the decade from the mid-1960s to the mid-'70s, its shelf life extended—unlike New Subjectivity's—because White and many of his students enthusiastically embraced the American counterculture of the times. His "spiritual" approach to photography became mixed up with such fashionable indicators of the zeitgeist as transcendental meditation, Zen Buddhism, Jungian psychology, and haiku, all personal interests of White himself—keeper of the Stieglitzian flame, sherry drinker, and self-styled guru. Issues of *Aperture* bore such titles as *An Octave of Prayer* and *Be-ing Without Clothes*,[3] and became littered with such aphorisms as "Illuminate the mind and cast shadows on the psyche"[4] and "At times of insight The illumination of surfaces reveals that I AM within."[5] Students were encouraged by some teachers to meditate before they made a photograph.

The patrician, elitist attitude of Stieglitz was replaced by a touchy-feely, hippy pho-

Thomas Joshua Cooper, *Looking towards Antarctica: The Drake Passage/Cape Horn, Chile, 2006–2008/ Very near the South-most point of all South America. 59° 59' S*

tography. Nothing wrong with that, it was a welcome democratization, many would say. And indeed, much interesting work was done under White's aegis, yet on the other hand, photographing rocks and tide pools or frost patterns on windows, could also be an easy way out for the simpleminded.

Then, in 1976, it all seemed to collapse. White died, and the whole Minor White School of Transcendental Photography appeared to die with the man. In a very short space of time it became something of an anachronism, and an irrelevance as far as photography's cutting edge was concerned.

This almost total collapse of a whole photographic philosophy with what seemed like inordinate haste, a philosophy that was very popular when I first became interested in the medium, has always intrigued me. Because, despite my misgivings about the quasi religious elements that accompanied it, as an approach it seems to me to be as valid as any other. Also—and this is something that those who disparage White seem to forget—he took the

notion of the photographic sequence to a new and potentially important level. I remember vividly the time White visited England in 1975, not long before he died.[6] I heard him talk at the Victoria and Albert Museum in London, then traveled up to Nottingham to attend a seminar at Trent Polytechnic, then the leading school in the country teaching his ideas.[7]

Although it seems obvious in retrospect, the demise of White's ideas was already well under way. There were a number of factors ensuring this. Firstly, landscape photographers—and transcendental photography was essentially a landscape movement, except of course for the Be-ing Without Clothes aspect—were becoming seduced by the New Topographical approach, which favored a dry-eyed concentration upon the man-altered rather than the unsullied landscape, viewing the natural landscape as an evidential site of sociopolitical activity and not a source of mystical solace.

Secondly, the early 1970s saw the beginnings of postmodernism. The kind of romantic individualism espoused by White was regarded by postmodernists as anathema. The whole genre of formalist modernism promoted by Stieglitz, with its elitist emphasis upon the artist's genius, universal aesthetic values, and print connoisseurship, came under particular attack. To be labeled a romantic formalist by the postmodernists was akin to being denounced as a bourgeois revisionist by Stalin.

Thirdly, color photography finally became not only respectable, but increasingly the medium of choice for younger photographers and would-be photographic artists. Moody black-and-white landscapes, placing an emphasis upon the fine print, are much more conducive to the White aesthetic than the relative uniformity of color prints.

I mention Minor White's visit to Trent Polytechnic, because teaching there at that time was a young American called Thomas Joshua Cooper. Cooper, who hailed from the coast of northern California, was an alumnus of the University of New Mexico in Albuquerque, where he studied with Beaumont Newhall and Van Deren Coke. He had come to the Midlands industrial town of Nottingham to teach alongside such British advocates of the White approach as Raymond Moore, Paul Hill, and John Blakemore.

While at Trent, Cooper began to make landscape photographs unlike any seen before in Britain.[8] He used an ancient five-by-seven-inch view camera (and still does), making exquisite contact prints, dark but sumptuous in tone. His subject matter was almost nebulous, a rock face in a quarry, a group of boulders, and his prints bore titles like *A Quality of Dancing* and *Ritual Indication*. I thought the titles (very much in the White mold) a tad pretentious, but was entranced by the imagery. Cooper's pictures did what they promised, and gave us a post–White vision, a thoroughly original and contemporary updating of Stieglitzian transcendentalism.

The subject of the images appeared to be genius loci, but the spirit of place in such a specific yet indeterminate way. Cooper drew the viewer into a dialogue with each small section of the landscape, partly because of the prints' small size and their rich, intriguing

tonalities, and partly because he withdrew not only the comfort of his subjects' size—you did not know whether you were looking at an anthill or a mountain—but also a grounding in the image, whether horizon line or foreground. It was the source of the photographs' potency, because once engaged, the eye would float around the picture space, freed from the necessity to make representational sense of it, which allowed one's thoughts to wander at will. We were compelled to inhabit the space of his images, and become immersed in them, an uneasy, yet heady experience that contributed to their considerable allure. We were invited, as it were, to become the spirit of the place ourselves. So our relationship with a Cooper landscape became an intensely personal one, full of emotional power.

And Cooper has remained largely true to this aesthetic ever since, even joking that he is a one-picture photographer,[9] though this is far from the truth. Indeed, although his work has remained admirably consistent, it has also evolved, partly as Cooper himself has evolved as an artist, and also because circumstances in the art world during the 1970s—the demise of the White School, for example, but also other shifts in fashion—necessitated that he change, or be in danger of becoming irrelevant, the worst thing that can happen to an ambitious artist. While he remained true to himself, it could be said that the theoretical platform underpinning his work shifted somewhat, or rather, broadened, and in so doing enriched his work, keeping it alive and growing.

I have mentioned that the White philosophy, and the formalist approach to photography in general, attracted the particular scorn of the postmodernists. In Britain, the Trent School, as it was called, came under fire from an establishment that largely subscribed to a politically motivated social documentary photography, theoretically underpinned by ideas revolving around representation. Photographers became obliged, rightly so, to examine how they represented women, gays, ethnic minorities, the working classes, and so on, except that toward the end of the '70s, there was a point where representation itself almost became the only acceptable subject to those advocating this new orthodoxy. Poetic, ahistorical, and apolitical photographs of rocks and trees were deemed dangerously irrelevant.

The doctrine of dialectic materialism that was an important part of the postmodern raft of theoretical tenets declared that the spiritual in art was anathema, the result of dogma and superstition. Only dealing with it in an ironic way, to mock it, in perhaps the manner of a Damien Hirst, could it be made acceptable to postmodernist dogma, which at times could be as inflexible as religious dogma.

Yet, however much materialism is promoted, aspects of the human condition remain that could be considered broadly ahistorical, or perhaps metahistorical, and largely universal, arising in the main from biological imperatives. And they will remain so until the great "Why?" can be answered satisfactorily. This fundamental question hasn't vanished with the advent of Darwin, Marx, Freud, Watson, Hawking, or anyone else. An art, however apparently disconnected with everyday material existence, that addresses any of the

biological and psychological mysteries of life, surely still has specific relevance. Stieglitz's original intention, that his imagery act upon the viewer in the manner of music or poetry in a primarily abstract way, remains an eminently laudable ambition.

But not, it seemed, in the mid-1970s. It is easy to decry fashions in art and culture, but if a particular style becomes outmoded, it impacts upon practitioners' careers, in ways that differ from the trivial and the merely annoying to the fundamental. By the advent of the '80s, many of those still working in the Stieglitzian tradition were left on the outside looking in, many giving up altogether or languishing in artistic obscurity. Cooper's art, however, was just too good to be ignored completely, whatever the vagaries of cultural fashion. Furthermore, a new development in British art allowed him to reposition himself, neither at the expense of what he was doing, nor at the risk of losing his integrity, but in terms of giving him a slightly different goal at which to aim.

In the early 1970s, another landscape trope had entered British art—art, it should be stressed, not photography. Part of the conceptualist/minimalist art movement was Land art, which began in America in the late '60s, where artists such as Robert Smithson made large-scale sculptural interventions in the landscape, partly to demonstrate that they could work on an industrial scale, partly in response to the commercialism of the art market, partly to protest the disengagement of high modernism from social issues, and partly in response to environmental concerns, which were becoming something of an issue. The *New Topographics* exhibition, as well as being about photo-aesthetics, also evinced some of the cognizance being taken about the state of the planet.

There was also a typically British branch of Land art, much more modest than the American, and concerned with, among other things, photography. British artists such as Richard Long and Hamish Fulton more or less invented a mode of Land art akin to performance art. Indeed, both have disclaimed the Land artist tag and have described themselves as "walking artists." They would make long trips into the wilderness and designate the walk itself as the work of art, although it was their careful documentation of each trip—in the form of surrogate objects like photographs, texts, maps, phototext pieces— that was exhibited (and sold) in the gallery back home. Long also made frequent direct sculptural interventions in the landscape with rocks or deadwood, even by scraping lines in the ground. His famous work of 1967, *A Line Made by Walking*, can be credited with starting the genre of Land sculpture. Fulton was less of an interventionist, he usually contented himself with taking photographs. But truth to tell, both men's work shared a number of similar characteristics, and superficially, it could sometimes be difficult to tell the difference between them. Long himself considers Fulton the better photographer: "I am not really a great photographer, sometimes my photographs almost by chance are quite beautiful, whereas Hamish Fulton is a natural photographer. He has a great feeling for landscape images."[10]

But both are fine photographers within the context of what they do. Except that what they do is not "photography." Theoretically, they do not consider themselves photographers at all in the strict sense. In their work, the photograph serves as a surrogate or mnemonic for the actual experience of the journeys, which are the real works of art.

It is a moot point that most photographs made by most photographers are mnemonics for some kind of experience. Long and Fulton were among the first in the artworld to be described as artists utilizing photography rather than photographers per se, and in the 1970s cultural climate—where art and photography did not mix on the same social level—"sculptor," "conceptual artist," "Land artist," or "walking artist"—anything but "photographer"—was a much more pragmatic thing to style oneself. Another leading British conceptual artist, the late Keith Arnatt, condemned himself to years of artistic obscurity when he began to practice straight photography rather than take a more conceptual approach, and worse, when he declared himself happy to be known as a photographer. Back in the 1970s, there was a lot in a name.

The example of Long and Fulton, however, enabled Thomas Cooper to look at his work in a different way, and take a different approach, augmenting the romantic spiritualism with concerns related to history, and addressing postmodern rather than modernist theory. In short, he was able to construct a broader, and more acceptable theoretical platform than romantic formalism. Of course, Cooper's work itself also changed, without losing its salient characteristics—its tonal richness, his particular sense of floating space and indeterminate scale. By his willingness to embrace new ideas, Cooper's work became richer, and more relevant, while the work of those stuck in a traditional Stieglitzian mode simply atrophied.

What Long and Fulton brought to landscape art was a sense of personal interaction, not just in the sense of looking, but in being. Much photography since the 1950s has been about articulating personal experience, not simply experience from a lofty, aesthetic viewpoint, but from an intimate, lived viewpoint—the so-called diaristic mode, which has burgeoned beyond all measure with digital photography, blogs, Flikr, and the like. It might be thought that this would be anathema to the postmodernists, extreme subjectivity replacing the proper objectivity and reasoned distance expected of an artist working with a documentary medium such as photography. It is not, however. From a certain postmodern perspective, a personal approach is merely admitting that everything is subjective, and by admitting it, critiquing it, one is making work that, so to speak, explores the problems of making representations as it is doing so.

Long's and Fulton's work was not only about how we relate to the land in a complex way—physically, culturally, psychologically, historically—but also about how we make representations, or maps, of these relationships. As Long has stated: "These walks are recorded or described in my work in three ways; in maps, photographs, or text works,

using whatever form is the most appropriate for each different idea. All these forms feed the imagination, they are the distillation of experience."[11]

Long deliberately chose nominally objective, scientific means to describe the walks in order to distance the work from the romantic landscape tradition. Maps provided measured (in both senses of the word) information. His texts utilized the dry, impassive tones of the surveyor or geographer: "A LINE OF 33 STONES / A WALK OF 33 DAYS." And his photography was as far from art photography as it was possible to get—initially developed at the corner drugstore, as artless as that of Ed Ruscha. If diaristic, they were diaries of objective fact—got up, did this, ate that—rather than diaries detailing emotion. We know where Long went—how long it took him and so on—but we know nothing of his feelings—whether he was awed, or unimpressed, hot, cold, tired. The scientific and the objective held sway. For Long, "walking—as art—provided an ideal means to explore relationships between time, distance, geography and measurement."[12]

Although the work's primary references were conceptual art, minimal art, even *Arte Povera*, and the "anti-reference," as it were, was romantic art, in Long's and Fulton's photographic pieces there was a reference they probably never even knew about, at least in the early days. In a review of a Hamish Fulton exhibition at the Institute of Contemporary Arts in London in 1976, I wrote the following: "I do not know whether Fulton has even heard the name, but I was continually reminded in his work of the photographs of Timothy O'Sullivan, and other early photographers of the American West."[13]

In particular, it was the mapping and measuring aspect of the work that invited what at first seemed a rather speculative comparison: "O'Sullivan and his fellow photographers were much more than makers of landscape images. Usually members of government survey teams, they were instrumentally involved in the cartography process, of mapping and recording the physical and spatial structure of the land. O'Sullivan's work is especially redolent of a recording, measuring process: he often included a human figure or figures placed at various points within the picture to impart a sense of scale, and in his famous Spanish Conquest Inscription Rock, even laid a rule upon the rock to delineate its precise dimensions."[14]

Timothy O'Sullivan is someone who has always been of the utmost importance to Thomas Joshua Cooper, ever since he made what he has termed his first "real" photograph, down the See Canyon in central California, in 1969. It is his example that might be kept in mind when Cooper aligned his work more with the objective, measured mode of the Long/Fulton axis, and when he began one of the most ambitious photographic projects any photographer or artist has attempted in the last twenty-five years. That project, which is not far off completion, is The Atlantic Basin Project—The World's Edge. It was conceived in 1992, after Cooper had read a particular book, although elements of the work were already in place, and had been for some years.

Photography is a natural medium for grand projects. The conceptual framework of a grand project limits the medium's inherent tendency to be promiscuous in an imagistic sense, yet takes full advantage of its profligacy. Profligacy without promiscuity—it is such a perfect combination that I wonder why more photographers do not attempt them. Of course, grand projects are more easily conceived of than brought to fruition. They demand perspicacity, obduracy, and dedication, an approach not necessarily commensurate with the quick results—and quick rewards—young photographers seem to demand these days.

The ultimate grand photographic project—though he may not have thought of it as such—was Eugène Atget's thirty-year exploration of Paris and French culture. Then there was August Sander's *People of the Twentieth Century*, and coming up to date, Bernd and Hilla Becher's work on the typologies of industrial structures. Robert Adams's decades of work photographing the American West, although like Atget, unacknowledged as a grand project, will also, I think, eventually be seen as one.

So Cooper is in some pretty starry company. Inspired initially by the historian William Manchester's 1992 book, *A World Lit Only By Fire*,[15] Cooper resolved to photograph the edges of the Atlantic Ocean—the northern, southern, eastern, and western perimeters of the ocean that divides the Old World (Europe and Africa) with the New World (North and South America). In his book, Manchester postulates that the most important achievement of the Renaissance was Portuguese sailor Ferdinand Magellan's circumnavigation of the world, which took place from 1519 to 1522. Magellan's epic voyage, argues Manchester, not only proved that the world was round, but in so doing, it challenged the Roman Catholic Church's Eurocentric view of civilization and also helped to confirm the tendency toward secularism and humanism in the Renaissance, marking the beginning of the Enlightenment.

The idea for the project also came after Cooper had begun to photograph the sea seriously, in what was a fundamental change of direction.[16] The kind of landscape photography practiced by Cooper is almost always concerned with time and change, and deriving from that concern, with elemental forces.

In photographing the land, the forces implied are measured by geological time, in eons. Such immense, long-term forces are also at work with the sea and with water, but visually, the power of water is much more apparent. This, I feel, is one reason why people respond more readily to photographs of water, although there may also be some universal subconscious memory within us, that draws us back instinctively to the element from which we came. I know of one very successful landscape photographer whose prints sell for very high prices. He makes images of the sea and of the desert that to my mind are equally compelling, though not, it seems, to others. Indeed, I personally prefer the desert pictures, yet the sea images outsell them easily. As John Masefield wrote, the siren call of the sea "is a wild call and a clear call, that may not be denied."[17]

It was not, however, a commercial decision that drew Thomas Cooper to the sea, but that siren call, and the rich mythological and historical associations he could give his pictures by heeding it. The work leading to The Atlantic Basin Project was made after Cooper began to teach at the Glasgow School of Art, and became enamored of the kind of northern landscape celebrated in Celtic and Norse mythology. It was a landscape of dense pine forests and wild seas that reminded him, he says,[18] of the redwood groves and surging Pacific Ocean back home in northern California. He began to photograph in Scotland, Ireland, Iceland, and Scandinavia, gradually turning his attention from rocks and trees to water, and then the ocean.

An important work in three parts, entitled *A PREMONITIONAL WORK: The Giant's Causeway: Message for M.S.* (1986–88) prefigures both the iconography and associative symbolism of The Atlantic Basin Project, so a description of it seems relevant. The first part, *EMERGING*, shows the strange, twisted basalt formations of the isle of Staffa, in the Inner Hebrides. On a rock promontory, a flight of steps has been cut, either leading into or out of the water. The second image, *SUBMERGING*, depicts the tops of the basalt "columns" that are such a feature of Staffa, gradually submerged by the sea. The third image, *EMERGING*, takes us across to County Antrim, in Northern Ireland, and the similar basalt columns that constitute the province's great natural tourist attraction, the Giant's Causeway. Three images that are about geological connections and also historical connections, since early Christianity spread from the north of Ireland to the islands and west coast of Scotland, while the Vikings sowed alarm down the coasts of Scotland and Ireland.

The work appeared in *Dreaming the Gokstadt*,[19] Cooper's book of images connecting the northern lands of Scandinavia, Iceland, Scotland, and Ireland, its title inspired by the discovery in Norway, near the village of Gokstadt, of a thousand-year-old Viking ship that had been buried in the ground. This was a project therefore about the connections between things—the cultural connections that have endured for centuries, the natural connections that have endured for eons. Here are the beginnings of The Atlantic Basin Project. It was the Vikings, of course, who first made voyages across the Atlantic, initially founding a colony on Greenland, and then reaching the North American mainland itself.

Much contemporary landscape photography is concerned with photographing the land as a kind of cultural map, sites of associations past and present, natural and cultural, mythological and historical. The sea is no different, although it might not be so apparent visually. Every ocean current and sea lane is part of a complex pattern, marking not only voyages by humankind, areas for fishing, but also the spread of faunal and floral species, carried by winds, tides, and currents. And on a geological scale, the oceans fill the voids left after continental land masses split away from each other.

But how does one photograph this? You cannot even stand easily on a boat in the

middle of the sea and photograph it, at least not with a large view camera on a tripod. The resultant pictures would probably tell us little anyway. So, as in his *EMERGING SUB-MERGING EMERGING* triptych, Cooper photographs the edges, the points where the land meets the sea, and where, so to speak, we may make the conceptual leap across the void.

He chooses his places to photograph carefully, using *The Times Comprehensive Atlas of the World* to determine the extremities in which he is interested (the furthest point north, or west, and so on), supplementing these with places with specific historical or geographical associations (where some voyager landed or set sail, a particular bay or estuary). This factual information, and mathematical map references, are embedded in the picture titles—akin to, although not as dense as the textual references Roni Horn incorporated in her set of pictures of the River Thames.[20]

Showing something of the land as well as the sea is important. It not only gives a grounding to the imagery but acts as the springboard for our imaginative leaps. Cooper continues with the free-floating compositions he has always favored, inviting us, as it were, to throw ourselves into the pictures and give ourselves up to them. Ben Tufnell has written an essay about Thomas Joshua Cooper entitled "Gazing at the Void,"[21] and that is entirely pertinent, but "Entering the Void" might have been an equally valid choice of title.

I have talked elsewhere of a relationship between Cooper's work and the philosophical legacy of Arthur Schopenhauer, and I think it is apparent in this sense of gazing at, or entering the void. It is an unsettling, highly ambiguous feeling, with both consoling and despairing aspects. Are we casting ourselves into the waters, or will we swoop and fly over them, like a seagull? Cooper's pictures, although among the most undeniably beautiful in contemporary art, have their distinctly disturbing aspects. That, it could be argued, is true beauty.

There is often a nagging sense of existential dread lurking in the dark recesses of the swirling waters. Our compulsion to enter the picture space can be regarded as a reflection of the Schopenhauerian denial of the will, which he saw as the supreme achievement of human consciousness. This is especially at work in Cooper's stunning two-part image of Gullfoss (Golden) Falls in Iceland, *A PREMONITIONAL WORK message to Timothy O'Sullivan* (1987), where, in the second picture, we are drawn almost compulsively into the churning depths.

But the corollary of the desire for self-annihilation is transcendence, and it is the transcendental aspect of Cooper's vision that generally informs his work; we are persuaded to be the gull rather than the drowned man. In Schopenhauerian terms, this equates to something that Minor White, with his penchant for Zen Buddhism, would have understood perfectly, and which deep down, underlies our need to get out into nature—a deeply subconscious desire to return to an all-embracing oneness with the universe. The two

impulses—two sides of the same coin in effect—positive and negative, light and dark, coexist in Cooper's imagery, frequently together in the same picture, and their perception is often dependent upon what the viewer brings to it.

In this particular aspect, I feel that the artist closest to Thomas Joshua Cooper in sensibility is another pillar of the northern transcendental mode, Mark Rothko.[22] Formally, Cooper's pictures often display a flat, yet shimmering field, and exhibit a seductive, yet dangerous allure. Like a Rothko painting, a Cooper photograph attracts (for most of the time), but also repels (for some of the time), presenting a point of entry for the most part, but sometimes forming a barrier.

Their attraction, however, tends to hold sway. I believe—like those of Long and Fulton—that Cooper's photographs are essentially "path" pictures, that genre of landscape image invented by the Dutch, whereby a path or a road is used as a device to draw the viewer into the picture space. In Cooper's case, the path is less a formal one than a psychological one. In Cooper's views of the ocean, there is usually no path in the sense of spatial recession, because the space in his imagery tends to be flattened somewhat. When you photograph the sea from a height, you don't get perspective, but a sense of a flat, vertical plane. Nevertheless, as I have stressed throughout this essay, Cooper pulls us in like few other artists (the link with Rothko), and the whole psychological feel of his imagery connotes a path, but one which—although free and unrestrained in that we are not restricted by the physical confines of the track—is hedged about with uncertainties and ambiguities.

The Atlantic Basin Project, as frequently happens with grand projects, has appeared in distinct tranches over the years, in the form of various books and exhibitions. As I write this, the latest installment has just appeared in the shape of the book and exhibition, *True*, shown at Thomas Cooper's London gallery, Haunch of Venison.[23] It was one of his more spectacular shows, fitting perfectly into the elegant rooms of the gallery's Burlington House location. *True* explored the extremities of The Atlantic Basin Project, the extremities both in a conceptual sense, and in the sense that the Arctic and Antarctic, the areas covered by the work in the exhibition, represent the most remote areas on Earth. At Prime Head, the northernmost point of continental Antarctica, Cooper made photographs at a place where, as Ben Tufnell notes, "fewer people have stood than have stood on the moon."[24]

At this point, I could possibly detail the expense involved and the sheer logistics of getting a photographer, view camera, and tripod to a place like this, a place so dangerous that the ship that took Cooper there ventured beyond the limits of its Lloyd's insurance cover. The heroics involved are similar to those of the early pioneers, like Timothy O'Sullivan, carrying their heavy glass plates by mule train, coating the plates, exposing them while wet, then developing them on the spot in a darkened tent. And in this sense, Cooper is truly an expeditionary artist, a true descendent of O'Sullivan. His photographic artworks are records of exploration and discovery, as well as equivalents for psychological states.

But whatever the heroics involved in getting there—and that is the basic challenge for any photographer, to "get there"—they do not guarantee the pictures will be any good, or, given that Cooper makes only one exposure per motif, there will be any usable result at all. It's not the place to go to and discover you've forgotten your exposure meter, or your focusing loupe, as even Ansel Adams did on occasion. The pictures from Prime Head, however, are superb.

Here, where Cooper is literally "gazing at the void," the degree of existential terror is at its most apparent. The poles, of course, are where global warming is having a fundamental effect, with the icecaps covering the polar seas diminishing year by year—with potentially disastrous consequences. So it is here that Cooper's imagery deals most immediately, not only with the past and present, but with the future. In the future, a photographer will not be able to make such Arctic images—at least in summer—because the places where Cooper stood will be open water instead of icecap.

There is a great sense of history in all The Atlantic Basin Project, but in the near-black and near-white images, it is at its most vivid, with connotations ranging from a nuclear whiteout to a time when, thanks to humankind's own shortsightedness, the Earth may become a dark, silent void, at least in terms of viable life-forms. In the black pictures, there is a clear premonition of the ultimate question. Would the last human leaving the planet please switch off the lights?

So we are a long way from the hippy coziness of the more flaccid elements of the White School in the 1960s and '70s. But then Thomas Joshua Cooper always was. And he is also a long way from the British understatement—not that there is anything wrong with that—of Long and Fulton. The dark side of the psyche was present in his work from the beginning, and has, if anything, increased over the duration of The Atlantic Basin Project.

But alongside the bleakness, there is also rapture. Not many contemporary artists deal with rapture; it is not, I feel, a quality prized much by the postmodernists.

This contrasting of light and dark is typically Schopenhauerian, and from Schopenhauer, of course, it is but a short step to Richard Wagner. There is something distinctly Wagnerian about the art of Thomas Cooper, in terms of its epic scale, in its willingness to work slowly in an era of unmitigated haste—and in its rapture. A great part of the second act of that most Schopenhauerian of Wagner's music dramas, *Tristan und Isolde*, involves an intoxicating philosophical discussion about the forces of light and dark, ruminating upon life and death, day and night, and much of Cooper's art reflects this. Cooper's old view camera and lens might not produce prints that are quite as sharp as a more modern combination, but it makes up for that in tonal quality, and that for him is what is of more importance. As Peter Bunnell has written about the formal qualities of the imagery:

"Light, and the sensation of darkness, is central to the meaning or portent of these pictures. One senses a gravity in them, as he seeks both the point of maximum obscurity and

the point of greatest luminosity. For Cooper it is the darkness and the light that creates the whole: that is, the world we inhabit. For him, times of day are of enormous importance. They echo in microcosm the passage of historical time. Night is part of the whole, emphatically so, and moonlight is a light he loves deeply."[25]

The sea, and water, also played a large part in Wagnerian mythology. His *Flying Dutchman* was doomed, perhaps like Cooper, to wander the seas in search of redemption, and the first act of *Tristan und Isolde* takes place on the Atlantic, or more precisely the Irish Sea. It is, among other things, about the power of love to redeem humankind's inherent desire for transcendent self-annihilation.

I shall end with some thoughts about Cooper and Wagner that I have long held, and feel are even more pertinent to his sea pictures, although since I first made this comparison,[26] Cooper's art has broadened and deepened in a most satisfying way. At the end of *Tristan und Isolde*, in the opera's last, wonderful cadences, accompanied by, as Thomas Mann put it, "that ascent of the violins that passeth all understanding," the lovers Tristan and Isolde finally reach their Schopenhauerian nirvana. They attain a blissful state of nonexistence, transcending earthly desire by becoming subsumed into the elemental swell of the natural fabric—melting, drowning, sinking into *höchste Lust*, the highest ecstasy. Like another of Cooper's great heroes, the American transcendental poet Ralph Waldo Emerson, they become nothing, yet see all.

Cooper's pictures, I think, really do evoke those kinds of thoughts, and those kinds of ideas, and many others, swim about in Cooper's turbulent, surging seas. In an essay for the catalog of an exhibition of seascape photography held in Tucson in 1998—an exhibition including Cooper—the writer James Hamilton-Paterson wrote that the seascape "offers aesthetic and sensual ravishment with underpinnings of annihilation: very much an art form for our time."[27] Those remarks may be applied particularly to the seascapes of Thomas Joshua Cooper. Almost single-handedly, he has proved that there is life, and relevance, in the transcendental photographic tradition of Alfred Stieglitz and Minor White—and indeed, has taken it to a new level.

Humankind perhaps—probably—is heading en masse to collective extinction and self-annihilation. In the face of such a fate, Thomas Joshua Cooper's art may offer us small solace, as does any art, but it is an undoubtedly beautiful, poetic, thoughtful, and provocative solace.

Notes

1. *Aperture* was cofounded by White, Ansel Adams, Barbara Morgan, Dorothea Lange, and Nancy and Beaumont Newhall, as well as Melton Ferris, Ernest Louie, and Dody Warren.

2. Dr. Otto Steinert, ed., *Subjektive Fotografie: Ein Bildband moderner europäischer Fotografie* (Subjective Photography: A Collection of Modern European Photography) (Bonn, Germany: Brüder Auer, 1952).

3. Minor White, ed., *Be-ing Without Clothes* (Millerton, New York), *Aperture*, Vol. 15, No. 3, 1970, and *An*

Octave of Prayer (Millerton, New York), *Aperture*, Vol. 17, No. 1, 1972.

4. Minor White, ed., *Light⁷* (Millerton, New York), *Aperture*, Vol. 14, No. 1, 1968, p. 12.

5. Ibid., p. 14.

6. White visited England in November 1975. He died on June 24, 1976, in Boston, at the age of sixty-eight.

7. Trent Polytechnic shared a joint photography MA course with Derby College of Art, a sister town some fourteen miles from Nottingham. John Blakemore and Richard Sadler were the leading teachers at Derby; Cooper, Paul Hill, and Raymond Moore at Nottingham.

8. Cooper had actually been making images since 1969, but prior to his arrival in Britain, his work had been little seen there, if at all.

9. Ben Tufnell, "Gazing at the Void: Some Notes on Thomas Joshua Cooper's Polar Pictures," in Thomas Joshua Cooper, *True* (London: Haunch of Venison, 2009).

10. Richard Long, "Interview with Martina Giezen (1985–1986)," in Ben Tufnell, ed., *Richard Long: Selected Statements and Interviews* (London: Haunch of Venison, 2007), p. 90.

11. Richard Long, statement entitled *Bristol 2000*, at www.richardlong.org.

12. Ibid.

13. Gerry Badger, "New Topographics: Hamish Fulton at the ICA," in *British Journal of Photography* (London), Vol. 123, No. 6,041, May 7, 1976, p. 385.

14. Ibid.

15. William Manchester, *A World Lit Only By Fire: The Medieval Mind and the Renaissance* (Boston and London: Little Brown and Company, 1992).

16. Cooper recalls reading Manchester as far back as 1989, citing his exhibit *The Swelling of the Sea*, shown at Kelvingrove Art Gallery and Museum, Glasgow, in 1990, as the first outcome of his decision to make The Atlantic Basin Project. Clearly the project was in embryo and taking shape in his mind some years before Manchester's book confirmed it. Telephone conversation with Cooper and the author, July 13, 2009.

17. John Masefield, "Sea Fever," from *Salt-Water Ballads*, 1913.

18. Telephone conversation with Thomas Joshua Cooper and the author, May 25, 2009.

19. Thomas Joshua Cooper, *Dreaming the Gokstadt: Northern Lands and Islands* (Edinburgh: Graeme Murray, 1988).

20. See Roni Horn, *Still Water* (Santa Fe, New Mexico: SITE Santa Fe in collaboration with the Lannan Foundation, 2000).

21. Tufnell, "Gazing at the Void," in Thomas Joshua Cooper, *True*.

22. See Robert Rosenblum, *Modern Painting and the Northern Romantic Tradition: Friedrich to Rothko* (New York: Harper & Row, 1975), for a discussion of Rothko and Northern Transcendentalism. Cooper, I believe, falls perfectly within this tradition.

23. See Thomas Joshua Cooper, *True*. The exhibition was on view, May 1 to May 30, 2009.

24. Tufnell, "Gazing at the Void," p. 27.

25. Peter C. Bunnell, "Thomas Joshua Cooper: The Temperaments," in Peter C. Bunnell, *Inside the Photograph: Writings on Twentieth-Century Photography* (New York: Aperture, 2009), pp. 250–51.

26. Gerry Badger, in Gerry Badger and Peter Turner, *Photo Texts* (London: Travelling Light, 1988), p. 141.

27. James Hamilton-Paterson, "The Cultural Impact of Oceans," in Trudy Wilner Stack, ed., *Sea Change: The Seascape in Contemporary Photography* (Tucson: Center for Creative Photography, University of Arizona, 1998), p. 12.

Invisible City: The L.A. Street Photographs of Anthony Hernandez

"A year later he was standing on the corner of Alvarado and Seventh Streets in the Mac-Arthur Park district of downtown Los Angeles, along with all the rest of yearning, hard-working Central America. No one like him was rich or drove a new car—except for the coke dealers—and the police were as mean as back home. More importantly, no one like him was on television; they were all invisible."—Mike Davis[1]

"I always believed that God would destroy L.A. for its sins. Finally, I realized that He had already destroyed it, and then left it around as a warning."—Lewis Baltz[2]

Los Angeles is at once one of the most photographed cities in the world and one of the least photographed of the best-known cities. It is the mise-en-scène for innumerable movies and television productions, and a familiar sight to a worldwide audience, even if they do not fully take it in as they follow a car chase through the streets of San Fernando Valley, empathize with a love scene in a Brentwood mansion, or ogle the babes of both sexes on a Malibu beach. These, however, are moving pictures. In terms of the other kind, the still photograph, Los Angeles seems relatively unexplored. We all know that Ed Ruscha photographed *Every Building on the Sunset Strip*,[3] but most people living outside metropolitan Los Angeles would be hard put to name more than a handful of photographers who have documented the city extensively. If pushed, one could venture Max Yavno, Robbert Flick, Garry Winogrand, Robert Adams, Lewis Baltz, Joe Deal, Karin Apollonia Müller—and Anthony Hernandez.

It is not as if other Angelinos have not made photographs in the city. But since the Second World War, and especially since the 1970s and '80s, the Los Angeles photographic tradition has been somewhat different from the kind of photography espoused by photographers such as Anthony Hernandez. The most prominent photographic artist in the city was Robert Heinecken, who taught at UCLA from 1960 until 1991, and the local photographers he inspired gravitated toward mixed-media and photography in the "directorial mode" rather than the documentary tradition. If there was a "Los Angeles School," it consisted of such photographers as Darryl Curran, Susan Rankaitis, Eileen Cowin, Jo Ann Callis, Barbara Kasten, Patrick Nagatani, and Jack Butler, and could be viewed as being in direct opposition to the straight, documentary-oriented New York School.

Of all contemporary photographers in Los Angeles, Anthony Hernandez probably has had the longest engagement with the city at a consistently high level. But Hernandez is essentially a street photographer and part of a different, no less important trend in American photography. Since the end of World War II, the street has been one of the primary places owned by American photography. From the stream of consciousness photographers

Anthony Hernandez, *Baseline rd. near I-15 — Fontana*, 1979

of the '50s such as Robert Frank and William Klein, to the New Topographical "school" of the '70s, many of the most important American photographers have made their best work on the street or on the road.

To define Anthony Hernandez as a street photographer is important, particularly as he is a native Angelino, for to do so immediately lays down certain assumptions for the work. It also raises questions. A street photographer in Los Angeles? It seems almost a contradiction in terms. The pickings would seem to be somewhat slim, for who walks there? Where do people congregate? It is a city whose citizens are not only cocooned in air-conditioned metal capsules clogging the freeways and poisoning the air, but where the tendency to live in guarded, gated, and walled communities has become an increasing feature—and a way of life exported to the rest of the Western world.

Let us consider Hernandez's work dating from the early 1970s, which he shot using the street photographer's traditional method, a 35 mm camera, stalking the main hunting grounds in Los Angeles: the sidewalk, the beach, the mall, and public open spaces.

The first observation to be made about these early pictures is that they are difficult. I use this term not as a value judgment, but as a statement of fact. Difficult photographs are not easy of access. They are not made to garner the plaudits of the crowd. But persist and their rewards are that much greater. Henry James is a difficult writer. Paul Cézanne is a difficult painter.

The early street portraits of Anthony Hernandez make no attempt to visually seduce or ingratiate themselves with the viewer. They are pictures of great honesty and integrity, made for no other reason than the photographer wanted—or needed—to make them. Many consist of single figures or sometimes pairs of people, although secondary figures may be seen in the background. Primarily, however, they are portraits in that they usually concentrate upon an individual.

In particular, they are environmental portraits, so the space each figure inhabits is of importance. The first point of difficulty for the viewer, however, is deciphering not only the psychological focus, but how the subjects interact with their backgrounds. They are not immediately portraits with a sociological intent. They do not seem to be of anything much except people going about their business. Yet Hernandez does not seem especially interested in what that business might be. As Jane Livingston, wrestling with this problem, wrote: "His people are perhaps at odds with their environment in the sense of stiffness and alienation, yet they are also actually defined by that environment."[4]

Livingston's use of the word *stiffness* is interesting, and tells us something crucial. Street photographers, by their very nature, tend to be engaged in freezing a brief moment out of the constantly moving panorama of life. The decisive moment approach is of course universally known, where the photographer seeks to freeze everything into a perfect balance of form and content, not necessarily capturing a moment of peak action, but one where all compositional elements attain a visual harmony, and any alteration to the equilibrium would ruin the image. The corollary of this might be termed the "indecisive moment," where the photographer deliberately seeks a slightly off-kilter effect, disrupting the poise of the perfect moment in favor of something more anarchic and raw, more spontaneous and edgy. Compare Henri Cartier-Bresson with Robert Frank and the difference becomes apparent.

But in his early 35 mm street photographs, Anthony Hernandez seems to have had the happy knack of making neither decisive nor indecisive moment pictures. He made photographs that seemed in more or less perfect equilibrium yet also at odds with it at the same time. The sense of time and space in his street pictures is so subtle and individual that we could almost talk of the "Hernandez moment," in which the picture frame is animated, energized by formal arrangements yet also in a peculiar state of stasis. It is not so much a formal quality as a psychological one. It is as if in these photographs, the subject is formally energized but psychologically enervated.

Livingston used another word that seems appropriate to describe the general tenor of

Hernandez's street photographs, *alienation*. Indeed, it might be argued that this is the primary subject of these painfully honest pictures. Certainly, the feeling of being alone in the city, of being different and isolated within the crowd, resonates strongly.

In Hernandez, this alienating effect derives from a sense of timing and space that is singular, and produces, as Livingston rightly states, "a genuinely original photographic approach,"[5] making these pictures some of the most distinctive to emerge from the explosion of activity in American photography of the 1970s. Hernandez does not photograph action, or gesture, but creates this strange feeling of desolation within the frame, a feeling that is independent of the social and political circumstances that might cause anyone to be alienated, or disenfranchised from the American dream. His work seems intensely personal and highly subjective. Nevertheless, as Lewis Baltz has written: "Usually, he witnessed the defeated (they are, after all, the majority) waiting, walking, waiting more, taking very, very humble recreations. One time he gathered evidence about the winners, the lumpen rich, enjoying the spoils of their victory on Rodeo Drive."[6]

And in that sense, Hernandez can be termed a political photographer, or at least one firmly on the side of the disadvantaged. In these early street pictures, the sense of injustice that permeates them seems to an extent privately directed, reflecting his personal concerns as much, if not more than those of his subjects. But when he acquired a five-by-seven-inch view camera in the late 1970s, the change of format changed the focus of his work.

The large-format camera entails a method of operation quite distinct from that of a 35 mm camera. While the view camera works at the expense of spontaneity and maneuverability, it expands the sense of space and detail, and therefore the potential amount of social information that might be included in a picture, even if unintended by the photographer. Although Anthony Hernandez used this camera in a formal way, it gave him both an apparent objectivity and a greatly expanded visual palette. Both of which he put to very good use, making pictures as political as any he has made in a career that has seesawed interestingly between the political and the formal without ever favoring one over the other.

Between 1979 and 1983, Anthony Hernandez made four bodies of work with the five-by-seven view camera. Each one is distinct, but they are interrelated. The four image groups are people waiting at bus stops, people lunching or sitting in public spaces, people fishing, and automobile repair shops. If the automobile repair shops seem an anomaly, their significance will become clearer in due course.

It is worth detailing Hernandez's working method with a view camera, for the change in his imagery at this point in time is largely, although not totally, dictated by the change in technical means. The view camera takes the photographer back to the methods of the nineteenth-century photographer, although it is used by some of the most cutting-edge of contemporary photographic artists, Andreas Gursky, Joel Sternfeld, Thomas Struth, and Jeff Wall, among them. One uses the view camera only on a tripod. It is all very slow, very

deliberate, and as far removed from 35 mm photography as possible. And yet Anthony Hernandez utilized it to make candid photographs of people in public spaces, pictures that choreograph his subjects and the city environment into compositions as complex as those of that master of the fractured, Cubist urban landscape, Lee Friedlander. Even taken at a simple logistical level, this is a major achievement by any photographer.

The main difference between the 35 mm and the large-camera work is that Hernandez took a physical step backward, to encompass a much wider field of view. In simple terms, he became a landscape rather than a portrait photographer. The people in his pictures have receded, not into the distance, but from the immediate foreground to, shall we say, the boundary between the foreground and the middle ground.

They become people as landscape. But he was specifically photographing a social landscape, documenting not only the physical landscape of the city in a partial but particular sense, but denoting its social structure—also in a partial and particular sense.

There are two primary elements in these photographs. They might be characterized as the visible and the invisible, or the depicted and the inferred. The depicted might be considered the lighter side (the city itself) and the inferred its darker side (the social realities). And in this, his work mirrors L.A., a city that promotes vigorously an image of sun and Hollywood glamour, yet is arguably the most socially divided city in America, a sunny city with a dark heart.

The external surface of Anthony Hernandez's imagery is the sunny exterior, the backdrop of the city itself, with every detail sumptuously recorded by the five-by-seven camera. By using a nineteenth-century method, Hernandez especially evokes the primary function of nineteenth-century photography, which is to "take us there." And he takes us there vividly, with a great deal of formal cunning, to the streets and open spaces of Los Angeles, as Carleton Watkins and Eadweard Muybridge once took us to Yosemite.

The large camera demands a different formal approach. It is generally a one- or two-shot operation at any one time, before the photographer picks up the heavy ensemble of camera, tripod, and film bag and moves to another picture location, which may be five feet, five yards, or five miles away. With the small camera, a photographer can shoot and move at the same time, and expose ten, fifteen, twenty rolls of film in a day's expedition (let alone with a digital camera). If Anthony Hernandez exposed ten to twenty sheets of film in a day, that was an extremely hard day's work.

So large-camera work is of necessity a more self-consciously formal business, and a more studied picture normally results. Large-format images tend to be static and monumental, and indeed, one of the primary problems is animating the picture frame, for many large-format photographs are static and dull. The large-format photographer's controls for making the picture both lively and interesting are light, line, texture, volume, and perspective. In a word, *composition*. And here Anthony Hernandez has been conspicuously suc-

cessful. In the three series featuring people, he was faced with static figures, and he ordered the whole frame specifically around them, using them as a fulcrum, so that they are among the most dynamic photographs of immobile figures in the landscape ever made.

The bus stop pictures, for instance, are essentially variations on a theme of vanishing perspective. Hernandez generally placed his camera near the edge of the sidewalk, and looked more or less along the curb line, so that the edge of the curb, the boundary line at the rear of the sidewalk, and the far side of the street all recede sharply into the distance, and we as spectators look toward where the bus will head, or from where it will come.

By such means, Hernandez set up a series of diagonals, producing a naturally lively frame. Then he interrupted this with vertical elements such as street furniture, buildings, even his waiting subjects. In his images of people eating their lunches, he established a similar matrix of verticals and horizontals, although space in these was more enclosed. Even in the fishing pictures, where Hernandez was dealing with more natural, less geometrically rigorous forms, he took care to emphasize diagonals wherever he could.

These then, are consistently brilliant photographs if considered from a purely formal point of view. But they are a lot more than that. We can delight in their formal precision, but we must also recognize that they reveal facets of Los Angeles life that, to the majority of wealthy Westsiders and middle-class suburbanites who travel the city cocooned in their automobiles, are largely disregarded, even invisible.

Who takes buses in Los Angeles? Clearly, those who do not own automobiles. And who is most likely to take a packed lunch to work? Generally the lower-paid worker. And who fishes for catfish in polluted pools, rather than blue marlin off the coast? Poor Latinos who have emigrated to Los Angeles and miss that particular delicacy. Though these images date from 1979 to 1983, these questions still hold true.

Clearly, we are talking of class issues here, but in Los Angeles—and indeed, in the United States and the Western democracies generally—class issues are also usually racial issues. Not all, but most of the people depicted in this work are black or Latino. That might seem natural, as Latinos constitute the ethnic majority in Los Angeles, with African-Americans a sizeable minority. But there is nothing natural about social inequality. Anthony Hernandez both shows and hints at this social pattern. Those waiting at the bus stops, one can readily surmise, are going to some menial job, perhaps over to the affluent Westside, to Beverly Hills, Bel Air, or Brentwood, where they work as cleaners or maids. As one drives through L.A. (off the freeways), especially early in the morning, one sees tired people at bus stops, forced to travel long distances and work long hours for a minimum wage, if they are not being exploited in sweatshops. It is to Anthony Hernandez's credit that his pictures do not dramatize, and are laudably cool and evenhanded. Yet if one looks carefully, and thinks about these images, his sympathies are made more than manifest.

A closer look at the lunching pictures reveals, for instance, interesting social details

about the architectural spaces in which books are read and sandwiches consumed. The walkways and plazas are hardly welcoming. That is, they are not designed for sitting outside, as say, Italian piazzas. Rather, they are defensive spaces, moats around the corporate castles, and there is little in the way of comfortable seating to encourage their use as genuinely communal spaces. They are used in this way by default rather than by design. People perch on the edges of planting boxes. A woman sits reading on a flight of ugly looking steps, jammed uncomfortably between two concrete walls.

Indeed, the architecture of the open spaces around downtown Los Angeles has been much criticized from this point of view. Downtown is in close proximity to Skid Row, and its open spaces have been designed largely as defensive barriers to keep undesirables—such as the poor—out of the sanctified, hallowed precincts of big business.

There is more sense of community in the fishing pictures, but these depict a very different kind of urban space, manicured or unmanicured, that people can annex much more readily and spontaneously for communal purposes. Hernandez shows kids fishing off a bridge over a river encased in a concrete culvert. Or intent adults fishing a small stream in a scruffy public park, overshadowed by a system of massive electricity pylons. Along with the fishermen come sunbathers and picnickers, and this series indicates that any stretch of water, however uninviting, will attract a rod and line, and any piece of natural or seminatural open space, however scrofulous, will be utilized for recreation.

Finally, what of the automobile repair shops? They reinforce the sociopolitical tenor of Hernandez's photographs. Cars priced at all of $199 or $249 (keeping in mind when these images were taken) indicate the whole industry—at a very basic and personal level— that supports the recycling of old, worn-out vehicles and makes them available to those who cannot afford to buy the latest showroom models and change them every year or so. The boundary between the auto class and the bus class resides in these decrepit yards.

The most frequent criticism of 1960s and '70s American photography, especially that of the so-called social landscape, is that formalist concerns predominated at the expense of the documentary. "I photograph to find out what the world looks like in a photograph," Garry Winogrand famously said,[7] and in talking about the significance of gas stations as a motif stated, "I don't give a rap about gasoline stations."[8]

But such remarks only reinforce the wisdom of D. H. Lawrence's dictum on artist intent, referenced earlier in this volume, to trust the tale, and not the teller. The basic impulse of any art is formal. If not, it should be, for the basic purpose of art is to make form from chaos, to give the artist's raw material shape. Yet too much has been made of the so-called empty formalism of '70s American photography, photography that according to some later critics of a postmodernist persuasion was all form and no content. Although Winogrand, Friedlander, and others may have been out on the streets making pattern, they were also (if they were any good) giving us their take on society.

Anthony Hernandez clearly does care about gasoline stations, and automotive shops, and fishing ponds. At the time he was making these five-by-seven pictures, a new generation of American scene photographers—among them Robert Adams, Lewis Baltz, and John Gossage—were photographing the urban landscape in a nominally nonjudgmental manner, but undercutting their apparent lack of concern with sophisticated inflections drawn from painting and the conceptual art movement. Such pictures may appear to be dry and objective on the surface, but beneath they contained a wealth of cultural references that confirmed their real position as subtle critiques of certain aspects of American society.

The view-camera images of Los Angeles made by Anthony Hernandez follow this tendency precisely. Visually complex, they can be appreciated at a purely formal level, but they are much more than that, for embedded within Hernandez's keen observation of the L.A. landscape are a whole raft of allusions and encoded signs that strip bare the racial and class stratifications of Southern Californian life. They are certainly among the most perceptive photographs of Los Angeles ever made, and can be recognized (if somewhat belatedly) as being among the best American photographs of the late 1970s and early '80s. Above all, Hernandez fulfills the ambitious brief outlined by the distinguished South African photographer, David Goldblatt: "The mission of the photographer is to put a frame around things you have seen all your life and yet haven't seen at all."[9]

This essay originally appeared as the introduction to Anthony Hernandez's book *Waiting, Sitting, Fishing, and Some Automobiles (Los Angeles, photographs of)* (Bethesda, Maryland: Loosestrife Editions, 2007). It has been amended for this volume.

Notes

1. Mike Davis, *City of Quartz: Excavating the Future in Los Angeles* (London: Pimlico, 1998), p. 12.

2. Lewis Baltz, "Forever Homeless: A Dialogue," in Anthony Hernandez, *Landscapes for the Homeless* (Hannover, Germany: DG BANK-Förderpreis Fotografie and Sprengel Museum, 1995), p. 15.

3. Edward Ruscha, *The Sunset Strip: Every Building on the Sunset Strip* (Los Angeles: Edward Ruscha, 1966).

4. Jane Livingston, in Anthony Hernandez, *The Nation's Capital in Photographs* (Washington, D.C.: Corcoran Gallery of Art, 1976), unpaginated.

5. Ibid.

6. Baltz, "Forever Homeless: A Dialogue," p. 14.

7. Garry Winogrand, quoted in Dennis Longwell, ed., "Monkeys Make the Problem More Difficult: A Collective Interview with Garry Winogrand," in *Image* (Rochester, New York), Vol. 15, No. 2, July 1972, p. 4.

8. Ibid., p. 5.

9. David Goldblatt, quoted in Diane Smyth, "After Apartheid," *British Journal of Photography* (London), June 28, 2006, p. 14.

Far from New York City: The Grapevine Work of Susan Lipper

In one sense, photography is easy. It's simply a matter of placing yourself in front of what you want to photograph, raising the camera, and clicking the shutter. If the subject is moving, it's slightly more complicated, you need to wait for the "decisive moment" before clicking. And although that might require a certain anticipatory skill, you either get the shot or you don't.

The real trick—and here photography becomes immensely difficult and complex—is deciding what to photograph. And that, in essence, is a two-step process, or more accurately, a two-level process. The first step, or level, deciding upon the raw material—trees, nudes, war, raindrops on windows—represents a photographer finding her or his subject matter. It's an important step, but not yet "job done." The second, and much more difficult step, is to say something—something unobvious and personal—about the raw material. The two are very different entities, and a photographer's subject may bear only the most oblique relationship to her subject matter.

The problem is the medium's presumed literalness, so the photographer is not only trying to go beyond subject matter and find subject, she has to take her audience with her. Most people, and this can include people quite sophisticated and well versed in other arts, assume that if the photograph is of a white horse, the photographer is talking about white horses rather than loneliness or loss, or any number of apparently unlikely subjects, as well as the more obvious metaphors like strength or grace. Of course, the ultimate task for any photographer is to talk about the most unlikely things and the white horse, in short, to tell the subject's tale as well as her own. And that, I feel, is what Susan Lipper has done with conspicuous success.

Needless to say, many photographers never progress beyond stage one, except in the most trite and obvious ways. The projects given to students at college, where they justify what they are about to photograph in writing, explaining at great and frequently unreadable length their theoretical position regarding the work, is one way of trying to get the student to progress from mere subject matter to subject. This strategy has educational merit, but I am somewhat dubious about its value in art. I am dubious about art education in general. Artists worthy of the name, it seems to me, educate themselves, primarily by using their eyes, not by writing essays.

Walker Evans once said that the best photographic education comes from "informal contact with a master,"[1] and I feel that he was right. I learnt more from hanging out with Garry Winogrand in Los Angeles for two or three memorable days in 1980, than from a year of college lectures. I would add that quality time spent with any great photobook might also be classed as "informal contact with a master."

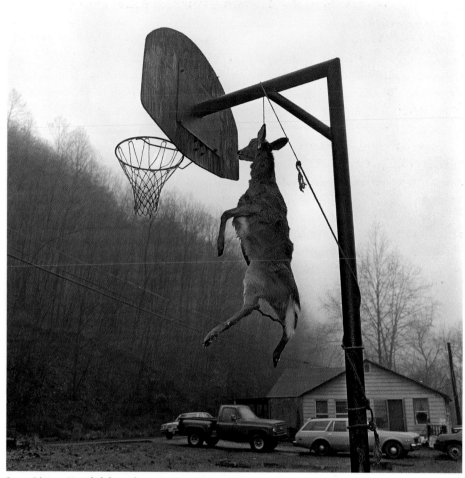

Susan Lipper, *Untitled*, from the series Grapevine, 1988–92

Susan Lipper had a good teacher—Tod Papageorge, Walker Evans Professor and Director of Graduate Studies in Photography at Yale University. Papageorge had a lot more informal contact with Garry Winogrand than I ever did, and the fruits of the wisdom he learnt were certainly imparted to Lipper, whose work fascinates me because it illustrates precisely the complex interrelationship between subject matter and subject. The subject of Lipper's art, indeed, could almost be considered a quest for subject.

Lipper is probably best known for her book *Grapevine* (1994),[2] taken in and around the remote rural community of Grapevine Hollow in West Virginia. Her follow-up publication, *trip* (2000),[3] is also highly regarded. There are direct links between the two books though they are different in form and content, but it is essentially *Grapevine* I wish to discuss because it is so central to her oeuvre, and after more than twenty years, she is still visiting the area and making work there.

Two interesting observations might be made about the work in these publications, particularly *Grapevine*. Firstly, they seem—and *seem* is the appropriate word—to fly in the face of what was going on in American photography at that particular time, the mid-to-late '90s, especially the kind seen in Chelsea galleries, and particularly the photography that was emerging from Yale. Lipper was making smallish, square black-and-white prints, while other members of the "Yale School" were making large color prints. She was apparently photographing in the documentary mode, while others were busy fabricating events to be photographed, and exploring the manipulative potentiality of photography and the computer.

Secondly, there was a tendency in '90s documentary-mode photography to photograph what one knew, for photographers to focus upon themselves and things close to them, and to explore such issues as memory and identity. Susan Lipper chose to photograph an environment, a tiny community in the Appalachians, as far removed as possible from her own, the Upper East Side of Manhattan. She chose to photograph people as far removed from her own background—Jewish, urban, and privileged—as it was possible to find. Pentecostal, rural, and far from wealthy.

When *Grapevine* appeared, there was a temptation not only to label, but to judge. Hardly since Walker Evans traveled south in the mid-1930s to photograph sharecroppers in Alabama had a photographer from the Yale-Harvard axis ventured forth to photograph ordinary rural Southerners. But Evans, no matter what his personal reasons, was nominally photographing for the government, for the FSA and Roy Stryker's documentary unit—and in addition, for an article on sharecropping he was doing with James Agee for *Fortune* magazine. Even Doris Ulmann, who came from a privileged background and made Appalachian portraits in the 1920s and '30s, was photographing what she knew. She emanated from a family of plantation owners, and her somewhat sentimental portraits resulted from a close but feudal relationship with her subjects, with "her people."

In fact, Lipper's Grapevine work is no more a document of rural West Virginia than the rural America depicted by Evans in the '30s, no more a record of rural everyday life than Sally Mann's images of her Virginia family. Nevertheless, by acting through what we might term documentary surface, Lipper's work, and that of similar artists, from Robert Adams and John Gossage to Alec Soth, begs a question. What has happened to social documentary photography? This is an issue that is debated frequently in these days of postmodernism, where photographic images are perceived not as simple records of what's out there, but complex webs of received ideas and hidden agendas. Photographers have been characterized as brutish aggressors in their never ending search for the telling image, violent mercenaries carrying cameras instead of guns. Even to say that one photographs to expose social ills is no mitigating factor, it would seem. Photographers of the social landscape are forced onto the defensive, caught between a rock and a hard place—political ethics on the one hand and on the other, the notion that straight photography is outmoded and passé, on the grounds that if the medium's fidelity to actuality is suspect, why bother?

Ironically, as still photographers have been forced to become a deal more circumspect, television reportage and "reality" programs intrude into the lives of people as never before. Practices that would cause outrage if perpetrated by a still photographer are openly tolerated, even invited, if carried out by the television camera. It is a question of media power, and, it would seem, of perception. Television subjects fondly imagine that because the medium allows them to "speak," that they have a degree of control, that they have a voice. Still photography is "mute," therefore its subjects by definition are mute.

In the work of Susan Lipper voice is clearly an issue. The tone in which her images (and videos) address us is all-important, for there is much debate—often ill-considered—as to whether an authentic portrait of a specific culture or self-contained community can be made by an outsider. The question is a thorny one. Current academic debate, reacting against past and present sins by those "colonizing the means of representation," would contend that only those born into a culture or community can truly know it, and therefore only the self-portrait is viably authentic.

Yet clearly, like all questions relating to imagistic representation, much depends upon point of view. The insider's view is likely to stress the culture's positive aspects, but is that any more authentic than the possibly critical view of the dispassionate outsider? Equally, does the so-called objective stance of the scientific, sociological reporter automatically predetermine a more truthful result than the perhaps more intuitive, psychologically tuned one of the expressively inclined photographer? Truths are relative and highly contingent, and in the long run, any answer depends upon individuals, upon indefinable mixtures of such qualities as sensibility, talent, perspicacity, insight, and even chance.

Rather than bracket Lipper in the sociodocumentary genre, Val Williams was more perceptive when she included some of Lipper's work in the exhibition she curated at the

Barbican Art Gallery in 1994, *Who's Looking at the Family?*[4] This exhibition identified a persistent trend in late twentieth-century photography, where, as a result both of serious questions regarding the medium's ethics and sociocultural factors, many photographers have chosen to retreat inward, to photograph only those communities they know, and are part of—where any charge of misrepresentation or intrusion is either invalid or unlikely. In recent years, the smallest, closest to hand, and most intimate community of all has become a fruitful area of enquiry for photographers. The family would seem refreshingly free of the ethical difficulties facing photographers delving into the world outside, especially if that world is of a different social class or culture. In representing one's nearest and dearest, after all, one is representing oneself.

But even here, the ethical thorns remain to snare the unwary or uncaring. Sally Mann, whose sensitive, sensuous images of her children acting out fantasy games are among the most remarked upon of her generation, has been called everything from a bad mother to a child abuser. Critics have failed to realize what might seem obvious to the photographically sophisticated: Mann's often pessimistic imagery is not a record of her children's lives, but a fiction, a game even. As the photographer herself put it, "many of these pictures are intimate, some are fictions and some are fantastic, but most are of ordinary things every mother has seen—a wet bed, a bloody nose, candy cigarettes."[5] Their ultimate purpose, however, is neither lighthearted nor playful.

In her book *Immediate Family* (1992), Mann wrote: "When the good pictures come, we hope they tell truths, but truths 'told slant,' just as Emily Dickinson commanded. We are spinning a story of what it is to grow up. It is a complicated story and sometimes we try to take on the grand themes: anger, love, death, sensuality, and beauty. But we tell it all without fear and without shame."[6]

Well said, but clearly it would seem that photographing from the inside rather than the outside is no guarantee against exploitation. Neither it is a guarantee against bad pictures nor fair and honest representation. Insiders have no monopoly on either artistic talent or good intention. The currently fashionable genre of the participative documentary, as it is known, has its dangers. For example, one of those included by Val Williams in *Who's Looking at the Family?* was Richard Billingham. The work shown was his series Ray's a Laugh, which pictures his own family, notably his unemployed, alcoholic father. Billingham has taken pains to stress the collaborative, participatory nature of his inside view, using it rather as a deflective shield against potential criticism, although he is unrepentant about the work's scabrous qualities. Would-be moralists and guardians of photographic ethics, shocked by his unblinking view of lives circumscribed by too little money and too much booze, were given the finger, left to take it or leave it.

Susan Lipper's position is more ambiguous. She is an outsider by virtue of her class, but certainly an insider in terms of her psychological involvement with the people of Grapevine.

In purely photographic terms, she sits comfortably within a tradition that encompasses such distinguished predecessors as Walker Evans and Paul Strand, and contemporaries like Mark Steinmetz, but also embraces some of the unapologetic fervor of Billingham, or in the United States, Nan Goldin and Jim Goldberg. She has spent considerable time, indeed still spends considerable time with her adopted community, and has become as much a part of it as any outsider with a camera possibly could. Lipper first visited Grapevine in 1988, and has returned on extended trips at least two or three times, sometimes five or six times a year since. That, at the time of writing, is just over two decades of her life.

So, what was a cosmopolitan Manhattanite doing in a place like Grapevine Hollow? It is so small that "if you didn't know it was a hollow you would think it was someone's driveway," as one local put it. The few trailers and mobile homes that make up the community are smack in the middle of a part of the United States badly hit by the decline of the coal industry, where alternative industries include the long-established one of distilling moonshine, and the newer agrarian initiative of cultivating marijuana.

Lipper found the community while on a cross-country trip. Something registered with her—certainly not simply an instinct that here were "good" pictures, because if that was the primary motive, her pictures wouldn't be as good as they are—and she stayed, and has continued to return. It's an obsession, and the best photographs come from obsessive photographers.

Her personal commitment to the community not just as subjects, but as people and as friends, would seem to be unquestionable, yet she is quick to echo the words of Richard Avedon: "My photographs are works of fiction. Any truth you see is my truth."[7] She is not saying, however, that her imagery is artificial, dishonest, or inauthentic. She is merely declaring candidly that she is not making a simple social document. She is making portraits not just of her subjects' lives but also her own. "This series of pictures is my journal,"[8] she says of the Grapevine project. Thus her imagery should be regarded as a deal more subjective, more ambiguous certainly, and probably more involving—records of experience, a portrait of her psychic interaction with the place and the individuals portrayed. Adopting a literary analogy, we might say that Lipper's Grapevine series is the equivalent of a Bruce Chatwin essay—redolent with all the poetry and intensity that implies—rather than an anthropologist's field report. We might say that Lipper is a spinner of ominous rural tales in the manner of West Virginian writer Pinckney Benedict, or casting further afield on the North American continent, of small town family psychodramas in the manner of Raymond Carver or Alice Munro.

"I began photographing in Grapevine because it was as far removed from the life I knew in New York City as it was possible to be," Lipper says,[9] which might seem somewhat disingenuous, but is actually revealing. Many artists, after all, cannot reason logically about the drive that moves them, about the instincts that compel them to their subject

matter—even if they rationalize prior to, or more likely, after the event. Such rationalizations, while useful, tell only part of the truth, and artistic creation as any artist knows, often owes much to serendipity. In effect, Lipper's explanation might raise the specter of *nostalgie de la boue*, perhaps amplified by her square, somewhat confrontational prints and a passing resemblance, both in her own social background and artistic concerns, to Diane Arbus. The profound results of her not inconsiderable endeavors, and the evident depth and seriousness of her commitment to the project belie such a cheap shot on the part of such critics, who also accused Arbus of exploiting subjects out of her realm.

We might look at the work itself for further clues. It is blindingly obvious yet clearly pertinent that metropolitan New York, considered as a community of souls, is vastly different from Grapevine Hollow, a string of isolated houses and mobile homes that barely registers as a blip on the map. Grapevine is a tightly knit community, if we define community as an agglomeration of interactive, interdependent human beings living in close proximity. Some might say that community hardly exists in social shifting Manhattan, at least not in the traditional sense of families settling a place and putting down roots over generations. And community, as we shall see, certainly is one of the book's primary themes.

Another leitmotif, closely related to community, is family. Grapevine Hollow is a typical small rural settlement, an isolated cluster of single or multigenerational family units, most of them interrelated. Indeed, given the inevitable nature of human relationships in such an enclave (popular myths about the Appalachians notwithstanding), the whole community may reasonably be described as an extended family—an extended family Lipper was privileged to join. That in itself was no mean feat on the photographer's part, because prurient preconceptions aside, this is a depressed, economically disadvantaged area, where long-term unemployment and its attendant deprivations are endemic, and where folks do not take kindly to strangers—any strangers, far less a lone, middle class, New York woman.

Human relationships, therefore, lie at the core of Susan Lipper's work. She was drawn to Grapevine because of its people, perhaps driven by a desire to know this extended family, to become a part of it. Yet we should not indulge in too much idle psychological speculation. The impulses driving the project were undoubtedly complex and highly personal, a combination of the artistic, the social, and the psychological, perhaps more psychological than social or artistic on Lipper's own admission, but then the compulsion to create art is so often driven by the psyche as much as the intellect. All we can say is that to overstress the personal at the expense of other, more considered and cerebral motives, is to misrepresent the vitality and complexity of Lipper's view.

Any photography that relates solely to the photographer's internal life, without reference to the external world, is likely to lack depth, as is work that is merely bland record, containing little or nothing of the photographer. Lipper does not fall into either trap, her

view is a fully rounded and eminently complex one. Some of the images in *Grapevine* surely emanate from Lipper's intellectual perceptions, some straight from her guts. The majority probably strike an ineffable balance between the two psychic states. Taking photographs on the wing is inevitably a spontaneous, intuitive activity (particularly if sharing a six-pack with the sitters). The more considered, unemotional, intellectually rigorous part of the process occurs later in editing, when images are tested in relation to each other, and potential meaning—the meaning of the book—slowly emerges. And that meaning, hopefully, is drawn from outside itself. It becomes, in a word, *social*—that is, in the sense that it has the capacity to engage the reader, both emotionally and intellectually.

By virtue of the personal and artistic risks she took, and by reason of the book's intelligent and cogent editing, that certainly can be said of Lipper's imagery, fully repudiating any charges of infiltration, colonization, and exploitation. The results confirm her motives, about which we might say the same as Robert Adams said of Paul Strand: "Photographs as exceptional as Strand's originate, I think, in personal need, in an urgency to find out what the artist has to have to be at peace (the mediocrity of much assigned work results from the lack of this compulsion). The necessity builds, sometimes from wholly private, individual factors, but often from the way these relate to the social context, until the artist is forced to take the risk of making something untried."[10]

The themes and motives in an extended photographic work as ambitious as *Grapevine* reveal themselves slowly. Groups of sequential images pick up the threads of argument and weave them together, as in a musical score, relaying them back and forth, amplifying, underlining, counterpointing them, adding variations, until the whole work sounds them all together. The musical analogy seems more apt than a literary one, for a photographic "text" is rarely as concrete as a text constructed with words. It tends to be a mood piece, a little fuzzy around the edges, open to interpretation in a way the precision of words (in theory) should not countenance. If a writer states that something is bad, then it *is* bad, no arguments. Of course, writing has its ambiguities and subtexts, but it is difficult to be as unequivocal in photography. Clear, unambiguous narrative is not one of photography's strengths. As Bertolt Brecht once famously remarked, a photograph of the exterior of the Krupp factory says little or nothing of the detailed nature of the institution within. To do so without the crutch of textual captions, the photographer must employ suggestion, metaphor, and allusion, in the form of carefully sequenced groups of images.

Consider the first image of the first six or seven in *Grapevine*. This opening sets the tone of the book and introduces the themes before development and recapitulation. The first picture, which also is featured on the front cover, can be considered a primary scene setter, the chief establishing shot. It shows a standard frame house, fronted with the rural staples of station wagon and pickup truck, set against the densely timbered hillside that confirms Grapevine's location in one of those narrow, wooded valleys that snake through

the Appalachians. Also in front of the house is a basketball hoop and backboard on a bent metal stand, confirming the nicely all-American nature of the scene. It's a scene setter, but much more than a scene setter, for the emotional temperature of this distinctly ordinary, ubiquitous tableau is raised considerably by another detail, not uncommon, also all-American, but perhaps defining a slightly darker side to the American dream than the peaches and apple pie cheer of a neat house and healthy slam-dunk exercise. Hanging from the hoop's strut is a dead deer, strung up in a casually brutal, ostentatious way that might remind us of a different rural order, perhaps that "pastoral scene of the gallant South," written about by Langston Hughes, and sung about so devastatingly by Billie Holiday.[11] If located elsewhere in the book, such an image might not have quite the same resonance, but picture number one and the front cover? The suggestion, although not absolute, seems clear enough.

The emotional charge generated by this image is lowered over the next two, which could also be said to be scene setting, and feature more cars, a mobile home, a horse, and another American icon, a poster of Elvis. Then the fourth picture introduces us to the first inhabitant of Grapevine, someone certainly attempting the surly swagger of the young Presley without quite pulling it off.

He is a bearded, narrow-eyed young man, dressed in a baseball cap, work boots, grimy T-shirt, and jeans. He stands with folded arms, legs slightly apart, eyes hooded—a posture that is part defensive, part confrontational. To emphasize his guarded body language, in his left hand—pointing away from the photographer, but glinting ominously—is a nickel plated handgun. It's a classic wannabe teenage gang pose, seen on Facebook sites worldwide. In the background, below the wooded slopes, are a number of vehicles, including two ambulances.

We move quickly from this image of bristling aggression and suspicion, where we are clearly outsiders, to one of extreme intimacy. Susan Lipper takes us right into a bedroom, where a young woman, wrapped in a bath towel, is making up in front of a dressing table mirror. She seems in an upbeat mood, and the ominous tone of the first few images is dispelled, although we should note in passing that while we might expect to see a reflection of her face, it is obscured by a "twelve pack" label, stuck to the mirror's surface.

The unsettling note, however, returns in the next picture. On a chair sits what is presumably a young baby, its face disturbingly blurred by a time exposure, so we are unsure whether we are looking at a real human being, a distorted rubber doll, a wrinkled fetus, or maybe a weird Ralph Eugene Meatyard–type scenario.

Now thoroughly rattled, we stay with the child theme for the next image. A half-naked boy struggles playfully in the arms of a woman who is presumably his mother. The mood is light-hearted, although once more it cannot escape us that the boy is waving the typical toy, it would seem, of boisterous young males everywhere—a large plastic dagger.

These opening half dozen or so pictures then, set the agenda for the book and its inter-related themes. There are images of calm normality, but Lipper always disrupts these with one or two of outright menace. Community, family, and gender relationships seem to be at the core of her investigations. They are at the heart of work by many photographers who deal directly with life, but are aired with a particular sharpness here. In a small place like Grapevine, isolation and hardship are potent forces, to which we might also add issues of fundamentalist Christianity and (to an extent) racism. All contribute to the various motifs Lipper mixes into her shifting, subtle, yet highly elliptical narrative.

There is, of course, also violence. Guns appear regularly, often joined in the same image by alcohol or drugs, and this—as seen the world over—is a potentially lethal combination. In dealing with the family, Lipper is also dealing with gender relationships, both within and without the home and hearth. She is dealing with animosity, even hate, as well as love. The males of Grapevine were one of the first aspects of the place to catch her attention. "I was both attracted and repelled by how macho the men were," she says. "Or rather how different their macho was from the men I knew in New York City."[12]

It's a rural macho, perhaps different from the macho of the city, or at least the macho in Lipper's peer group. Life is slower in the country, but the gender divide is more dif-ferentiated, although implicit in her imagery is the fact that boys will always be boys. They will still play their games together, the games that men everywhere play, games based upon competition and aggression, even if just horsing around. Men hunt, whether in the woods of Grapevine or on Wall Street, while the women—wherever traditional "values" pertain—keep house and raise the kids. When the men and women get together, and drink together—that's when things get a little dangerous, and violence as well as sex and court-ship is in the air.

As well as Susan Lipper's search—for another "family," or another self, whatever it might be—a basic theme of *Grapevine*, I would suggest, is claustrophobia, the effect of barriers and fences, both material and psychological, which press in upon us, shaping our lives and circumscribing our ambitions. Enclosures, and the desperate measures taken to break free of them, is surely a primary leitmotif, from the wooded walls of the valley itself, to the four walls of domesticity that enclose women saddled with kids at an early age, to the ring fence of boredom around the men, most of them without regular work, to the tight, enclosed society created by geographical isolation. And yet, as Lipper points out,[13] the isolation and claustrophobia cut both ways. What some might rather melodramatically see as a grave, could also be seen as a womb. In their isolation, and enforced indolence, the inhabitants of Grapevine might feel safe and protected, free from real responsibilities, except within their own world.

Rural life might present its inhabitants with grand horizons in a physical sense, but in depressed areas be tightly circumscribed in a psychological and emotional sense. Lack of

work, even if nine to fivers think that an ideal lifestyle, inevitably leads to terminal boredom. Throw in a third factor—lack of education—and the social implications of Lipper's work, resonating far beyond Grapevine itself, can be readily seen.

So Lipper's pictures cut both ways. She can be objective—in her outsider mode, we can say—and ruthlessly delineate these social facts. But when in her subjective—that is, her insider mode—she is as tender and sympathetic as any photographer who photographed such subject matter. Of course, there is no hard and fast dividing line between each mode, and these apparently contradictory feelings can appear in the same picture, or at least within each small sequence of pictures. Lipper is a complex artist, and appreciation of her work has been hindered by the fact that both her books were published first in England (neither her fault nor the publisher's) where some reviewers were quick to label them as either Southern Gothic or social documentary, or both. And they are far from that.

Let's now return to Lipper's more personal search, by looking briefly at her book *trip*. As the title might suggest, *trip* is a book of road photographs, and represents another aspect of Lipper's search for subject. One could say that it is almost a rite of passage for an American photographer to cross the country, possibly in search of America, possibly in search of the self. But Susan Lipper had apparently found her America and her self in *Grapevine*, so what was she looking for in *trip*?

Well, different aspects, I guess, of the same thing, is the immediate answer: a different body of work, a different approach. The *trip* photographs, at least to an American if not to me, were unmistakably taken in the South. Although I don't think they are directly about the South. I think pictures similar in feel could have been taken in other parts of America, except that Lipper drives south from New York City to Grapevine, so driving south comes naturally to her.

The *trip* images are not Grapevine. It's important they aren't Grapevine, and yet they are related to Grapevine, though not directly. She herself sees the Grapevine work, taken over years, as an insider's view—inside looking out, while the *trip* imagery, taken on brief stopovers, is the outsider's view—outside looking in.

Typically, the *trip* pictures are fragments snatched along the journey, enigmatic glimpses of urban landscapes and interiors. The book has been described as nonnarrative, yet as Matthew Drutt has written, "though neither travelogue nor visual diary, this series of photographs has a journal-like structure."[14] Certainly, the narrative is highly elliptical, but there are definite relationships between the pictures—it wouldn't be as good a book if there weren't.

Two things crop up frequently, firstly signs and signage, and secondly, photographs themselves. This leads me to speculate—possibly a little wildly—that maybe Lipper is searching for her photographic roots here, in the shape of Walker Evans, a big influence upon photography at Yale. A further reason for this reading is the fact that *trip* is a

particular kind of text and photographs collaboration. Susan Lipper worked with writer Frederick Barthelme, who provided texts that are not captions, but which work with the images, rather in the manner of random, subconscious association. Another book that had an abstruse, although rather different relationship between words and photographs was Evans's and James Agee's *Let Us Now Praise Famous Men*.

Whatever the substance or not in that speculation, *trip* is one of the great road photobooks, certainly one of the best in recent years, and a persuasive counterpoint to *Grapevine*.

Lipper's recent work in Grapevine—that which I have seen at least—is very different from that published in the book, consisting in the main of a group of landscapes made in and around the woods, and a number of short video films that generally feature residents. The work, however, retains the quality that nearly everyone mentions in connection with her, that is, ominous. But if the landscapes are ominous, and if they focus often upon tiny pieces of landscapes in a way that could also be described as forensic, paradoxically, they also have a strange expansiveness. And these dual, rather conflicting qualities can also be applied to the videos, which can be regarded, to use a term of Paul Graham's, as "filmic haikus."

The new landscapes and videos, in fact, seem to be saying that, finally, Susan Lipper is thoroughly at home in Grapevine. Although one must remember that even if home is where the heart is, it still remains a place where one has to remain watchful and on one's guard. Any family member knows that.

It will be interesting to see how this new work will pan out, and what will follow it, for it seems clear that Lipper is not yet done with Grapevine Hollow. This essay is only an interim report.

Susan Lipper might have slipped a little under the radar in terms of recent American photography, but the quality of her work will hopefully bring her more recognition. She is a particularly intelligent photographer, her work an especially intriguing blend of the modernist with the postmodern, the objective with the subjective, and the outsider with the insider. She deals with many of the issues that concern contemporary photographic art, especially revolving around the relationship of the self to the "other," but does it in a uniquely personal and highly original way.

Notes

1. Walker Evans, "On Photographic Quality," from *Quality: Its Image in the Arts*, Louis Kronenberg, ed. (New York: Balance House, 1969), p. 170.

2. Susan Lipper, *Grapevine* (Manchester, England: Cornerhouse Publications, 1994).

3. Susan Lipper, *trip* (Stockport, England: Dewi Lewis Publishing Ltd., 2000).

4. Val Williams, *Who's Looking at the Family?* (London: Barbican Art Gallery, 1994).

5. Sally Mann, *Immediate Family* (New York: Aperture, 1992), unpaginated.

6. Ibid.

7. Richard Avedon, quoted in the *Evening Standard* (London), January 19, 1993.

8. Susan Lipper, telephone conversation with the author, July 22, 2009.

9. Ibid.

10. Robert Adams, "Strand's Love of Country: A Personal Interpretation," in Maren Stange, ed., *Paul Strand: Essays on His Life and Work* (New York: Aperture, 1990), p. 240.

11. Billie Holiday, "Strange Fruit" (written by Lewis Allan, 1939, recorded Commodore Records, New York City, April 20, 1939). Based on the poem by Langston Hughes, the song "Strange Fruit" also concerns lynching.

12. Lipper, telephone conversation with the author, July 22, 2009.

13. Ibid.

14. Matthew Drutt, afterword to Susan Lipper, *trip* (Stockport, England: Dewi Lewis Publishing Ltd., 2000)., unpaginated.

Country Matters: Anna Fox's *Photographs 1983–2007*

Photography was invented primarily as an illustrative medium, and when William Henry Fox Talbot devised the negative/positive system, which enabled photographs to be reproduced relatively easily and cheaply, it quickly became a publishing medium. Recently, we have become so enamored of photography as an art form and eager to place it in the context of the gallery, we have tended to forget that all those stunning nineteenth-century photographs we see framed, and which fetch such high auction prices, were for the most part originally bound into albums, and designed to be "read" with their fellows as part of illustrated works, not appreciated primarily for their formal qualities. Even today most photographs are made to be published and seen in print, somewhere along the line at any rate.

Publishing can be very important to a photographer's career, even when they consider themselves an artist and make large-scale, small-edition prints for the gallery wall. It is interesting that even those who might be considered to epitomize this career path—members of the Düsseldorf School, including such masters of the wall-sized print as Andreas Gursky, Thomas Struth, Candida Höfer, and even the school's guiding lights, the Bechers—take great care to publish their work in regular photobooks or limited-edition artists' books.

The photographer I want to consider here, Anna Fox, has had a somewhat lower profile than other British photographers of her generation although she has certainly exhibited widely and frequently, and also internationally. I think it's probably because she hasn't published the requisite number of high-profile photobooks since her well-received *Workstations* (1988), which made a strong initial impact upon the British photographic scene.[1] This seems something of a paradox, for she has always been interested—like her former tutor, Martin Parr—in the photobook form, and has published important work in the shape of modest catalogs and limited-edition artists' bookworks. Now, this (relative) publishing paucity has been handsomely rectified by a full-blown retrospective monograph, *Anna Fox: Photographs 1983–2007*.[2]

One of the most interesting questions for any photographer who makes photobooks and exhibits widely is the problem of the monograph. Over the last decade or so, I have become particularly associated with the photobook, thanks to my collaboration with Martin Parr on a two-volume survey of this quintessential photographic form.[3] As we prepared this history, we debated whether retrospective monographs—that is to say, career overviews of a photographer's oeuvre—should be included, after we had carefully set up our definition of the photobook as a body of work that was "about" something. Of course the debate, while not precisely futile, was certainly inconclusive, and whether it clarified or muddied our thinking is difficult to say. In the end, we played it by ear. We

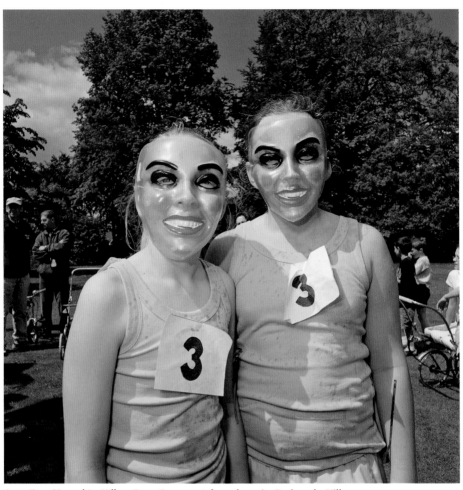

Anna Fox, *Hampshire Village Pram Race*, 2006, from the series Back to the Village

clearly had to include such signficant books in the history of photographic literature as the 1930 monograph *Atget, Photographe de Paris*[4] and Henri Cartier-Bresson's *Images à la Sauvette* (The Decisive Moment, 1952).[5] Apart from their importance, our justification was that they were something more than just a cataloging of the photographer's greatest hits, a standard presentation of the best-known images.

All too often, the career survey monograph simply recounts the hits, whereas in Anna Fox's book a conscious effort has been made to present the work in a way where the sum adds up to considerably more than the parts, so we have a coherent and complex whole.

In recent years, photographers have been giving thought to this problem, and some monographs, far from being routine, are becoming essential purchases for the more serious enthusiasts. Parr himself gave a substantial lead in this area, with the catalog/book that accompanied his widely traveling retrospective exhibition, first seen at the Barbican Art Gallery in London in 2002,[6] adding all kinds of bells and whistles to ensure that the book was not just a simple run-down of his best-known projects. In 2008, Susan Meiselas produced *In History*, a retrospective monograph for her exhibition at the International Center of Photography, New York, which is a splendid career survey, autobiography, and polemic—not to mention a visually complex photobook—rolled into one.

The two examples above set a high bar, but Fox's monograph matches them, and is a welcome showcase. That being the case, my one criticism is that I wish a more imaginative title had been chosen than simply *Photographs 1983–2007*. Much as *Diane Arbus: An Aperture Monograph* masked, to some extent, the cogency and ambition of that volume, Fox might have been better served by a less prosaic title, admirably modest though it is.

Anna Fox is a leading member of what might be termed the second generation of "New British Color Documentary" photography, which could be called a subset of the New European Color Photography School. The first generation, arriving in the early 1980s, consisted of figures such as Parr, Paul Graham, and Peter Mitchell, but the second generation, including Jem Southam, Paul Reas, and Paul Seawright, developed quickly, indeed so quickly that they are almost, but not quite synchronous. Fox, who was taught by both Parr and Graham at University for the Creative Arts, Farnham, in Surrey, is both typical and atypical of this group of color photographers. She is typical in that she employs color to refute the perceived nostalgia and apparent sentimentality of the black-and-white humanist documentary mode that prevailed in Britain prior to the 1980s. She is atypical because she has chosen (for the most part) to focus upon her own neighborhood. Furthermore, though she may be considered a photographer in the "documentary mode," the innate inadequacy of that term becomes apparent yet again. And although I don't want to make too much of this, she is a woman. As for a lot of contemporary photographers, but especially women photographers, the documentary becomes personal. Conversely, one might say that the personal becomes political.

Fox's imagery is a potent amalgam of the brutally objective and the intensely personal, concentrating upon myth and fantasy as much as fact. And she is willing to mix in staged photography to complement the observed, although she is not seeking to fool us into confusing the "real" with the "fictional." The context of her imagery in that sense is always transparent and scrupulously delineated. The portraits of Katy Grannan have similar qualities, although Fox came first, it might be noted. And as a spinner of dark tales about country life—with more than a hint of male violence—she shares certain themes with Susan Lipper, although there is a more overt sense of the political in Fox's work.

I am reminded quite forcibly by Fox's approach of one of my favorite writers, the Canadian Alice Munro, who favors the short story form to the novel, and has concentrated upon the local and small scale as opposed to the monumental and the portentous. A Munro collection of short stories details individual and collective lives, often, but not exclusively women's, in rural areas and small towns.

Fox, it seems to me, does something very analogous, documenting the lives of friends and neighbors, even the houses in which she has lived, creating a delicate and finely judged balance between the social and the personal. And when she does become personal, she does so without exhibiting that annoying, self-indulgent "me me me" tone that afflicts certain contemporary artists and photographers. The tone of Fox's voice is serious but with a sense of humor, often macabre and absolutely clear-eyed without being cruel, although at times she displays the ruthlessness of her mentor Parr. Artistically, at all times, she displays a proper perspective and intellectual distance, even when dealing with something as up close and personal as the cockroaches that infested one of her London homes.

Each Munro story is distinct and unique, yet each volume of Munro stories has a unity and a coherence, a point I would reiterate in relation to Fox's monograph. Another member of the second-generation colorists, Jem Southam, called one of his books *Landscape Stories*. "People stories" might be the watchword for the various projects of Anna Fox. And also "regional stories"—for although she has ventured as far afield as India, I feel that Fox is at her best in her own backyard, the county of Hampshire.

Hampshire is regarded as one of the archetypical English counties, as English as strawberry jam, primarily because it has two particular literary associations that are invaluable to the heritage industry, which promotes a view of an idyllic, pastoral England, stuck around the beginning of the nineteenth century, and makes millions out of those who want even a few hours of this total fantasy in preference to the rather more prosaic, and even grim reality.

Fox in fact lives in the village of Selborne, known for the naturalist Gilbert White, who immortalized it and the surrounding countryside in his *Natural History and Antiquities of Selborne* (1789), a book that could be broadly described as occupying a similar place in English literature as Thoreau's *Walden* (1854) occupies in American. From this base, Anna

Fox can weave her tales of country life, as did the greatest of English nineteenth-century novelists, Jane Austen, who lived only a few miles from Selborne.

Some might think that Fox's rather macabre take on English rural life is less *Sense and Sensibility* and more like another well-known novel, Stella Gibbon's *Cold Comfort Farm* (1932), a savage satire on country life. But Austen was a far tougher and more satirical writer than the English heritage tendency or cozy television adaptations would have us believe. Under the thin veneer of romance, Jane Austen was a clear-eyed realist and implicit social critic. Lizzy Bennet states quite unequivocally that she only fell "in love" with Mr. Darcy when the magnificence of his country house, Pemberley, was revealed, and another country estate, Mansfield Park, is built upon the profits of slavery, although this is hinted at rather than stated as a fact.

A linking of Fox with Austen suggests a preoccupation with women's lives, and that is certainly an important constituent of the work. But like those of her great predecessor, Anna Fox's themes venture far beyond gender issues. Indeed, the more local and specific that Fox is, the broader the range of issues tackled.

Her primary theme, it seems to me, is the contemporary dilemma of country life, specifically the tug, impossibly fierce at times, between tradition and modernity, which might also be expressed as the tension between country and city, for Hampshire is within easy commuting distance of London. People move out from London to reap the benefits of a rural life while reaping the financial rewards of the capital, so large swathes of Hampshire villages are turned into dormitory suburbs. This distorts the property market, pushing up property prices. Locally, jobs are scarce and poorly paid, and small shops close down, because developers are swallowing up land around towns like Basingstoke (Fox's nearest market town) to build business parks and malls—which provide well-paid jobs for some, but ultimately perpetuate the gulf between "townies" and traditional country dwellers.

Fox's earliest project indeed looked at Basingstoke from this point of view. David Chandler quotes Fox as saying that the town, "clearly had problems. At one time the multi-storey car park was said to be the most violent in Europe and the shopping center was not a place to be alone in late at night. There was not enough for the local teenagers to do and this led to big social difficulties."[7] It was here that she developed a strategy that has stood her in good stead since (although she doesn't always employ it), that of combining photographs with texts, texts that are often as ironic in tone as that of Jane Austen. For example, under a picture of three fat men staring fixedly at computer equipment in a soulless office environment is the caption, drawn from the local newspaper: "This town needs love says priest."[8]

The same kind of ironic captioning continued in her London office project, Workstations (1986–88). Although this project might not appear to have anything to do with rural life, in fact, the City of London has the biggest of all on a county like Hampshire. Many

office workers will commute daily from "nice" counties around London—the "home counties" as they are known—putting pressure on road and rail communications alike and creating the impact outlined above.

By now, Fox had developed the habitual technical mode of the "New British Color" movement, a medium-format camera used with flash that was so typical of Parr after he switched to color, and which has become almost ubiquitous across contemporary photography. Importantly, this method, which combined a high degree of lucidity with a certain frozen quality—and can be interpreted as aggressive, satirical, or edgy, according to your point of view—distinguished this new wave of photographers from the black-and-white, humanist, left-leaning view of the more traditional British documentary mode. Not that the new generation was any less left-leaning, but their political commitment was sometimes questioned—although not in Fox's case, as Workstations, unusually, concentrated upon the middle classes, or the aspiring monied classes, and its "right on" target was the culture of greed ushered in by the Conservative government of Margaret Thatcher.

A typical caption from Workstations, under an image of a secretary taking dictation, reads: "Having a secretary is a status symbol."[9] This clearly indicates Fox's gender position—as long as you get its irony. (The man in the picture probably wouldn't.) Another caption, accompanying a picture of a boisterous office celebration, shifts the metaphor. "Celebrating the killings" it reads,[10] indicating that business is regarded by its protagonists as a war, the dog-eat-dog, Darwinian ethos of extreme capitalism. And this violent symbolism, interestingly coupled with a metaphor of military organization, is continued with a photograph of two men waiting while a woman at a desk finishes a telephone call: "Should a competitor threaten to kill a sale, the modem would provide a lifeline back to base computer."[11]

The jargon is laughable, and meaningless, but somehow utterly scary, and the military symbolism leads directly into Fox's next project, Friendly Fire (1989–94). While working on Workstations, Fox encountered the phenomenon of paintball, weekend war games played in the countryside on abandoned army bases or decommissioned farmland. Office workers were encouraged to participate in these mock war games in order to promote competitiveness and team spirit. Needless to say, as Fox shows, the men were generally the most enthusiastic players, and her images of manic paintballers confirm not only the theme of male violence but the fact that office culture remains very much a predatory male domain—alpha males only need apply.

The most delicious irony is saved for the last image in the series—a paint spattered image of Mrs. Thatcher herself. Anna Fox must have thanked the gods of photography when she came across that one. Or perhaps she encouraged a few paintballers. The picture connotes how successful the Iron Lady's revolution of selfishness and greed actually was—with the revolution's own "children" having absolutely no compunction in "killing" their "mother." Freud would have a field day with that.

But then I think Anna Fox is one of the most Freudian of photographers, if I can put it like that. Some of the paintballers in Friendly Fire wear bizarre Halloween masks, and Fox carries these twin themes—violence and the bizarre—into much of her work, although in a thoughtful and probing rather than sensational way.

Returning to rural life, another well-known observer of the recent English countryside, the Suffolk writer Ronald Blythe, has long been concerned about how the heritage industry has distorted our view, creating a fantasy and obfuscating the gap between the myth of arcadian idyll and the harsh realities. Our affection for tales of grand country houses masks the exploitation of agricultural workers and ordinary country dwellers.

Fox's Hampshire stories can be set alongside Blythe's Suffolk tales—most notably his renowned chronicle of a lightly fictionalized village, *Akenfield* (1969). They employ different media and methods but display similar sentiments about the truer nature of country living. The case of Maria Martin, a young girl violently murdered by her swain, in 1827, is one of Suffolk's most enduring folk tales; a true story that has become embroidered later in fiction, rather like the American Alamo. Anna Fox and her friend, Alison Goldfrapp, were fascinated by the Hampshire equivalent, the tale of Sweet Fanny Adams, a little girl who was murdered in Alton in 1867.

Country Girls (1996–2001) was the result of that interest. A series of staged portraits, Fox's images of Goldfrapp are an examination of the restricted lives led by young women in the country. The pictures vary from sedate photographs of Goldfrapp dressed in upper-class tweeds or twinset and pearls, to her stumbling along a road at night dressed in a party dress, to a naked corpse dumped in a hedgerow—women bound by tradition and in danger from traditional gender roles. The images of the dead Goldfrapp/Fanny Adams illustrate graphically the underlying violence and despair that can blight rural life.

The staged, or should we say collaborative, portrait is also in evidence in another extended series Fox made of another close friend, Linda Linus, the singer in a local punk band, Fashionable Living Death. Linus had asked Fox to photograph her in order to promote the band. Fox is still photographing her, over twenty-two years later, documenting her moods, changing fashions, hairstyles, piercings, their friendship, and inevitably, the aging process. As Linda Linus clearly intends to grow old disgracefully, this Stieglitzian–style extended portrait is both lively and penetrating. And, as Jason Evans points out, it also subverts the innate conservatism of the countryside, as well as highlighting the repression of any overt display of female expression.[12]

It is as a portraitist (I also include portraits to mean pictures of the interiors she and others inhabit) that Anna Fox excels. Another still unfinished series included in her monograph is Back to the Village (begun in 1999) and it is one of her best. Inspired by Sir Benjamin Stone's photographs of English customs and festivals at the beginning of the twentieth century, she began to make a similar record of events in Selborne and surround-

ing villages—events like fetes, Halloween festivities, Guy Fawkes Night, and plays.

These portraits, mainly of single figures, examine the masquerade of village life. The urge to put on fancy dress, even if badly designed and made, represents both a desire to escape a humdrum daily life and also to preserve a vanishing, or vanished England. Both motives indicate a desperate need to escape the present—to reinforce the uniqueness, that is, the "otherness" of rural life and push back the encroaching tide of modernity, which represents the "other" in a different sense, the sense of a weakened, diluted Englishness.

So Fox's apparently simple portraits of happy villagers at play carry quite a heavy baggage of layered meanings. They are certainly not devoid of her avid interest, as Val Williams puts it, in "the 'ordinary menace' of country life."[13] Traditional English festivals such as Halloween and Guy Fawkes Night celebrate both the ghoulish and the violent, while many others commemorate wars and religious threat, and reinforce the notion of the countryside as a place that is under constant threat.

One of the most popular current English television shows is a police procedural drama called *Midsomer Murders*. It takes place in a fictional county—which might be Hampshire—and the sheer longevity of the series has ensured that the body count is extremely high. It's a long-standing joke among television critics that Midsomer is a more dangerous place to live than either Baghdad or Detroit. However, the real irony of the show's conceit is that while it promotes the heritage view of a countryside steeped in the good old gentlemanly traditional ways that made England great, it also portrays its inhabitants as thoroughly venal, avaricious, amoral, snobbish (of course), and frankly, murderous—the real qualities that made England great and created the British Empire.

A frequent, almost weekly plotline is that the murders—always multiple—take place while the village fete or play, or some such community ritual or celebration is in full swing, where disguise is the order of the day and inhibitions are lessened. Of course, *Midsomer Murders* doesn't really subvert the English heritage view of rural life, because rural mayhem in the form of the country house murder is a long-established literary tradition. So I can hardly look at Fox's portraits of the local players and mummers and the like without wondering who will get shot with an arrow at the archery contest, or done to death at the medieval tournament. In real life, no one does—not very often anyway—but the underlying violence, which takes many forms, not necessarily murder or physical mayhem, is a powerful presence. It's why Fox is such a good portraitist—her images both document and question.

Anna Fox, unlike *Midsomer Murders*, completely subverts the cozy view of the English countryside, yet does so with great intelligence and a nicely judged degree of contradiction. As Williams writes, Fox's images both "satirize and affirm" rural life.[14]

Through her various projects Anna Fox has created a valuable, individual, and suitably eccentric body of work about contemporary British society. She has gone a long way to

redressing a perhaps understandable bias on the part of photographers to concentrate upon the urban scene, by demonstrating that urban and rural issues are inextricably linked. Furthermore, she has brilliantly re-addressed the problem of the photographic monograph. To use a musical analogy, this is less of a compilation album and more of a concept album — and all the better for it.

This essay originally appeared as a review of *Anna Fox: Photographs 1983–2007* (Brighton, England: Photoworks, and Bradford, England: Impressions Gallery, 2008). It has been amended for this volume.

Notes

1. Anna Fox, *Workstations: Office Life in London* (London: Camerawork, 1988).

2. Val Williams, ed., *Anna Fox: Photographs 1983–2007* (Brighton, England: Photoworks, and Bradford, England: Impressions Gallery, 2008).

3. Martin Parr and Gerry Badger, *The Photobook: A History*, volumes 1 and 2 (London: Phaidon Press Ltd.: Vol. 1, 2004; Vol. 2, 2006).

4. Berenice Abbott and Henri Jonquières, eds., *Atget, Photographe de Paris* (Atget, Photographer of Paris) (Paris: Henri Jonquières, Paris, and New York: E. Weyhe, 1930).

5. Henri Cartier-Bresson, *Images à la Sauvette* (The Decisive Moment) (Paris: Éditions Verve, and New York: Simon and Schuster, 1952).

6. *Martin Parr: Photographic Works, 1971–2000*, on view at the Barbican Art Gallery, London, 2002.

7. Anna Fox, quoted in David Chandler, "Vile Bodies," in *Anna Fox: Photographs*, p. 18.

8. Fox, *Workstations*, unpaginated.

9. Ibid., p. 46.

10. Ibid., p. 48.

11. Ibid., p. 47.

12. Jason Evans, "On the Path," in *Anna Fox: Photographs*, p. 183.

13. Williams, "Anna Fox: Village Masquerades," in *Anna Fox: Photographs*, p. 216.

14. Ibid., p. 219.

Odysseys: Patrick Zachmann and Contemporary Diaspora

A degree of attention has been given throughout this book to what the work of certain photographers is really about, to the fundamental question of the difference between a photographer's subject matter and his or her subject. It might seem that I give too much attention to what is an obvious matter. Surely there is a difference in every photograph between what is photographed and what is actually said.

Alas, it seems to me that in all too many cases photographers might photograph something without actually saying very much about it, except to compose the image competently and record something of what is there. In other words, too many photographers have little to say, beyond the obvious and superficial. Many photographers do not move beyond the stage of being interested in photography for its own sake rather than being interested in the world. If Garry Winogrand had actually followed his own famous maxim and simply photographed to see what the world looked like in a photograph, I do not think his work would interest me so much. The fact that he went way beyond that to reveal not only his worldview, but a complex, slippery, tortured human being is what made him a great photographer.

You might say that I am interested primarily in the serious photographers, and serious photography. I take photography seriously, very seriously indeed—I'll admit that I perhaps take it too seriously—but I like nothing in photography better than when a photographer has a serious subject and really gets his teeth into it. There is too much superficiality in the medium and not nearly enough depth.

Coming back to the subject matter and subject relationship, it might be assumed that the difference between the two is least discernible in so-called reportage photography, where the photographer is involved nominally with "mirroring" the facts of the world. To be sure, even back in the 1950s, which now seems a long-lost "golden age" of photojournalism, the reportage photographer was never considered to be totally neutral, but was expected at the very least to evince a generally humanist concern, to have a point of view about the social facts he or she was documenting. Nevertheless, it was assumed that there was a fairly direct correlation between photographer and subject matter. The reportage photographer was deemed to be an immediate witness to the world's events, large or small.

In this mediawise twenty-first century, however, even the least media-savvy person on this planet takes a jaundiced view of the visual facts presented by the camera. No one believes any more in that old adage about the camera never lying, a skepticism that was once confined to those who produced visual documents rather than those who consumed them.

Interestingly, as I write this, the old controversy about Robert Capa's iconic image of

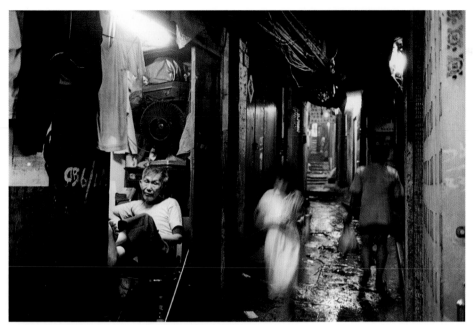

Patrick Zachmann, *Kowloon, "The Walled City," Hong Kong*, 1988

a Spanish Civil War militiaman at the moment of death has reared its head again. Having been accepted by photo-historians in recent years as genuine, it would now appear from new evidence that the "dying" soldier might have been acting for Capa's camera some thirty miles from the actual conflict. Discussing the dilemma this causes in the *Guardian* newspaper, Euan Ferguson concluded as follows (italics are my emphasis):

"In a world saturated with new media, at a time when it is easier than ever to fake a photograph, or spread partisan 'facts' of dubious authenticity and lineage, it is more crucial than ever that what we see and read can be trusted. Every time something turns out to have crossed the line, it damages all our futures, because it damages all our trusts. Capa is culpable and it's a crying shame. It almost *shouldn't* matter, but it does. *It matters more today, that he did what he did, than it mattered on that day in 1936.*"[1]

Capa of course was a founding member of Magnum, the world's leading photo agency, and an organization of great integrity, an integrity, let it be said, instilled in it by Capa and the other founders. But this controversy over what may turn out to be a youthful indiscretion or once again may be put to rest proves, as Ferguson demonstrates, even today there

is a lingering, and stubborn residue of faith in the photograph's ability to convey the truth, or at least a belief in the potency of the camera lie. This makes the news and reportage photographer's task a dangerous one in areas where there is conflict, as those embroiled in it are wary of reporters, yet at the same time court the visual media.

It is these basic changes in attitude, that we disbelieve before we believe the camera, as well as changes in markets, which have generated great shifts in the work of Magnum. Though still regarded as the epitome of the reportage mode, the Magnum of today is a very different organization from the Magnum of Capa's day, and even thirty years ago. Although there are young Magnum photographers who remain faithful to the traditional reportage mode, many do not. Around the mid-'80s, the acceptance of such figures as Harry Gruyaert and Martin Parr for membership saw Magnum photographers not only working in color, but stretching the conceptual notion of a Magnum photographer to breaking point. In a world of postmodern attitudes, marked by skepticism, irony, and ambivalence, the business of being a Magnum photographer became more complex, as markets not only shifted, and in some cases diminished, but the old certainties about the role of the reportage photographer became blurred and eroded.

Patrick Zachmann is a particularly interesting example of the "new breed." Both a photographer and a filmmaker of distinction, he cannot be pigeonholed and put into the preconceived Magnum slot, although at first glance he might appear more traditionally "Magnum" than some of his colleagues. But reportage photographer, documentarian, or artist are inadequate terms in which to define his approach to the two photo-based media. He is, if you like, simply Patrick Zachmann, and his photographic sensibility is defined by an overarching subject that permeates his work. In short, his work is defined not by style but by content, and his sensibility is one that ventures way beyond the purely photographic. Like that of some of the other "new breed" members, his artistic persona is not just a thoroughly postmodern one. His imagery is infused with a combination of intellectual analysis and the deeply personal.

This is not to say that, when he for instance photographs Malian immigrants in Paris, he is actually photographing "himself," but that his perspective is wholly personal, and importantly, an integral part of the general theme that underpins all of his work. That theme can be defined broadly as diaspora—not only the Jewish Diaspora in which he, as a French Jew, is naturally interested, but the global wanderings of other ethnic and religious groups.

However, under that general subject rubric, Zachmann deals with other issues, some political, others arising from the specific nature of the medium with which he is engaged. Diaspora means not just a wandering, but a scattering of peoples. And the scattering, or breaking up of people, seems an increasing feature of contemporary life. In the past, America was held up as a model for immigration and cultural diversity, but now many countries,

particularly of course "First World" countries, have also become "melting pots" for different ethnic groups, bringing both problems and opportunities, both a healthy sociocultural broadening and a potential increase in intolerance.

When a people scatters, spreading out across the globe, they tend to cling tenaciously to memories of the homeland, cherishing their tribal identity with special pride. And here the photograph has a particular role to play. It has become something of a cliché to say that the snapshot documents and embodies our memories and our desires, yet that is true not just of snapshots but other kinds of photographs, especially those that fall under that very diverse classification, "personal documentary."

A fundamental—perhaps the most fundamental—reason for making photographs of oneself and one's nearest and dearest, or of places to which one travels, is to prove the fact of one's existence. There is a photograph of me, or a photograph by me, therefore I *am*.

Identity, shored up by both collective and individual memories, is a crucial function of photography, and identity, both cultural and personal, is at the core of Patrick Zachmann's work on diaspora and other issues arising from either the healthy or unhealthy collisions of cultures.

Zachmann's background is an important factor in his work, perhaps more so because he was not brought up in the faith of his forefathers. His father's father, an Ashkenazi from Poland who had emigrated to France in 1910, had wanted his family to integrate, to become "French" rather than Jewish, and this process continued into the next generation. So as Zachmann says in his first film, *La Mémoire de mon Père* (My Father's Memory, 1998),[2] the usual customs were not observed: "At home all traces of Jewishness had been eliminated, no celebration of Kippur or Shabbat, no Yiddish or Hebrew spoken."[3]

As a result, after becoming a photographer at the age of twenty-two, he spent ten years photographing French Jewry. The work became the basis for his first photobook, *Enquête d'Identité* (Search for Identity, 1987),[4] a book that was at once a document of French Jewish life and a retrieval of his own cultural roots. As he says, "my parents' desire to erase their cultural background is probably what made me a photographer."[5] A photographer in the sense that he uses the camera not just to record the surface of life, but to inquire below the surface, uncover a cultural heritage like an archaeologist, delve into a collective race memory like a psychologist. Putting these all together, one might say that his whole approach to photography is that of the forensic sociologist.

The term forensic is an apt one here. Patrick Zachmann is seeking to uncover, and reveal through photography, the memories of his subjects, his own memories, the collective memories of peoples, of tribes and ethnic groups. When people move to a new society—an increasing phenomenon in today's world—certain things are hidden from the eyes of the mainstream of the new society. New immigrant groups are, so to speak, under the radar of the new society. Like old people, they are invisible while in plain sight—at best

ignored, at worst vilified. Criminal activity is frequently involved, both in getting them out of the old country and into the new, then in "supporting," or rather exploiting them. Groups at the bottom of the food chain in the new country sometimes have to resort to dubious means in order to survive. Zachmann is often investigating crime scenes as much as uncovering social facts.

He says that the "strength of photography lies in its silence, although that is also its limitation."[6] It is the photographer's job to make photographs speak, not by hectoring us, but making us pensive, forcing us to think. But the photograph can also be too mute, so the photographer must also make it speak up at times, by making a series, adding text, incorporating the testimonies of those photographed. Zachmann is dealing with broad, very complicated subjects, therefore he states: "I want to introduce complexity into photography. I am not interested in single pictures, but a series, which tells a story."[7]

To be sure, it is the stories of his subjects that Zachmann rightly and properly wants to tell, and he takes great care to do so, but he also remains aware that he is also telling his own story, which is woven into the fabric of his long-term projects. For instance, the subject of his film *Allers-retour* (Go and Return, 2002)[8] was the "disappeared," those dissidents (and innocents) taken away, imprisoned, and murdered by totalitarian regimes. The film's main focus was Chile, and the fate of the supporters of the late President Salvador Allende, the first democratically elected Marxist head of state. Allende was deposed in 1973 by the man he had personally appointed a month before as commander-in-chief of the army, General Augusto Pinochet. It has been estimated that under the harsh measures taken by Pinochet's military dictatorship, at least eighty thousand supposed Allende supporters were incarcerated without trial, and some thirty thousand tortured to some degree.

Zachmann tells this sad story in interviews, but also visually through landscape, photographing bleak, yet beautiful places where bad things happened. We visit the Pisagua military base, where women detainees were held; a villa where many were tortured, now demolished to make a seafront promenade, as Chile's tourist industry is on the rise; and Chacabuco, a site of a former saltpeter mine, where there was a large concentration camp. Zachmann also made a book of panoramic landscapes to tell the story in a different way, *Chili, les Routes de la Mémoire* (Chile, Highways of the Memory, 2002).[9] His pictures of the Atacama Desert and its abandoned villages and derelict industries seem at first to have nothing to do with the political conflict, which is eventually revealed through the captions at the end, the story completed with portraits of some of the disappeared, compiled by Chileans Claudio Perez and Rodrigo Gomez. Thus the reader goes through the same process as Zachmann, gradually uncovering these layers of history and memory. This interweaving of still photography and film on the same project is typical for Zachmann. He feels that it keeps him on his toes, to continually go from, as he puts it, "the team game of film to the individual game of photography."[10]

Allers-retour moves to other places where people have disappeared in large numbers, namely Argentina, Rwanda, and Bosnia. Then, at the film's finale, it gets personal. We end at Auschwitz. Zachmann's grandparents died in the camps of the Holocaust. His aunt had been denounced as a Jew by the concierge of her apartment building in Belleville, Paris, but survived the notorious transit camp at Drancy, near Paris. His grandfather was betrayed to the Gestapo by a so-called friend of his father, after having paid the man money to conduct him to the Free Zone, near Lyon. Here is the source of Zachmann's deep and abiding interest in the subject of immigration and diaspora—the iniquities caused by conflict between tribes of people, and also within tribes. As John Gossage said to me recently, and it is very pertinent to the practice of Patrick Zachmann: "One has to photograph one's own history; all the rest is tourism."[11]

Giving his attitude, it comes as no surprise to find that Zachmann is the opposite of the image we tend to have of the globetrotting reportage photographer, jetting off to a country for a week or two, shooting a story, then never returning. Like all of his Magnum colleagues, he will take commercial assignments, but Magnum is a crazy organization, a business that is not simply a business, but also a crusade, so in common with most of his colleagues, his primary energies are devoted to long-term, personal projects, which he funds as he can.

One important long-term interest is China, a country to which he returns again and again. The tumultuous social changes in the region have been a particular interest of Magnum's, ever since Henri Cartier-Bresson went there in 1949 to photograph the Civil War and the beginnings of the Red Revolution. Marc Riboud and René Burri have made notable bodies of Chinese work, as have other Magnum photographers. A number of them, including Zachmann, were in China covering other stories when the student protests in Tiananmen Square were brutally crushed by the regime.

That event showed Magnum acting totally in accordance with many peoples' perception of them, as gatherers of hard news. They lucked out then, with Zachmann and Stuart Franklin in particular getting some memorable imagery from Tiananmen, but that is not generally their way. Zachmann's best-known book, *W. ou l'oeil d'un long-nez* (W. or The Eye of a Long-nose, 1995),[12] was the result of ten years' work, investigating China itself, and those Chinese who live in other cultures.

In order to do justice to this immensely ambitious subject, Zachmann traveled not only to mainland China, but to diaspora communities in Europe, the U.S., Tahiti, Hong Kong, Cambodia, Vietnam, Thailand, Indonesia, Taiwan, the Philippines, Malaysia, and Macao. The title comes from a somewhat derogatory Chinese term for a European, "long-nose," and "W" was Zachmann's "fixer" in China, a Chinese man he met in Paris who became his guide, helping him to understand the complexities of each situation, and guiding him—the long-nose—through his world. Zachmann's relationship with W, becomes a parallel text

within the main text of the photographs, told in the form of extended captions: "But, far from unveiling mysteries, this 'ideal guide' nurtures them, making the truth elusive. Both voyage of initiation and detective thriller, this book weaves a complex intrigue around the question: who is W?"[13]

This hardly sounds the stuff of standard Magnum practice, yet *Long-nez* sits comfortably within the bibliography of other recent Magnum books, which I shall discuss in due course. We have seen that Zachmann is at pains to tell his stories in a far from simple way, in order to do full justice to their complexities. As well as the W subtext, he also provides a multilayered context for the photographs, dividing them into black-and-white and color sections, but doing so with intent. The monochrome, which is much more investigative in tone, details some of the photographer's inquiries into the problematic side of Chinese life and the Diaspora—the influence of the Triads and their role, inside and outside the country, in arranging illegal emigration, the trafficking of drugs and girls, and racketeering in foreign countries—especially in Southeast Asia. The color, by contrast, takes the form almost of family snapshots, depicting the smiling faces of those who have "made it" thanks to China's "economic miracle," either in the new "capitalist" republic or abroad.

The book's main theme is that although emigration is done for a reason—personal betterment—for many it can be difficult. Leaving the protective bosom of one's own culture, no matter how unsatisfactory that might be, is not a decision made lightly. Some of course can leave without problems and make a successful life elsewhere. Others have great difficulty, leaving illegally, entering a new country illegally, and thus remaining prey to exploitation and poverty. *Long-nez* demonstrates graphically, in powerful, affecting photographs, that however much we might wish it, the grass is not always greener on the other side of the fence. Zachmann is telling an old story, but one which needs constant reiteration.

Patrick Zachmann's newest project in China delves below the surface of the great "economic miracle," reflecting the bewildering pace of change, which has brought both pluses and minuses for the Chinese. *Chinese Confusions* will look at how both young and old can feel lost by the enormous changes in society and the inevitable conflict between modernity and tradition brought about by the importation of so much Western influence.

Although for Zachmann, the problem of any diaspora could be considered "close to home," naturally the situation pertaining to his native France is closest to his heart, including the relationship with its former colony, Algeria, because his mother is a Sephardic Jew who emigrated from Algeria. He has photographed successive waves of immigration into the motherland from her former colonies, from Arab North Africa to indigenous Africa further south. The situation with Algeria is particularly fraught, as this former colony had a particularly painful separation from France, one where the wounds remain open and the ramifications still very much are present in the *banlieues* of the major cities, home to the majority of immigrants.

Zachmann's latest book and exhibition look specifically at these neighborhoods, the French equivalent of the American ghetto, and all that that implies in terms of social deprivation and inequality. *Ma Proche Banlieue* (My Next-door Neighborhood, 2009),[14] summarizes twenty-five years of work investigating immigration into France, a comprehensive survey that both demonstrates his own approach, and also the complexities and the issues surrounding any contemporary photographer who is interested in, for want of a better term, social anthropology.

The book contains work from a number of projects, but may or may not be the last word he has to say on each, for although a book and an exhibition may be considered a retrospective of sorts,[15] for Patrick Zachmann nothing is ever finished—"signed off," so to speak. All that an exhibition or a book represents is a stage in his life's work. He says that *allers-retour*—go and return—sums up his artistic philosophy precisely. He will pick up a project, work on it for a while, put it aside, perhaps publish or exhibit some of it, then at some point return to it. He will work with film for a while, put that aside, and return to photography for a period. Sometimes he will try to work as much as possible from "inside" a particular community that interests him, at other times he will be content to work from the "outside."

All the time, he is aware that he is venturing into peoples' lives for a time and then disappearing from them. This cannot be helped, but such is his commitment to the subject of diaspora and cultural memory that he returns whenever he can—outside photography or the project, so to speak. He and his family have become friends with some of his subjects. He is not naïve enough to delude himself into thinking that his photographs will change the world significantly, but his expectation, and his hope is that they will contribute in some small way to a more progressive perception of the world.

For example, in a project he did on immigration into France from Mali, a former West African colony, *Maliens ici et là bas* (Malians Here and Over There, 1997),[16] and later included in *Ma Proche Banlieue*, he deliberately set out to confound expectations for this kind of project. The norm, he says, would have been to portray life in Africa in color, depicting it as exotic, and life in France in black-and-white, reflecting the misery and squalor of the immigrant's lot in an unwelcoming and prejudiced society. But Zachmann did exactly the opposite, photographing Mali in monochrome and France in color, deliberately subverting the notion that immigrants "are necessarily miserable and non-integrated, and instead portraying them as happy, complex, and modern."[17]

Zachmann is well aware, of course, that life for many African immigrants in France is difficult, with opportunities for social and economic advancement limited. He would not deny that, but points out that life and society are complicated, and that the issues of immigration are complicated. And so are the problems facing photographers and journalists trying to portray those issues in all their bewildering complexity. He is always trying

to show another, less expected side of any story, and thanks to Magnum, has the time and space to do that. Here, if anywhere, is the justification for an organization like Magnum, which has enabled Patrick Zachmann to spend some twenty-five years investigating a huge subject, encouraged and supported by his colleagues. And to take just a few other, almost random examples, Magnum has nurtured years of work in Africa by Chris Steele-Perkins, in Nicaragua by Susan Meiselas, and a worldwide study of Islam by Abbas.

It is time, hard work, obduracy, and passion that reap the rewards when a photographer is engaged with such a broad subject. In another section of *Ma Proche Banlieue*, Zachmann revisits the northern suburbs of Marseilles, to search for young Algerian immigrants he photographed in 1984. The avowed aim of most of them back then was to escape from this ghetto and make it in wider French society. When he returned some twenty years later and tracked some of them down, he was disappointed, yet hardly surprised to find that, besides growing older and having kids of their own, their lives had not changed much. They were still circumscribed by prejudice, the difficulty of scraping together a living, and the soulless project housing of the *banlieues*. A few had managed to leave and better their circumstances, but they were the exceptions rather than the norm.

As in all his projects, the Marseilles work is multilayered and multimedia. There is a hard-hitting film, *Bar Centre des Autocars* (Coach Terminus Bar, 2008),[18] which perhaps lays bare the bleakness of some of the lives portrayed and the dashed hopes more directly than the book or the exhibition.

All of Zachmann's work on immigration and the Diaspora is collaborative. He is careful, indeed eager, to incorporate the voices of those whose lives he is depicting, and into which he, as an outsider, is intruding, however sensitively. At the same time, he is adamant about defending his right to tell the story as he sees it, his rights as an auteur. He will not be an unthinking mouthpiece for these communities, however sympathetic he is to their situation. It is a tricky line to walk, but Zachmann is sure of his favorable disposition and his integrity.

But one thing bothers him. He doubts whether, if he were beginning such a project today, he would be able to work so freely in the immigrant communities. "It is very difficult to photograph in the *banlieues* today," he says, with some feeling.[19] The *droit d'images* (image rights) law which has been introduced in France to prevent misrepresentation and abuse when someone is photographed has made it difficult for reportage photographers to work with impunity. Zachmann feels that the onerous conditions imposed upon image "release" have led to photographers' work being controlled by their subjects, or alternatively, a great deal of self-censorship.

Zachmann might be totally compassionate, essentially well-disposed, and in tune with his subjects, but he is also a firm believer in journalistic freedom. If he sees anything to criticize, he needs to feel free to do so—like, for example, the wearing of the burka in

France, which he is against. "The biggest problem for the photographer/journalist today," he believes, "is far too much political correctness."[20]

The Capa dilemma seems a long way away from the complexities facing today's Magnum photographers, yet the very difficulties are helping to produce some remarkable work. Among themselves, Magnum members are constantly discussing their motives and their aims—there is no more self-critical group in photography. And Zachmann's books, especially *Long-nez* and *Ma Proche Banlieue*, represent a tendency, both within Magnum and other reportage circles, where the work reflects the photographer's role inside it, that is, the whole process of making it. By incorporating in a book first-person narratives, interviews, and scrapbook material, the photographer/author sets up a parallel commentary upon the work, much like a Greek chorus commenting upon the action in a play, or film directors' commentaries contained on DVDs. The subjectivity of the enterprise is declared openly, although the Greek chorus can be embedded more subtly in some books than others. This particular facet of the endemic tendency in contemporary photography to stress the personal has made reportage not just more honest, but more interesting and complex. It could be described as postmodern reportage.

Magnum photographers have been at the forefront of this tendency. Just recently, we have had books like Susan Meiselas's *In History* (2008),[21] a kind of autobiography, yet nevertheless one that offers remarkable and valuable insight into the business of reportage photography, both as a witness to history and as art. Jim Goldberg's *Open See* (2009)[22] looks at the problems of refugees and immigration, doing so in his own inimitable style and brand of interactive collaboration.

For more than three decades, Patrick Zachmann has made an invaluable contribution to the Magnum debate, which means an invaluable contribution to the wider debate about how photography depicts the world. During the 1970s, there was a brief attempt, yet one that still resonates, to talk about the "concerned" photographer. The attempt petered out, largely because the debate was a specious one. Every photographer should be a concerned photographer, although unfortunately today, too many photographers seem to be concerned solely with themselves.

That's not the case with Patrick Zachmann. Firstly, his photographs evince a concern for photography as a repository for our collective memory—and that means having a proper respect for the medium and using it carefully. Secondly, he is concerned for the people he photographs, those whom by photographing, he represents—in both senses of that word. And that means having a proper respect for them. At the beginning of this essay, I mused about how to designate his practice, whether reportage photographer, documentarian, artist, or whatever. On second thought, I think concerned photographer will do very well.

Notes

1. Euan Ferguson, "The Truth Is Rarely So Black and White," *Guardian* (London), July 26, 2009, p. 25.

2. Patrick Zachmann, director, *La Mémoire de mon Père* (My Father's Memory) (Paris: Gédéon Programmes, and Angers, France: TV10, 1998), color, 31 minutes.

3. Zachmann, narration to *La Mémoire de Mon Père*.

4. Patrick Zachmann, *Enquête d'Identité* (Search for Identity) (Paris: Éditions Contrejour, 1987).

5. Zachmann, narration to *La Mémoire de Mon Père*.

6. Patrick Zachmann, in conversation with the author, London, June 30, 2009.

7. Ibid.

8. Patrick Zachmann, director, *Allers-retour: Journal d'un Photographe* (Go and Return: Diary of a Photographer) (Angers, France: TV10, and l'Institut National de l'Audiovisual, 2002), color, 68 minutes.

9. Patrick Zachmann, *Chili, les Routes de la Mémoire* (Chile, Highways of the Memory) (Paris: Éditions Marval, 2002).

10. Zachmann, in conversation with the author.

11. John Gossage, telephone conversation with the author, July 8, 2009.

12. Patrick Zachmann, *W. ou l'oeil d'un long-nez* (W. or The Eye of a Long-nose) (Paris: Éditions Marval, 1995).

13. Dust jacket text to *W. ou l'oeil d'un long-nez*.

14. Patrick Zachmann, *Ma Proche Banlieue* (My Next-door Neighborhood) (Paris: Éditions Xavier Barral, 2009).

15. The exhibition *Ma Proche Banlieue* was shown at the Cité Nationale de l'Histoire de l'Immigration, Paris, from May 26 to October 11, 2009.

16. Patrick Zachmann, *Maliens ici et là bas* (Malians Here and Over There) (Paris: Éditions Plume, 1997).

17. Zachmann, in conversation with the author.

18. Patrick Zachmann, director, *Bar Centre des Autocars* (Coach Terminus Bar) (Paris: Les films d'ici productions, 2008), color, 56 minutes.

19. Zachmann, in conversation with the author.

20. Ibid.

21. Susan Meiselas, *In History* (Göttingen, Germany: Steidl Verlag, in association with International Center of Photography, New York, 2008).

22. Jim Goldberg, *Go See* (Göttingen, Germany: Steidl Verlag, 2009).

From Diane Arbus to Cindy Sherman: An Exhibition Proposal

I am very conscious that nearly all the photographers I have written about so far in these essays have been male. I would of course contend that I never consider the gender of a photographer when I am looking at work or judging it, yet feminists would point out that my omission of female photographers represents an unconscious favoring of male over female. Furthermore, they would argue that this is precisely the kind of thing that happens in a male-dominated society, and is the reason why women are marginalized in so many spheres of life.

They have a point. I am sure that the kind of photography I particularly like is made primarily by male photographers. The reason why I like it is probably because I am male, and have been conditioned to like it, and so on and so forth. And so a self-perpetuating cycle is established that creates a gender divide in all aspects of society.

And yet I can lay my hand on my heart and say that I never *consciously* consider the gender of a photographer when looking at work. But there are aspects of society that have particularly interested women photographers, and which have led to some fascinating work that has engaged me just as much as areas of interest that could be described as the province of male photographers. As a critic, I have not written as much about women as I have about men, but then again, I haven't been asked as much. Critics tend to write about certain things because they are asked, and I think that many women photographers quite naturally ask fellow women to introduce their monographs or review their shows. Yet when I curated a traveling exhibition for the British Arts Council in 1980, a survey of photographic printmaking,[1] I discovered to my surprise that, of all the photographers in the show who worked after about 1970, a good percentage were women.

Why should that have been a surprise to me? Of all visual media, women have made a substantial contribution to photography from the beginning. The first, and one of the best photographic critics was Lady Elizabeth Eastlake. Photographed by David Octavius Hill and Robert Adamson as Miss Elizabeth Rigby, she married Sir Charles Eastlake, a future director of Britain's National Gallery. Her essay "Photography," written in 1857,[2] remains essential reading for anyone interested in the medium's conundrums.

The first photobook was not William Henry Fox Talbot's *The Pencil of Nature*,[3] but Anna Atkins's *Photographs of British Algae: Cyanotype Impressions*.[4] The first part of her epic work, ten years in the making, predated Talbot's by a few months. However, some scholars have argued that *Algae*, privately distributed to friends in a very few copies, should be regarded as an album rather than a book available for public purchase. The *Pencil* was sold by public subscription, so in certain quarters, Talbot is awarded the palm, although clearly Atkins, as much as Talbot, had the crucial idea of putting a cogent group of photographic images between covers.

Judith Golden, *Live It as a Blonde*, 1975, from the series Chameleon

One does wonder whether certain male commentators are uncomfortable with the thought of a man being beaten to such a significant first by a woman. Some of the arguments for or against either book have certainly been somewhat specious. On the other hand, *The Pencil of Nature* sounds a deal more grandiloquent than the prosaic *Photographs of British Algae*—though some might suggest even that just proves the pomposity of men.

For various reasons, some of which may have been practical as well as social, there were not many women photographers in the nineteenth century, but there is one name we all know. Julia Margaret Cameron is one of the most renowned in the medium's first sixty years. At the time she was working, critics tended to disparage her perceived lack of technique. Technology was always a popular male argument to use against women. Later generations, however, have come to recognize that when it came to making photo-portraits which suggest a certain psychological intimacy, Cameron was decades ahead of her male counterparts.

But it was in the twentieth century, following the First World War to be precise, that women photographers made a great contribution. The 1920s was the era of the modern woman—the flapper—and photography became a suitable modern occupation for the new, emancipated twentieth-century woman. Figures such as Germaine Krull, Florence Henri, Imogen Cunningham, and others were at the forefront of photographic modernism—the New Vision as it was called.

Yet even here it seemed there was a degree of condescension and disparagement from both male commentators and colleagues. Of course, Paul Strand and Edward Weston in America, and Albert Renger-Patzsch in Germany are the key figures, but that does not excuse the relative marginalizing of Krull or Cunningham until relatively recently. Krull created *Métal* (1929), one of the greatest, if not the greatest of classic modernist photobooks,[5] and Cunningham made photographs of the nude that, compared to Weston's, could be considered both more psychologically acute, even more erotic. Indeed, a prescient critic, Julius Craven, made exactly that point in 1931, though he was very much in the minority. Reviewing a Cunningham exhibition at the de Young Museum in San Francisco, he noted that her prints "are softer and less brutal than Weston's prints, her photographs are equally as direct as his, and are frequently, in our opinion, finer than some of his."[6]

I write this preamble and make a particular point about male critics because I wish to consider another, much more recent generation of women photographers, in which the issues surrounding women's photography are particularly acute. This generation is American, was at its most productive and innovative during the 1970s, and yet I have on occasion described it as a "lost" generation, in that many of these photographers and photographic artists have not, in my opinion, been given their proper due in the history of late twentieth-century photography. I want to speculate why this is so, if indeed it is the case, and I am not mistaken in my impression. And I want to do so in the form of an essay that is an exhibition

proposal—a suggestion for an exhibition that would rectify this state of affairs, or at least illuminate a corner of recent photographic history that has been somewhat neglected.

The exhibition would be entitled *From Arbus to Sherman: American Women's Photography, 1965–1985*, and would feature the work of the most interesting of the many photographers active from the mid-'60s to the mid-'80s, who seem to have fallen under the shadow of the two dominant figures in late twentieth-century American photography—Diane Arbus and Cindy Sherman. Featured in this exhibition would be such relatively overlooked artists as Judith Golden, Bea Nettles, Marcia Resnick, Joyce Neimanas, Susan Rankaitis, Eileen Cowin, Barbara Crane, Betty Hahn, Jo Ann Callis, Joan Lyons, Ellen Brooks, Barbara Kasten, Nancy Rexroth, and Barbara Blondeau, to name a few.

This is not to say that all of the individuals above have failed to have successful careers, but in general their names do not arise as often in discussions of American photography from that fruitful period—as do for instance the names Lee Friedlander, Garry Winogrand, Ralph Gibson, David T. Hanson, and Joel Meyerowitz. Whether that is because they are women, and were ignored by the photographic establishment of the time is a moot point. There are complex reasons for this state of affairs, and gender is a part, but only a part of it. Other tangible reasons include the politics of the photo world, geography, and the kind of work they were making.

Although the proposed exhibition would examine the work of individual artists, it would also take an overview, and draw some connections, considering them not as a "school," but as a group of photographers who have certain shared attitudes toward the medium, and broad themes in common. And I would add that these general attitudes derived largely, though not totally, from their gender—and the Women's Movement in particular.

What has been called the "first wave" of contemporary feminism began around the mid-1960s, and was at its height during the period considered here. The same period, between 1965 and 1980, also saw great changes in American photography, when the medium finally gained the (sometimes grudging) acceptance of the art museum and the academy, when galleries devoted solely to the selling of photographic prints encouraged photographers of all persuasions to believe that they could express themselves through the camera. It was an era when many women took up photography, and it was a natural progression that many of them were influenced—some directly, some indirectly—by the issues being aired by the Women's Movement.

The 1960s through the '70s was also a period of widespread formal experimentation in American photography. With the adoption of photography by the museum, and the beginnings of a new collecting culture sponsored by the auction houses and galleries, came an interest not only in photographic history but in the photograph as an object. Photographers became aware that there was more to photographic printmaking than the ubiquitous

gelatin-silver print, and many began eagerly to explore alternative printing processes, both old and new. The influence of Pop art here was vital, as photographers not only saw the appropriation of photographic images by artists such as Robert Rauschenberg and Andy Warhol, but saw them reproduced by means of adventurous printmaking techniques.

Two key exhibitions shown at the Museum of Modern Art were Peter Bunnell's *Photography as Printmaking*, in 1968, and *Photography Into Sculpture*, in 1970.[7] Ironically, both these shows were held at the headquarters of photographic purism, where the director of the Department of Photography, John Szarkowski, was championing a very different kind of photography—the straight, unmanipulated transcription. But as Bunnell explained in a wall introduction to the first show:

"The universally held characterization of the photographer is that he is an observer, that he possesses a vision. In addition to this tenet there is the less realized fact that the photographer is also a printmaker—whether working with paper, metal or plastic, whether in terms of the unique original image or in multiples, whether through customary direct techniques, or synthetics, or combinations. Not all of the photographers who possess vision impart equal sensitivity in printmaking."[8]

Despite these groundbreaking exhibitions, it is here, at the Modern, that we may find one of the possible reasons why we are proposing the notion of a "lost generation." Shortly after curating *Photography Into Sculpture*, Bunnell left the Museum of Modern Art for a professorship at Princeton, leaving Szarkowski free to pursue a program at the museum that focused predominantly upon his rather particular notion of the straight photograph.

It was not that Szarkowski specifically ignored women photographers—we are back here to my opening remarks, and he of course promoted Arbus—but the kind of documentary, usually street-based photography that he espoused was largely a male preserve. It was also a New York thing. The photographers he proposed as the most important of their day—Arbus, Friedlander, and Winogrand—lived on his doorstep, and had an easy entrée to the Modern, although as Szarkowski himself complained, he did not "make" their careers, he merely recognized their talent and encouraged it. Nevertheless, Szarkowski had become the leading arbiter of taste in early '70s photography, not solely because of his position at MoMA (not exactly a hindrance) but because he had such strong views about the medium, and was able to articulate them so persuasively through his elegant writings.

Meanwhile, the women were elsewhere, many miles away from New York—in the Midwest, in the Southwest, in California—and they were making anything but straight photographs. They weren't out on the street photographing "to find out what the world looks like in a photograph." They were in the darkroom or the studio, employing a great variety of photographic techniques, making staged tableaux, and exploring issues like the self, identity, memory, and desire. The kind of photography many of them practiced was not the MoMA-approved variety—largely phenomenological, primarily documentary in

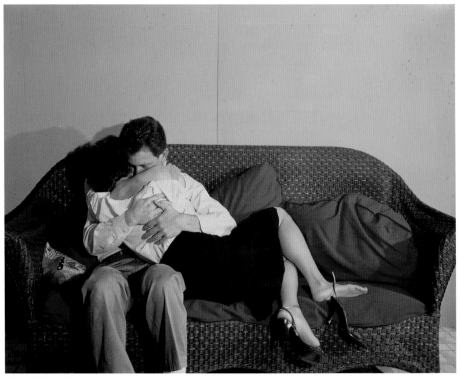

Eileen Cowin, *Untitled*, 1983

mode if not intent—but represented the beginnings of an alternative tradition, parallel to the kind of art that was beginning to be referred to as conceptual. And, when certain European ideas in critical theory, such as semiotics and structuralism, were translated into American practice, the term postmodernism arrived on the scene in the early '70s, and became the great artistic buzzword toward the end of the decade.

American women's photography of the 1970s may be seen therefore, as a challenge to both the largely male culture of straight photographic modernism, and the hegemony of New York and the Museum of Modern Art, in particular. It was not centralized, and certainly not coordinated. We cannot talk of a school, but merely identify certain tendencies. However, it is important to note that with photography being taught more and more in the academy, photographers gathered around centers of learning that boasted outstanding and inspirational teachers. With regard to the type of work I am talking about, we might

mention Van Deren Coke at the University of New Mexico, Nathan and Joan Lyons at the Visual Studies Workshop in Rochester, New York, and Robert Heinecken at UCLA, but there were others at various institutions scattered throughout the country.

In particular there was Minor White, firstly in Rochester, and later at MIT, in Cambridge, Massachusetts. White is crucial. As discussed earlier in this volume, the magazine he had founded in the 1950s, *Aperture*, was the leading journal for the discussion of theoretical issues in American photography. And his own practice, with an emphasis upon the spiritual in photography derived from the transcendentalism of Alfred Stieglitz, was a clear antidote to what some saw as the hard-headed, macho cynicism of the New York "school" of street photographers.

Furthermore, White's brand of modernism embraced the diverse printmaking practices that characterized Bauhaus photography in pre–War Europe, and which had been introduced to America in the 1940s by expatriate Europeans Gyorgy Kepes and László Moholy-Nagy at the New Bauhaus in Chicago, later renamed the Institute of Design. The political imperative that fuelled European modernist photography in the 1920s and '30s had largely dissipated, but the formalist imperative had not.

Inasmuch as one can identify trends in such a diverse and widely spread group of individuals, the general tenor of women's and "alternative" photography in the 1970s might be defined as follows. There were two broad strains, both challenging the photographic document, and both mirroring wider trends in the art world.

The first was the printmaking strain, which encompassed everything from fine printmaking in the classic modernist tradition, to the rediscovery of nineteenth-century photographic techniques, like the cyanotype, platinum printing, and photogravure, to methods borrowed from the traditional arts, such as lithography, seriography (screenprinting), etching, and xerography. The utilization of non-silver processes became an issue, as the preservation of a diminishing natural resource like silver became debated by photographers.

The second major trend, deriving from conceptualism, nineteenth-century photography, and even performance art, was the so-called "directorial" approach. It is as old as photography itself, the notion that perhaps simply recording the world is not enough, and why not "make" photographs rather than simply just "take" them. Although male photographers, including Arthur Tress and Ralph Eugene Meatyard, for example, would arrange scenes to be photographed in the 1970s, this approach seems particularly suited to women photographers, partly because they had something specific to say—something metaphotographic, one might propose—and perhaps also because photographing outside on the street was not without its attendant dangers for a woman.

Within the framework of these two general approaches, two major themes run through much of this work. One was the identity and representation of women, the other was memory and desire.

Of course, these are extremely broad rubrics. What serious photographer is not exploring memory and desire in some way? But the American women photographers of the 1970s honed in on these themes again and again as they related to their lives, and laid the foundations for the concerns of later generations of women photographers, not just in the United States, but worldwide.

However, all this sounds a little generalized and somewhat vague. I think I can better explain the particular qualities of this work by taking a couple of examples. The first is Judith Golden, who both utilized herself as a model to explore representational issues, and also employed complicated printmaking techniques.

Golden's exemplary pictures of the '70s were generally head-and-shoulders portraits. She was of a certain age when she came to photography, and a focus upon feminine icons, who became so because of their looks, had been a major interest. Golden explored the world of the movies some time before Cindy Sherman, representing herself as Marilyn Monroe and, for instance, altering her own appearance not just by using wigs but also by painting and drawing on her prints. She was also noted for appropriating found imagery and incorporating other collage elements into the work, such as sequins, feathers, and scraps of jewelry.

The print as object was also an important element in Golden's armory. Because she painted and drew directly on them, each print was unique, and she added further craft elements, often covering the image with mylar attached by stitching. At the time, stitching was an important part of feminist iconography, as American feminists pointed out that the making of patchwork quilts was a neglected artform, disparaged by men because it was "women's work." Learned treatises were written about the semiotics of embroidery,[9] and a number of photographers and artists like Golden incorporated either actual stitching or representations of it in their work.

Judith Golden can be seen as a key figure in American women's photography between the death of Diane Arbus and the advent of Cindy Sherman. Her work is absolutely exemplary. It is about the self, about the representation of women and their cultural roles, and it foregrounds the craft of printmaking.

Another key figure to my mind is Eileen Cowin, who utilized the "directorial mode," setting up each image with actors, predating Gregory Crewdson by decades. Cowin's pictures slip between reality and illusion, although we are meant to contemplate their "reality" rather than view them as illusions or surrealistic in tenor. But she was not, unlike the documentary photographer, making photographs of specific situations, but instead creating generic situations for the camera. She herself termed them "family docudramas," and that explains their primary focus. She used the form of the set-up carefully controlled, but apparently documentary photograph—studied and calm, without any attempt at heightening reality—to pursue a broadly feminist agenda, to question the whole nature of hetero-

sexual relationships and the central notion of the nuclear family within society. The notion of such a critique was more aligned to a postmodern rather than modernist approach.

Prior to Cowin, most photographers of families, from the snapshooter to more formal portraitists, even social documentarians in the humanist mode, tended to substantiate the idea of domestic bliss, or at least domestic equability. It was no accident that the biggest feel-good photographic exhibition of the twentieth century was called *The Family of Man*, reinforcing a wholly positivist view of family and applying it to the whole of humankind. But *The Family of Man* ignored deep rifts and divisions within the global family. Cowin does not do this with regard to the individual nuclear family. Her rather sour, but telling tableaux depict the family as a place of potential discord, of tensions, and even violence. Her work emphasizes the fact that the traditional patriarchal structure of society tends not to favor the lot of women within the family. She reminds us that human relationships, especially where people are living cheek by jowl, are difficult to sustain without some kind of conflict, as differing aspirations and petty arguments take their toll. Within the family unit, says Cowin, individuals frequently feel solitary and alone.

Judith Golden and Eileen Cowin represent the two main trends in the group of photographers we are considering, the printmaking and directorial strains, although we are most definitely talking about a group of individuals, and within these broad rubrics, there is an extremely wide range of expression. Indeed, individual photographers from this period, since they were caught up in a collective feeling of experimentation washing around American photography, often moved from one mode of expression to another, sometimes slipping between modernism and postmodernism, and combined them as they sought to find their personal voices.

So while I think it is venturing too far to talk of a feminist school of American photography, one can at least point to a range of subject—like the family—that particularly attracted women photographers of this period. However, this concentration upon what might be termed personal and domestic matters does not imply a soft option. Indeed, much of the work in my proposed exhibition would be quietly but insistently political in tone. And while male photographers of the mid-'70s—especially of the New Topographics "school"—were proclaiming their work's "nonjudgmental" qualities, much women's photography was concerned with asking questions, both about gender and American society.

But we must return to that perplexing question—why have so many of these photographic artists been relatively overlooked? We have already speculated upon the hegemony of the Museum of Modern Art and John Szarkowski's resistance to non-straight photography. We have noted that many women photographers were working in established photography centers, but away from established art centers, again, especially New York.

And there seems to me to be another important factor. They can, I think, be considered to have been ahead of their time, making their best work, just on the wrong side of

the postmodernist explosion. With the emphases upon gender and sexual representation, and its skeptical approach to some of society's cherished values, much of this work could be considered "postmodern" in both intent and concept, yet it was often considered to be formalist, and therefore modernist in actuality. Furthermore, it was being shown, in the main, in the likes of university art galleries, in specialist photographic galleries, and in "provincial" galleries at a time when postmodernist and conceptual photography was being introduced in the avant-garde New York galleries and in international art centers such as London, Berlin, and Düsseldorf.

The establishment of the new era of modernist "art photography" in the 1960s was primarily an American phenomenon. When Lee Witkin opened his photographic gallery in New York, in 1969, he created a trend that spread rapidly throughout the United States, aided greatly by the Washington, D.C., dealer Harry Lunn, the single figure most responsible for the establishment of a market for "fine photographs," a hitherto unknown phenomenon. But it was not until the late '70s—beginning in 1975—that Leo Castelli, the doyen of New York art dealers, began to include a few photographers in his stable of artists, and then only in his uptown "works on paper" space and not his main downtown gallery.

Postmodern photography however—photography by "artists utilizing photography"—was international in scope and emanated from the art gallery, not the photographic gallery or under the patronage of John Szarkowski. In 1980, a new gallery opened in New York City. Founded by Janelle Reiring and Helene Winer, the first exhibition at Metro Pictures (a postmodern name if there ever was one) was a group show that included photographs by Sherrie Levine and Cindy Sherman. And they duly took their place alongside the likes of Bernd and Hilla Becher, Richard Prince, Jeff Wall, and Barbara Kruger as leading members of the hottest new art movement in town. They didn't call themselves photographers. They didn't admit to being *photographers*—indeed the last thing they would admit to was being a photographer. They made *photographs*, or rather "lens-based pieces," but it wasn't *photography*, it was *art*.

And many of the women under review, although by no means all, were not perceived as part of this movement, but rather as part of the formalist-experimental phase of '60s and '70s modernist photography. With their emphasis upon female representation and female roles, even upon using photography for role playing, many aspects of what they did anticipated Sherman, yet, as often happens in art, things intermingled and overlapped. Although they may have laid the ground for Cindy Sherman, they came to be overshadowed by her. To be sure, Sherman was a phenomenon, a touchstone for a generation of American art, but both her themes and aspects of her way of working had been under review for a decade or so before she burst upon the American, and then the international art scene.

Apart from a few key figures, many of those involved in the explosion of photographic culture in the United States during the 1960s and '70s have been relatively ignored,

particularly those working in mixed-media. The reputation of figures such as Winogrand and Friedlander continue to grow apace (rightly so), while those of such figures as Jerry Uelsmann and Robert Heinecken atrophy somewhat. The whole Minor White "school," once so vigorous, seemed to die in almost the same instant the master himself died, in 1976. It seems to me that we are now sufficiently distanced to begin to look at this fascinating period in American photography in some depth. It also seems to me that we could do worse than begin with the women.

Notes

1. Gerry Badger, *Photographer as Printmaker* (Arts Council of Great Britain, London, 1981). The exhibition of the same name, containing 153 works by almost as many photographers and artists, was shown at the Ferens Art Gallery, Hull, from August 5 to August 30, 1981, and toured a further five venues in England until April, 1982.

2. Lady Elizabeth Eastlake, *Photography*, in the *London Quarterly Review* (April 1857), pp. 442–468.

3. William Henry Fox Talbot, *The Pencil of Nature* (London: Longman, Brown, Green & Longmans, 1844–46).

4. AA (Anna Atkins), *Photographs of British Algae: Cyanotype Impressions* (Halstead Place, Sevenoaks: Anna Atkins, 1843–53).

5. Germaine Krull, *Métal* (Paris: Librairie des Arts Décoratifs, 1928). There is some dispute as to whether this book came out on December 28, 1928, or January 29, 1929. As Martin Parr and I were researching this issue for the photobook history, we were led to believe that copies were available for the Christmas 1928 market.

6. Julius Craven, "The Art World," in *The Argonaut* (San Francisco), December 25, 1931, p. 8.

7. Peter C. Bunnell's exhibition *Photography as Printmaking* was shown at the Museum of Modern Art, New York, from March 19 to May 26, 1968. *Photography Into Sculpture* was on view from April 8 to July 5, 1970.

8. Peter C. Bunnell, exhibition text from *Photography as Printmaking*.

9. See, for example, Rozsika Parker, *The Subversive Stitch: Embroidery and the Making of the Feminine* (London: Women's Press, 1984).

Without Author or Art: The "Quiet" Photograph

Throughout the development of twentieth-century photography there has been a consistent and obdurate tendency that has been underrated within the general scheme of things. It is so fundamental as to be taken absolutely for granted, largely disregarded, and certainly little remarked upon. It is a characteristic that is invariably in fashion, but is inherently unfashionable. Some of those recognized as being among the medium's greatest practitioners have their work defined by this trait to a large degree. For others, it has proved a contributing factor in their relative neglect. The result of this tendency is what I term the "quiet" photograph.

The "quiet" photograph is a difficult notion to define with any exactitude, partly a question of style, more a question of voice. To begin with, it means essentially what it suggests, that the photographer's voice is not of the hectoring kind, that his or her artistic persona from first to last is modest, self-effacing. The egotistical mediation of the determinedly expressive auteur is politely shunned. The "quiet" photographer focuses upon modest rather than determinedly grand subjects, eschews quirky tricks of technique or vision, and (perhaps crucially) presents the work in an understated way. One cannot really consider a photograph two meters wide to be a quiet photograph, no matter how calm, meditative, or unadorned its subject matter, no matter how much it meets the criteria in other ways.

As Thomas Weski has observed: "Photographers who work in this way do not compose their pictures in the way that artists do; they do not assemble them from various parts, they do not achieve results that are autonomous. Instead, they shape them subtractively and use photographic methods to select, on the basis of their own themes, only a part, a detail, from what is present—from the world, to which they are linked by use of the medium of photography and the obligatory attachment to the referent that it technically requires. . . . Because photographs that are produced in this way have an effect of simplicity, aesthetics for a long period regarded them as being mere documents, and they were not recognized as independent forms of original artistic expression."[1]

The American photographer Lewis Baltz defined the principal criteria of the quiet photographer when he talked of photographs that appear to be "without author or art."[2] He was writing about the New Topographics School of the 1970s, that loose grouping of American photographers who actively explored the notion of minimal mediation. The New Topographers for the most part adopted a stark, frontal, classic style that could be characterized as "non-style," but not all of them were quiet photographers by any means, for it is not style alone that makes a quiet photographer.

Let us, however, briefly consider the question of style. It is one of the more vexing

Stephen Shore, *Room 316, Howard Johnson's, Battle Creek, Michigan*, July 6, 1973

issues confronting the photographer of ambition and serious intent. Every photographer needs to get his or her work noticed, and the most immediate, therefore most conventional way of achieving this is to formulate an instantly recognizable style, an individual voice. It is, they say, the squeaky wheel that gets oiled, the loudest most obvious voice that gains instant attention, though in the long run, the stentorian clamor might not necessarily be heeded. Nevertheless, every artist must develop some kind of authorial consistency in his or her work, or else it is formless—and form, in one way or another, must always be the artist's goal. There are, of course, many ways of cultivating this necessary state of affairs, some of which are consciously, even artificially grafted on to the corpus of the work, others that emanate from deep within the photographer's persona, as ineffable as his or her subconscious. It is safe to say that the style each individual eventually settles upon, their

creative calling card, is a complex mélange of conscious and unconscious elements, carefully considered or completely intuitive, imported from the "outside" or dredged up from "within."

The great problem with style is that it is essentially reductive, a refining of the look of a work so that each single image relates formally to another. Style indeed, might be defined as the formal establishment of constraints by the artist—be they technical, formalist, conceptual, or contextual. Think of almost any major painter or sculptor of the twentieth century (for style is largely, though not exclusively a twentieth-century issue), and you can name a few key works that define the style, all others emanating from or revolving around the keys. Only the very greatest individuals, those with huge artistic personas, and imaginations to match—like Picasso or Duchamp—escape the straitjacket, or the discipline of style, and then sheer force of personality, rather than the more usual stylistic traits becomes the "style." The rest of us are confined to plowing narrower furrows, although the narrow furrow can contain its depths, as we might see if we consider, for example, the relatively buttoned-up Braque in relation to the protean Picasso.

The Mark Rothko tendency, the desire to distill and refine an imagery of rigidly finite scope, has been, and is, a popular trait in modern photography. Many photographers adopt a consciously reductive stance in relation to subject matter. They become known for focusing upon a particular subject, often in conjunction with a particular technique, deliberately restricting the choices open to them in the search for style. It is especially marked in current photographic circles, promoted in part by the postmodern interest in serial imagery, but also, I believe, by the exigencies of style.

Hiroshi Sugimoto, for instance, repeats the same photograph over and over again in long series. His seascapes repeat the same view, with the horizon splitting the frame exactly in two. In each image, the light might be very different, giving the work a lot of variation, yet the simple compositional strategy immediately marks them as "Sugimotos." Bernd and Hilla Becher's choice of subject matter, viewpoint, and technique is so refined and reductive that a very strong authorial stamp indeed has been established, almost to the extent of proscribing their subject matter, far less their approach, for anyone else. Understated, calm, meditative—certainly—but quiet, not in the least. The images of both Sugimoto and the Bechers positively scream that they are predestined for eloquently serial hanging in the dazzling white restraint of the contemporary gallery space—and that, I suspect, is a major reason for their current near ubiquity.

Neither *understated* nor *quiet* are adjectives that could be utilized to describe the work of Bill Brandt or W. Eugene Smith, two of the best-known exponents of another well-used strategy by photographers in search of authorial recognition, and which might be considered the antithesis of the Bechers and the Düsseldorf School approach. Brandt, like many photographers, roamed over diverse subject matter, ranging from gritty social documents

to theatrical portraits to glowering landscapes to abstractionist nudes. He pulled this diversity together in the darkroom, by adopting a consistently moody printing technique—in his early days by printing everything in dark, muddy gray tones, then, from around the mid-'60s onward, by using bold blacks and whites. Smith, desperate to get his concern across, used an exaggerated chiaroscuro that often lent his images a schmaltzy rather than dramatic air. Their influence upon young photographers of the 1960s and '70s was a pervasive one, so much so that much European photography in particular seemed to misplace the subtle art of the soft, long-scaled print for almost two decades. And all too few of those making photographs of an unremitting, but undeniably graphic harshness bothered to question why they were doing it, except that it created instant mood and was the prevailing tendency.

Operatic is the word for photographs like Brandt's and Smith's, which bellow for attention, and that blatantly and often self-consciously mediate between reality and image. *Arty* might be another word, and while one would hardly deny that the photographic medium, in some hands, is capable of high art, this essay would contend that the "art" of photography frequently does not lie in the hands of the self-proclaimed arty photographer—despite popular conception, and even critical opinion to the contrary. Brandt and Smith, *despite* and not *because* of the graphic ebullience of their work, were clearly major photographers, their work evincing psychological complexities and subtleties way beyond the many who would propose that stark chiaroscuro equals profundity.

It should be clear from the preceding that the quiet photograph should not be confused with that key tenet of photographic modernism—the notion of the "straight" photograph, where an "unmanipulated" print is made from a negative that has not been tampered with to any degree. By definition, the quiet photograph must always be a straight photograph, but the straight photograph is not necessarily a quiet photograph. In terms of the generally accepted conventions of modernist photography, both Brandt and Smith are considered straight photographers, although both photographers' penchant for heavily worked prints places them near the fringe of the straight tradition. A rather more obvious example that straight is not necessarily quiet might be the master of the bravura American landscape, Ansel Adams.

There is, as I have intimated, another relatively recent tactic in the attention-grabbing stakes. It is now almost de rigueur for exhibition photographs to be enlarged up to mural size, whether they are technically suitable for such extremes or not—though to ignore the shibboleth of technical perfection for its own sake is not altogether a bad thing. Some work undoubtedly gains from being printed big, but much does not, and there are many instances I can cite of imagery being pushed beyond its natural limits. If it is a mediocre image when printed at 24 by 20 centimeters, it might be superficially more impressive in a 240-by-200-centimeter print, but physical presence should not be the sole criterion

and confused with artistic gravity. That is the kind of thinking behind some of the worst excesses of the nineteenth-century salon exhibition. Which, upon reflection, is perhaps not so far removed from *certain* postmodernist strategies.

However, what of the photographer who will not restrict him or herself to the drastically limited subject or to the rigidly prescribed pictorial schema? Or who eschews flamboyant printing techniques or refuses, per the slogan of the popular hamburger chain, to "go large?" What of the photographer who will not shout by drawing attention to style in any way? I think it is high time that we celebrate them, for they have chosen—and it is a matter of deliberate choice, guided by sensibility and temperament—to take a potentially hard road. The quiet photograph, by definition, does not court popularity and easy plaudits.

"Without author or art" . . . I return to that phrase by Lewis Baltz, which seems as good a place as any to begin a more detailed consideration of the philosophical attitudes that underpin the quiet photograph. In reference to New Topographics, Baltz was describing a documentary ideal, and relating the work of the New Topographers to that of the "Old Topographers," such photographers of the American West as the exemplary Timothy O'Sullivan, whose stark expeditionary landscapes appeared to fulfill the non-authorial criterion to perfection. Until rescued from obscurity in the 1930s (rather improbably it might seem) by the far-from-quiet Ansel Adams,[3] O'Sullivan's empty, unflashy landscapes had been regarded as rather dull and unlovely, plain pictures taken for a plain purpose, for purely functional, documentary reasons, without any attempt at self-expression on the part of their maker. Although it has been demonstrated recently that, contrary to received wisdom, the degree of authorial mediation in O'Sullivan was quite considerable,[4] for the young landscape photographers of the mid-'70s, the imagery of the early Western photographers amply fulfilled its role as a model for a photography that was less about authorial gesture and expression, and more about seeing—that is to say, about replicating the world with the maximum degree of transparency, and drawing minimal attention to itself as either artifact or work of art.

Coupled with an interest in early topographical photography, some of the New Topographers were also influenced by ideas culled from conceptual art practices, relating to "automative" photography. These ideas derived once more from photography by anonymous journeymen, but rather less directly, filtered through Surrealism, conceptualism, and notions of serial imagery, where viewpoint and subject choices were made at "random" in an attempt to limit the authorial role. William Jenkins's exhibition, *New Topographics*, a seminal influence on mid-'70s photography, considered work in this conceptual vein as well as imagery influenced directly by early documentary photography.[5] It should be stressed, however, that the two tendencies produced work that is very different in concept and intent, though to the uninitiated or the careless it may look almost identical. But that of course is one of the perennial problems of criticism. To many people still, a photograph is

a photograph is a photograph. The results derived from these differing philosophies, however, may be characterized as follows. One is derived essentially from an appreciation and adherence to photography's documentary roots, the other is embedded deep within the history of twentieth-century art practices. As Jenkins pointed out in his introduction to the exhibition's catalog, the difference between artist Ed Ruscha's *Twentysix Gasoline Stations* or the Bechers' cooling towers, and photographer John Schott's series documenting hotels along Route 66 is both fundamental and significant. Schott himself, acutely aware of the distinction, summarized it with admirable brevity: "[Ruscha's pictures] are not statements about the world through art, they are statements about art through the world."[6]

It would follow that a photographic image therefore, which proposes some kind of proposition about art will not fall within our remit for the quiet photograph, for no image dealing essentially with art rather than the world is devoid from making a noise about art, of existing "without art." Indeed, we have already observed this in the work of the Bechers and Sugimoto, or, for that matter, of Thomas Struth or Andreas Gursky, or numerous other German "artists using photography" who derive from the "typological" tradition established by the Bechers at the Düsseldorf Academy of Fine Arts. And of the original American participants in *New Topographics*, it is interesting to note that it is Lewis Baltz, arguably the most programmatic member of the group at the time, who has made the most calculated shift from photography to "art." Baltz moved to Europe—a perhaps not insignificant factor—and now makes photographic "installations" for specific gallery spaces, eschewing neither author nor art in the process. Stephen Shore, Robert Adams, Frank Gohlke, and Nicholas Nixon, however, have continued to make photographs, and eminently quiet photographs at that.

It may be, without being too dogmatic about it, that we are beginning to propose a possible cultural divergence here, between an essentially American and European way of considering the photographic image—despite cross-cultural influences and the establishment of the postmodernist hegemony in America. We certainly can point to the differences between a "painterly" and "photographic" approach to the photograph. For example, the yawning chasm dividing the notion of the quiet photograph from its corollary was never better illustrated than in an exhibition organized by James Lingwood and Jean-François Chevrier for London's Institute of Contemporary Arts in the late 1980s. *Another Objectivity* proposed, in the words of Iwona Blazwick, a notion of art using photography that "refuses equally the consolations of manipulation, nostalgic lyricism, and an uncritical fascination with the simulacrum, and which does not accept the orthodoxies of critical and institutional life which divide description from fiction, the act of recording from creation."[7]

To my mind, having produced in that statement a definition that would serve serious documentary photography equally well as conceptual photography and "photo painting," what the show actually delivered for the most part was *big* prints—large photographs of

often banal subject matter by such scions of the "artists utilizing photography" movement as the ubiquitous Bechers, Struth, Craigie Horsfield, Hannah Collins, and John Coplans. The muralist syndrome writ large. There was, however, tucked away in a remote upstairs gallery, a conspicuous and welcome exception to this grandiosity, in terms of both conception and presentation. In the midst of this display of the photographic "size queen" tendency and precisely programmed, preconceived auteurism, the work of Robert Adams shone out by virtue of its modest and clearly intuitive approach—the quiet, one might say, trumping the clamorous, and photography being clearly differentiated from "art," although whether that was the curators' precise intention I am far from certain.

The quiet photographer then, remains a photographer, and would seek to be recognized as such, though undoubtedly seen to be practicing an independent form of artistic expression. The crucial difference remains one of voice. The voice of the quiet photographer remains modest because his or her referent is not the art scene, but the world. For example, the Bechers' enormous catalog of industrial structures, though it may function as an extremely valuable documentary archive, nevertheless is not "about" these structures— it is essentially "about" an issue of aesthetics. Whereas the Los Angeles images of Robert Adams shown in *Another Objectivity* were primarily "about" environmental ravages in the Los Angeles basin. This is not to say that the Bechers were unconcerned about the things they recorded (they were absolutely passionate), nor that Adams is oblivious to the "look" of his images, but that their prime concerns are fundamentally different. And in Adams's case, and in that of others I would characterize as quiet photographers, this does not predicate an "uncritical fascination with the simulacrum," as Blazwick avers, nor a "division of description from fiction."[8]

One might add also that it is not a question of differentiating between a *mirror* and a *window* upon the world—the successful photograph by the serious quiet photographer is most likely to be a complicated amalgam of mirror and window, an ineffable struggle between subjectivity and objectivity. Like anyone else wrestling with this tricky medium, the quiet photographer is totally assured of the fact that a "simple," "straightforward" act of recording is anything but. The quiet photographer, however, will not draw *undue* attention to that process, nor, for that matter, to the process of apprehending the resultant image by the viewer. The goal of the quiet photographer is an elusive one, the illusion of transparency, but not a dumb or mute transparency. Quiet photographs do not lack a voice, but that voice is always calm, measured, appropriate, reasonable—even when at the service of strongly held political opinion. As Nicholas Nixon has written: "The world is infinitely more interesting than any of my opinions concerning it. This is not a description of a style or an artistic posture, but my profound conviction."[9]

That frequently quoted statement is an essential plank in the quiet photographer platform, but it should not be misconstrued. At the time of the *New Topographics* exhibition,

when the statement was made, two of the critical buzzwords defining the work in the show were *nonjudgmental* and *neutral*. Such adjectives and Nixon's aphorism, coupled with similar observations from fellow New Topographers, would seem to indicate that the quiet photographer has little interest in what he or she photographs, that the world is simply grist to the image mill, that the results of their labors will be baldly asocial or ahistoric, that the photographic will mean nothing in relation to the world, only to itself as an image or artifact—the classic so-called "modernist" position in fact.

Yet if we think of the work of say Robert Adams, Gohlke, Richard Misrach, or even Nixon and Stephen Shore—essentially quiet photographers all—it is patently obvious that they care about the "world" they photograph. Indeed, the essence of the quiet approach is that the "world," the subject, is respected as much as possible, and the mediation— the interference—of the auteur kept to a minimum. Nixon's photographs of dying AIDS patients are a case in point. As a quiet photographer, he scrupulously maintains the camera's inherent neutrality, keeping the emotional temperature on an even keel, knowing that there is emotion enough in the subject to make the point that he, as an artist, is trying to communicate. The quiet photographer, in other words, respects and trusts his subject— and for that matter, himself. By maintaining a discreet emotional distance from his subject, he allows it to tell its own story, and as the conduit for this story, is content, indeed insistent upon subordinating his own "story," if you like. The quiet photographer does not lack a voice nor emotional engagement, but deliberately relegates it and allows it to emerge through the subject, rather than imposing it from the outside and thereby, to his mind, potentially confusing the issue. The quiet photograph is not necessarily a cool photograph, though its warmth may take a little time to emerge.

Let us take an extreme, yet pertinent example. If we were unfortunate enough to encounter a pile of corpses, one of those atrocities of war that still seem all too common, we could arguably take two primary approaches to the business of providing photographic evidence for the world. We could take what one might term the Gene Smith or Don McCullin approach, and try to intensify the horror of the scene, firmly indicting those responsible. We could compose our images artfully in pietà-like aspects, employ the stark, horrific close-up and dramatic chiaroscuro—do everything, in short, to force the issue into the minds of readers with (we perhaps arrogantly assume) the attention spans of gnats. Or we could take the quiet photographer approach, and simply show dry facts, in a calm, measured way, like Nixon, or a police crime scene photographer. Either approach will have its advocates—and its successes and failures (for it comes down, in the end, to photographer talent)—but the studied neutrality of the quiet photographer does not mean that the photographer himself lacks emotion or opinion. He just will not garnish, or overlay the facts in an overly tendentious display of gratuitous subjectivity.

As Heinz Liesbrock writes, in reference to Stephen Shore, the quiet photographer

is seeking a delicate, almost imperceptible balance between subject and object, between record and image: "What he is attempting to achieve is a balance between the external world and the photographic author, or, to put it more precisely, an absolute point at which the photographer, with his personal tendencies and preferences, withdraws behind the visible world, and dissolves himself into the formal structure of the images—which also means, precisely, that he makes himself present in it."[10]

Shore himself quotes Hamlet's injunction to "o'erstep not the modesty of Nature" and the example of the Chinese poets: "Chinese poetry rarely trespasses beyond the bounds of actuality. Whereas Western poets will take actualities as points of departure for exaggeration or fantasy, or else as shadows of contrast against dreams of unreality, the great Chinese poets accept the world exactly as they find it in all its terms, and with profound simplicity find therein sufficient solace. Even in phraseology they seldom talk about the thing in terms of another, but are able enough and sure enough as artists to make the ultimately exact terms become the beautiful terms."[11]

Nevertheless, despite Shore's apparently uncritical acceptance of Asian fatalism, he is still talking about art, and the necessity of art to transcend. While remaining exactly what it is, subject matter is also transformed into image. Such a notion is not so far removed in fact and spirit from nineteenth-century American transcendentalism, which of course had its own philosophical links with Asian thought, including the mutual idea of the artist as a near anonymous, but vital conduit—Ralph Waldo Emerson's "transparent eyeball."

That seems perfectly in accord with Shore's vision, and that of innumerable American straight photographers, whose almost mystical regard for the integrity of the object and a nonjudgmental approach is part of a major, perhaps *the* major strain in not just photography, but American visual art over four centuries. It is not by chance that so many quiet photographers are American, and afflicted by what Europeans tend to regard as a maddening reluctance either to practice intellectual aggrandizement or make overt political judgments in their imagery.

The quiet photograph then, might be considered as both ethic and aesthetic, for like any issue concerning the making of visual images, formal considerations are inevitably involved. The quiet photographer may share the kind of determined will toward objectivity with conceptual photographers such as Gursky or Struth, but if the means are congruent the end is divergent. The quiet photographer and the practitioners of the new conceptual objectivity may share, at the moment of taking, a predilection for what can be discerned as a hiding of the artist's hand. Frank Gohlke has written of his desire to achieve what he terms a "passive" frame, in which the image appears not to have been composed actively, with any great forethought, but has happened "naturally," as it where. The image reads as merely a part of the world with a boundary placed haphazardly around it, and there is a "sense of the frame having been laid on an existing scene without interpreting it very

much."[12] This is very different from the strict, rigidly formalized framing of the Becher school and its satellites.

The sense of noninterpretation in the quiet photograph, however, which can be somewhat discomfiting to many, is basically formal. The primary involvement of this kind of artist—transcending the merely formal—is with reality, and simple, unfettered reality can be uncomfortable. We *are* talking simulacrum to a large degree, but not, I would submit, an uncritical or unthinking simulacrum. Clearly, the objective "conceptualist" and the quiet photographer share a number of mutual concerns, particularly revolving around photography's faculty to provide a simulacrum that is not a simulacrum and so on. The difference, as I have reiterated constantly, is one of emphasis, and voice, but the importance of that subtle distinction cannot be overemphasized. To make successful quiet photographs— particularly in a climate where, arguably, the world has been overphotographed and some would propose a moratorium—is not easy. Quiet photographs demand a high degree of intellectual rigor, awareness, and purpose on the part of their makers—and I use the word *maker* rather than *taker* advisedly. Furthermore, quiet photographs also require work on the part of their viewers in order that their subtleties might be fully appreciated. The quiet photograph is neither document nor aesthetic object nor simulacrum nor fictional tale, but a combination of all four, a different combination in the hands of every individual photographer. Its finer pleasures are perhaps not easily enjoyed, yet might be ruefully appreciated by anyone who has attempted—and who among us has not?—the nominally simple, but endlessly slippery task of freezing reality with grace, economy, and truth.

As we stand not long after the beginning of a new millennium, it seems clear that the quiet photograph is a threatened species, but it was ever thus. It was always an unshowy breed, difficult and diffident, unused to the limelight, but by that token a stubborn and obdurate creature. As Lincoln Kirstein wrote (was it really over sixty years ago?), good photography has modest yet enduring standards. Imagistic fashions and stylistic exaggerations come and go, excess and superficial profundity have their seasons, but the basic root of the photographic endeavour must continue to exert its fascination, heralded or not: "Always, however, certain photographers with a creative attitude and a clean eye have continued to catalogue the facts of their epoch. . . A large quality of eye and a grand openness of vision are the only signature of great photography and make much of it seem, whatever its date or authorship, the work of the same man done at the same time, or even, perhaps, the creation of the unaided machine."[13]

Notes

1. Thomas Weski, "Expeditions to Explored Areas," in *Stephen Shore: Photographs 1973–1993* (Munich: Schirmer Art Books, 1994).

2. Lewis Baltz, review of *The New West: Landscapes Along the Colorado Front Range* by Robert Adams, in *Art in America* (New York), Vol. 63, No. 2 (March–April, 1975), p. 41.

3. See Beaumont Newhall, "This Was 1937," in *Popular Photography* (New York), Vol. 60, No. 5 (May 1967), p. 144. Having invited Ansel Adams to participate in his exhibition *Photography 1839–1937* at the Museum of Modern Art, Newhall writes: "He replied to my invitation with enthusiasm. Not only did he send his own photographs, but he brought to my attention the photographs of the Southwest by a 19th century photographer known only to me by his Civil War photographs: Timothy H. O'Sullivan."

4. See, for example, Joel Snyder, *American Frontiers: The Photographs of Timothy H. O'Sullivan, 1867–1874* (New York: Aperture, 1981) and Rick Dingus, *The Photographic Artifacts of Timothy O'Sullivan* (Albuquerque: University of New Mexico Press, 1982). Both authors demonstrate convincingly that O'Sullivan's images were not composed spontaneously, taking their cue entirely from what was in front of the camera, but were in fact the product of complex cultural ideas regarding the land, its formation, and its representation.

5. In this regard, the inclusion of the "typologies" of Bernd and Hilla Becher and the citing of Ed Ruscha as a seminal influence in the catalog essay was crucial.

6. John Schott, quoted in William Jenkins, introduction to *New Topographics: Photographs of a Man-altered Landscape* (Rochester, New York: International Museum of Photography at George Eastman House, 1975), unpaginated.

7. Iwona Blazwick, preface to James Lingwood and Jean-François Chevrier, *Another Objectivity* (London: Institute of Contemporary Arts, 1988), unpaginated.

8. Ibid.

9. Nicholas Nixon, quoted in Jenkins, *New Topographics*, unpaginated.

10. Heinz Liesbrock, "That You O'erstep Not the Modesty of Nature," in *Stephen Shore: Photographs 1973–1993*, p. 11.

11. Stephen Shore, quoted in Liesbrock, p. 11.

12. Frank Gohlke, quoted in Jenkins, *New Topographics*, unpaginated.

13. Lincoln Kirstein, afterword to Walker Evans, *American Photographs* (New York: Museum of Modern Art, 1938), pp. 188–189.

Elliptical Narratives: Some Thoughts on the Photobook

When we began our history of the photobook, Martin Parr and I quickly realized that we were dealing not simply with a study of books, but a history of photography — one of the many alternative histories that could be written about this ubiquitous and culturally diverse medium. It was our conscious intention from the beginning not just to write about photobooks per se, but how they were culturally embedded, shaping our notion of the times in which they were produced. Clearly, most photography reflects — indeed should reflect — the age in which it was produced, but it was interesting how sharply this became apparent when we had a number of photobooks from a particular era or country in front of us.

So we could determine that nineteenth-century books from Great Britain and France were largely about exploration and discovering the world (in order to "acquire" it), demonstrating the natural impulse of the two great colonial powers. We could appreciate how in the troubled 1930s, the photobook became an effective tool of political propaganda, whether in the totalitarian Soviet Union and Nazi Germany, or as part of Roosevelt's New Deal program in the United States. Following the Second World War, photobooks both looked back at the conflict and forward to the making of the new Europe. In the late 1960s and early '70s in Japan they became vehicles for apparently nihilistic photographers who were still consumed by Hiroshima and Nagasaki and Japanese-American relations. Through the medium of the book, photographers reacted in different ways, some obliquely, some directly, to the political and cultural events of their era.

We were therefore not writing a peripheral history of photography, an alternative history, but what was in our view a central and thoroughly mainstream history of the medium, yet one harvested from soil that had hardly been tilled before.[1] It could be argued (although I'm not going to do so here) that a history of photography through the photobook is a deal broader, more mainstream, more culturally and historically relevant than a history of photography through photographic art.

However, we were not denigrating photographic art, far from it. We also were not proposing a history of the photographically illustrated book — a near impossible task anyway — but a history of the genre we defined, as have others, as the *photobook*. This might be termed the "literary novel" of photographically illustrated books, if you like, although frequently we were concerned with result and affect rather than initial intent. In the main, we were concerned with the photobook as a means of expression on the part of those producing it, not only photographers, but typographers, graphic designers, and producers. We were concerned with the art of photography, but also with the art of the book. As Ralph Prins has written: "A photobook is an autonomous art form, comparable with a piece of sculpture, a play or a film. The photographs lose their own photographic character as

Paul Graham, *Las Vegas, 2005 (part 4 of 6)*, from the series a shimmer of possibility

'things in themselves' and become parts, translated into printing ink, of a dramatic event called a book."[2]

As we got more immersed in our task, I for one was slightly surprised—not Martin because he has the disease in spades—at how avid photobook advocates are, and how many of them there are around the world. On a scale of fanatical cultural partisanship, they rank with devotees of Bob Dylan and Richard Wagner. That is to say, they are passionate beyond measure. And that includes collectors as well as photographers who make photobooks.

Above all, lovers of photobooks believe—and I am with them on this—that it is here where photography sings its loudest, and importantly, its deepest and most complex song. And there is one simple, but far-reaching reason for this. The photobook can be regarded as an extension of the photo-essay, a group of images brought together to make a "picture story"—the genre that came of age in the 1920s and '30s, and which defined a new profession, that of the photojournalist. This is why, despite the fact there were great photobooks

prior to the '30s—from the very beginnings of the medium—I would contend that the form as defined by Prins really only came of age at the end of the '20s. It is an essentially modernist form—more so indeed than the photo-essay, which had its generic beginnings in the engraved illustration.

The goal, of course, and the reason for the photographer's attachment to the photo-book, is meaning. The photobook, in short, is about narrative, making photographs tell a story, giving them relevant meaning. For in spite of their apparently clear and concrete relationship to the world, photographs are fragile and slippery carriers of meaning, at least beyond the level of "what you see is what you get." A photograph is an abstracted trace of reality, in which time is abnormally suspended, making photography an inherently unreliable witness—precisely because it seems so finite and irrefutable compared to other forms of documentary imagery.

Paradoxically, the closer a photograph comes to being a dry, expressionless record, the more ineffable it can appear to be. A single photograph can express much, but in a narrative sense, it is like a single word. Without other "words," there can be no sentences, paragraphs, and chapters. The single photograph can only go so far, although in the case of a masterpiece, many might think that is far enough—and on occasion it is so.

However, many photographers of ambition seek that extra ten yards, and strive for narrative content, seeking to become authors as well as *auteurs*. Lewis Baltz once said (and I make no apology for quoting this for the umpteenth time) that, "*it is possibly useful to think of creative photography as a narrow but deep area lying between the cinema and the novel.*"[3] It is the search for this quality, for narrative, that draws photographers to the photobook. Few of the greatest photographers have failed to make a significant photobook. And paradoxically, there are many who could not be accounted for as great, but who have made significant photobooks. One might say that there is at least one photobook in every photographer—or should be. It is one of the most positive things about the digital photography age, with the advent of online printing and "print on demand" books, that there is a boom in self-made photographic books. In a real sense, we are back at the medium's beginning, when all photographs were made for books, or at least presented in albums.

Primarily through narration, the photobook gives photographers a voice as well as style. Because of narrative voice, style becomes less important, and photography less of a formalist medium, a much more rounded form of expression.

The goal of the photobook then, is narration, but what kind of narrative are we talking about? In theory, the possibilities are endless, but sticking a few photographs together in sequence does not instantly solve the problem of photography's ineffability. Indeed, it seems to me that many of the best photobooks do not attempt to address this particular quality, but harness it and use it to advantage rather than fight against it. It is this kind of photobook I want to talk about, one that utilizes elliptical, or nonlinear narrative—the

kind of photobook in which poetry and mystery are the order of the day rather than clarity and the concrete.

In this essay I intend to consider the photographic book in terms of the film rather the novel, for a number of reasons. The most obvious is that the photobook is imagistic. We talk frequently of the language of photography, its vocabulary and its syntax. That's fair enough, I've just done so myself a few paragraphs ago. It's a perfectly acceptable way of coming to grips with some of the medium's complexities, as long as we remember that photography is not a language in the strict sense. A photograph is not really a word, but it is certainly synonymous with the single film frame—in fact they are exactly the same thing—and as a collective entity, the photobook, as I hope to demonstrate, shares particular characteristics with the film.

Furthermore, the photobooks I want to consider here were made during periods when the most advanced filmmakers were exploring various kinds of nonlinear narrative expression. And photographers were not immune to filmmaking ideas, even if unconsciously. Photography and film have always been closely linked—many still photographers, many photobook makers, have also tried their hand at making movies—and the thought processes involved in editing and sequencing a film are not so different from editing and sequencing a photobook.

Therefore, despite my instinctive aversion to theory, a little film theory on the subject of narrative is, I feel, a useful tool for understanding the photographic book.

I have mentioned nonlinear, or elliptical narrative, in relation to photobooks. Actually, they are not exactly the same thing, so we had better define our terms before we proceed further. Basically, narrative as understood by film theorists involves the linear arrangement of events, selected and sequenced in a logical order, especially in a temporal sense. Cause and effect is the keynote, a story that proceeds logically and sequentially in time. A gang plans a robbery. They carry it out, but something goes wrong. They fall out, someone betrays them, and they are brought to book, after a lot of shooting, blood, and guts. That is traditional linear movie narrative, which is often called—usually pejoratively— "Hollywood narrative." Films utilizing linear narrative have a beginning, a middle, and an end—preferably, from a Hollywood point of view, a happy, or at least a resolved ending.

Jean-Luc Godard agreed with that, but with a decided sting in the tail. "A film should have a beginning, a middle, and an end," he famously remarked, "but not necessarily in that order."[4] That, of course, is nonlinear narrative defined in a nutshell.

Elliptical narrative is slightly different. It is possible for linear narrative to be elliptical. The narrative might proceed straightforwardly in say, a temporal sense, but the imagery driving the narrative could still be related to the story in an off-kilter, allusive, or abstruse way. However, an author who has chosen to narrate in a linear manner does so because it is more comprehensible. Linear narrative is inherently populist, accentuating the familiar,

the known, and the predictable. We can go further and say that it offers reassurance and solace. We usually know where we are with linear narrative, any plot twists merely delay the inevitable resolution. Therefore, we can say that this form predicates a certain conservatism, whereas nonlinear narrative, by its very nature somewhat more uncertain and unpredictable, is much more radical in concept, both formally and politically.

Indeed, there was a whole tendency on the part of the avant-garde in twentieth-century art, in literature, the theater, and the cinema—the narrative arts in short—to explore nonlinear and elliptical narrative forms, primarily in response to the conservatism of linear narrative. But even among conservatives, the attraction of the more elliptical voice could not be denied. In the Hollywood film, for instance, nonlinear and elliptical episodes could creep into otherwise straightforward narratives, in the form of such interruptions as flashbacks and dream sequences.

If, as I have contended, the photobook really came of age in the late 1920s and '30s, it is surely no coincidence that this was the era that saw the rise of both popular and avant-garde cinema—commercial, experimental, documentary, and propagandist filmmaking all making great strides. It was also the era of Dada and Surrealism, and the first "artist films," the progenitors of video art.

From the Surrealist movie, and film in both Russia and Germany, came the notion of montage as a device, where scenes and images are intercut and overlapped, and narrative continually disrupted. And although Surrealist film had certain different objectives, it was closely linked to the montage-driven, modernist *Cinéma Pur* movement of the 1920s. As Ian Aitken has written: "The *Cinéma Pur* attempted to isolate the fundamental formal properties of shape, form, rhythm and movement of the medium of film."[5]

Man Ray of course was a multidisciplined artist, known as a painter, a photographer, and a maker of sculptural readymades—as well as a producer of photobooks. He is probably least known as a filmmaker. Influenced by fellow Surrealists, including Luis Buñuel, he made a number of experimental films, in which the narrative is elliptical to say the least. Man Ray's earliest films, *Le retour à la raison* (Return to Reason, 1923) and *Emak-Bakia* (Leave Me Alone, 1926), are more purely abstract and modernist in style—*Cinéma Pur* in short, albeit with a surreal twist or two. In these movies, he made use of devices like animated screen textures, Rayograms, double exposures, and soft focus effects, creating filmic collages that are essentially photo-poems. Later films like *L'étoile de mer* (Starfish, 1928) and *Les mystères du château du Dé* (Mysteries of the Château of Dice, 1929) are more conventionally Surrealist in tone, if conventional is the apposite way to describe a Surrealist film. Here, Man Ray created some kind of narrative flow, but they were narratives of dreamscapes, replete with disjunctive imagery and disrupted flows.

In 1920s Russia, filmmakers also were exploring the language of film and nonlinear narrative. Their agenda was more actively political, but like the Surrealists, they were

inherently anti-bourgeois, and in their films they determinedly eschewed stock theatrical devices and literary conventions that had their origins in "bourgeois culture," such as story, setting, and character. Leading theorist and filmmaker Dziga Vertov advocated the use of montaging to structure a movie, whereby shots and scenes are piled up, not to create a linear narrative, but to weave a complex tapestry of what he termed *kino-fakty* (film facts) in order to connote *zhizn r rasploch* (life caught unawares). He demonstrated it brilliantly in his masterpiece *Chelovek s Kinopparaton* (Man with a Movie Camera, 1929).

All this clearly had parallels with the new forms explored in still photography, especially the "candid camera" essays found in the photographically illustrated magazines, and perhaps even more so in the photobook. Two volumes published in that same miraculous few years for the photographic arts—1928 to 1931—demonstrate a comparable sensibility, a sensibility that was carried forward in subsequent years.

The Lithuanian photographer, Moï Ver, had studied at the Bauhaus, and had come to Paris at the beginning of the '30s in order to study film when he made the photographs that would be published in his photobook masterpiece, *Paris* (1931).[6] This is one of the primary examples of a photographic book being structured like a film—both within the single image and within the sequence—whereby the technique of montage is utilized to create a kaleidoscopic effect. It produced a volume in which almost all narrative is sublimated in favor of a whirlwind of sight impressions, even impressions of motion, with photographs appearing to vibrate and move, like almost no others in still photography. Like some of the Surrealist films where cogent narrative progression is hinted at, simply because we seek meaningful connections however tenuous or illusory they might be, *Paris* challenges us to make our own meaning out of the vibrant flux of collaged imagery.

But *Paris* is a product of modernism, not Surrealism. Its great predecessor, or rather near contemporary, was Germaine Krull's *Métal* (1928).[7] One could argue whether Krull's monument of modernist photography was a book or a portfolio. It was a "book in a box" and its imagery created not one, but endless elliptical narratives, as the pictures could be shuffled at will and read in any way the viewer desired. Krull had worked with, and even contracted a morganatic marriage with the Dutch filmmaker Joris Ivens, and like *Paris*, *Métal* is not only filmic in concept but a paean to the modern metropolis and modern engineering. In their uncertainties and jagged edges, both are exciting books, yet their excitements seem to reflect both sides of the modern era, not only its energies but also its alienation and anonymity, the dehumanizing effect of the machine world.

This idea of the duality of contemporary urban life as both brave new world and as nightmare—it could also be applied to rural life but seems more appropriate to the metropolis—is a strong theme running through the photobook from the 1920s onward, and is most often expressed by the use of elliptical or nonlinear narrative. This perhaps goes against the grain, for at first glance it appears that the very idea of the book predicates

a linear narrative structure. One proceeds from one page to the next, from beginning to end. But in actuality, the book is set up even more efficiently than the film for nonlinear narrative. The film begins, and you cannot help but watch it through in a strict temporal progression. You can dip into a book, however, at any point. How many people pick up a photobook and begin flicking through the pages from back to front? The Japanese photobook is even programmed for a dual reading; one can turn the pages from left to right in the traditional Japanese way, or do the opposite, if looking at it in the Western manner.

For instance, Takuma Nakahira's *Kitaru beki kotoba no tame ni* (For a Language to Come, 1970)[8] is deliberately ambiguous in this way. I believe that it reads from the "back," in the Japanese manner, but its maker was probably aware that an alternative reading from the "front" is feasible. The resolution—if there is in this work of extreme ambiguity—comes near the middle with a matching pair of stained and hand-worked images that hint backward, or forward, at some kind of apocalyptic conflagration, so it works either way.

Of course, the physical form of the book is one thing. Narrative derives from the imagination of its creator, and the structure imposed by the physical aspects of the book form is there to be subverted. Increasingly, some photobook makers try to go beyond the restrictive physical envelope of the conventional book, though the majority are still content only to play around with narrative forms.

Just as it is said that there are only five basic stories available to novelists, it can be said that there are not all that many general narrative schema or strategies from which a photobook can be structured. Among these are linear, montage, and serial, as well as borrowings or reworkings of "literary" devices such as the diary, the journal, the memorial, and the dream. Seriality is clearly a favorite schema for the "conceptual" photobook, but the journey and the diary came into their own after the Second World War, when social documentary photography became more inward looking and personal.

And as documentary photography became more personal, becoming documents of internal experience rather than of external aspect, here was a great opportunity for narrative to become more allusive and elliptical. The kind of photobook I have termed "stream of consciousness" is a case in point. The two most renowned examples of the genre, William Klein's *New York* (1955)[9] and Robert Frank's *The Americans* (1958), are examples of elliptical narrative successfully fighting a conventional linear structure, although both make references to a traditional chapter layout—Klein more overtly than Frank. In narrative terms, Klein favors a montage approach, while Frank's is more symbolic and slyly poetic.

Like other major artists, both Frank and Klein were closely attuned to the cultural zeitgeist, which, during the '50s, was heavily informed by the political aftermath of World War II and the prospect of nuclear annihilation. The prevailing artistic philosophy of the day was based in one way or another upon Existentialism, itself a reaction to the horrors

the world had just suffered. Art of the '50s turned inward, placing a new emphasis upon the expression of individual experience through a spontaneous process of tapping into the subconscious. Collective ideologies having failed in a spectacular way, "me me me" became the preferred option. The artistic forms that emerged from this kind of thinking were indulgently expressive, determinedly spontaneous, calculatedly rough, and loosely structured—or apparently so—and once again favoring elliptical narrative.

In 1950s film especially, conventional narrative was challenged at every turn. The enormously influential French *Nouvelle Vague* (New Wave) of filmmakers, the cinematic face of Existentialism, extolled free-form expressive poetry and ideas rather than plot. In Alain Renais' notorious 1961 film *L'Année Dernière à Marienbad* (Last Year at Marienbad), the famously convoluted, indeterminate, and obscurant plot—in effect surrealist non sequiturs revisited—had cinéastes arguing over it like few films in history. It was a case of those who enjoyed being baffled against those who were intensely irritated at being baffled.

A year later Chris Marker, in *La Jetée* (The Jetty), fashioned a highly elliptical parable of a film from still photographs. It was Marker, to some the embodiment of an annoyingly obtuse French intellectual, who had facilitated the publication of Klein's *New York* by the Paris-based Éditions du Seuil. Klein, in turn, "played" a role in *La Jetée* as "The Man of the Future." It may or may not be a coincidence that Marker's man of the future was well versed in the photographic arts. All the photographic arts, because both Klein and Frank, the most important photobook makers of their generation, also made films.

Between 1959 and 1969 Robert Frank made several Beat movies that are an integral part of the American underground film movement of the 1960s and '70s—although they are neither as diaristic, rambling, nor spontaneous as they seem at first glance.[10] In turn, William Klein is a filmmaker of distinction. His most renowned movie, *Mr. Freedom* (1969), has been widely described as the first Pop art film. Its cartoonlike, broad style, larded with doses of Surrealism, should not blind the viewer to its political edge, and it was possibly this political edge, as well as the riotous exuberance of his work, that made him such an influence upon the Japanese photobook.

Marker's *La Jetée* uses still photography effectively to talk about memory, and the role of memory in shaping not only our view of the past, but the present and future. This might be said to have been the primary theme of Japanese photobooks of the 1960s and the *Provoke* period, books that were heavily influenced by Klein and Pop art. Indeed, it would not be too fanciful to see *Mr. Freedom* as a Japanese film of the period, both stylistically and for its anti-imperialist, anti-American stance.

It might be said that elliptical narrative at its most extreme invokes a sense of schizophrenia, and this describes perfectly the Japanese *Provoke*-era photographers and their radical deconstruction of narrative—stream of consciousness taken to its logical conclusion, almost to the end of narrative. Yet, as even nonnarrative implies narrative, there was

a strong narrative theme running—albeit obliquely—through *Provoke* books. It was a mood, if you like, a tone, expressed frequently as a sense of narcissistic rebellion and existential alienation, but underlying this was a somewhat schizophrenic relationship with all things American, a love-hate duality that veered between an embrace of American popular culture and nationalistic rage over the legacy of Hiroshima and Nagasaki.

Fractured narrative was ideal for expressing this often extreme duality, but some of the *Provoke* books went further, attacking the physical form of the book itself, such as Kikuji Kawada's *Chizu* (The Map, 1965).[11] *The Map* is the ultimate photobook-as-object, combining a typical Japanese attention to the art of refined packaging with hard-hitting photography, text, and typography—a true photo-text piece. It is structured as a series of layered foldouts, which are unwrapped, then peeled away like archaeological strata. Images, or parts of images, can be viewed separately or together, so the viewer is asked to compile his or her own narrative, the elements of which are intensely speculative—although the central event, the bombing of Hiroshima, is clearly the primary leitmotif.[12] But the paradoxical view of American popular culture is also very much in evidence. The interactive nature of the book, in terms of what it asks of the viewer, reminds us that in the same year as it was published, Italian filmmaker Pier Paolo Pasolini was arguing in his essay, "The Cinema of Poetry," that film's subjectivities made movie viewing a highly personal experience for each member of the audience, thus endowing it with many narratives.

Another book from the *Provoke* period that packages the narrative, as it were, is Yutaka Takanashi's *Toshi e* (Towards the City, 1974).[13] Two books in a box. With even the outer box contributing to the narrative, the reader is in for another intense interactive experience. The narrative is an amalgam of the diaristic with the cinematic; a small book in the bottom of the box couched in the familiar stream of consciousness *Provoke* mode, while the main book employs the filmic strategy of repeating almost identical shots, like frame grabs.

Of course, in any discussion of elliptical narrative and the photobook, we should consider the ultimate *Provoke* book, the book that threw out almost any kind of coherent narrative, along with technique and any sense of certainty, except the feeling that it was doing it brilliantly, and making a profound language out of a vibrant nihilism. Daido Moriyama's *Shashin yo Sayonara* (Bye, Bye Photography, 1972)[14] takes everything, not just narrative, to the edge of incoherence, without tipping over into incoherence itself.

With its grainy, out-of-focus, blurry and off-kilter imagery, *Bye, Bye Photography* is an ultimate expression of the tendency that we have suggested informs many photobooks documenting modern life, especially life in the city, whereby elliptical narrative forms are employed to convey the complexities of the urban experience, and in particular our frequently ambiguous feelings toward it. Delirious, angst-ridden nightmare rather than comfortable reverie is higher on Moriyama's agenda, but we must not discount the manic energy, almost gleeful in its exhilarating vigor, with which he invests the book's narrative.

Nor should we be blinded to the book's political edge by what seems a slide into extreme subjectivity. It would seem, as happened frequently in photobook history, that elliptical narrative, which predicates subjectivity, has been used to construct a political mode. Elliptical narrative is used, not simply to confuse or confound us, but to stimulate us—to make us think. Moriyama, in contrast to his deeply political *Provoke* colleague, Takuma Nakahira, was seen to be on the "nonpolitical" wing of the movement, more interested in distilling raw experience. But the vision of the "apolitical" Moriyama, which attempted to go beyond even subjectivity and establish a dialectic of anonymity, nevertheless reflected the alienation, the angst, that accompanied the love-hate relationship with American materialism felt by the Japanese student rebels of the 1960s. And here the relationship with Klein and *Mr. Freedom* becomes apparent. As his friend Tadanori Yokoo has rightly said of Moriyama: "The more he tries to avoid political themes the more political his work seems to become."[15]

I hope that I have identified a pattern, not simply in the kind of narrative employed frequently in the twentieth-century photobook, but why photographers employ it so much. So let us end firmly in the twenty-first century with a recent photobook—one of the most interesting and significant in recent years, in my view. Paul Graham's *A Shimmer of Possibility* (2007)[16] utilizes, like the *Provoke* books, elliptical narrative to talk—albeit even cryptically—about political matters. It employs the ambiguities inherent in ordinary, everyday actions to demonstrate a narrative art of poetic description rather than "story." It uses a filmic language in the sequences to construct these vague narratives. Indeed, Graham calls each sequence a "filmic haiku," which returns us precisely to Lewis Baltz's remark about the cinema and the novel.

A Shimmer of Possibility is one book composed of twelve separate volumes, each containing a sequence of photographs shot in America, varying in length from one image to sixty pages of images.[17] The "events" depicted are ordinary in the extreme—a man smokes a cigarette as he waits for a bus in Las Vegas; we are taken for a walk down a street in Boston; we stand at an intersection in New Orleans where people pass by. A man mows a lawn in one of the "story"/books, and as he works it begins to rain, until the sun breaks through again, illuminating each drop.

The stories are little, open-ended moments with no definite beginnings and certainly no satisfactory endings, describing short periods of time when we notice a particular subject or person, or perhaps two in tandem, as in Las Vegas and San Francisco, two distinct sequences intertwined. They have an interesting temporal and spatial quality, as if time is telescoped and space compressed, both as laid out and sequenced in the book, and as exhibited in the gallery.

Graham states that the book was inspired by the short stories of Anton Chekhov, a statement that worried me a little at first. Photographers who claim affinity with famous

writers or painters are in general photographers of pretension rather than achievement. However, those with built-in bullshit detectors need not worry in this case. Graham's relationship with Chekhov is entirely apposite and organic.

Chekhov is credited with inventing the modern short story, even the modernist-inflected literary novel, for some of his tales have a stream of consciousness flavor about them. Many are apparently about nothing of any consequence. His 1886 tale, "A Trivial Incident," perhaps sums this up, and a brief outline of a few others demonstrate their flavor. Two peasants standing in a stream try to catch a fish with their hands. A husband and wife discuss what they would do with potential lottery winnings. A child eats his first oyster. Chekhov deals with the minutiae of life, describing small, but certainly not trivial incidents from the point of view of the protagonists, and sometimes taking two or three pages to produce detailed descriptions of nominally inconsequential things.

So the link to Chekhov is about the fine texture of realism, about how an artist depicts the most ordinary, undramatic events of life, describing then without any overt expressionist overtones or stylistic tricks, yet still making them interesting and of significance.

In literature this is frequently done by employing a deliberately prosaic style, devoid of rhetorical flourishes, yet not so flat as to make it inelegant. It takes a really accomplished writer to do it well. In photography, the equivalent is to make a picture so apparently "ordinary" that it might have been taken by an amateur for posting on Flickr, or even taken by a surveillance camera. Graham is attempting what, for an experienced professional, is a difficult balancing act to pull off successfully. Of course, any professional, especially in these profligate digital days, can snap away like a novice—the trick is to recognize the images that are just on the line between form and formlessness. Comments about *Shimmer* on the photoblogs—where argument has raged about the mundane nature of Graham's imagery—suggest that he has largely succeeded in this aesthetic high-wire act.

We are not talking about decisive moments or even the corollary indecisive moments, but moments that could be regarded as being in between. One is tempted almost to call them missed moments, in the sense that they are not the normal moments of art photography, and that any moment, that is to say frame, with the span of a fraction of a second or so would suffice just as well. Indeed, many of Graham's pictures have for me the feeling of frame grabs, single stills from a piece of movie footage, which tend to have a different quality of stopped motion than still photographs.

I believe that a new "aesthetic" of still photography is emerging from the burgeoning use of digital cameras and their ability to make quick, machine-gun bursts of frames—although users of motor-drive cameras had this facility decades ago. But one is given a new appreciation of this effect when one "runs" consecutive frames from a rapid sequence of shots on the camera screen. It can be like viewing a slow motion movie sequence.

Paul Graham used both digital and film cameras during the shooting of *Shimmer*, and

seems to have taken advantage of the aesthetic I have described frequently. For instance, in *Louisiana*, 2005, a man walks toward the camera. As he gets near, Graham includes two frames in the sequence that are so close to each other, they are difficult to tell apart. Indeed they could be the same frame. I flicked back and forth between the two for some time and could see little discernable difference, which is typical of a frame burst.

However, as John Gossage has pointed out, there are punctuation points, "stopper" pictures as he calls them—such as the moment when the man smoking leans wearily against the wall as he takes another drag. One might surmise that they are there to add a sliver of drama, but that would spoil the restrained moods Graham has so carefully established. But the term stopper is most apposite, for they bring us up short, perhaps making us retrace our steps, preventing us from rushing through the sequence. They are subtle devices to hook us, cunning lures that make us pause and ponder. And, as Gossage says, they are vital in making "the book more complex, not just a group of sequences."[18]

So, ordinary people doing ordinary things, in most cases in fact, doing very little. And shot in a deadpan, almost amateurish way. As stories they are about as elliptical as it can get, we can manufacture our own narratives at will from the few clues Graham gives us. But one clue seems more important than the rest, because it is the most prominent through *Shimmer*, and that is the social profile of the photographed.

They are black, white, Hispanic, but are drawn mainly from the other side of the tracks, those who do the menial jobs no one else wants if they are lucky enough to have a better job. Some appear to be street people, like the wild haired young man who appears out of the night and offers flowers to the photographer. Some are anxious, like the smoking man. Some seem a little disturbed, like the orange-haired black woman eating greasy food from a take-out carton and then gratefully grabbing a cigarette. Perhaps some are illegal. Graham is focusing careful and respectful attention upon the kind of people more affluent Americans—and that means almost anybody with a steady job above the most menial— tend to ignore.

A Shimmer of Possibility is remarkable for its intelligence and understatement—although it is understatement with a distinct rhetorical flourish, if that isn't a contradiction in terms. It is a maddeningly inscrutable, but haunting book, the kind that stays in the mind and simply refuses to leave. The political undercurrent is never overtly proclaimed, yet is clearly there, the book's aesthetic ambition is rather more out there, yet is finely judged and realized.

At a photobook conference in spring 2009[19] David Campany talked about Walker Evans's feature "American Homes" in *Fortune* magazine, in which Evans is typically, deliberately ambiguous and elliptical. The short text introducing the photo-essay quotes Herman Melville, and it is a perfect injunction for this essay: "Let the ambiguous procession of events reveal their own ambiguousness."[20] Narration in the photobook is one of the most effective ways of securing some kind of meaning for the photograph. Elliptical

narrative might seem to undercut that ambition, but historically, avant-garde artists have employed the tactic in order to throw us off balance, puzzling us or making us uncomfortable in order to make us think.

Notes

1. Although we had begun our project before they appeared, we were beaten into print by two books by Andrew Roth, *The Book of 101 Books: Seminal Photographic Books of the Twentieth Century* (New York: PPP Editions, in association with Roth Horowitz LLC, 2001), and *The Open Book: A History of the Photographic Book from 1878 to the Present* (Gothenburg, Sweden: Hasselblad Center, 2004).

2. Ralph Prins, in a conversation with Cas Oorthuys in 1969, quoted in *Photography Between Covers: The Dutch Documentary Photobook After 1945* (Amsterdam: Fragment Uitgeverij, 1989), p. 12.

3. Lewis Baltz, quoted by Mark Haworth-Booth, afterword to Lewis Baltz, *San Quentin Point* (New York: Aperture, 1986), p. 63.

4. Jean-Luc Godard, quoted in Don Fairservice, *Film Editing: History, Theory and Practice—Looking at the Invisible* (Manchester, England: Manchester University Press, 2001), p. 315.

5. Ian Aitken, *European Film Theory and Cinema: A Critical Introduction* (Edinburgh University Press, 2001), p. 80.

6. Moï Ver, *Paris* (Paris: Éditions Jeanne Walter, 1931).

7. Germaine Krull, *Métal* (Paris: Librairie des Arts Décoratifs, 1928). As noted in an earlier essay, there is some dispute as to whether this book came out in 1928 or 1929, but as Martin Parr and I were researching the photobook history, we were led to believe that copies were available for Christmas 1928.

8. Takuma Nakahira, *Kitaru beki kotoba no tame ni* (For a Language to Come) (Tokyo: F dosha, 1970).

9. William Klein, *Life Is Good and Good For You in New York: Trance Witness Revels* (Paris: Éditions du Seuil, Album Petite Planete I, 1956).

10. The best-known of these films are *Pull My Daisy* (1959), *The Sin of Jesus* (1961), and *Me and My Brother* (1965–8).

11. Kikuji Kawada, *Chizu* (The Map) (Tokyo: Bijutsu Shuppansha, August 6, 1965).

12. As can be seen in the previous note, the publication date is given specifically as August 6, 1965. This was the twentieth anniversary to the day of the bombing of Hiroshima.

13. Yutaka Takanashi, *Toshi e (Towards the City)* (Tokyo: Izara Shobo, March 31, 1974).

14. Daido Moriyama, *Shashin yo Sayonara* (Bye, Bye Photography) (Tokyo: Shashin Hyoronsha, 1972).

15. Tanadori Yokoo, *A Cowering Eye*, in Daido Moriyama, *Karyudo* (Hunter) (Tokyo: Chuo Koron-sha, 1972), unpaginated.

16. Paul Graham, *A Shimmer of Possibility* (twelve volumes), (Göttingen, Germany: Steidl Verlag, 2007).

17. In 2009 Steidl published a consolidated version of the book, with all the sequences combined into one volume.

18. John Gossage, email to the author, April 10, 2009.

19. Photobook Conference, Birkbeck College, University of London, April 3–4, 2009.

20. Walker Evans, "Homes of Americans," in *Fortune* (New York), April 1946, pp. 148–5; for the introductory text, see p. 148.

It's Art, But Is It Photography? Some Thoughts on Photoshop

Here in Britain we have a television series called *Grumpy Old Men* (and *Grumpy Old Women*) in which celebrities of a certain age have a good moan about the way in which the world is progressing, or in their view, regressing. This is my grumpy old man essay, or the most obvious one, and it was inspired by looking at and thinking about the work of an artist who was certainly regarded in his day as a grumpy old man, not to say grumpy young man, Paul Cézanne.

For me, the middle and late periods of Paul Cézanne constitute a body of artistic work that is second to none. The exhibition *Cézanne in Provence*, especially in its Washington incarnation,[1] was one of the finest I have ever seen. I remembered the splendid retrospective from the Tate Gallery in London,[2] some years previously, but as I walked into the National Gallery in Washington, I think it was the third or fourth room, I was unprepared to be as moved as I was, to the point of tears, by much of the work in that room and those that followed. To see an impeccably chosen selection of works from his late landscape series such as the Bibémus Quarry, the Château Noir, and Mont Sainte-Victoire paintings is to be astounded by a painter demonstrating invention and an intensity of vision that was almost deliriously creative.

But among these marvelous series is one I just don't "get." And interestingly, this is exactly the body of work that commands the inordinate attention of art historians—the *Bathers*. At the behest of the distinguished art historian Virginia Spate, I have even spent a hot and dusty, but interesting afternoon in Aix, searching for and photographing the place on the River Arc that in all probability inspired the *Bathers'* sylvan setting. Even that has not inspired me to fall in love with those monumental, rough hewn, and—let's not beat about the bush—ugly figures.

I fully appreciate their importance in the grand scheme of modernism. I even somewhat perversely love Picasso's *Demoiselles d'Avignon*, a clear homage (and challenge) to Cézanne's nudes, and I know that the majority of art historians mark the *Baigneuses* as the highpoint of his artistic legacy. Yet I still don't respond to the *Bathers* as I do to the landscapes, the still lifes, or the portraits. And being arrogant enough to assume this was a collective failure on the part of art historians rather than my own, I asked myself why so many art historians, though not all, regard the *Bathers* so highly.[3]

This led to some nagging doubts about art historians, critics, and the art market in relation to photography. I believe that this issue in relation to Cézanne and the *Bathers* is paralleled by the attitude of many art historians, and by extension certain curators and dealers, to the business of contemporary photography.

We'll return to the *Bathers* in due course, and draw conclusions that might apply in

Luc Delahaye, *132nd Ordinary Meeting of the Conference*, 2004

general to attitudes—and aspects that, I shall admit, trouble me—surrounding the whole question of art and photography. But first I want to kick the discussion off, as it were, by asking a question: When is photography not photography?

It might seem a strange question at first glance, but of course, nothing in photography is clearcut, and critical battle lines are constantly being drawn over precisely how we might define the medium, and more important, how we might define its function.

So, when is photography not photography?

When it's art.

That might seem an equally strange answer. Photography can surely be art as well as a technology, and art can certainly be photography. Indeed, much contemporary art is photographic in nature, so what exactly am I getting at?

My purpose is to look at the perennial debate from a different viewpoint. The "is photography an art" question has been around since the medium's inception, and even today, despite photography's almost ubiquitous presence in the contemporary art gallery and museum, has not been put entirely to rest. Indeed, the purpose of this essay is to demonstrate, despite appearances to the contrary, that many remain uncomfortable with the notion of photography as art.

Further, I would like to reverse the inquiry: "It's art, but is it photography?" The question is not an idle one, for it has both practical and philosophical implications. The practical implications impact upon the art market and the status of photography, the philosophical implications revolve around the crucial and far-reaching issue of photography's veracity.

I was prompted to ask this question by a sequence involving Andreas Gursky on the BBC television series *The Genius of Photography*, for which I wrote the accompanying book.[4] Gursky is a star of the photographic art market, who embodies the acceptance of photography into the art market fold, who seems to fit the soubriquet that photography is the "new history painting." Known for his monumental panoramas of the more soulless aspects of contemporary civilization, Gursky has set record after record for the highest prices at auction for a photograph—currently standing at over $3 million.[5] That means his work is taken very seriously indeed.

On the television film, Gursky was talking about one of his recent images, an aerial view of the Grand Prix motor racing track in Bahrain. It was a typical Gursky picture, large in scale, and combining a strong, almost abstract formal sense with a distant objectivity. The track snakes about—indeed from above it looks like a giant black snake—the dark asphalt of the road surface contrasting with the white sand of the desert where this monument to money, speed, and power was created.

Pointing to an area at the bottom of the image, Gursky stated that he hadn't particularly liked the actual shape of one of the bends on the track, so he used the computer to alter it. For the same reason, he changed one of the bends at the top of the picture. Like a painter, but to somewhat different effect, Gursky had smoothed out the world's imperfections to create a perfect result.

Does this matter? In the grand scheme of things it probably doesn't. Gursky's racetrack was not a photograph of a news event purporting to be evidence of something. It was not one of those grotesque products of overworked computer manipulation, that look like airbrushed illustrations from pulp sci-fi magazines of the '50s, and which seem almost ubiquitous in a certain type of Chelsea or London gallery. Yet I was disturbed by Gursky's admission, even though I know that he and others have been doing this kind of thing for some years now.

I remember being similarly shocked when I learned of an act of computer manipulation in one of his early works, an act so singular that it must rank as a key work in the history of photographic manipulation by digital means. In *Rhein* (1996), a view across the River Rhine, Gursky used the computer to "airbrush" out a whole factory, to demolish it with the click of a mouse. I like the picture, yet I don't think I could ever love it, because something still nags at me. I wonder whether I would have liked a photograph of the unaltered scene better, an admittedly irrational reaction because I never wonder whether I might like a particular Cartier-Bresson if he'd snapped it a second later.

Irrational, yes. The hyper-real sci-fi illustrations are one thing—bad art, hardly photography at all—but I am disturbed by photographs where the computer work is less obvious, and I am blissfully unaware that they've ever been altered. Can I ever trust a photograph again?

I'm not sure whether a photograph could ever have been trusted without reservation—from the moment of the very first daguerreotype—but there is another point to be made about Gursky's Rhine scene. By removing the offending factory, Gursky created not only an ominous empty landscape, a landscape with a certain haunting power, but also a minimalist image in which three bands of almost featureless tone give the effect of a Color Field painting.

Painting—the magic word. Painting is art. And those are the comforting terms around which discourse on Gursky revolves. He has taken photography back into the fold, he has legitimized and tamed the unruly, bastard child of pictorial representation. The discourse discusses the kind of world Gursky has photographed, but even in these terms, critics frequently refer to "Gursky's World," thereby reinforcing the constructed nature of his imagery. However, it is also discussed widely in art historical terms—as part of the discourse of postmodernism certainly—but also as part of the discourse of painting. North German romanticism and the name of Caspar David Friedrich in particular are frequently invoked. This is typical of the way that the new photographic artists are discussed as a way of legitimizing their practice. It is typical of the way they themselves reference their practice in order to legitimize it in art market terms. As his racetrack picture, *Bahrain 1* (2005), was described in the publicity material: "It illuminates the phenomena of the Formula 1 and at the same time seems like an expressive painting. In his work, Andreas Gursky compiles the continuity and objectivity of the medium in the tradition of Bernd and Hilla Becher with the gesture of a painter."[6]

Painting and painters are mentioned in two consecutive sentences, privileging Gursky within the "higher" discourse of painting. This is the crucial difference, the gulf that still divides "photographer" from "artist." The kind of prices asked for a Gursky as opposed to say, a Robert Adams or a Lee Friedlander, are enough to suggest that. The gap is not as wide as it was, and narrows daily, but it is still there. I would suggest that it represents the residue—quite a substantial residue—of a prejudice pertaining in favor of the artist as opposed to the photographer, a notion that there is something not quite right about photography.

Both Adams and Friedlander are now recognized, not only as two of the most important American photographers of the late twentieth century, but two significant artists—and their print prices are now very respectable. Nevertheless, they seem meager compared to even lesser members of the Düsseldorf School and their many imitators. Furthermore, Adams and Friedlander took years to get even where they are. Pricewise, they can still be outstripped by kids barely two years out of college who make enormous, digitally enhanced color prints and insist on calling themselves artists rather than photographers.

Of course, the "more bang for your buck" syndrome plays its inevitable part. It is more prevalent in the art world than it perhaps ought to be, but this is nothing new. Adams and

Friedlander make relatively small prints, in the manner of traditional photography, whereas the "artists" opt for size, in the manner of the nineteenth-century salon or the recent stages of easel painting. Smallish prints immediately connote a traditional photographic, that is to say, a phenomenological approach. Large prints herald artistic ambition, the conceptual approach of the artist rather than the "simple" reaction to the world of the photographer. The "size queen" factor is a powerful force in the art market.

As is the phenomenological versus the conceptual approach. Let's return to Cézanne, and consider the *Bathers* further. Is it an accident that this subject, and in particular the three largest paintings in the series, his *Grandes Baigneuses*, command such attention from art historians? Their size alone would indicate that these are the most singularly ambitious of Cézanne's works. The "bigger is better" syndrome at work once more, while their subject, nothing less than the European tradition of figure painting stood on its head, gets art historians salivating. There is immediately so much more for them to talk about, more cultural referencing for them to gleefully detail—his love for Virgil, Arcadian poetry, Poussin, and so on, just for starters—than is generally the case with the more modest landscapes or still lifes. They are based upon immediate sight impressions. While there may be cultural issues revolving around Provençal politics, and there are always formal and technical issues, they are considerably more difficult to interpret.

To be fair to art historians, Cézanne himself bought into this hierarchy of subject, as do many painters—and photographers. If the *Bathers* series are considered the most intellectually ambitious, it is because they are obviously the most "conceptual"—imaginatively conceived compositions, painted in the studio, relating to the theme of art itself. The late landscapes, by contrast, are the most phenomenological of his paintings—the most documentary—where he was drawing upon a motif directly in front of his eyes, en plein air. Of course, I am not saying that Cézanne was seeking to make an unvarnished record of the landscape. He was just about as far away from the documentary as any artist could get, but the apparent privileging of the *Bathers* over the landscapes—or even the still lifes, which again are studio bound—indicates that the philosophical dichotomy between phenomenological and conceptual can be extended to painting. Although it is much more exaggerated in photography, where there is still a degree of uncertainty as to where the art in the medium, if any, actually resides.

As Alan Trachtenberg has written, it is hardly a new syndrome. Whether we are talking about Pictorialists or modernists, "artists utilizing photography" or experimentalists, commercial hacks or pretentious photojournalists, the desire to deny photography seems to be endemic: "Art-photographers tried every trick available to get away from the embarrassing literalness of their medium. Fortunately, enough practitioners continued simply to record, for the sake of the miracle when a good, clear image comes up in the printing bath, or to have faithful pictures of what things and people look like."[7]

Looking at photography, and in particular the new digital art photography, two points seem to be at issue. The first is photography and truth. This is always a tricky area. Photography's relationship with truth can be both uncertain and troubling, and any truth is relative anyway. But photographic truth is something we think of as being particular, and unique to the medium. It is also different from artistic truth. Cézanne's *Bathers* and his landscapes have their artistic truth, any art worth its salt does. Gursky's Rhine view might have its artistic truth, but the question is, having manipulated the image so drastically, has he lost or degraded photographic truth?

Again we might ask—if Gursky has compromised photographic truth at the expense of artistic truth, does it matter? Clearly, the popularity of the new "photo painting," with photographers—sorry, artists—manipulating photographs with Photoshop and formulating complex tableaux to be photographed, indicates that many people regard it as an issue of little or no consequence. It is the brand of photography that is consistently popular with collectors, the photographic art that is unquestionably "art," where the stamp of the auteur is most visible. It is the brand of photography, therefore, that makes the big money. If one looks at the highest prices fetched in auction, photography in the documentary mode, especially gritty documentary photography, hardly features at the highest level.

The second issue, which is related to the first, could be termed the world of the photograph, not simply the conceptual world explored but the actual world depicted. Much of the new photo-painting is fabricated photography, not only photomontage done in the computer, but also scenes fabricated to be photographed. Artists—photographers? (even I'm confused)—such as Jeff Wall and Gregory Crewdson select locations, direct actors, and control every aspect of the image. In one of the *Genius of Photography* episodes, Crewdson is seen making an image, employing all the crew needed to make a motion picture—casting director, set decorator, lighting technicians, continuity person, and so on. He even employs someone else to click the shutter, before the thirty or so eight-by-ten negatives resulting from the shoot are scanned into the computer, and the "best bits" stitched together perfectly to make the final image—a thoroughly manipulated digital file ready for printing.

The result is a world—an image world that is as conceptually imagined, as self-contained and as hermetically sealed as the world of Cézanne's *Bathers*. But, as it's photography and apparently seamlessly garnered from the actual world, we almost automatically assume that it relates far more closely to the real world than the *Bathers*. We are in effect looking at a photomontage, but not a photomontage in the manner of the Russian constructivists or the European modernists, where their artificiality is obvious, and the handcrafted element is both clear and important. Most of Crewdson's images are palpably artificial—but some clearly are not. These, and the hundreds by other leading members of the new photo-painting tendency, are photomontages that we might believe are actually documentary records of the world.

It works the other way as well. There are debates within Magnum about computer manipulation of documentary images, and so many pictures by photojournalists and documentary photographers bear a stamp on the back stating that the image was in way no computer-manipulated. I am told that some entries have been thrown out of photographic competitions because the judges felt that they had been "over-Photoshopped."

The French photographer Luc Delahaye, a former member of Magnum, has made a series entitled History, which pointedly throws up some of these issues. History is a series of apparently documentary photographs that the photographer insists are art, and that are presented as large-scale photographic works on the gallery wall. Their subject matter is world events, the familiar subject matter of photojournalists, such as the wars in Iraq and Afghanistan, and major media events like G8 conferences and Vatican convocations. But the subject of these images becomes something else—Delahaye has deliberately shifted his practice from the world of photojournalism and the forum of the printed page to the arena of the gallery wall and the single oversized print.

The issue I have with Delahaye's work is not this change of context—from printed page to wall, from taking to making, from small-scale to large, from documentary to art—but the role the computer plays in constructing the imagery and the implications of that. I'm interested in what has been added by computer manipulation, but also, in what has been taken away.

At first, Delahaye did not Photoshop beyond what are considered the normal bounds of controlling color balance, contrast, density—the kinds of control that photographers have always exercised using traditional photo-printing methods, the controls used to produce a believable and visually well-balanced print. His pictures, although Salon painting size, were to all extents and purposes, straight, documentary photographs.

Delahaye has been working on the History project for some time, and published an interim book in 2004.[8] The images featured there had not been Photoshopped to any great extent, but since then, he has made more extensive use of the computer. For example, in two pictures, one made at a luncheon at the World Economic Forum in Davos, Switzerland, and the other at an OPEC press conference in Vienna, he combined separate shots made from a fixed vantage point, "shifting figures from one part of the composition to another, substituting gestures, eliminating unwanted persons and objects, and so on, to arrive at the final images, which looked at closely give no indication of having been manipulated," writes Michael Fried.[9]

I believe that generally Delahaye has reverted to the minimal Photoshopping option, so clearly for him the question is a movable feast, dependent upon what he feels about a particular image. I personally like History, the book I thought, was exceptional. More pertinently, I like the *idea* of History, in that it is asking us to consider the whole process of news reporting and representing historical events. And yet I am somewhat disturbed by

the rider at the end of Fried's observation, that certain images "give no indication of having been manipulated."

This surely means that someone stumbling across these photographs, someone without a detailed knowledge of the philosophical and aesthetic issues involved, might "believe" them at a documentary level. Of course, they are art, they don't pretend to be anything else. They are art that comments upon the fact that history is a cultural construct, and therefore upon the way in which history is depicted visually is also a construct. In short, Delahaye's world is as much a fiction as Gursky's or Crewdson's.

Nevertheless, there is a difference. Has Gursky, by dint of altering a curve here and there on a racetrack, effectively written his photograph out of history, in the sense that it can be regarded as a historic document but not a historical one? Has Gursky ensured that his Bahrain image, whatever else it is, cannot be taken seriously as a document, that is, a "photograph," while Delahaye's History pictures, whatever else they are, can—the non-manipulated images at any rate?

But what of the manipulated History pictures? Reproduced in a newspaper, if only in the context of a review, they could perhaps escape their art context, and be misread. Gursky's images might mimic reality, but they do not report upon events. Crewdson's are for the most part palpably artificial. Could Delahaye's, however, flitting as they do between documenting and recreating news events, be considered much more insidious in their effect, more dangerous because their artificiality is not made absolutely transparent? The patently artificial is one thing, the faux-real quite another.

Have we now reached a situation where photography has separated into two parallel worlds? Not art and documentary, but something much more fundamental—between recreating the real world and creating a fake world. This is hardly a new issue, indeed it has been current since the medium's inception, manifest in everything from Pictorialism to Surrealism to propaganda. However, with the rise of the new photo-painting, and above all, the seamless way it can now be done, the manipulative tendency within the medium may be approaching critical mass.

What conclusion can we draw from all this? We all have our particular stance and I am fully aware that the way things are going I may seem nonconformist, possibly curmudgeonly, and even retrograde. But we hear phrases like "photography is dead" and books and exhibitions are proposed along the lines of "Photography After Photography." Certainly, in this digital age, photography is changing rapidly. As the value of photography as art rises inexorably, its value as documentary seems to be decreasing. Photography in the documentary mode might not be dead, or even terminally ill, but it is under threat.

We are rightly suspicious of documentary photography, but then again, we always should have been. All photography is an interpretation of the world. The very act of framing a scene and clicking the shutter at a certain moment is a conscious act, a quite radical

and artificial act of mediating actuality. A frozen, two-dimensional image that pretends to act as a simulacrum of a four-dimensional world is already putting a strain upon our credulity.

There is no such thing as an absolutely transparent photographic document, yet at its best, at its simplest, the contact with actuality is as direct as it possibly could be. You see, you click. Photography has an astonishing capacity to annihilate time and space, to replicate the world in a profound and moving way.

Yet for so many this marvelous faculty is not enough. For deep down, they do not believe that photography, that the photographic act in its basic simplicity, is an art—or at least, not enough of an art. For many, whether the feeling stems from reasons of insecurity or status, to be art, photography must be *seen* to be art. And that, to put it crudely, means tricking it up—making a print the size of a room, or controlling everything from first to last.

It all comes down to perceptions about authorial mediation. One person with a camera, wandering around taking photographs, making small black-and-white prints, does not seem nearly so impressive as a photographic artist employing a studio full of assistants, utilizing the latest computer wizardry, then generating the perfect print three meters wide in hyperreal inkjet color. A sixteen-by-twenty, even twenty-by-twenty-four-inch print, far less an eleven-by-fourteen-inch, is less likely to cut it with the collector looking to make the impressive decorating statement, or who wants more bang for his buck. The simple documentary photograph is not so tailored to the desires of the critic, who wants a whole raft of cultural references to write about. In fact nowadays, when I look around museums and art galleries, I often feel that photography in the documentary mode impresses no one any more except me.

I am certainly unimpressed by size alone. Indeed, I am downright suspicious of large photographs. I feel they are often pretending to be what they are not. The best prints I have seen recently have been those of Stephen Shore at the International Center of Photography in New York.[10] I like his work, to be sure, but I feel that Shore has taken a sensible course in relation to print size. Early in his career, when he first began to use the eight-by-ten-inch view camera, he tended, in the tradition of the great American modernist masters, to make only contact prints. Later, as his career was reinvigorated with a series of new books, he made larger prints, rightly claiming that, as there was so much detail in the large negatives, some of it was invariably lost in the contact prints. At the ICP show, the eight-by-tens were enlarged to twenty-four by twenty inches, and looked magnificent, among the best and most sensuous color prints I have ever seen. He has made larger prints, and they are superb, but I feel that twenty-four by twenty inches, or just slightly larger, is an optimum high-end size for most photographs, an ideal compromise because it holds its own on the average domestic wall at least, and is just about small enough to look at held in the hand.

I'm afraid that I also have a great suspicion of much photographic art that revolves around art historical references, art about art. Although here, contrary to what I have said earlier, I feel I should exonerate the likes of Gursky, Jeff Wall, and the early work of Cindy Sherman. While I remain uneasy about their Photoshopping and directorial methods, I concede that their art is actually talking more about the world than art, and indeed, like all good art, is creating a persuasive and viable world of its own. In short, in the work of these three there is a quality of both imagination and seeing.

Unfortunately however, that is not generally the case. There is far too much work around that uses the fabricated tableau and art historical reference as a crutch, far too many recreations of painters from Vermeer to Hopper. My reaction to them, I'm afraid, is to quote the great Miles Davis: "So What?" I know all art is a reassembling of preexistent signs and modes, but there are imaginative and fresh ways of doing it, and there are unimaginative and stale ways of doing it. And while fabricated or self-referential photography can fulfill the essential criterion of, as it were, proclaiming itself as art, other photographic endeavors are being ignored. Much good photography in the documentary mode—not at the exalted level of Robert Adams or Friedlander—but what I would term good honest photography, is being ignored in the clamor over the large and flashy pieces of photographic "art."

Interestingly, Tod Papageorge, Walker Evans Professor and director of graduate studies in photography at Yale, a school that has a particular reputation for turning out photographic art of the hybrid variety, has voiced his own reservations about much of it—although he naturally tends to exclude his own students and colleagues from his strictures: ". . . my argument against the set-up picture is that it leaves the matter of content to the imagination of the photographer, a faculty that, in my experience, is generally deficient compared to the mad swirling possibilities that our dear common world kicks up at us on a regular basis."[11]

Even more interesting, since he is such a leading exponent of the directorial mode, Jeff Wall ventured the following in an interview with Jean-François Chevrier, explaining his attitude toward photography at the beginning of his career, and how that has now shifted: "I was interested in the way cinema affected the criteria for judging photography. Cinematography permits, and validates, the collaboration between photographer and subject that was largely excluded in classic documentary terms. That exclusion limits photography, and so my first moves were against it—working in a studio with all the technical questions that implies."[12]

So, although he began by challenging the photographic status quo, its presumed fidelity to nature, by the mid-'80s, Wall says he felt a need to reexamine his views about the very photography he had been questioning: "As I saw more of the 'new' photography in exhibitions through the '80s, I began to realize that I preferred Walker Evans or Wols to most of the newer work, and I preferred them to my own work. Classical photography might have

been displaced from the center of attention by the newer forms but it was not diminished in the process. It became stronger through having been confronted with alternatives, as far as I was concerned."[13]

Unfortunately, I am not so sure that many of Wall's colleagues share that point of view. Any trawl through the galleries or a visit to a photo fair gives the impression that classical photography has been displaced quite some way from the center of things, but Jeff Wall's comments are certainly welcome. Richard Avedon once observed that, "the limitation and the grandeur of photography is that you are forever linked at the hip to the subject."[14]

In the long run, my own basic objection to the new hybrid photo-painting is virtually the same as Papageorge's. I just do not like the ersatz factor. Fake worlds, whether hyper-real, unreal, or surreal are being created, and for the large part, I just don't find them interesting. They satisfy a desire for art to be larger than life, theatrical, and an exaggeration. Yet if any art could be called the "art of the real," it is photography. However, so many feel frightened of, threatened by, or are perhaps scornful of plain, unadorned photographic reality, preferring to play around with it rather than actually engage with it head on.

I began with Cézanne, I'll finish with him. Although he struggled long and hard with the theme of the *Bathers*, he was always aware of the importance of a painter heeding his primary motif and observing the landscape directly. And he was scornful of painters simply making pictures about pictures: "Ces musées! les tableaux des musées! nous ne voyons pas la nature, ne revoyons des tableaux!" (Museums! Museum pictures! We no longer see nature, we re-see pictures!)[15]

Notes

1. *Cézanne in Provence* was shown at the National Gallery of Art, Washington, D.C., from January 29 to May 7, 2006, and at the Musée Granet, Aix-en-Provence, from June 9 to September 17, 2006. There were omissions and additions from one venue to the next, and the disposition of the pictures was different, which is why I slightly favored the Washington hang, although the glory of the pictures remained.

2. The retrospective, *Cézanne*, was shown at the Galeries Nationales du Grand Palais, Paris, from September 25, 1995, to January 7, 1996; Tate Gallery, London, from February 8 to April 28, 1996; and Philadelphia Museum of Art, from May 30 to September 1, 1996.

3. There are, of course, dissenters like Fritz Novotny (1902–1983), who tend to regard the late, distant views of Mont Sainte-Victoire rather than the Bathers as the culmination of Cézanne's career, but this group seems to be in the minority.

4. Tim Kirby, producer; Tim Kirby, Chris Rodley, and Deborah Lee, directors, *The Genius of Photography* (London: Wall to Wall, 2007); Gerry Badger, *The Genius of Photography* (London: Quadrille Publishing Ltd., 2007).

5. Gursky's *99 cent II Diptychon* (2001) sold for $3,346,456 at a Sotheby's auction in London on February 7, 2007. Previously, another copy of the same work sold for $2,480,000 at Phillips de Pury & Company in New York on November 16, 2006.

6. Press release for *Andreas Gursky: New Work*, shown at Sprüeth Magers, London, from March 22 to May 12, 2007.

7. Alan Trachtenberg, "Walker Evans: The Artist of the Real," *Afterimage* (Rochester, New York), December 1978, Vol. 6, No. 5, p. 10.

8. Luc Delahaye, *History* (London: Chris Boot Publishing, 2004).

9. Michael Fried, *Why Photography Matters as Art as Never Before* (New Haven and London: Yale University Press, 2008), p. 183.

10. *Biographical Landscape: The Photography of Stephen Shore, 1969–79* was shown at the International Center of Photography, New York, from May 11 to September 9, 2007.

11. Tod Papageorge, interviewed by Richard B. Woodward, in *BOMB* (New York), Fall 2006, No. 97.

12. Jeff Wall, "Interview with Jean-François Chevrier," in *Jeff Wall: Selected Essays and Interviews* (New York: Museum of Modern Art, 2007), p. 322.

13. Ibid.

14. Richard Avedon, quoted in the *Evening Standard* (London), January 19, 1993.

15. Paul Cézanne, quoted in Vernon Blake, *The Art of Drawing* (Oxford, England: Oxford University Press, 1927), p. 9.

Index Page references in *italics* refer to illustrations.

Acknowledgments

Although many photographers are fiercely ambitious and competitive, in general the world of photography is an extremely friendly global village of like-minded obsessives. I would therefore like to acknowledge all those colleagues over the years, photographers, curators, gallerists, and critics, who provided me with encouragement, advice, support, and importantly, good company—especially those who commissioned essays and books. I also would like to thank all the photographers, living and deceased, who made the work I have written about. Without them, and their work, the rest of us would be without jobs.

Acknowledgment is due to the artists and institutions who generously granted permission to reproduce their images as well as the two previously published essays.

Finally, I would like to thank Aperture, specifically Juan García de Oteyza, executive director; Lesley A. Martin, publisher; Inger-Lise McMillan, design manager; Matthew Pimm, production director; Simone Eißrich, design work scholar; Arielle de Saint Phalle, who obtained all the permissions; and lastly, but certainly not least, my editor, Susan Ciccotti.

Reproduction Credits

All reproduction material is copyright and courtesy of the artist, unless otherwise noted.

Front Cover: Courtesy Eileen Cowin
Interior Photographs: Page 4: Courtesy John Gossage/Stephen Daiter Gallery; Page 10: Courtesy Bibliothèque nationale de France; Page 23: Digital image copyright © The Museum of Modern Art/Licensed by SCALA/Art Resource, New York; Page 37: Digital image copyright © The Museum of Modern Art/Licensed by SCALA, Art Resource, New York; Page 52: Courtesy Fraenkel Gallery, San Francisco; Page 54: Copyright © Estate of Paul Strand and Hazel Strand; Page 61: Copyright © 2010 The Richard Avedon Foundation; Page 74: Copyright © Martin Parr/Magnum Photos; Page 88: Courtesy John Gossage/Stephen Daiter Gallery; Page 100: Copyright © Robert Adams, Courtesy Fraenkel Gallery, San Francisco, and Matthew Marks Gallery, New York; Page 112: Digital image Copyright © The Museum of Modern Art, New York/Licensed by SCALA/Art Resource, New York; Page 115: Image Copyright © The Metropolitan Museum of Art/Art Resource, New York; Page 117: Copyright © The Dorothea Lange Collection, Oakland Museum of California, City of Oakland, Gift of Paul S. Taylor; Page 119: Courtesy Stephen Shore and 303 Gallery, New York; Page 121: Copyright © Martin Parr/Magnum Photos; Page 123: Courtesy Anthony Hernandez and Christopher Grimes Gallery; Page 125: Courtesy John Gossage/Stephen Daiter Gallery; Page 127: Copyright © Robert Adams, Courtesy Fraenkel Gallery, San Francisco, and Matthew Marks Gallery, New York; Page 129: Courtesy Jitka Hanzlová and Mai 36 Gallery Zürich; Page 131: Copyright © Thomas Joshua Cooper, Courtesy Haunch of Venison, London, 2009; Page 133: Copyright © Michal Rovner, Courtesy Pace/MacGill Gallery, New York; Page 135: Copyright © Anna Fox, Courtesy James Hyman Gallery, London; Page 137: Courtesy Paul Seawright; Page 139: Courtesy Susan Lipper; Page 141: Copyright © Patrick Zachmann/Magnum Photos; Page 143: Copyright © Donovan Wylie/Magnum Photos; Page 145: Copyright © Thomas Joshua Cooper, Courtesy Haunch of Venison, London, 2009; Page 159: Courtesy Anthony Hernandez and Christopher Grimes Gallery; Page 167: Courtesy Susan Lipper; Page 180: Copyright © Anna Fox, Courtesy James Hyman Gallery, London; Page 189: Copyright © Patrick Zachmann/Magnum Photos; Page 200: Copyright © Judith Golden, 1975; Page 204: Courtesy Eileen Cowin; Page 211: Courtesy Stephen Shore and 303 Gallery, New York; Page 222: Courtesy and copyright © Paul Graham; Page 235: Courtesy and copyright © Luc Delahaye

Previously Published Essays: Pages 158–65: "Invisible City: The Los Angeles Street Photographs of Anthony Hernandez" copyright © Gerry Badger; Pages 179–87: "Country Matters: Anna Fox's *Photographs 1983–2007*" copyright © Gerry Badger.

7/10 30.00

Cover: Eileen Cowin, *Untitled*, 1983
Frontispiece: John Gossage, *First Day with the Leica, Washington, D.C.*, 2007

Editor: Susan Ciccotti
Designer: Inger-Lise McMillan
Production: Matthew Pimm

The staff for this book at Aperture Foundation includes:
Juan García de Oteyza, *Executive Director*; Michael Culoso, *Chief Financial Officer*; Lesley A. Martin, *Publisher, Books*; Jenny Goldberg, *Assistant to the Publisher*; Nima Etemadi, *Assistant Editor*; Andrea Smith, *Director of Communications*; Kristian Orozco, *Sales Director*; Kellie McLaughlin, *Director, Limited-Edition Photographs*; Maria Laghi, *Director of Development*; Simone Eißrich, Paula Kupfer, and Arielle de Saint Phalle, *Work Scholars*

This volume is part of Aperture Ideas: Writers and Artists on Photography, a series devoted to the finest critical and creative minds exploring key concepts in photography.

First edition
Printed in Hong Kong
10 9 8 7 6 5 4 3 2 1

Library of Congress Cataloging-in-Publication Data

Badger, Gerry.
 The pleasures of good photographs : essays / by Gerry Badger. -- 1st ed.
 p. cm.
 Includes bibliographical references and index.
 ISBN 978-1-59711-139-3 (pbk. : alk. paper) 1. Composition (Photography) 2. Photography--History. 3. Photography--Philosophy. I. Title.

 TR185.B3195 2010
 770.1'1--dc22

 2010005314

Aperture Foundation books are available in North America through:
D.A.P./Distributed Art Publishers, 155 Sixth Avenue, 2nd Floor, New York, N.Y. 10013
Phone: (212) 627-1999, Fax: (212) 627-9484

Aperture Foundation books are distributed outside North America by:
Thames & Hudson, 181A High Holborn, London WC1V 7QX, United Kingdom
Phone: + 44 20 7845 5000, Fax: + 44 20 7845 5055, Email: sales@thameshudson.co.uk

aperturefoundation
547 West 27th Street
New York, N.Y. 10001
www.aperture.org

The purpose of Aperture Foundation, a non-profit organization, is to advance photography in all its forms and to foster the exchange of ideas among audiences worldwide.